POSTMODERN TIMES

POSTMODERN TIMES

A Critical Guide to the Contemporary

Edited by Thomas Carmichael and Alison Lee

Northern Illinois
University
Press
DeKalb
2000

© 2000 by Northern Illinois University Press

Published by the Northern Illinois University Press,

DeKalb, Illinois 60115

Manufactured in the United States using acid-free paper

All Rights Reserved

Design by Andy Wong

Library of Congress Cataloging-in-Publication Data

Postmodern times: a critical guide to the contemporary / edited by

Thomas Carmichael and Alison Lee.

 P. cm.

Includes index

ISBN 0-87580-251-6 (alk. paper)

1. Postmodernism — Social aspects.

I. Carmichael, Thomas Joseph Daniel, 1955– . II. Lee, Alison, 1957– .

HM449. P67 2000

306--dc21 99-28171
 CIP

A portion of Susan Strehle's essay is adapted from her book,

Fiction in the Quantum Universe.

Copyright 1992 by the University of North Carolina Press.

Used by permission of the publisher.

CONTENTS

ACKNOWLEDGMENTS

We would like to thank Martin Johnson, Susan Bean, Anne Taylor, and the staff at Northern Illinois University Press for their editorial encouragement and direction. In addition, we would like to thank Susan McDonald and Haytham Mahfoud for all their editorial assistance in the preparation of the manuscript, as well as J. Harlow and M. Asquith. Finally and at long last, we want to extend our heartfelt thanks to our patient contributors.

POSTMODERN TIMES

Introduction

Postmodern Life, Or What You See Is What You Get

Thomas Carmichael and Alison Lee

In some remarks to a post–Cold War audience in Stuttgart, Germany, in the late summer of 1991, the American novelist John Barth observed: "2000 seems an appropriate target date for winding up Postmodernism as a cultural and aesthetic dominant, just as 1950 or thereabouts was a historically tidy date for bidding auf Wiedersehen to High Modernism" (309). Whether Barth's periodizing prescription is accurate or not, there is widespread agreement that the condition of postmodernity and its superstructural expression in the intersecting, competing, and overlapping practices that travel together under the sign of postmodernism have dominated the structure of lived experience in the developed world in the second half of the twentieth century (Barth 277).[1] Although it is a multinational cultural dominant of the world's most developed economies, postmodernism, like modernism before it, emerges from specific historical situations and national conditions. In Europe, and particularly in France,

for example, postmodernism might well be said to come about in the arrival of a fully developed consumer culture and in the economic and social transformations that began to take hold, as Jean-François Lyotard points out, at "the end of the 1950s, which for Europe marks the completion of reconstruction" (3). In this reading, postmodernism comes into its own in the wake of the failed anti-Oedipal revolts of 1968 and in the intellectual climate of post-Althusserian and poststructural discourse.

In North America, the emergence of the cultural forms of postmodernisn might be said to date from the very different breakup of the authoritarian consensus of Cold War liberalism in the countercultural disruptions of the Vietnam era, which mark the end of the imperial American 1960s in the political sphere. Others, particularly those sensitive to the dynamics of the cultural imaginary in the United States, might choose November 22, 1963, and its televised aftermath as a primal moment of symbolic transformation, particularly since the event in the contemporary cultural imaginary has subsequently become saturated with an eerily postmodern sense of its own representation; still others would point with approval to Charles Jencks's assertion that postmodernism properly began at 3:32 P.M. on July 15, 1972, the moment the Pruitt-Igoe housing development, inspired by Corbusier and his modernist project for modern living, was demolished after being deemed uninhabitable.[2] Nonetheless, almost all would agree with the broader claim that postmodernism and the condition of postmodernity are produced out of what Fredric Jameson describes as "the brief 'American century' (1945–73) that constituted the hothouse, or forcing ground, of the new system" (xx). Jameson argues that postmodernism represents the first "specifically North American global style," and on this point he has been joined by Stuart Hall, who claims that postmodernism is largely "about how the world dreams itself to be American" (Jameson xx; Grossberg 46). Yet, while few would contest the notion that postmodernism has been fueled by the dominance of American-based multinational cultural production in the West since World War II, Jameson's broader notion of a new world system is perhaps more central to reflections on the culture of postmodernity.

The essays in this volume represent an attempt to map the new world system. Collectively, they aspire to what Jameson, following Sartre, calls a moment of totalization, or taking stock. Although a charged term in the discourse that surrounds postmodernism, totalization for Jameson implies not some systemic mastery but rather the opposite: the need from time to time for a provisional "summing up, from a perspective or point of view, as partial as it must be" (332). The present provisional summing up takes as its starting point the recognition that to speak of postmodernity currently is not to speak of a nascent dominant but of a culture whose practices and modes of understanding have come to take on the ideological taint of common sense. In this respect the current collection is engaged in

a project of recovery in order to expose and to make plain again, for the first time, the assumptions of postmodernism and the logic of its historical moment. The thirteen essays in this volume focus on how the transformations of postmodernity have occasioned a critical rethinking of crucial modes of cultural understanding. The categories of this collective exploration—from the subject to representation, from technological mediations to generic disruptions, and from specialized to everyday exchanges in cultural practices and institutions—have been chosen in order to throw into relief the major sites of postmodern reconfiguration. They have been drawn together here in order to sketch out the axial lines that might offer the necessary terms for a provisional totalization, that is, to sketch out an introduction to advanced postmodernism.

As Jameson suggests, the proliferation of postmodern cultural practices and styles is part of the vast transformation to a post-Fordist economy that began in the industrialized world in the early 1970s. Many have attempted to mark the beginnings of this reconfiguration of the cultural space of late capitalism, from David Harvey, who carefully mapped the sea-change in cultural and political practices that first became felt around 1972, to Jameson, whose own impressionistic sense "that both levels in question, infrastructure and superstructures—the economic system and the cultural 'structure of feeling'—somehow crystallized in the great shock of the crises of 1973 (the oil crisis, the end of the international gold standard, the end of the great wave of 'wars of liberation' and the beginning of the end of traditional communism)" (xx). What these descriptions hold in common is the assumption that postmodernism is a periodizing notion in which cultural practices are to be understood as historical expressions of transformations in dominant modes of production and circulation. In one sense, of course, this is to assert that postmodernism is merely another instance in the historical procession of period styles in the West, but it is also to suggest that the specific historical situation of postmodernism—its conflicted relationship to modernism and modernity and its deeply implicated relation in the world system of late capitalism, to cite but two aspects of that situation—represents a new and freshly reconfigured world system within which styles and discourses find themselves represented in unfamiliar and uncanny ways.

But even so meager a historical narrative of postmodernism might well be contested, starting from the very notion of periodization that began this discussion. After all, postmodernism has been celebrated as the last cultural dominant of "prehistory," the cultural period that has finally banished the notion of periodization, along with totalization and the illusion of universal subject, so that marginality and heterogeneity might finally occupy the emancipatory center of a fully politicized culture. Even Terry Eagleton has recently admitted, albeit somewhat grudgingly, that on these grounds postmodernism is not "just some sort of theoretical

mistake" but rather represents "the ideology of a specific historical epoch in the West, when reviled and humiliated groups are beginning to recover something of their history and self-hood," a movement Eagleton calls "the trend's most precious achievement" (121). As Eagleton and others before him have pointed out, however, the construction of postmodernism as an oppositional culture can never escape from the mimetic logic that is so deeply inscribed even in its most emphatically radical strategies and discourses.

Whether considered as a habit of thought or as a field of situated cultural practices and artifacts, postmodernism has long been recognized as a critical culture often undermined by the very premises and conditions of its critique.[3] In its poststructural affiliation, for example, postmodernism has articulated a powerful message about the nonconceptual space of *différance* and the decentered subject, but postmodernists have found it more difficult to carve out a space for agency in some now globally defined notion of the public sphere. In part, this difficulty stems from the inability of postmodernism to think beyond antifoundationalism and the proliferation of identity positions, except in terms of local movements, micropolitics, and group affiliations; however, the political problems of the postmodern subject may in the end have more to do with its inescapable complicity with the system within which it is constructed. The thoroughly constructed and fragmented subject of heterogenous desire is, after all, also the subject of the market par excellence. In this regard, as Terry Eagleton wryly notes, at least in the sphere of the market, "Many a business executive . . . is a spontaneous postmodernist" (133). In the same vein, Fredric Jameson observes that, while often divided on the question of technology, every variant of modernism embraced a hostility to the market: "The centrality of this feature is then confirmed by its inversion in the various postmodernisms, which, even more wildly different from each other than the various modernisms, all at least share a resonant affirmation, when not an outright celebration, of the market as such" (305). Modernism's hostility to the market, Jameson reminds us, is principally asserted in its love of archaic and solitary forms of cultural production that "glorified, celebrated, and dramatized older forms of individual projection which the new mode of production was elsewhere on the point of displacing or blotting" (307). Of course, this is only half the story, for it was modernism's celebration of individual production as a mode of resistance that made it possible for its most radical formalist gestures to be appropriated as the "official" avant-garde culture of the Cold War state-corporate apparatus in North America. But this, too, is perhaps Jameson's point, particularly when it comes to the relation between postmodernism and the condition of postmodernity.

In one sense, as Thomas Docherty has remarked elsewhere, postmodernism's vexed relation to the world system of late capitalism is a question

of Marxism, at least in the tradition of the Frankfurt School and its reflections on technology, reason, mass culture, and enlightenment. But the precise nature of this vexed relation is perhaps best conveyed not in the older vocabulary of the Frankfurt School but in Fredric Jameson's assertion that postmodernism signals that moment in cultural history at which "everything in our social life—from economic value and state power to practices and to the very structure of the psyche itself—can be said to have become 'cultural' in some original and yet untheorized sense" (Docherty 3; Jameson 48). As Terry Eagleton suggests, a critical postmodernism typically "scoops up something of the material logic of advanced capitalism and turns this aggressively against its spiritual foundations"; that is, postmodernism finds its most conspicuous expression within the dynamic of late-capitalism cultural production, where it has been fueled by the culture of spectacle and consumption, whose totalizing, disciplining, and homogenizing imperatives it has so resolutely parodied, but whose technologies of virtual mediation, for example, it has so often enthusiastically embraced (Eagleton 133).

To suggest that there is a solution to this dilemma is of course to indulge in a fantasy of some foundational vantage point outside the present moment from which the contradictions and antagonisms of contemporary history and its forms of cultural production might be resolved. But to suggest that there is a dynamic condition to which this dilemma corresponds and out of which we might apprehend the situated historical conditions of postmodernity is a very different notion, one that is at the heart of the collective project of the essays in this volume. Our opening essays by Michael Zeitlin and Diane Elam initiate this project by addressing the reconfigured situation of the subject in postmodernity. Although the celebrated claims of the death of the subject and of the end of the solid identities of liberal humanism are by now simple axioms of contemporary thought, there is a continuing preoccupation with the subject in postmodernism. Zeitlin and Elam address the extent to which the legacy of modernism and modernity persists, whether it is understood as the history of liberal constructions of the self in the West or as the continuing project of Enlightenment reason. Taken together, their discussions of the historical situation of the postmodern subject and of the reconfigured political potential of that subject set the terms of a conversation that will appear in different guises and with different emphases throughout this volume, as the conversation does every day in the professional and public discourse devoted to postmodernism and postmodernity.

Elam's emphasis on the political dimension of postmodern thought opens the way for those political readings of the project of postmodernism that inevitably take postmodern rethinking of the function and field of the subject as a starting point. Thomas Docherty's essay on postmodern politics indeed begins with the historical observation that the subject as

constituted by modern political thought is fundamentally a psychoanalytic construction, which effectively precludes a genuine political discourse. Whether conservative or oppositional, Docherty argues, a politics premised upon a depth model and an appeal to a foundational truth ignores the transformations of the postmodern moment. Following the work of Paul Virilio and Michel Serres, Docherty argues that the present political culture is driven not by a depth metaphor but by a metaphor of surfaces "in which the very fact of appearance on the surface is crucial." In many ways, Docherty's description of the subject in postmodern politics echoes Elam's formulation of a subject of feminism as one who would think beyond the horizon of identity politics; insofar as both are concerned with the enactment of justice and with the worldly dimensions of postmodern theory, however, Elam and Docherty also look forward to Henry Giroux's discussion of the politics of youth culture and the literal production of the subject in the "consumer pedagogy of almost every aspect of youth culture."

Giroux's essay invites us to read postmodernism as the lived experience of the system of late capitalism and as a response to that system, one which, he insists, must be enlivened with the promise but not the practice of modernity. For Giroux, postmodernism is useful to the extent that it provides a discourse that might be used to understand the proliferation of diversity amid the diminution of authority, the economic uncertainty, and the exponential increase in forms of electronic mediation that come together to inform and to construct youth. The positive potential of postmodernism, then, comes from its ability to encourage an openness to plurality and a skepticism toward claims to authority and mastery.

To the extent that Giroux's call for a postmodern pedagogy is also an argument for a postmodern politics of representation, his essay provides an introduction to the next four essays in this collection, which take up the question of the specific transformation of the culture of the image in postmodernism. The first two essays, those by Margot Lovejoy and Peter Lunenfeld, address what many would consider to be the central fact of postmodern visual culture: the qualitative transformations brought about by the proliferation of new forms of visual technologies and the impact of technological mediations on the production, distribution, and consumption of art culture. Lovejoy's essay argues for a consideration of the Utopian space of new electronic communications technologies in postmodernity, which, she argues, mark not merely a shift in period styles but also a "fundamental global reorganization." At one level, newer and more accessible forms of reproduction have raised serious questions about claims to originality, authority, and proprietary rights with respect to images and texts, which have in turn challenged older notions of individual artistry and production. Docherty's essay touches on these issues, and they are the focus of Wendy Griesdorf's consideration later in this volume of

the importance of contemporary forms of parodic reproduction within the professional discourse and practices of the law. The emphasis in Lovejoy's essay, however, is on the democratic and empowering possibilities made available by technology in the dissemination of art through advanced forms of reproduction, in the freedom of image manipulation through the pixellated image, and in the promise of interactive forms of production and consumption.

Peter Lunenfeld's major concern is not merely the appropriation of possibly emancipatory technologies into the system of late capitalism but rather the failure of even those who are fully persuaded by the new mediations to develop a worldly aesthetic that might fully account for their practices. In Lunenfeld's terms, we need to develop a "hyperaesthetic" as a means of thinking beyond the horizon of what we now accept as critical theory, which, he notes, "remains completely imbricated in analog systems." Lunenfeld then sketches the necessary conditions for a hyperaesthetic, which would be grounded in a rigorous critical practice that "encourages a hybrid temporality, a real-time approach that cycles through the past, present, and future to think with and through the technoculture."

Wendy Griesdorf's contribution to this volume invites us to consider postmodern art, particularly its use of parody and the subversion of originality, as a scene of literal conflict, played out in the context of the law and legal discourse. Even though contemporary antifoundationalist thinking has begun to make its way into legal studies (as in the work of Stanley Fish, for example), postmodern skepticism with respect to notions of originality is still very much at odds with the thought that informs the legal system, specifically United States copyright laws, which, as Griesdorf puts, "are built around concepts of originality, creativity, and authorship." Griesdorf explores the consequences of this conflict through a study of the case of Jeff Koons, an "appropriation" artist who was sued for copyright infringement by the photographer Art Rogers because Koons made a sculpture (two copies were sold) that parodied one of Rogers's photographs. Griesdorf's close reading of the clash between postmodern art and the legal system also marks a turning point in this collection. Having considered the postmodern reconfiguration of the subject, the political forms that might be made possible by that reconfiguration, and the politics of postmodern representations, the collection turns its attention to other forms of cultural expression dominated by or inflected by the postmodern condition.

The first of these essays, Charles Jencks's reconsideration of the modes of postmodern architecture, might also be thought of as another beginning for this volume since it is from the field of architecture, particularly from Jencks's discussions of it, that much of our understanding of the characteristics of postmodern representations derive. In this updated

account of what we can now call the history of postmodern architecture, Jencks asserts that the primary division between modern and postmodern architecture rests in two very different attitudes toward history and in what an older vocabulary might term "context." Jencks traces the history of architecture's return to historicism, a problematic return when postmodern architecture begins to take on programmatic features, such as those of the mass-produced modernism of Cold War architecture. But as he observes, this circumstance is perhaps mitigated by the recent postmodern interest in the dynamics of continuing change or, as Jencks terms it, the emergence "of sudden new order out of chaos," and "the metaphysics of self-organizing systems." Jencks's description of the connection between chaos theory and postmodernism has figured prominently in his recent reflections on the course of current cultural movements, and he returns to this connection in his discussion with Alison Lee at the end of the volume.[4]

If Jencks tracks the trajectory of postmodernism as a cultural dominant, Linda Hutcheon maps the place of postmodernism within the field of opera, a cultural form that has only recently been influenced by postmodern impulses. She argues that postmodernism has entered into contemporary opera largely as a function of the reconfiguration of the spectacle itself: "Reflexivity, parody, and this kind of re-historicizing of meaning are the field markings of the postmodern in operatic productions." To the extent that opera has always been metamusical, postmodern forms of reflexivity are not entirely unfamiliar; still, there are distinctly postmodern forms of reflexive parody at work in many contemporary operas, and Linda Hutcheon's extended discussion in this essay of John Corigliano and William M. Hoffman's 1991 opera *The Ghosts of Versailles* does much to demonstrate the presence of a postmodern dynamic in contemporary operatic productions. However, as Hutcheon explains, opera's postmodern moment is also inescapably caught up with the particular situation of opera as a form of cultural production, so that, as with visual art practices, the possibilities for postmodern opera are shaped by the market, that final source of the mimetic and ironic logic of postmodernism itself.

Glenn Hendler's consideration of the postmodern presence in the culture of mainstream television is, like Hutcheon's essay, an examination of postmodernism's relation to a fully developed cultural expression, but whereas, as Hutcheon notes, postmodernism may enjoy something of an eccentric relationship to the tradition of grand opera, postmodern television, as Hendler amply demonstrates, presents the critic with a dense series of entanglements. Because of its dependence upon straightforward realistic modes of narration and its devotion to convention, mainstream commercial television has often been regarded as not particularly postmodern in its orientation, despite its frenetic, technologically mediated culture of images. Hendler argues, however, that television is very much

at the heart of postmodern cultural practices, which is perhaps most true not in the scattered examples of television's attempt to be "postmodern" but in its everyday circulation of a thoroughly commodified flow of self-referring, incommensurable, mass-directed signs. For Hendler, this means that television is to be understood not as a coherent form of cultural expression but as a form in which incompatibility, self-referentiality, and the logic of late capitalism come together day after day to attract the attention of millions of us who find in television, reading with or against the grain, postmodernism's most conspicuous representation of the pleasure of the text.

The next two essays in this volume address postmodern literature, which, along with architecture, might be thought of as one of the original fields of postmodern culture, the starting point for much postmodern theorizing, and the source for many of the traits now considered hallmarks of a postmodern style. But the institution of literature as a form of cultural expression occupies something of an uneasy situation in postmodernism, having succeeded by divorcing itself from mass culture and from the mass-cultural forms of literary expression, a separation that has only lately tried to redress through the imperial gestures of cultural studies and, historically, through the much-vaunted opening of the canon. The two essays on literature in this volume present very different responses to this dilemma. The first, by Bill Readings, invites us to consider the relationship between postmodernism and literary history as a fundamental rethinking of the weight of history, of literary culture, and, finally, of the aim of reading itself. Following the work of Lyotard, Readings argues that, in contrast to the modernist fantasy of an ahistorical present from which the past might be viewed and ordered, postmodernism signals the haunting return of the past as something that "can neither be inhabited (it is past, it is not completely present) nor abandoned (it is not completely past)." For Readings, a postmodern literary history would remind us that we are implicated in a history that is not our own, that we are constructed by that history, but also that as bodies we are made up of affects and intensities. A postmodern literary history would thus restore the cultural past to the present as the living experience of implication and of responsibility, signaled in the strangeness in every claim to self-presence and in the affective investment that continually outruns knowledge and mastery.

For Susan Strehle, the relation of postmodernism to literature finds perhaps its most complete development in the connection between postmodernism and chaos theory. Postmodern culture and postmodern science, she observes, both embrace the view that "uncertainty is basic and fundamental, that some problems cannot be solved, [and] that knowers always enter into and shape what they can know." In a detailed recounting of the history of quantum physics, Strehle explains how Heisenbergian uncertainty and Neils Bohr's principle of complementarity are continuous with

the contemporary interest in chaos theory and self-organizing systems. Strehle then demonstrates, through a close reading of Margaret Atwood's short story "The Age of Lead," how postmodern literature thematizes the preoccupations of postmodern science and thereby opens up the discourse of science to history and to lived experience.

The final formal essay in this volume serves up Paul Budra's reflections on postmodern cuisine. In his analysis of styles of consumption, technological mediations, and the simultaneously eclectic and homogenizing semiotics of contemporary culinary presentations, Budra's discussion is a cogent demonstration of the postmodernity of everyday life. Budra's essay is also a fit summary statement of the preoccupations that have informed the other contributions to this volume. Budra reads postmodern cuisine historically as a scene of post-Fordist consumption and symbolic capital accumulation largely made possible by Fordist technologies of food production and distribution. But whereas Fordist production sought to create and to satisfy the needs of a narrowly defined universal subject, the culture of consumption that shapes postmodern cuisine in turn constructs a consuming subject who comes very much to resemble the subject of postmodern psychoanalysis. That the subject of postmodernity and the subject of the market come to be identified with each other is no coincidence, as we pointed out earlier, following Terry Eagleton's observations. But what Budra's discussion manages to do is provide a compelling account of how the logic of the fully commodified world system of postmodernity actually works in constructing the subject who at every level is an effect of the system.

Our volume concludes with a conversation with Charles Jencks that takes up many of the fundamental questions that inform this volume—from the definition of postmodernism to the future of a critical postmodernism in a world system that for a time at least (and who knows for how long) seems willfully stalled in its acquiescence to the mystifications of the market. Jencks also reflects upon the spiritual movements within postmodernity and on the ways in which this often overlooked dimension of contemporary culture holds much that might be considered proleptic with respect to the course of cultural dominants in the early twenty-first century.

Together the essays in this volume provide the means for a partial summing up of the postmodern condition. *Postmodern Times* is very much about how we currently live in late capitalism and offers a critical guide to the contemporary. This collection is designed to encourage us to reflect on the dynamic of the present or, more precisely, on the logic of a world system in which, as the American novelist Don DeLillo describes it, "desire tends to specialize, going silky and intimate" while at the same time "an instantaneous capital . . . shoots across horizons at the speed of light, making for a certain furtive sameness, a planing away of particulars that

affects everything from architecture to leisure time to the way people eat and sleep and dream" (786). It is to mapping the lived experience of desire and representation in this world system that the collective project of *Post-modern Times* is dedicated.

<div align="center">NOTES</div>

1. It is not clear, however, whether Barth believes this millennial logic. By his own admission, his presence at those 1991 Stuttgart seminars was also designed to put the lie to just such a sense of an ending: *"I wanted,"* he recalls, *"like Mark Twain to make the case that reports of my demise were being greatly exaggerated"* (277).

2. For David Harvey's now often cited description of the "sea-change" into postmodernity, see *The Condition of Postmodernity*, 39–66. Harvey also quotes Jencks's identification of a precise moment of death for modern architecture (39). Jencks's original comment can be found in his *The Language of Post-Modern Architecture*, 9.

3. The critical response to this cultural logic varies widely, from Linda Hutcheon's largely descriptive notion of "complicitous critique," which she finds characteristic of postmodernist fiction, to Christopher Norris's contempt for Jean Baudrillard's aphoristic celebration of the culture of simulation. See Hutcheon, *A Poetics*, and Norris, *Uncritical Theory*.

4. Although Jencks's connection of recent postmodernism to chaos theory is not universally acknowledged, it is a view shared by John Barth and one upon which he elaborates at length in "4½ Lectures," 328–42.

<div align="center">WORKS CITED</div>

Barth, John. "4½ Lectures: The Stuttgart Seminars on Postmodernism, Chaos Theory, and the Romantic Arabesque." In *Further Fridays: Essays, Lectures, and Other Nonfiction, 1984–94*. Boston: Little, Brown, 1995. 275–348.

DeLillo, Don. *Underworld*. New York: Scribner, 1997.

Docherty, Thomas. "Postmodernism: An Introduction." In *Postmodernism: A Reader*, ed. Thomas Docherty. New York: Columbia University Press, 1993. 1–31.

Eagleton, Terry. *The Illusions of Postmodernism*. Oxford: Basil Blackwell, 1996.

Grossberg, Lawrence. "On Postmodernism and Articulation: An Interview with Stuart Hall." *Journal of Communication Inquiry* 10 (1986): 45–60.

Harvey, David. *The Condition of Postmodernity: An Inquiry into the Origins of Cultural Change*. Oxford: Basil Blackwell, 1989.

Hutcheon, Linda. *A Poetics of Postmodernism: History, Theory, Fiction*. New York: Routledge, 1988.

Jameson, Fredric. *Postmodernism, or, the Cultural Logic of Late Capitalism.* Durham: Duke University Press, 1991.

Jencks, Charles. *The Language of Post-Modern Architecture.* London: Academy Editions, 1981.

Lyotard, Jean-François. *The Postmodern Condition: A Report on Knowledge.* Trans. Geoff Bennington and Brian Massumi. Minneapolis: University of Minnesota Press, 1984.

Norris, Christopher. *Uncritical Theory: Postmodernism, Intellectuals & the Gulf War.* Amherst: University of Massachusetts Press, 1992.

Postmodern
Subjects

Psychoanalysis and the Postmodern Subject

The Question of a Metapsychology

Michael Zeitlin

With the famous dying away of the old modernist or bourgeois individual, a traditional unit of cultural analysis fades into something wider and more amorphous: the whole contemporary sign-sprawl as endlessly produced, reduplicated, and overdetermined by a global web of corporations, ad agencies, Hollywood production studios, radio and television networks, Internet providers, and publishing companies. According to a compelling definition of postmodern social reality, the waxing of the public image-world coincides with the waning of the traditionally valorized private subject who might be thought capable of resisting its seductions. Yet in the wake of the expiration of the old modernist subjectivity and the various languages with which it used to be represented, how are we to imagine and to describe the conditions in which genuine privacy, resistance, and praxis (whether personal or collective) might be reclaimed in the postmodern world? From a psychoanalytic point of view, the question thus posed demands a metapsychological answer,

whose project would be to isolate, map out, and so reinforce the last ves-
tiges of interior space from which critical and creative resistance and
agency might be said to flow.

Here I am using the term "metapsychology" in the orthodox Freudian
sense to suggest a mapping of the mind—or "psychical apparatus"—in its
various interlocking economic, dynamic, and topographical structures.[1] If
at the present time a general postmodern metapsychology is both lacking
and urgently needed, this predicament is to be understood as bound up
with the ongoing dissolution of the border between the private and the
public spheres. That is, in contemporary theory (as in contemporary life),
the actual "point of interaction" between postmodern realities and "sub-
jective existence is still a relatively mysterious one" (Smith xxx). And pre-
cisely because "the relationship between the individual and the system
seems ill-defined, if not fluid, or even dissolved" (Jameson, *Late Marxism*
252), it has tended to generate a rich but also somewhat arbitrary and un-
stable mixture of descriptive metaphors and tentative scare-quote con-
structions, as might be noted, for example, in Michel Foucault's preface to
Deleuze and Guattari's *Anti-Oedipus:* "Informed by the seemingly abstract
notions of multiplicities, flows, arrangements, and connections, the analy-
sis of the relationship of desire to reality and to the capitalist 'machine'
yields answers to concrete questions" (xii).

The abstraction and uncertainty that attend any definition of the con-
tours of the would-be concrete postmodern individual are also to be un-
derstood as reflecting another aspect of our general representational crisis,
what Fredric Jameson describes as "the incapacity of our minds, at least at
present, to map the great global multinational and decentered communi-
cational network in which we find ourselves caught as individual subjects"
(Jameson, *Postmodernism* 44). As the postmodern communicational appa-
ratus, in its very efficiency, extends and reduplicates itself by means of the
television set and the computer screen, it comes to "penetrate the older
autonomous sphere of culture and even the Unconscious itself" (122). If
even this last domain of interiority has now been colonized by the forces
of an imperializing exteriority (though postmodernism—by definition—
deconstructs this binary), how are we to imagine the place from which
postmodern culture may be judged, rejected, or transformed?:

> For it seems plausible that in a situation of total flow, the contents of the
> screen streaming before us all day long without interruption (or where the
> interruptions—called *commercials*—are less intermissions than they are fleet-
> ing opportunities to visit the bathroom or throw a sandwich together), what
> used to be called "critical distance" seems to have become obsolete. (Jame-
> son, *Postmodernism* 70)[2]

To be sure, the loss of critical distance with respect to "the totality"
should not be understood as being wholly unprecedented. Indeed, the

history of this loss is a ground theme of the whole twentieth century, from the time of World War I and the Russian Revolution; to the rise of the totalitarian regimes of Germany, the Soviet Union, and China; through World War II, the Cold War, and the current post–Cold War world, in which death camps, mass psychology, and charismatic leaders are hardly antiquated, historical, or obsolete. For Herbert Marcuse of the famous Frankfurt School, the subversion of the autonomy of the individual subject or ego was to be understood in the first instance as preparing "the ground for the formation of *masses*. The mediation between the self and the other gives way to immediate identification" with outside forces and figures ("Obsolescence" 235). As an emigré from Hitler's Europe, Marcuse had in mind not only the mass psychologies of European fascism but also what he felt to be the fascism-in-readiness of postwar American society. Both scenes implied a radical impoverishment of the power of individual autonomy as rooted in the resistant ego:

> The shrinking of the ego, its reduced resistance to others appears in the ways in which the ego holds itself constantly open to the messages imposed from outside. The antenna on every house, the transistor on every beach, the jukebox in every bar or restaurant are as many cries of desperation—not to be left alone, by himself, not to be separated from the Big Ones, not to be condemned to the emptiness or the hatred or the dreams of oneself. (Marcuse, "Obsolescence" 235)

What Marcuse called this "immediate, external socialization of the ego, and the control and management of free time—the massification of privacy" has come to signal for Jean Baudrillard not merely "the weakening of the 'critical' mental faculties: consciousness and conscience" but also their complete annihilation in the technological nightmare of schizophrenia, that everyday postmodern pathology that has displaced all the old, "bourgeois" pathologies (Marcuse, "Obsolescence" 238; 237).[3] Baudrillard's harrowing passage from "The Ecstacy of Communication" is worth quoting at length:

> No more hysteria, no more projective paranoia, properly speaking, but his state of terror proper to the schizophrenic: too great a proximity of everything, the unclean promiscuity of everything which touches, invests and penetrates without resistance, with no halo of private protection, not even his own body, to protect him anymore. . . . What characterizes him is less the loss of the real, the light years of estrangement from the real, the pathos of distance and radical separation, as is commonly said: but, very much to the contrary, the absolute proximity, the total instantaneity of things, the feeling of no defense, no retreat. It is the end of interiority and intimacy, the overexposure and transparence of the world which traverses him without obstacle. He

> can no longer produce the limits of his own being, can no longer play nor stage himself, can no longer produce himself as mirror. He is now only a pure screen, a switching center for all the networks of influence. (132–33)

"This forced extroversion of all interiority, this forced injection of all exteriority that the categorical imperative of communication literally signifies" is the ultimate Pavlovian nightmare (Baudrillard 132). As a way of resisting this nightmare, at least in theory, I shall argue below that the persistent power of the psychoanalytic tradition lies in its effort to zero in on the subject as that psychosomatic place where forces converge, where the action of absorption by or opposition to the system or the machine or the totality may be said to occur. The interface still has an unmistakable psychological dimension, here to be understood as the problem of the subject's "susceptibility" (Adorno et al. 1) or resistance to mass culture's "total flow," which spreads outward only to draw the mass gaze inward toward certain significative consumer images and objects, including the radiant faces of central figures of eros and authority.[4] In opposition to such images projecting from the flat luminous surfaces of everyday life, the gazing subject who has a psychology still has to remain very much in focus precisely because, along with the traditional metapsychological theory with which he had been formerly mapped and comprehended, he is supposedly fading into a nostalgically remembered past: "The evolution of contemporary society has replaced the Freudian model by a social atom whose mental structure no longer exhibits the qualities attributed by Freud to the psychoanalytic object" (Marcuse, "Obsolescence" 233).

For Marcuse, the Freudian subject (of the unconscious id, ego, super-ego), along with the liberal, mediating institutions with which he was involved, was destroyed (literally) by European fascism. And as if to make sure of the matter, this shattering violence was merely an episode in a larger historical transformation of conditions that had enabled the bourgeois birth of Freudian man in the first place, conditions that

> came to an end with the changes in industrial society which took shape in the interwar period. I enumerate some of the familiar features: transition from free to organized competition, concentration of power in the hands of an omnipresent technical, cultural, and political administration, self-propelling mass production and consumption, subjection of previously private, asocial dimensions of existence to methodical indoctrination, manipulation, control. (Marcuse, "Obsolescence" 235)

What was left of the Freudian subject-of-depth, in the Cold War period and after, was being leveled into the capitalist "one-dimensional society," a society without latent sources of critical resistance or "negation" (Marcuse, *One Dimensional Man* 123–43). Just about finished was the

autonomous, resistant sphere of the ego or the coherent interior scene of the family, along with its poignant aporia here pithily summarized by Lionel Trilling: "the family is the conduit of cultural influences, but it is also a bulwark against cultural influences" (46). Formerly the primary agency of socialization and identity formation, the family had given way, with the decline of the father's economic power and hence his objective authority, to the ego's direct management by the television set, the radio, the newspaper, the external institution, the school, the sport team, the gang, the paramilitary club, the Brown Shirts, the Boy Scouts, and so on (my apposition of Brown Shirts and Boy Scouts is, of course, absurd and hyperbolic, but it is meant to suggest the persisting force of Marcuse's German experience, which made him fix on the hypothetical growth conditions for fascism's reemergence in America).

Whether or not the Freudian subject has actually faded from the postmodern scene totally, I shall argue that it is too early to pull the plug on the psychoanalytic metapsychology altogether, especially before anything analytically potent enough arrives to take its place. I suggest that Freudian theory (id, ego, superego, unconscious, dreams, fantasy, oedipus, group psychology, sexuality, perversion, and so forth) and its human subject are still meaningful enough, if only in a transitional or even nostalgic sense. "In a certain way all this still exists, and yet in other respects it is all disappearing" (Baudrillard 126).

Indeed, in the actual everyday scene of the proximity or fusion of human subject and machine-generated sound/image, one suspects that the evacuation of the former's interior is not so absolute. There remains sufficient evidence of the survival of "older" forms of subjectivity, as it is shaped—in its interaction with television's "rot and glut and blare" (DeLillo, *The Names* 266)—by fantasy, dependence, addiction, mourning, fascination, and depression, which themselves signal a kind of latent protest if not a romantic survival of that older, modernist self-as-alienated. That is, the distinction between "watching" and "not watching" television is still somewhat meaningful and is worth attempting to preserve:

> He knew an immense depression would settle in between the time he turned off the set and the time he finally fell asleep. He would have to resume. That's why it was so hard to turn off the set. There would be a period of resuming. He wouldn't be able to go to sleep immediately. There would be a gap to fill. It caused a tremendous wrench, turning off the set. He was *there,* part of the imploding light. (DeLillo, *Players* 125)

In the following discussion, I will link the question of a postmodern metapsychology with the prospects of the resistant ego in the early twenty-first century, pursuing the theme mainly through the text of Lacan. Precisely because of its formidable attack on the ego and its famous

delusions, yet also because of its embeddedness in the texts of Freud, La-can's theory offers us valuable perspective on where we have been and where we may be heading, metapsychologically speaking. For Lacan, lan-guage is the dominant model and metaphor for the ways in which "lines," "nets," or "fields" of force can be imagined as constituting the subject's fundamental actuality (not only in its economic, social, and political di-mensions but also in its "imaginary," "symbolic," and "real" dimensions, to use Lacan's terminology). The language and textuality of the word and the image are privileged sites for psychoanalytic theorizing since it is in re-lation to discourse that the subject is said to be decentered, misaligned, and yet always overdetermined. The task of a psychoanalytic cultural criti-cism would thus be to locate the subject with respect to the discourses and signifying practices that would both "speak" him and speak through him (with various enabling or damaging tensions and consequences). As a principal theorist of the structure and economy of "the Symbolic order," Lacan then is an obvious place in which to search for the potential mak-ings of a metapsychology for the twenty-first century.

Yet it has become somewhat conventional to note that, for Lacan (in ways I hope to clarify below), the signifier is perpetually on the move; hence, a Lacanian metapsychology that is true to itself can only be a com-plex, contradictory, and fugitive "ensemble of conceptual figures" for which we can only postulate a moment of future integration and coher-ence (a moment, of course, to be endlessly deferred) (Laplanche and Pon-talis 249).[5] The subject projected by Lacanian theory, along with the the-ory projected by the Lacanian subject, remains trapped in the "impossible" conditions of its own existence, unable by definition to close the distance or to repair the misalignment between itself and its mirror image, which it can only approach asymptotically. From within the logic of Lacan's text, such conundrums are not easy to transcend. But viewed from a point of appropriate critical distance, Lacan, despite himself as it were, does give us a useful terminology with which to describe the world and its subjects.[6]

Lacanian theory is rooted in and literally unthinkable without the the-ory of Freud, who, in the inaugural instance of his metapsychology, di-vides the subject into two separate, conflicting, yet also in some sense overlapping and mutually interpenetrative regions, one part conscious, one part (the greater part) unconscious. As Lacan moves through Freud's text in pursuing the implications of Freud's radical division of the psyche, he becomes for us a key theorist of the subject's Imaginary alienation, which accompanies his subjection by and dispersal into the postmodern Symbolic order. Yet when Lacan claims that, as a result of Freud's revolu-tionary discovery of the unconscious, "the very centre of the human being was no longer to be found at the place assigned to it by a whole humanist tradition," he tends to misrepresent all in Freud's theory that, in

dialectical relation to its harrowing vision of the subject as *subjected* by the unconscious, seeks to reinforce the capacity of the ego (Lacan, "Freudian Thing" 114). For Freud, there was nothing on the planet but the values and forces associated with the ego's power of analysis, reality testing, reason, and rationality that could hope to succeed against a world dominated by the persistence and tyranny of "emotionally-charged fictions" (Freud, Letter to Fliess 216). In this sense, "the whole humanist tradition" has never had a more powerful thinker than Freud.

LACAN'S SUBJECT

> Freud went back to madness at the level of its *language*, reconstituted one of the essential elements of an experience reduced to silence by positivism. . . . [H]e restored, in medical thought, the possibility of a dialogue with unreason. (Foucault, *Madness and Civilization* 198)

From a Lacanian perspective, Freud's *The Interpretation of Dreams*—the wellspring of psychoanalytic theory—concerns itself, above all, with the subject's relation to language, speech, "the signifier," domains par excellence of an unconscious seen to be "structured in the most radical way like a language" (Lacan, "Direction" 234). For Lacan, human subjectivity and desire are constituted by this speech of the unconscious, this "discourse of the Other" ("Agency of the Letter" 172). Because it, among other things, projects an essentially fraudulent image of the subject's own future wholeness and completion, the discourse of the Other establishes self-delusion and self-division as the subject's native condition. Accordingly, Lacan's paramount question is always, "Who [or what] is speaking?" at any given moment of consciousness, speech, or interhuman discourse ("Freudian Thing" 123). The answer is always, "*it* speaks," or "the Other speaks"; that is, it is never the coherent and volitional self that speaks, the delusion of which, nonetheless, always sustains the dream of a "full discourse."[7] In this sense, Lacan's master narrative is essentially narcissistic: the self is an Other. It can never make full contact with itself or be identical with itself, though "dealienation of the subject" is the (endlessly deferred) object of the psychoanalytic enterprise, both clinical and theoretical (Lacan, "Function and Field" 90).

Much attention has been devoted to Lacan's rewriting of Freud's theory of the unconscious in the language of Saussurean linguistics, but it may be worth reconsidering some of the basic implications of this phenomenon for Lacan's theory of the subject. One might begin by repeating the fundamental Lacanian proposition that "the unconscious is structured like a language" and that language, therefore, is its principal field of operation: *ça parle*. Insofar as "Symbol and language [are] the structure and limit of the psychoanalytic field," the whole project of attempting to locate the

origin or place of the unconscious (in biology, for example, or phyloge-
netic prehistory) is more or less abandoned (Lacan, "Function and Field"
56). Discourse always speaks (for) the unconscious; the unconscious, in
turn, is accessible only *as* discourse, a formulation that resolves itself, in
effect, into an elemental equation: the unconscious *is* discourse. For
Michel Foucault, this unconscious discourse is the very grammar and lexi-
con of the human "soul and body":

> Language is the first and last structure of madness, its constituent form; on lan-
> guage are based all the cycles in which madness articulates its nature. That
> the essence of madness can be ultimately defined in the simple structure of a
> discourse does not reduce it to a purely psychological nature, but gives it a
> hold over the totality of soul and body; such discourse is both the silent lan-
> guage by which the mind speaks to itself in the truth proper to it, and visible
> articulation in the movements of the body. (*Madness* 100)[8]

If for Freud the unconscious is to be understood as always "present and
operative even without betraying its existence in any way to conscious-
ness" (*Dreams* 612), for Lacan the unconscious is present and operative
within and *as* discourse itself: it is everywhere inside and about us, exert-
ing its force, channeling its "silent language" into the perceptible registers
of speech, movement, and symbolic action. Insofar as human being and
consciousness are "orientated in a field of language," the whole psychoan-
alytic enterprise is legitimately focused *on* language (Lacan, "Function and
Field" 39). Hence for Lacan, "the understanding of human speech, and
linguistics, rhetoric and poetics are its indispensable allies" (Bowie 11).

If Lacan retains a sense of the beyond, of the "other" place from which
the discourse of the unconscious always comes to us, his stress on lan-
guage tends to deconstruct any easy binary of surfaces and depths as such
dimensions might be projected by the notion of a mental topography. In
the words of Lacan, "what is analysed is *identical* with what is articulated"
in the encounter between analysand and analyst, and what is articulated
is always language, the signifier ("On a Question" 216; my emphasis). Be-
yond the subject-of-discourse, one encounters no prior signified, core
identity, or biological darkness—only language: it is an "illusion that im-
pels us to seek the reality of the subject beyond the language barrier"
("Function and Field" 94). Hence, the psychoanalyst (or literary or cultural
critic) analyzes "a message that does not come from a subject beyond lan-
guage, but from speech beyond the subject" ("On a Question" 214):

> it is not only man who speaks, but that in man and through man *it* speaks
> (*ça parle*), that his nature is woven by effects in which is to be found the
> structure of language, of which he becomes the material, and that therefore
> there resounds in him, beyond what could be conceived of by a psychology
> of ideas, the relation of speech. ("The Significance of the Phallus" 284)

For Lacan, then, "the ego of the subject is [never] identical with the presence that is speaking to you" ("Function and Field" 90). In his invocation, however, of the "other" place from which discourse always comes, of the elsewhere or the alibi of an ego never fully present to itself or to its interlocutor, Lacan cannot quite lay the specter of an originary inner depth to rest. For the structuralist model he inherits from Saussure, with its division of the Sign into a Signifer and a Signified, inevitably postulates the presence of a diachronic or paradigmatic dimension remarkably compatible with Freud's notion of an unconscious lying "beneath" the conscious domain:

> The psychoanalytic experience does nothing other than establish that the unconscious leaves none of our actions outside its field. . . . It is a matter, therefore, of defining the topography of this unconscious. I say that it is the very topography defined by the algorithm:

$$\frac{S}{s}$$ ("Agency of the Letter" 163)

The hierarchical positioning of Signifier over signified readily blends into Freud's arrangement of manifest over latent, dream content over the underlying dream thoughts, conscious over unconscious, symbolic distortion over "the true psychical reality" (Freud, *Dreams* 613). At this point, however, post-Freudian theory returns to an original Freudian insight. The duplicity of the sign (as both signifier and signified) does not necessarily imply a hierarchy of conscious and unconscious, dispersal and plenitude, but suggests a dialectical "switching between two ways of seeing. . . a change in relationship between manifest and latent significance *of the same material*" (Skura 218; my emphasis). In "Freud and the Scene of Writing," Derrida cites Freud's *Interpretation of Dreams* to this effect: "What we are doing here is once again to replace a topographical way of representing things by a dynamic one. What we regard as mobile *(das Bewegliche)* is not the psychical structure itself but its innervation" (94).[9]

Lacan, therefore, is being (deliberately) reductive and elusive when he insists that "what is analysed is *identical* with what is articulated," since what is articulated must always be evidence of an agency, dynamic principle, or meaning *Other* than what is articulated ("On a Question" 216; my emphasis). Freud's attempt to move past this aporia lays the emphasis differently. Noted Freud, "We have no hope of being able to reach the latter [the unconscious] itself, since it is evident that everything new that we have inferred must nevertheless be translated back into the language of our perceptions, from which it is simply impossible for us to free ourselves" (Freud, *Outline* 196). Yet an unconscious impulse "must pass through a fixed series or hierarchy of agencies" in order to emerge as a translatable, conscious idea (*Dreams* 615). Therefore, once the impulse

emerges, it is the task of the analytic process to track the process "back" along the pathways of its transfiguration, until one "arrives" at the hypothetical place at which something like the original, preverbal thought or impulse can be reconstructed. For Lacan, the paradox of this formulation— "preverbal thought or impulse"—implies that it is "always already" structured like a language, that it would not *be* in any sense if it was not already structured and constituted by the discourse of the Other. In this sense, in the Lacanian register one is always arriving at language or at the system of language: indeed, in Lacan's realm of permanent displacement, in which signifiers lead on only toward other signifiers, one can never arrive at anything else.

As Malcolm Bowie notes, Freud, contrary to Lacan, insists on the radical "discontinuity between the unconscious and the preconscious-conscious and guards the border between the two systems with fierce vigilance. . . . [Lacan] excludes from his sketch . . . any active sense that Freud's account of language had its stubbornly discontinuous registers" (50, 54). In other words, there is a significant difference between, on the one hand, the notion that one must infer the presence of an unconscious that can never be known except through its effects and "representatives" (that is, through discourse) and, on the other, the notion that the unconscious exists nowhere but in discourse. Indeed, even Lacan writes that "the *Trieb* implies in itself the advent of a signifier" ("Direction" 236), acknowledging, in this sense, that without the *Trieb* there can be no signifier.[10] He is unwilling, however, to go the next step with Freud in the direction of a prelinguistic, unabashedly biological source of the drives, a nature prior to the structuring action of a language and culture. Again Bowie's formulation of the matter is particularly effective: Freudian "psychoanalysis proudly keeps watch over the border territories between nature and culture. The drives are an essential part of its subject-matter, and they belong to nature long before they make their oblique and obstructed appearances in the cultural realm" (53).[11]

Lacan is primarily interested in the cultural realm, which is why he tends to abstract Freud's definition of the ego from its embeddedness in biology, a strong Darwinian sense of which lies inseparably bound up with Freudian metapsychology, as it evolves from the so-called first topography to the second topography. In order to gain perspective on Lacan's "return" to Freudian metapsychology (a return that takes the form of a sometimes radical rereading and rewriting of it), a brief exposition is called for at this point.

Freud's first coherent schema of the metapsychological structure, also known as the first topography, comes together in the final two chapters of *The Interpretation of Dreams*. Freud's model is extraordinarily nuanced and complex, but briefly it can be said that the first Freudian metapsychology is a system dominated by the dynamic pressure and counterpressure,

negotiation and contestation, of "primary" and "secondary" psychoso-
matic processes. The primary processes are driven by desire and aim for its
immediate expression and release; the role of the secondary processes is to
"inhibit and overlay" the primary processes and thus to divert their forces
onto acceptable pathways and objects (*Dreams* 603). In the course of this
conflict, desire (which is always essentially "taboo"—the incest wish is its
prototype) is always distorted into symbolic forms so that it might circum-
vent the apparatus of censorship and repression and make its way into hu-
man culture. The entire psychical apparatus is a closed system offering no
release (short of death), no final compromise, no cessation of mental
process. The single constant in the system is the pressure of unconscious
wishful impulses, an incessant flow of energies and impulses that must be
"bound" and transformed through an intensive and largely unconscious
process of imaginative work.[12] Nowhere is the primary-process stream of
energy more readily apparent (albeit in distorted symbolic form) than in
dreams, where the forces exerted by the secondary system are afforded a
much-needed but only partial relaxation of their vigilance:

> [W]hen conscious purposive ideas are abandoned [as in sleep], concealed
> purposive ideas assume control of the current of ideas. . . . The renunciation
> of voluntary direction of the flow of ideas cannot be disputed; but this does
> not deprive mental life of all purpose, for we have seen how, after voluntary
> purposive ideas have been abandoned, involuntary ones assume command.
> (*Dreams* 531, 590–91)

The relative waning of the secondary system's watchfulness during sleep
gives perspective to the magnitude and high intensity of its forces in
general, which are necessary to "bind" the constant flow of primary-
process energy.

Amid this complexity of forces lie consciousness and self-consciousness,
which Freud will locate in a small though significant part of what he will
soon begin to call "the ego." Yet the ego is to be understood as the site and
origin not so much of the "self" or of "identity" as of the overall defensive
(that is, secondary) agency, a complex organization of mental forces de-
signed to preserve and to enlarge the domain of a perpetually threatened
centrality, from which something like creative self-volition might spring.
As conceived on the psychoanalytic model, consciousness represents the
human organism's means of perceiving as well as of protecting itself
against a mainly dangerous external reality. But it is also an inseparable as-
pect of those overall defensive operations that are arrayed around the
literal core of the subject's own primary being, which is why Freud will
insist on "the intimate and reciprocal relations between censorship and
consciousness" (*Dreams* 618): thought both enables and constrains the ex-
pression of desire.

In this sense, the secondary processes—and the principle of inhibition, control, and censorship inherent in them—"deserve to be recognized and respected as the watchman of our mental health" (Freud, *Dreams* 567). That is, they prevent the organism from being overwhelmed, traumatized, and destroyed, as much by excessive quantities of its own primary force per se as by "the reality principle" that is activated, fatalistically as it were, in response to the transgressive act or thought (which invariably owes its principal thrust to the primary process). Invariably, however, the secondary processes themselves are the source of *excessive,* irrational, and equally unconscious forms of repression: the deterioration of "mental health," in this sense, will owe as much to the secondary system's excessive "downward" force as to the primary system's "upward-pushing" insistence. This conflict is the essential definition of neurosis. It is from the basis of this theoretical understanding of consciousness that Lacan will develop his notion of pathology and paranoia as normative for the human subject.

The second topography of id, ego, and superego is to be superimposed upon the first topography. In the second topography even more explicitly than in the first, unconsciousness is a structural feature of all three "agencies." That is, as we move from the first to the second topography, the unconscious domain expands, even as its complex structures and operations become steadily more intelligible and representable. In this model of the psychical apparatus, the id, which lies "beyond" the ego, is to be understood as the instinctual pole of the subject, what had generally fallen under the category of the primary process or what Freud called first the system *Ucs.* and later, simply, the unconscious. Lacan's general term for this will be, simply, Desire, the motive principle of the signifier. In the second topography, however, id is shown to have a direct channel into the superego, which is to be understood as a terminological reification of the repressive, judging, and censoring aspects of consciousness itself. And here it is as much the self as the Other that is so judged and censored. That is, the superego is experienced by the subject (both consciously and unconsciously) as an internalized system of prohibitions, as a voice, as a gaze, as an all too often inimical presence. The prefix "super-" is meant to convey the relative positionalities of metapsychological agencies, which we may picture as structured on the child/parent model: no matter how mature the ego is to become, the superego will always gaze "down" upon it.

Precisely at this point, Freud conveys into his metapsychology the presence of something additionally menacing: whereas in the first topography the essential opposition is between sexual drives and self-preservative instincts and defenses (or between sexuality and the ego), in the second topography the essential opposition is between life and death drives (see *Beyond the Pleasure Principle*). Such drives imbricate all three agencies, but the superego is given special status in connection with the death principle:

Following our view of sadism, we should say that the destructive component had entrenched itself in the super-ego and turned against the ego. What is now holding sway in the super-ego is, as it were, a pure culture of the death instinct, and in fact it often enough succeeds in driving the ego into death, if the latter does not fend off its tyrant in time. (*Ego and Id* 53)

Lacan is deeply engaged, then, with these critical elements of Freud's second topography: the ego as a permanently divided and perpetually besieged and fragile entity; the narcissistic and delusional nature of the ego's relation to itself; the paranoid construction of (self-)knowledge and reality; and the propensity of the subject to take itself as an object for sado-masochistic or even suicidal impulses. Like Lacan, Freud sees the ego as a "poor creature owing service to three masters and consequently menaced by three dangers: from the external world, from the libido of the id, and from the severity of the super-ego" (*Ego and Id* 56). The ego is "hemmed in and hampered by the demands of the id and the super-ego," inhabiting the "impossible" position of having to reconcile radically incompatible demands (Freud, *Outline* 177): "As a frontier-creature, the ego tries to mediate between the world and the id, to make the id pliable to the world and, by means of its muscular activity, to make the world fall in with the wishes of the id" (Laplanche and Pontalis 139). Each successive gain of the id into the territory of the ego invokes "that obscene, ferocious figure in which we must see the true signification of the superego" (Lacan, "Freudian Thing" 143). Furthermore, repression, as opposed to sublimation, of the id entails the scattering loss of primary, libidinal mental force, which is necessary "to master the material of the external world psychically" (Freud, "Goethe Prize" 212).[13] Ominously, it appears that id and superego are in league together against the ego:

Freud himself pointed out that the superego feeds on the forces of the id, which it suppresses and from which it acquires its obscene, malevolent, sneering quality—as if the enjoyment of which the subject is deprived were accumulated in the very place from which the superego's prohibition is enunciated. The linguistic distinction between the subject of the statement and the subject of the enunciation finds here its perfect use: behind the statement of the moral law that imposes on us the renunciation of enjoyment, there is always hidden an obscene subject of enunciation, amassing the enjoyment it steals. (Žižek 159)

That is, no matter in any given instance how coherently organized, how strong, or how enlarged the ego may actually become, there will always be, structurally speaking, a fundamental "antithesis between the coherent ego and the repressed which is split off from it" (*Ego and Id* 17). This superego-driven splitting of the subject, however, should not imply the ossification

of the border separating ego from its antithesis. The ego literally cannot exist apart from "the very field of conflicting forces in which it comes to be constituted and which define the very defensive contours necessary for its preservation" (Bowie 26). The ego, in fact, is the epitome of "the internal space which has become permeable and porous," a space never to be sovereign (Foucault, *Madness* 149). Still, from a Freudian perspective, the ego's task and goal are all too clear: it must strive ceaselessly to secure for itself a measure of autonomy and relative independence.

For Lacan this desire on behalf of the ego is a dangerous illusion. Any effort to shore up the defenses of the ego simply feeds those forces that would fatally compromise and deconstruct, negate and undo it from within. One might approach this paradox of the Lacanian ego in the following manner: The ego is not to be thought of as a central place around which one can erect barriers or as a coherent unity whose sphere can be enlarged. The ego, rather, is a hall of mirrors in which there is no way to distinguish the "true" self from its reflection: "the ego [is] constituted in its nucleus by a series of alienating identifications" ("Freudian Thing" 128). Hence "the mechanism of systematic [self-]*méconnaissance*" (128) is a permanent, constitutive feature of subjectivity. Between the subject and itself, between the self and the Other, between the mind and the reality somehow external to it, the image, the imago, always interposes itself: "Psychoanalysis is the science of the mirages that appear within this field" ("Freudian Thing" 119). The very notion of a "true self," in this sense, is, structurally speaking, an ideological mirage, a projection. To celebrate the "true self" is merely to set in play the forces of a tyrannizing personal and cultural narcissism.[14]

This link between narcissism and tyranny, as forged in Freud's theory, is structural to the complicated relations that obtain between Lacan's so-called Imaginary and Symbolic realms. For Lacan, the Symbolic order is the order of language, law, and patriarchal force; the Imaginary order, which imbues and impregnates the Symbolic, is the order of the image, of resemblances, of the pursuit of sameness—of narcissism, in short. Desire is the dynamic principle of both registers, but since desire must unfold in the realm of language and culture, under the weight of taboo, censorship, and proscription, it must always configure itself, in a never-ending process, into indirect representations of its aims and objects—signifiers "never to be resolved into a pure indication of the real, but always refer[ing] back to another signification" ("Freudian Thing" 126). The Symbolic order designates in this sense the place of the subject's "'impossible' relation to the object-cause of its desire" (Žižek 6). Hence we may recognize as fused into its innermost structure the principle of the law-giving Father:

> It is in the *name of the father* that we must recognize the support of the symbolic function which, from the dawn of history, has identified his person with the figure of the law. ("Function and Field" 67)

It is as if, in Freudian terms, the superego is incorporated into the very structure not only of the self but of human reality, desire, and culture in general.

In Freud's theory, narcissistic self-love is a necessary aspect of human being: one must love and approve of one's self in order to love and to work successfully in the world. But narcissism is also a form of alienation in this sense, for it implies one part of the self as sitting in judgment of the other. In other words, by definition, the self constantly assesses itself and constantly finds its actual ego wanting in some degree or other. Hence, the subject strives to rediscover his ideal self in others (either real persons out of his social milieu or fictional composite figures out of narrative and fantasy, for example, film actors; either way, the ideal self will be informed by partly unconscious images traceable to earliest childhood). What the subject perpetually "projects before him[self] as his ideal," then, "is the substitute for the lost narcissism of his childhood in which he was his own ideal" (Freud, *On Narcissism* 93). In Freud's male-gendered discussion of the phenomenon, the subject learns to love himself in a process of identification with the ideal, all-powerful, (pre)oedipal mother, the one who loves him utterly and absolutely, the one who encloses the self in a comprehensive ideal unity. Such a fantasy, of course, conveniently ignores or represses the precedence of the father in the chronology of the mother's affections, and it elides altogether the circumstances of the self's own procreation. To be a self is, in this sense, to have experienced the deepest of (fantasied) narcissistic loves and the deepest of (real) narcissistic wounds: one's very existence implies that one is always already secondary.

We need not insist on this precise universalizing history of the self to see that the subject—any subject—has always "set up an *ideal* in himself [or herself] by which he measures his actual ego" (Freud, *On Narcissism* 93). This measuring action betrays both the narcissistic origins of the superego and the superego's presence on the scene even before the coming-into-being of the self as such—the self at whose nucleus one always encounters the ego ideal. In the pessimistic and tragic registers, then, the ego ideal designates that point at which the self repeatedly throws himself against his own "impossibility":

> The super-ego is, however, not simply a residue of the earliest object-choices of the id; it also represents an energetic reaction-formation against those choices. Its relation to the ego is not exhausted by the precept: "You *ought to be* like this (like your father)." It also comprises the prohibition: "You *may not be* like this (like your father)—that is, you may not do all that he does; some things are his prerogative." This double aspect of the ego ideal derives from the fact that the ego ideal had the task of repressing the Oedipus complex; indeed, it is to that revolutionary event that it owes its existence. (Freud, *Ego and Id* 34)

Lacan's theory of the mirror stage and the Imaginary order focuses upon the tragic implications of Freud's theory of narcissism. The mirror image "situates the agency of the ego, before its social determination, in a fictional direction" (Lacan, "Mirror Stage" 2). The words "'dans une ligne de fiction' underscore the psychic function of narrative and fantasy in the attempts of the subject to reintegrate his or her alienated image" (Jameson, "Imaginary and Symbolic" 85). The plot of the fantasy narrative engendered by the mirror image leads in a progressive direction, toward a future moment of successful self-integration and coherent coordination (in both the physical and mental senses):

> The mirror image is a minimal paraphrase of the nascent ego. It would have been possible, on the basis of this very limited fund of observational data, to look forward in hope to the ego's later career and to perceive in outline upon a still distant horizon the "mature" self, the self-made man and the social success. (Bowie 22)

In accordance with Freud's theory of narcissism, the self is, essentially, an imaginary organization; in Lacan's emphasis, the imaginary character of the self is a sign of its permanent "discordance with his own reality" ("Mirror Stage" 2). Encumbered with "the armour of an alienating identity, which will mark with its rigid structure the subject's entire mental development" ("Mirror Stage" 4), the subject can "never constitute [himself] as anything but object" ("Agency" 165). For Lacan, "the self's radical excentricity to itself with which man is confronted, [is] in other words, the truth discovered by Freud" ("Agency" 171).

Once again, the self is an Other: "my freedom is alienated by the duplication to which my person is subjected in it" ("Direction" 228).[15] As always, it is possible to trace Lacan's understanding of the matter to Freudian sources. For Freud, the ego or personality constitutes itself through a process of identification with parents, siblings, friends, and role models. Human society is, by definition, the field in which the subject is constructed by—and of—others:

> In the individual's mental life someone else is invariably involved, as a model, as an object, as a helper, as an opponent; and so from the very first individual psychology, in this extended but entirely justifiable sense of the words, is at the same time social psychology as well. (Freud, *Group Psychology* 69)

Whether empowering or debilitating, identification generally subverts the subject's claim to radical and unprecedented originality:

> Each individual is a component part of numerous groups, he is bound by ties of identification in many directions, and he has built up his ego ideal upon the most various models. Each individual therefore has a share in numerous

group minds—those of his race, of his class, of his creed, of his nationality, etc.—and he can also raise himself above them to the extent of having a *scrap of independence and originality*. (Freud, *Group Psychology* 129; my emphasis)

From this Freudian point of view on human culture, Lacan's Symbolic order is to be understood as the field of personal and cultural transferences and fantasies, which are reified as language and sociopolitical institutions and practices. One is always trapped in the imaginary/symbolic field of the Other. (This is how Freud attempted to understand, for example, his objective historical context, one dominated by European crisis, anti-Semitism, and the rise of fascism). It is Freud himself, then, who prepares the way for the postmodern displacement of the unconscious from the personal biopsychic "inside" of the individual human subject to the cultural and discursive "outside," where it becomes the dominant constitutive feature of the very texture of the interhuman world, in both its symbolic and imaginary dimensions.[16]

For Freud, "the boundaries of the ego are not constant" (*Civilization* 66), a formulation that takes us with dispatch further into the heart of Lacan's master narrative of paranoia:

Pathology has made us acquainted with a great number of states in which the boundary lines between the ego and the external world become uncertain or in which they are actually drawn incorrectly. There are cases in which parts of a person's own body, even portions of his own mental life—his perceptions, thoughts and feelings—, appear alien to him and as not belonging to his ego; there are other cases in which he ascribes to the external world things that clearly originate in his own ego and that ought to be acknowledged by it. (Freud, *Civilization* 66)

But the frontier between states of mind described as normal and pathological is in part a conventional one and in part so fluctuating that each of us probably crosses it many times in the course of a day. (Freud, *Dreams* 44)

Lacan doubts whether this line between frontiers can ever be drawn correctly or authentically (and he soundly berates those who claim it can be done). In this sense, delusion and paranoia define the basic structure and condition of human subjectivity itself. We may say, after Freud, but insisting upon the emphasis given by a Lacanian reading of the line, that the "delusional remoulding of reality" is a general and universal condition of postmodern subjectivity:

It is asserted, however, that each one of us behaves in some one respect like a paranoic, corrects some aspect of the world which is unbearable to him by

> the construction of a wish and introduces this delusion into reality. A special importance attaches to the case in which this attempt to procure a certainty of happiness and a protection against suffering through delusional remoulding of reality is made by a considerable number of people in common. (Freud, *Civilization* 81)

Freud has a clear target in the passage just cited: "The religions of mankind must be classed among the mass-delusions of this kind. No one, needless to say, who shares a delusion ever recognizes it as such" (*Civilization* 81). Here it should be noted that by "religion" Freud meant also to include any kind of mass irrational "faith" in a higher authority, as might characterize the psychosocial structure of nations, armies, political parties, and so on. We might further add that it was the major project of the Frankfurt School to analyze the ways in which what they called "the culture industry" also depends on and fosters such mass psychologies of delusion (see Horkheimer, *Dialectic of Enlightenment*). For Lacan, it is not mass psychology but simply imagination itself that is essentially paranoid in its construction of knowledge and reality. "After Lacan," writes Ellie Ragland-Sullivan, "reality, rationality, and objectivity appear as comforting illusions—*points de capiton*—amid the truths of plurality, ambiguity, and uncertainty" (xvii).

Even with his radical displacement of the centers of human subjectivity, however, for Freud there is still the possibility that, with the help of genuine analytical "work," the self or ego might help shape a provisional accommodation among the incommensurable regions of its own subjectivity and beyond. After all, if we tend toward paranoia, this is all the more reason to stress the urgent necessity and highest value of "reality testing." The ethical, therapeutic, and political tasks for Freud, therefore, are clear (consciousness, in this sense, is not always, by definition, mystified). If we truly wish to "return to Freud" (as Lacan exhorts us), we should not overlook or mistake Freud's emphasis:

> Psychoanalysis is an instrument to enable the ego to achieve a progressive conquest of the id. (*Ego and Id* 56)

> [T]he property of being conscious or not is in the last resort our one beacon-light in the darkness of depth-psychology. (*Ego and Id* 18)

> [A]fter all, analysis does not set out to make pathological reactions impossible, but to give the patient's ego *freedom* to decide one way or the other. (*Ego and Id* 50n)

For Lacan, as we have seen, the very hope for self-knowledge, freedom, and self-integration is nothing but an index of the subject's original and

permanent self-alienation with respect to its own mirror image. For Lacan (as for Barthes, Foucault, Althusser, and the much celebrated theoretical ethos of postwar intellectual culture in France), insofar as the "bourgeois norm" remains the "essential enemy" (Barthes 9), so too must be the goal of adaptation to its dominant modes of existence. For Lacan it is not *here,* in the ego in its strength, that we should "come to being" ("Freudian Thing" 129) but always, perpetually, *elsewhere.*

Thus we see that the critical question to be posed to Lacanian metapsychology, given its withering attack on the ego and its famous delusions, mystifications, and forms of false consciousness, is whether it can conceive of any authentic form of individual human agency that might resist and transform the Symbolic order. Yet we continue to deploy its potentially formidable analytical power even as Lacan's text contains no sense of hope that "dealienation of the subject" can be achieved or that his "primordial Discord" can be harmonized ("Function and Field" 90; "Mirror Stage" 4). In the end, we will have to look elsewhere for something like Marcuse's explicit declaration of political urgency in face of the impending "obsolescence of the Freudian concept of man":

> Thus, psychoanalysis draws its strength from its obsolescence: from its insistence on individual needs and individual potentialities which have become outdated in the social and political development. That which is obsolete is not, by this token, false. If the advancing industrial society and its politics have invalidated the Freudian model of the individual and his relation to society, if they have undermined the power of the ego to dissociate itself from others, to become and remain a self, then the Freudian concepts invoke not only a past left behind but also a future to be recaptured. (246)

NOTES

1. See Laplanche and Pontalis: "Metapsychology: Term invented by Freud to refer to the psychology of which he was the founder when it is viewed in its most theoretical dimension. Metapsychology constructs an ensemble of conceptual models which are more or less far-removed from empirical reality. Examples are the fiction of a psychical apparatus divided up into agencies, the theory of the instincts, the hypothetical process of repression, and so on" (249).

2. "[H]e could easily have watched through the night, held by the mesh effect of television, the electrostatic glow that seemed a privileged state between wave and visual image, a secret of celestial energy" (DeLillo, *Players* 17). "Sitting that close all I could perceive was that meshed effect, those stormy motes, but it drew me in and held me as if I were an integral part of the set, my molecules mating with those millions of dots. I sat that way for half an hour or so" (DeLillo, *Americana* 43).

3. "The end of the bourgeois ego, or monad, no doubt brings with it the end of the psychopathologies of that ego" (Jameson, *Postmodernism* 15).

4. I have in mind here the current fascination with the private life of the president of the United States. Let such enormously popular and profitable films as *The American President, Independence Day,* and *Air Force One* suggest the scale of this mass interest in (a) the president as a human character with whom it is possible to have a fantasy relation; (b) American technological, military, moral, and ideological superiority; and (c) "the vertigo before power" (Sontag 87).

5. "To attempt to contain the meaning of 'Symbolic' within strict boundaries—to define it—would amount to a contradiction of Lacan's thought, since he refuses to acknowledge that the signifier can be permanently bound to the signified" (Laplanche and Pontalis 440). See also Lacan's famous and crucial essay "The Mirror Stage" (to be addressed below).

6. Such an approach to Lacan is to be distinguished from the enormously influential one taken by Shoshana Felman: "Lacan's writing disconcerts us precisely because it is consumed by a 'fire' that can never be *located* by the discourse of Meaning. Reading Lacan is like . . . surrendering ourselves to a blindness that *works us over* and *thinks us through* without our necessarily ever achieving an exhaustive understanding of it" (*Writing and Madness* 140).

7. With the formulation "it speaks" (ça parle), Lacan means to suggest various things: the autonomous and automatic speech of Freud's id, of the unconscious, and of language itself. The subject is thus not primarily "the intending and knowing manipulator of [language], or . . . the conscious and coherent originator of meanings and actions" but rather the subject as spoken and subjected by discourse (Smith xxviii). On Lacan's distinction between full speech and empty speech, see "The Function and Field of Speech and Language in Psychoanalysis" (45–46).

8. It should be noted that for Foucault, following Freud's theory of hysteria (in which psychic realities are "converted" into somatic expressions), madness and the unconscious are cognates. It might also be noted that "body and soul" come to be included in postmodernism's "imperializing enlargement of the domain of language" (Jameson, *Postmodernism* 68).

9. "Innervation: Term used by Freud in his earliest works to denote the fact that a certain energy is transported to a particular part of the body where it brings about motor or sensory phenomena. Innervation, which is a physiological phenomenon, is possibly produced by the conversion of psychical into nervous energy" (Laplanche and Pontalis 213).

10. *Trieb:* "instinct, drive: impulses or drives can be changed in various ways: into their opposites; directed against the person himself; or suppressed; or sublimated" (Bettelheim 105). "[D]ynamic process consisting in a *pressure* (charge of energy, motricity factor) which directs the organism towards an aim. According to Freud, an instinct has its *source* in a bodily stimulus; its *aim* is to eliminate the state of tension obtaining at

the instinctual source; and it is in the *object,* or thanks to it, that the instinct may achieve its aim" (Laplanche and Pontalis 214).

11. There is much at stake in the question of biology, not only in light of Lacan's famous attack on Ego Psychology for its essential "error" of "biologism" (see Zeitlin) but also because a certain psychoanalytic tradition (including both the "Cold War liberal" Lionel Trilling and the Frankfurt School Marxists) sees in biology the basis of a potentially "liberating idea" (and not just some bad memory from the nineteenth century): "Now Freud may be right or he may be wrong in the place he gives to biology in human fate, but I think we must stop to consider whether this emphasis on biology, whether correct or incorrect, is not so far from being a reactionary idea that it is actually a liberating idea. It proposes to us that culture is not all-powerful. It suggests that there is a residue of human quality beyond the reach of cultural control, and that this residue of human quality, elemental as it may be, serves to bring culture itself under criticism and keeps it from being absolute" (Trilling 48). Freud's stress on the biological basis of the ego is unmistakable in *Beyond the Pleasure Principle* and *The Ego and the Id,* texts with which Lacan is deeply engaged as he elaborates his own theory of the subject. In these texts Freud renews his focus on body as the biological basis of metapsychological principles. "The ego is first and foremost a bodily ego; it is not merely a surface entity, but is itself the projection of a surface [that is, of the body: the ego is a mental projection of the surface of the body]" (*Ego and Id* 27). For Freud, metapsychology itself, on the analogy of metaphysics, implies an attempt to get beyond psychology. "Beyond" is here understood in the fundamental sense with which Freud deploys the term in *Beyond the Pleasure Principle,* that is, not only beyond consciousness in the direction of the unconscious but also toward the body's mesh of nerve and tissue as the source of the drives. One moves with the theory back in time, toward the archaic, primitive, elemental—back, finally, to the death drive and Fechner's principle of constancy, that is, not only toward the body's organic mass but also to the inorganic earth from which it ultimately derives, our common Darwinian origin.

12. "Binding: Term used by Freud . . . to denote an operation tending to restrict the free flow of excitations, to link ideas to one another and to constitute and maintain relatively stable forms" (Laplanche and Pontalis 50).

13. The Freudian concept of libidinally driven "work" is not incompatible with a certain Marxian sense of labor and praxis, as that which might reshape and transform the historical world of objects and institutions and so reveal their impermanence and temporality.

14. Lacan's main polemical target here is not only what he called "American psychoanalysis" but also American capitalist society in general. For a discussion of the ideological contexts of Lacan's ego theory, see Zeitlin.

15. Felman gives a succinct summary of the Lacanian position: "As distinct from other psychoanalytic theories of the ego, for Lacan the ego is

not an autonomous synthetic function of the subject, but only the delusion of such a function. The outcome of a series of narcissistic identifications, the ego is the mirror structure of an imaginary, self-idealizing *self-alienation of the subject*. It is a structure of denial: denial of castration (through a unified self-aggrandizement) and denial of subjectivity (through objectification of others and self-objectification)" (*Jacques Lacan* 11).

16. "The unconscious is, so to speak, 'outside' rather than 'within' us—or rather it exists 'between' us, as our relationships do. It is elusive not so much because it is buried deep within our minds, but because it is a kind of vast, tangled network which surrounds us and weaves itself through us, and which can therefore never be pinned down. The best image for such a network, which is both beyond us and yet is the very stuff of which we are made, is language itself" (Eagleton 173).

WORKS CITED

Adorno, Theodore W., et al. *The Authoritarian Personality.* 1950. New York: John Wiley and Sons, 1964.

Baudrillard, Jean. "The Ecstasy of Communication." Trans. John Johnston. In *The Anti-Aesthetic: Essays on Postmodern Culture,* ed. Hal Foster. Port Townsend, Wash.: Bay Press, 1983. 126–34.

Bettelheim, Bruno. *Freud and Man's Soul.* New York: Alfred Knopf, 1983.

Bowie, Malcolm. *Lacan.* London: Fontana, 1991.

DeLillo, Don. *Americana.* New York: Penguin, 1971.

———. *The Names.* 1982. New York: Vintage, 1989.

———. *Players.* New York: Penguin, 1977.

Derrida, Jacques. "Freud and the Scene of Writing." Trans. Jeffrey Mehlman. *Yale French Studies* 48 (1972): 73–117.

Eagleton, Terry. *Literary Theory: An Introduction.* Oxford: Basil Blackwell, 1983.

Felman, Shoshana. *Jacques Lacan and the Adventure of Insight: Psychoanalysis in Contemporary Culture.* Cambridge, Mass.: Harvard University Press, 1987.

———. *Writing and Madness: Literature/Philosophy/Psychoanalysis.* Trans. Martha Noel Evans and the author with the assistance of Brian Massumi. Ithaca: Cornell University Press, 1985.

Foucault, Michel. *Madness and Civilization: A History of Insanity in the Age of Reason.* Trans. Richard Howard. New York: Vintage, 1988.

———. Preface. *Anti-Oedipus: Capitalism and Schizophrenia.* By Gilles Deleuze and Félix Guattari. Trans. Robert Hurley, Mark Seem, and Helen R. Lane. Minneapolis: University of Minnesota Press, 1983. xi–xiv.

Freud, Sigmund. *Beyond the Pleasure Principle.* Vol. 18 of *The Standard Edition of the Complete Psychological Works of Sigmund Freud,* trans. and ed. James Strachey. London: Hogarth and the Institute of Psycho-Analysis, 1966. 1–64.

———. *Civilization and Its Discontents.* Vol. 21 of *The Standard Edition of the Complete Psychological Works of Sigmund Freud,* trans. and ed.

James Strachey. London: Hogarth and the Institute of Psycho-Analysis, 1966. 57–145.

———. *Delusions and Dreams in Jensen's "Gradiva."* Vol. 9 of *The Standard Edition of the Complete Psychological Works of Sigmund Freud,* trans. and ed. James Strachey. London: Hogarth and the Institute of Psycho-Analysis, 1966. 1–95.

———. *The Ego and the Id.* Vol. 19 of *The Standard Edition of the Complete Psychological Works of Sigmund Freud,* trans. and ed. James Strachey. London: Hogarth and the Institute of Psycho-Analysis, 1966. 1–66.

———. "The Goethe Prize." Vol. 21 of *The Standard Edition of the Complete Psychological Works of Sigmund Freud,* trans. and ed. James Strachey. London: Hogarth and the Institute of Psycho-Analysis, 1966. 205–12.

———. *Group Psychology and the Analysis of the Ego.* Vol. 18 of *The Standard Edition of the Complete Psychological Works of Sigmund Freud,* trans. and ed. James Strachey. London: Hogarth and the Institute of Psycho-Analysis, 1966. 65–143.

———. *The Interpretation of Dreams.* Vols. 4 and 5 of *The Standard Edition of the Complete Psychological Works of Sigmund Freud,* trans. and ed. James Strachey. London: Hogarth and the Institute of Psycho-Analysis, 1966. 1–338; 339–751.

———. Letter to Wilhelm Fliess (September 1897). In *The Origins of Psycho-Analysis: Letters to Wilhelm Fliess, Drafts and Notes: 1887–1902,* ed. Marie Bonaparte, Anna Freud, and Ernst Kris, trans. Eric Mosbacher and James Strachey. New York: Basic Books, 1977. 216.

———. *On Narcissism: An Introduction.* Vol. 14 of *The Standard Edition of the Complete Psychological Works of Sigmund Freud,* trans. and ed. James Strachey. London: Hogarth and the Institute of Psycho-Analysis, 1966. 67–102.

———. *An Outline of Psycho-Analysis.* Vol. 23 of *The Standard Edition of the Complete Psychological Works of Sigmund Freud,* trans. and ed. James Strachey. London: Hogarth and the Institute of Psycho-Analysis, 1966. 141–207.

Horkheimer, Max, and Theodor W. Adorno. *Dialectic of Enlightenment.* Trans. John Cumming. New York: Herder and Herder, 1972.

Jameson, Fredric. "Imaginary and Symbolic in Lacan." In *The Ideologies of Theory: Essays 1971–1986,* vol. 1, *Situations of Theory,* by Fredric Jameson. Minneapolis: University of Minnesota Press, 1988. 75–115.

———. *Late Marxism: Adorno, or, the Persistence of the Dialectic.* London: Verso, 1990.

———. *Postmodernism, or, The Cultural Logic of Late Capitalism.* Durham, N.C.: Duke University Press, 1991.

Lacan, Jacques. "The Agency of the Letter in the Unconscious." In *Écrits: A Selection,* trans. Alan Sheridan. New York: Norton and Norton, 1977. 146–78.

———. "The Direction of the Treatment and the Principles of Its Power." In *Écrits: A Selection*, trans. Alan Sheridan. New York: Norton and Norton, 1977. 226–80.

———. "The Freudian Thing, or the Meaning of the Return to Freud in Psychoanalysis." In *Écrits: A Selection*, trans. Alan Sheridan. New York: Norton and Norton, 1977. 114–45.

———. "The Function and Field of Speech and Language in Psychoanalysis." In *Écrits: A Selection*, trans. Alan Sheridan. New York: Norton and Norton, 1977. 30–113.

———. "The Mirror Stage as Formative of the Function of the I." In *Écrits: A Selection*, trans. Alan Sheridan. New York: Norton and Norton, 1977. 1–7.

———. "On a Question Preliminary to Any Possible Treatment of Psychosis." In *Écrits: A Selection*, trans. Alan Sheridan. New York: Norton and Norton, 1977. 179–225.

———. "The Significance of the Phallus." In *Écrits: A Selection*, trans. Alan Sheridan. New York: Norton and Norton, 1977. 281–91.

Laplanche, J., and J. B. Pontalis. *The Language of Psycho-Analysis*. Trans. Donald Nicholson-Smith. London: Hogarth Press and the Institute of Psycho-Analysis, 1973.

Marcuse, Herbert. "The Obsolescence of the Freudian Concept of Man." In *Critical Theory and Society: A Reader*, ed. Stephen Bronner and Douglas MacKay. New York: Routledge, 1989. 233–46.

———. *One-Dimensional Man: Studies in the Ideology of Advanced Industrial Society*. Boston: Beacon Press, 1964.

Ragland-Sullivan, Ellie. *Jacques Lacan and the Philosophy of Psychoanalysis*. Urbana: University of Illinois Press, 1986.

Smith, Paul. *Discerning the Subject*. Minneapolis: University of Minnesota Press, 1988.

Sontag, Susan. "Fascinating Fascism." In *Under the Sign of Saturn*, by Susan Sontag. New York: Farrar, Straus, Giroux, 1980. 73–105.

Trilling, Lionel. *Freud and the Crisis of Our Culture*. Boston: Beacon Press, 1955.

Zeitlin, Michael. "The Ego Psychologists in Lacan's Theory." *American Imago* 54 (Summer 1997): 209–32.

Žižek, Slavoj. *Looking Awry: An Introduction to Jacques Lacan through Popular Culture*. Cambridge, Mass.: MIT Press, 1991.

Lost in the Post?

Feminism's Divided Relationship to Postmodernity

Diane Elam

Where has all the talk about postmodernity left feminism? Does feminism have any place in postmodernity? Could it be postmodern? And what would it even mean to call feminism "postmodern"? Over the years, these questions have proved difficult to answer. To some extent, they have been difficult to ask in the first place, because one of the obstacles to developing something that might be called "postmodern feminism" is that many of the initial discussions of postmodernity—from Lyotard to Jameson to Baudrillard—more or less left feminism out of the frame. Even the stray reference to gender or women often proved rare. For instance, Fredric Jameson's weighty tome *Postmodernism, or, The Cultural Logic of Late Capitalism* manages to mention feminism in four sentences over the course of more than four hundred pages, and then only to relegate it to the sidelines. "Women," "gender," and "sexual difference" do not figure in the index, much less as central concerns of the

argument. Feminists are rightly suspicious about the political motives that lie beneath such pretensions of theorizing the allegedly cultural dominant form today when that theorizing cannot even raise questions of sexual difference. This postmodern life is a boy's life.

The problem here, however, is not simply finding ways to add feminism and gender to postmodernity's mailing list or tracking down whether some of the invitations to the postmodern party simply got lost in the post. The postmodern life is not necessarily one that feminism has wanted to lead or a party it has been anxious to attend. Feminism has not always been attracted to the kinds of political claims made in the name of postmodernity. "The subject," liberation narratives, free choice, and organic communities have all come into question in the name of postmodernity. Such dismantling of the grounds upon which modern notions of politics rest can certainly spell trouble for feminism.[1] Indeed, identity politics and rights-based politics are at the very heart of feminism, and a postmodernity that calls these forms of politics into question stands to pose a threat to the very project of modern feminism. For instance, how is feminism to understand itself if it is no longer conceived as a modern project of the historical realization of women subjects through political action?

There are legitimate reasons to be worried about what postmodernity might have in store for feminism, and I do not want to use the name of postmodernity as a way to dismiss modern forms of politics lightly and to assume that feminism can just move on to other things, taking for granted that modernity is now over. For one thing, it is a radical oversimplification to assume that postmodernity marks the end of modernity, that it puts an end to modern politics. Although I have argued in the past that postmodernity may be the name that feminism gives to its escape from identity politics, I was not trying to suggest that postmodernity marks a complete repudiation of identity politics.[2] Both identity and rights-based politics still work; they continue to be effective for feminism. The mistake—one to which postmodernity calls attention—is to assume that identity and rights are either natural or stable.

What I would like to emphasize is that, just because difficult questions need to be addressed in the name of postmodernity and just because potential risks are involved in relinquishing modern notions of politics, this does not mean that feminism can afford merely to refuse to open all correspondence marked postmodernity, hoping that one day it will stop being delivered. For feminism to continue to matter politically, to go beyond the possibilities and to get around the limitations of modern politics, it needs to consider how something called postmodernity names a change in the way politics happen. I suggest that feminism can, in fact, politically afford to understand itself as something other than a part of the metanarrative of modern politics. Despite the risks, feminism *can* entertain a postmodern

life and live to tell the tale. Indeed, much of feminism's political strength has come from its very diversity, from its fragmentation, from its insistence on the politics of feminism*s*. Even the feminist metanarrative of the oppressive power of monolithic patriarchy is due for some time in the incredulity penalty box. Patriarchy has worked so well for so long precisely because it is not the same thing in all times and in all places. It functions in different and diverse ways, which can be good news for feminism; as many women already know, patriarchy is not always as big as it thinks it is.

Some feminists might still say that it is only by putting differences aside, by recognizing common political goals in the name of coalition building, that any political action happens, including the fight against proliferating narratives of patriarchy; multiple forms of patriarchy are not necessarily best opposed by an equal number of different forms of feminism. This approach has some validity in that the battle to claim positions of oppression and difference can splinter the feminist movement to the point that the only political action it can perform is its own self-destruction. In a similar manner, pitting modern and postmodern versions of feminism against one another is not the answer. It is not enough to shout, "Let the battle begin, and may the stronger feminism win." Feminism should be wary of thinking about postmodernism's difference from modernism in terms of a simple opposition that can be mapped onto conflicts within feminism. Instead, the troubled mixture of difference and dependency that characterizes the most rigorous accounts of the relationship between postmodernism and modernism provides a helpful way of conceptualizing the politics of gender difference and of articulating different forms of feminism.

In this sense, a postmodern feminism is not an alternative to the modernist narrative of emancipation that characterizes traditional identity politics. It is instead a way of thinking of the simultaneous necessity and impossibility of a notion of gendered identity in the feminist struggle. More simply, postmodernity does not yet equal a postgendered world any more than it does a postfeminist one. While there may be cause to imagine a time in which gender and feminism cease to be prominent features of the social landscape, if the current rate of change is any indication, that time, if ever it arrives, is still a long way off and may not prove to be entirely desirable anyway. If postmodernity is not the same thing as postfeminism (which itself does not necessarily add up to the postgender condition), then, more precisely, postmodern feminism is a feminism that rethinks what constitutes gender difference, reevaluates gender hierarchies, and calls into question the stability of gender as a category. Gender is never autonomous, and postmodern feminism, rather than arguing for female autonomy, attempts to keep sexual difference open as the space of a radical uncertainty.

This is not to suggest, however, that there is an exact formula for putting feminism and postmodernity together; the situation of feminism

with regard to postmodernity is neither simple nor stable. Feminism has been changed by postmodernity, but postmodernity has also been changed by feminism. I could not pretend to do justice here to all of the possible narratives that can be told about this.[3] If I were to risk a generalization I would say that postmodernity activates feminism's abiding suspicion of modernity, while feminism reminds postmodernity of its ongoing obligation to do justice to questions of sexual difference. In the following discussion, I will look more closely at what a version of postmodern feminist politics might look like, taking into account this two-way traffic of influence.[4] I will also argue that a certain postmodern temporality is at stake: feminism is still waiting for what will have been delivered by postmodern politics.

To begin with, then, a critique of modern identity politics should bear in mind these crucial questions: *How* will we decide to put aside our differences? *How* will we arrive at a position of political solidarity? These questions should serve as a reminder that feminism can no longer afford to ignore questions about identity, either through an appeal to modernity that takes the existence of identity for granted or through a recourse to postmodernity that assumes identity has irretrievably fragmented. It is important to consider alternatives to identity politics alongside feminist and postmodern critiques of identity. Specifically, a modern politics of the subject is not the liberating spirit it may once have been considered to be, and feminism is beginning to recognize the injustices brought about by its own political practices.

But where feminism would turn next is certainly not self-evident, especially since a return to classical political theory would stall in its failure to welcome women into the rank of full citizens. From Plato to Aristotle to Rousseau, women have been written out of the social contract. In this respect, identity politics along with (theoretically) a representative democracy look like a great improvement. As the project of modernity expanded, it at least seemed capable of including women in its ranks of political subjects. But herein lies another problem feminism inherits from the legacy of the universal subject of contract law, from Hobbes to Locke and now to Rawls: this tradition assumes that there can be no politics without a subject and that being a political subject is desirable.

Feminism has often questioned tradition, and this particular tradition should be no exception. Do girls really just want to be subjects? Our horror at the long history of the objectification and commodification of women should be matched by horror at the specter of calculable subjectivities, which have taken the form of "crowds in concentration camps or in the police computers or those of other agencies, the world of the masses and of the mass media" (Derrida 317). The achievement of a definitive or calculable subjectivity is, as Derrida points out, not solely liberatory. Indeed, the constraint of subjectivity, even when subjectivity seems to offer

agency, is clear when we realize that women become subjects only when they conform to specified and calculable representations of themselves as subjects. To take a common example, only when you have been assigned a license number and have undergone testing and classification are you "free" to drive a car. The driver's license has become, in the United States, the primary instance of subjective identification before the law. To produce proof of one's identity is to show a driver's license. There is a similarity between being objectified and assuming a subject position already determined: subject positions are occupied by objects. So Debbie may not be doing Dallas or the dishes this time, but when Debbie does driving she is still conforming to preexisting, restrictive criteria in order to take up the subject position "woman." Moving from the back seat to the front is not the same thing as getting out of the car.

These arguments lead me, as a feminist, to suspect the wholehearted understanding of feminism as a project for the liberation of a subject by analogy with other modernist projects—such as the Enlightenment project of universal emancipation for the human subject through the educated exercise of reason or the Marxist project of the liberation of the proletarian subject. Judith Butler gestures toward the possibility of doing politics without a stable subject (a subject in possession of a verifiable identity). In this context, the question that needs to be asked is, What happens when feminism stops assuming that identities have to be in place *before* political action is possible?[5] First, it would mean redefining what might constitute politics. Certainly, politics would be more than negotiating power between individual subjects.[6] But politics would also involve more than securing the relation of the citizen subject to society. For feminism to take account of the deconstructive critique of the subject, it must displace the centrality of the subject in our understanding of political action. This will have enormous political implications for our understanding of the nature of political struggle: feminism would seek neither to liberate a female subject nor to secure certain fundamental rights for her. I have already discussed the problems attendant upon an understanding of feminist struggle as the attempt to realize or to liberate a supposedly universal subject—"woman." However, the feminist rethinking of politics does not merely consist of relinquishing this particular utopian ideal and finding other reasons to engage in action. On a more basic level, the postmodern displacement of the subject means that we need to rethink the way in which political discourse claims "rights." For feminism, this rethinking would mean questioning the desirability of making political appeals to a "woman's *right* to choose" or to "equal rights."[7]

Feminism need not accept modernity's terms of the debate—whether they are articulated as the right to life, the right to privacy, or the right to equality—because these terms are based on a fundamental misconception about the subject. Subjects do not define rights for themselves; rather,

rights produce subjects who can hold them. The attribution of a right as "human" is implicitly a definition of the nature of the human: it is supposedly a human attribute to be free, to conduct political discussion without recourse to torture, and so on. The appeal to rights suggests that these are not inherently political questions: such a description of politics contains the mark of the Fall that allegedly has separated mankind from its own nature, stripped it of its rights. If those who advocate political rights are to be believed, the politics in which the newly enfranchised will engage is the struggle to escape from politics and to return to nature.

Politics is not simply a matter of according or balancing rights, and a distributive notion of justice is unjust because it assumes the prior existence of those to whom justice is distributed as self-evident entities. Drucilla Cornell has attempted to redress this injustice by calling for "equivalent rights" rather than for "equal rights." Her idea is that "rights should not be based on what men, as conventionally defined under the gender hierarchy, need for their well-being, as if there was only one genre of the human species" (293). This is a first step in getting away from rights politics that are based on presumably universal notions of a human subject, which has always really been a male subject. Rather than appealing to rights or to subjective liberation, a postmodern feminism should practice what I have called a "politics of uncertainty," a politics that has, I believe, always been feminist.

This politics of uncertainty to which I am referring is not necessarily the same thing as a politics of indecision. By "politics of uncertainty" I mean a politics that remains open to new modes of political calculation: a politics that would not judge events on the basis of preexisting criteria. It would require nothing less than our admission that there is a politics to our definition of the political. Feminism is perhaps the clearest instance of a force that has retained its political drive precisely through a refusal to be pinned down to certainties. In the academy, a recurrent strategy of opposition to feminism, even when it masquerades as sympathy, is to demand clear definitions. Not infrequently, feminists are given the "choice" of categorizing themselves as either campaigners for equal rights or as separatists. This pressure to define one's position can even be felt within feminism itself, which asks whether the members of its ranks are essentialists or constructionists. Postmodernism names this refusal to be pinned down on issues raised by the patriarchs of modernity.

It is important to recognize, however, that these issues are *not feminist;* they presuppose a desexualized ground on which we form our philosophical assumptions (that the female gender is or is not a cultural construct) or our political aims (that women should be equal to men or separate from them). What I want to argue is that postmodernism's rethinking of the political moves us away from understanding politics as a matter of drawing up balance sheets of real effects. Rather, the disruptive politics of feminism

and postmodernism consistently refuse to allow sexual difference to be controlled and to be kept in check as a decidable opposition of genders (female/male). In these terms, the community of feminism and postmodernism is not a step on the way to demystifying or revealing the truth of woman's gender so much as it is an engagement with the way in which gender has always been a women's issue, a recognition that the question "What do women want?" is a patriarchal one. If an orthodox feminism has sought to demand that women be accounted for, and a more apparently radical trend has sought to transvalue and reaffirm woman as the unaccountable, the lesson of postmodernity is that feminism might do well to be suspicious of either method of accountancy.

Feminism has always been at its strongest when it has simply refused to answer such questions and has insisted that the question of women cannot be answered in isolation from personal, institutional, and political practice. In other words, what characterizes feminism is a refusal to go away. Feminism at its best refuses to pose its utopia of equality or isolation. It recognizes oppression but does not sell itself back to its oppressors as a definable program that can be satisfied once and for all. Thus, feminism is a politics of uncertainty, because it insists that we do not yet know what women can be and that it is always men who have wanted the question of woman decisively answered once and for all, as Tiresias found to his cost. This is a feminist politics that will have been delivered by the post.

NOTES

1. Sabina Lovibond argues, for instance, that the feminist movement "should persist in seeing itself as a component or offshoot of Enlightenment modernism, rather than as one more 'exciting' feature (or cluster of features) in a postmodern social landscape" (179). In a similar fashion, Christine Di Stefano and Sandra Harding also more or less dismiss postmodernism as a threat to the feminist political project. Significantly, Di Stefano's and Harding's essays appear in Linda Nicholson's anthology, *Feminism/Postmodernism,* which set out to redress the exclusion of feminism from discussions of postmodernism and postmodernity.

2. See Elam, *Romancing the Postmodern* 19.

3. Certainly, others before me have questioned feminism's modernist impulses, while also offering nuanced arguments about feminism's divided relationship to postmodernism. For instance, see Butler, "Contingent Foundations"; Giroux; Hutcheon; and Morris.

4. An extended version of this argument appears in Elam, *Feminism and Deconstruction: Ms. en Abyme.* It is important to stress that I am not trying to suggest that postmodernity and deconstruction are interchangeable terms. Theorizations such as Fredric Jameson's, which position postmodernity as a particular historical moment in late capitalism that follows

on from an earlier modernity, bear little relation to what is often referred to as deconstruction. Deconstruction does not trail along after modernity like a caboose at the end of a train. Rather, deconstruction is better understood as an event that is *in and outside* of modernity, both a part of modernity as well as an event that comes before and after it. In this respect, deconstruction could name something that happens in what Jean-François Lyotard has called the postmodern condition. The difficulty here, though, would be to think of deconstruction as an event that *only* happens in relation to modernity or postmodernity; deconstruction is in excess of either. To follow this through with my argument about feminism, what I am highlighting in this essay is both a deconstructive account of postmodern feminism and a deconstruction of postmodern feminism—the moment when feminism cannot be contained within postmodernity.

5. Judith Butler also raises this question in both *Gender Trouble* and "Contingent Foundations." Butler best summarizes her answer in "Contingent Foundations" when she writes that "any effort to give universal or specific content to the category of women, presuming that the guarantee of solidarity is required *in advance,* will necessarily produce factionalization, and that 'identity' as a point of departure can never hold as the solidifying ground of a feminist political movement" (15). My answer does differ from hers insofar as I disagree with her claim in *Gender Trouble* that "the deconstruction of identity is not the deconstruction of politics; rather it establishes as political the very terms through which identity is articulated" (148). My argument for postmodern politics is more radical: the deconstruction of identity is also the deconstruction of politics—which means not the end of politics but rather the opening up of different ways of doing politics.

6. For a discussion of this point, see Ferguson and McClure iii–vi.

7. Three particularly interesting texts that treat the complexity of rights-based politics are Jaggar, "Sexual Difference and Sexual Equality"; Rhode, *Justice and Gender;* and Kirp, Yuduof, and Franks, *Gender Justice.* Jaggar argues that "both the sex-blind and sex-responsive interpretations of equality seem to bear unacceptable threats to women's already vulnerable economic and social status" (245). In her extensive survey of the women's rights movement in the United States, Rhode does not so much propose an alternative to rights discourse as she argues for the importance of "reimagin[ing] its content and recogniz[ing] its limitations" (3). Kirp, Yuduof, and Franks focus on public policy issues related to gender. They believe that gender justice means "enhancing choice for individuals, securing fair process rather than particular outcomes for the community" (12).

WORKS CITED

Butler, Judith. "Contingent Foundations." In *Feminists Theorize the Political,* ed. Judith Butler and Joan Scott. New York: Routledge, 1992. 3–21.

———. *Gender Trouble*. New York and London: Routledge, 1990.

Cornell, Drucilla. "Gender, Sex, and Equivalent Rights." In *Feminists Theorize the Political*, ed. Judith Butler and Joan Scott. New York and London: Routledge, 1992. 280–96.

Derrida, Jacques. "Sending: On Representation." Trans. Peter and Mary Ann Caws. *Social Research* 49 (1982): 294–328.

Di Stefano, Christine. "Dilemmas of Difference: Feminism, Modernity, and Postmodernism." In *Feminism/Postmodernism*, ed. Linda Nicholson. New York and London: Routledge, 1990. 63–82.

Elam, Diane. *Feminism and Deconstruction: Ms. en Abyme*. London and New York: Routledge, 1994.

———. *Romancing the Postmodern*. London and New York: Routledge, 1992.

Ferguson, Kathy E., and Kirstie M. McClure. "Introduction." *differences* 3.1 (1991): i–vi.

Giroux, Henry A. *Border Crossings: Cultural Workers and the Politics of Education*. New York and London: Routledge, 1992.

Harding, Sandra. "Feminism, Science, and the Anti-Enlightenment Critiques." In *Feminism/Postmodernism*, ed. Linda Nicholson. New York and London: Routledge, 1990. 83–106.

Hutcheon, Linda. *The Politics of Postmodernism*. London and New York: Routledge, 1989.

Jaggar, Alison. "Sexual Difference and Sexual Equality." In *Theoretical Perspectives on Sexual Difference*, ed. Deborah L. Rhode. New Haven, Conn.: Yale University Press, 1990. 239–54.

Jameson, Fredric. *Postmodernism, or, The Cultural Logic of Late Capitalism*. Durham, N.C.: Duke University Press, 1991.

Kirp, David L., Mark G. Yuduof, and Marlene Strong Franks. *Gender Justice*. Chicago, Ill.: University of Chicago Press, 1986.

Lovibond, Sabina. "Feminism and Postmodernism." In *Postmodernism and Society*, ed. Roy Boyne and Ali Rattansi. New York: St. Martin's Press, 1990. 154–86.

Lyotard, Jean-François. *The Postmodern Condition: A Report on Knowledge*. Trans. Geoff Bennington and Brian Massumi. Minneapolis: University of Minnesota Press, 1984.

Morris, Meaghan. *The Pirate's Fiancée: Feminism, Reading, Postmodernism*. London and New York: Verso, 1988.

Rhode, Deborah L. *Justice and Gender*. Cambridge, Mass.: Harvard University Press, 1989.

Postmodern
Politics and Culture

Just Events

Thomas Docherty

In modernity, the question of the political has always been—usually tacitly—a question of psychoanalysis, for the key abiding issue is the formulation of an identity for the human Subject. The "political" task is to find a formulation that characterizes that human Subject as the free autonomous agent of history, in terms either of the single Subject in various forms of individualism or of the collective Subject or agent in various forms of Marxism. The modern problem for political thinking, it follows, derives essentially from what we might call a "romantic ecology." The romantic poets, for instance, determined themselves in a contradictory stance as being an integral part of the natural world, intimately implicated in its natural workings (some of which even traverse and constitute the poet), as well as being alienated, through the curse of the gift of consciousness itself, from "mere" sublunary forms. The romantic "I" is both an entity *in* the natural world and a self-constructing Subject conscious *of* that position and thereby distanced from it. It is a "je fêlé," so to speak: the "I" *of which* romantic poetry writes is represented as

within nature, while the "I" that writes is, by definition of its capacity for self-identification independent of the world of nature and in the realm of speech or writing, alienated from the world.

This "romantic ecology" goes all the way from Wordsworth through to Sartre, for whom the question is reiterated in terms of the struggle to become an agent *pour-soi* in the face of the nauseating ease of the determined *en-soi*. It seems clear that there is in effect here an evasion of the political, its slippage into the psychoanalytical, even at the heart of the discourses that most directly characterize themselves as political, or at least as "culturo-political." In this essay, I shall indicate how this evasion is addressed in the reconsideration of the political under the sign of the postmodern, which is considered a counter to this modern romantic ecology.

Consider one of the great political calls of our recent times. "Always historicize!" wrote Fredric Jameson in his great polemical rallying cry for Marxist criticism (9). The postmodern arises whenever we subject such a phrase to reflexive analysis:[1] When did Jameson write this? Under what determining historical conditions was it written? What forces were at work in shaping the demand? What forced Jameson to want to say it at all? Issues such as these culminate in the great question, Is the "I" that *says* "Always historicize" an "I" that is itself also the addressee of the demand, interpellated by the demand even as it makes it? There is, implicitly, a double stance in Jameson's great injunction. On the one hand, there is a manner of reading the phrase that would exclude the phrase itself from its own injunctions: "always historicize everything—except this demand for historicization." Let us call this the "modern" manner, for it recapitulates the thrust of our romantic ecology. On the other hand, in a linguistic turning of the romantic predicament, the postmodern asks the question, Where is the Subject of this enunciation? Is the Subject of the enunciation "in" the enunciation itself, or does the Subject stand outside of the enunciation? This is a reformulation of the romantic ecology whose central question is the psychoanalytical one, evading the political in the interest of constructing the human Subject as the agent of its own destiny.

To be the agent of one's own destiny is to be in control of events, to shape the "future" from a position that acknowledges its own determination by a "past," as if the "present" were always a moment of inauguration, a moment of the new beginning in which the Subject establishes its autonomy, its freedom from necessity.[2] These are all the terms of a radical politics whose roots lie in the great European project of Enlightenment; they are also, of course, the terms of a bourgeois, conservative politics predicated upon a liberal individualism that can also be traced to eighteenth-century origins. The inevitable focus on the present (or presence of the) Subject of consciousness in modern political thought precludes the possibility of ever managing to establish a genuinely political discourse in the first place, for its main purpose is to solace the Subject with the good form

of her or his autonomy in a fundamentally psychoanalytic exercise that is better served by poetry than by history, better served by aesthetics than by politics.[3] It is into this situation that the postmodern mood inserts itself in the search for the meaning of the political, a search that is also, inevitably, not for the meaning of history but rather for the fact of history, for the "event"; it is not an epistemological search but rather an ontological one.

In the following discussion, I approach the issue under two main headings. First, I explore what might be called the new social condition evidenced by the technologies that shape postmodernity. Those technologies call the ontological substance of the real into question and necessitate a reconsideration of the political not under the sign of our (spatial, architectonic) social "relations" but rather under the sign of temporality. That is the properly "political" aspect of the argument. Second, I turn to the notion of agency and ask how it might be possible in a philosophy that questions foundational grounds for action. This latter half of the essay addresses pragmatic issues in a way that calls the *theory* of political action itself into question.

• • •

One way of thinking about human history is in terms of the development of technologies that extend the body into space and time. For instance, the basic technologies of athleticism, embodied in the messenger at Marathon, allow the body to cover a terrain well outside its locale in a surprisingly little time. Time and space are thus foreclosed; the body is (not quite) in two places "at once." In a similar manner, writing and the development of print culture allow for the illusion that Plato is as contemporaneous as Putnam, Demosthenes as Derrida, Longinus as Lyotard; such illusions are predicated upon a kind of "speed" that, as at Marathon, collocates places and forecloses or collapses different instants of time. It is a commonplace, at least since McLuhan, that the development of electronic media has effected a further and even more radical shift in human history. The erasing of national boundaries in Europe after the Maastricht Treaty is nothing compared to the internationalism of a community already established by those who "surf the net" via their computer modems. Clearly, things have changed since the development of an Enlightenment discourse of emancipation from slavery to the vagaries of nature or superstition.

Given such a change in the conditions under which we live our history (and under which those in powerful states shape the history of others), we require a different politics, a politics that will attend to such technological forces shaping the environment and to the ways in which human beings negotiate their worlds. Yet critics who wish to examine rather than to describe the world—and even more so the radical critics who wish to change it—are concerned as much as their precursors with the issue of human

emancipation. In a word, the genuine critic must work *within* the terms established for an earlier culture by Marxism. The question is whether such Marxism can itself engage in an auto-critique that will enable us to address our different technologies.[4]

The contemporary thinker who, at first sight, has been most influenced by the question of technology is Baudrillard. Baudrillard begins as a fairly conventional Marxist sociologist, concerned, in the first instance, with the analysis of consumer society. This analysis is, at its root, linked firmly to the romantic predicament described above, for it is concerned with the question of how the consuming Subject identifies herself or himself through the objects she or he can command. The Subject believes itself to be in control of the objects, but, of course, it is the object that seduces and controls the Subject. Later, Baudrillard will explore the various ways in which a contest for supremacy between the Subject and its (now constitutive) objects is organized. Classical forms of Marxism find that this struggle is always displaced onto a different struggle, a struggle between competing Subjects; hence the "political" opposition becomes a struggle between (at least) two competing groups for mastery, and the mastery over objects (from factories to institutions to works of art) is but a means to the end of mastery over other people.

At stake in the analysis of this political situation is a struggle over what constitutes the real. Those in power at any given instant will strive to claim a "natural" authority or legitimacy for their position and will claim that they are but the characters in the enactment of a naturally given or essential state of affairs. Bourdieu analyzes this in terms of those who claim "cultural capital" and the power or authority that goes with such (not necessarily financial) capital.[5] Those in cultural power assume the position of the "aristocracy of culture": they sustain their position of power not because of anything they may *do* but because of what they *are*. As Bourdieu puts it, "aristocracies are essentialist" (23–24). If, for example, I try to *learn* the language of art history in order to "join" the aristocracy of culture (those who not only own but also control the value and meaning of the works of art themselves), then the simple fact that I have to *do* something in order to join the aristocracy demonstrates clearly my "essential" vulgarity. Were I "cultured" or in possession of cultural capital, I would simply not need to bother with the laborious task of learning or of legitimized criticism: I would simply assert the inherent value or disvalue of a work, based on its reference to myself. The essentialism in question here is one whose purpose is to maintain a particular social order against any possible criticism or change. Hence, those in control of the social order must claim for it an essential "reality" that is beyond question, doubt, or criticism.

Yet, of course, this social order does not go uncriticized. The oppositional critic, who considers the social order in historical rather than given essentialist terms, makes a rival claim upon the real. She or he claims that

the aristocracy of culture (or those in power) have managed to establish a validity for a purely imaginary or illusory state of affairs that, though seductive, masks the real conditions between social Subjects. In short, the critic who makes this political gesture in her or his criticism is always necessarily a hermeneut who skeptically examines what seems to be the given in order to find the constructed. At her or his best, such a critic will not only unmask ideology but will also subject the ideology in question to a deconstruction whose effect will be to shift the ground or terms upon which the ideology formulated itself in the first place—no longer merely interpreting the world but changing it thus.

My claim here is that *both* positions are limited. Both positions hypothesize a "real"—either conservative or radical—that is used as a ground upon which to base their validity claims. The postmodern is, among other things, a mood that is inimical to such foundational philosophical premises, requiring instead a different attitude to the question of self-legitimation. The position I have characterized here as radical or critical is one that shares with psychoanalysis the suspicion of the apparent or of the self-evident. As in psychoanalysis, the surface state of affairs is considered to be illusory or symptomatic, requiring elucidation or the uncovering of a latent state whose "essence" is that it is more real than the apparent. In psychoanalysis, one may uncover a psychopathology; in Marxist criticism, one uncovers a sociopathology. The structure is parallel; my anxiety lies in the fact that the concern for the sociopathological reveals simply another psychological problem on the part of the critic.[6]

To substantiate this argument further, one should consider more fully the stakes of oppositional—radical—criticism. Critics as diverse as Said and Parrinder have advocated a form of constant opposition, constant autocritique, constant "disagreement" (Said 28; Parrinder, chap. 3). Theoretically, this position is perhaps admirable—it seems unwilling ever to restrain its energies, unwilling to remain smug or self-assured. Fundamentally, of course, it is Cartesian: it is but the contemporary equivalent of the great foundational statement of modern philosophy, the *dubio* that paves the way for the Subject's reemergence as the controlling, self-engendering, and self-legitimizing *cogito*. The problem with such relentless skepticism as advocated by Said is that it is eventually paradoxical: if I am to resist the shout of "solidarity before criticism," then, of course, I must eventually (or, rather, immediately) call into question the injunction to resist the shout of "solidarity before criticism." If, like Parrinder, I claim that criticism is based on disagreement, then I must immediately "agree" with Parrinder by disagreeing with him, and so on. This is akin to the Cretan liar paradox so avidly considered by those disposed to the postmodern mood: what do I do with the phrase "I am lying"? I can presumably only proceed to link with this phrase if I put in place a "real" state of affairs, a truthful proposition that makes a validity claim on grounds of the

self-evidential, the "reasonable," the essential—all of which have already been rejected by the radical critic as the very loathed terms upon which the aristocracy of culture lay their claims to power.[7]

Perhaps the problem lies in the very nature of a dialectics of opposition itself. Baudrillard again ponders this, indicating that the forms of oppositional criticism in question here work as a kind of inoculation within any given system. He offers two great examples: Watergate and Disneyland. Watergate is a scandal that results in a demand for the purgation of the White House by the critics of the untruthful and untrustworthy regime of a man who is thought only to be acting the part of an honorable politician. The purgation is duly carried out, and Nixon is removed. Almost immediately, the governing system of politics in the United States reemerges not only unscathed but actually strengthened: an individual whose very *profession* is acting blinks his way serenely into the White House. Disneyland operates in the same way: Disneyland with all its fantasy, argues Baudrillard, is there to persuade people that the rest of America is real, not fantasy. This allows the rest of America to carry on living an infantilized and superficial cartoon culture safe in the "knowledge" that this must be reality since fantasy is the province of Disney (Baudrillard, *Simulations* 23–30).

In short, a dialectics of opposition will allow the critic who would be political to get nowhere in our contemporary cultures. The dominant powers that shape and validate our societies will actively encourage forms of opposition *as part of their system or technocracy:* opposition is thus always contained even at the moment it seems to be most critical or troublesome. One might say, controversially and paradoxically, that capitalism thrives upon Marxism. Baudrillard's philosophical point is more far-reaching even than this.

The criticism I have been describing above as "psychopolitical," or as the evasion of politics under the structures of psychoanalysis, depends always upon a final ground called "the real" against which variants (lies, mystifications, ideologies) can be evaluated. It may once have been the case that this real was accessible to consciousness; but at least since Romanticism (and in fact since the beginnings of modern philosophy) there has been some doubt about precisely this availability of the real. Contemporary technologies, most specifically the technologies of representation, have made this question of the availability or otherwise of the real a much more pressing problem.

Baudrillard asks us to consider the perfect representation, which is more of a possibility for us than it ever was for his great precursors in this question, Heidegger and Benjamin. Go and organize a fake holdup, he suggests. What would be the consequences of this? One might be arrested for things such as "wasting police time," or one might be answerable to the fact of someone's cardiac problems; but what cannot be put in the dock is the specific act of faking. For if we imprison someone for faking an evil act, we would also, in principle, have to imprison all those who spend

their time in faking virtuous acts as well. The fake, as a perfect representation, has the effect of calling the very principle of reality into question, which is why we cannot (politically) deal with it directly, for our politics require a principle of the real against which to measure deviations from truth (Baudrillard, *Simulations* 38–44).

When Benjamin considered the question of representation in the light of the new technologies of photography and cinema, he alerted criticism to the changing relation between the Subject (the critic) and the object: the "distance" (physical, metaphysical, geographical, historical) between Subject and object changes with the loss of aura, the loss of a specific located history for the object. Baudrillard, facing a televisual technology and aesthetic of representation whose avowed purpose is the production of the real, finds the situation ever more vexed. What should criticism do when faced with an art of parody in which the "representation" becomes more perfect than its derivative? For example, what do we do with Sherrie Levine's photographs of classic American photographs? What should the philosopher do when the objects of her or his concern are themselves representations of representations whose origin may not even exist as such. For example, what do we do when faced with Cindy Sherman's poses? For Baudrillard, the answer is the extreme one of "fatal strategy"—going over to the side of the objects. Given the resonances of the consumerism with which he began his sociopolitical analyses, Baudrillard recalls the seductiveness of the object for its consumer, the *soi-distant* autonomous Subject. The fatal strategy to be adopted when one goes over to the side of the objects is one of seduction: a play of powers or forces that is not dialectical but rather *physical*, based on the vectors of force.[8] Such a situation, in which the physics of seduction is proposed in place of the operations of reason, is anathema to "enlightenment" critique, which prefers always to operate at the level of the mathematical abstraction or *theory*. Whatever one's view of the implications of Baudrillard's trajectory, one thing remains clear: his philosophy leads to a consideration of the availability of the real as a foundation upon which to build truth claims or political action. What does the political critic do when reality disappears?

The answer is this: look for it somewhere else.

• • •

"Look for it *somewhere else*." The very terms of the injunction reveal the fallible limitations of such a project. Conservatives and radicals alike behave in these political matters in accordance with a utopian philosophy, as if the real were "located," were a place or space somewhere (a here to be replaced with another place, even a nonplace or utopia). There is, of course, the other dimension: that of historical, temporal ontology. The real may be found at the intersection of time rather than of space; for the radical critic

who wishes for change, such a temporality is surely of the essence of the critical act. If a part of the contemporary political problem derives from those electronic technologies of reproduction whose basic principle is speed, then time itself becomes a factor of political importance.

Three thinkers have made this time factor an important aspect of their thinking: Serres, Virilio, and Gorz. Serres offers a useful starting point here because he opens up the possibility of living in different times or moments at once. His simple example is the motorcar, a great twentieth-century phenomenon:

> Considérez une voiture automobile de modèle récent: elle forme un agrégat disparate de solutions scientifiques et techniques d'âges différents; on peut la dater pièce à pièce: tel organe fut inventé au début du siècle, l'autre il y a dix ans et le cycle de Carnot a presque deux cent ans. Sans compter que la roue remonte au néolithique. (Serres 72)[9]

The contemporary—indeed any given "instant"— "contains" a history and is not simply a point to be located upon or within the linear unfolding of some great narrative of abstract "History." Hence, time is not only interiorized within the object; it is also the very fluid within which the Subject constructs and deconstructs itself as such. Furthermore, time is fully plural here: we do not live, as Subjects, in only one time but rather are traversed by histories that are radically other than those in which we perceive ourselves to be. Times (in the plural) are the very condition of our emergent subjectivity.[10]

Paul Virilio has pondered time in explicitly political terms. There is, he argues, a fundamental relation between speed and politics.[11] At the risk of caricature, I will present some of the pertinent implications of Virilio's thought in simplistic terms. Virilio begins his argument from the proposition that the emergence of the city, of the city state or *polis,* and thus of politics depends upon a war mentality and not simply a geography. In the early stages of the history of warfare, fighting is very direct. Technology soon changes this: my athleticism, to take a very basic example of technology, means that I can run away from a hand-to-hand battle I appear to be losing, thus circumventing direct defeat. But if I am to put a safe distance between myself and my aggressor, I not only must run faster but must also strive to delay my aggressor by throwing obstacles in her or his pursuing path. What we have here is a dialectical play of my speed against the slowness I impose upon the enemy. As this develops, I *produce* time—time as a factor of *difference* (even of *différance*) between myself and the enemy, and time in which I can halt and look back. At some point, I need to look back and get a better view. So you, my ally, stand on my shoulders to provide the most basic elevated observation post: I have begun to build upward in one place in an effort to control, even minimally, my hostile environment.

But such building is entirely dependent upon my greater speed and the advantage it gives me over my tardy enemy. As with the observation post that I have time to elevate, so also with the rampart, the defensive wall, and so on that I have time to build; such building—in and through time—culminates in the defended city. This city is a political entity constructed upon *time* rather than simply upon space: its spatial constitution depends upon its temporal relation to its enemies, both external and internal.

Such a state of affairs can never be static, of course; eventually we face a situation in which two great powers face each other at the height of the Cold War not over a distance in space but over the extraordinarily foreclosed length of time it will take for their advanced technological missiles to blow each other away. The Cold War was not a war about territory but rather a war about time. Such a war, ostensibly over as I write, is in fact simply displaced: the speedy "First" world continues to wage technological war upon the "tardy" Third world. Colonialism and its legacy is but one glaring effect of the politics of time in which one state, by claiming itself to be "advanced" (that is, speedy), arrogates to itself a power over other states. This is the condition of politics in our time.[12]

These politics are global, of course, but one might rightly ask about more "local" forms of politics. Once more, the issue of technology plays an important role. In "psychopolitics," as indicated above, the fundamental opposition at stake for criticism is a hermeneutic based upon the revelation of a real that supposedly lies obscured behind an obfuscating appearance. In a world organized by the power of the spectacle and by the reproductive technologies of television, a different opposition assumes a more central role. What criticism must attend to in our time is no longer the opposition of the real to its appearance but rather an opposition between appearance and disappearance. Politics has moved away from a "depth" metaphor in which the real underlies the apparent and has moved toward a "surface" metaphor in which the very fact of appearance on the surface is crucial. The difference in question is similar to the one between theater and cinema, whose different ontologies necessitate different cultural politics. Virilio thinks of this in terms of the replacement of the ancient *agora* with the screen, hence the pertinence of his recurring example of the women of the Plaza de Mayo in Buenos Aires, whose presence as they process around the square at regular intervals attests to the ghostly status of the "disappeared." Here, one Subject appears in order for the disappearance of another to be realized as a fact or event. The ritualized rhythmic processions regulate a political temporality, punctuating history and political space in order to attest to another order of time (Virilio, *L'Horizon négatif* 244–46).

This, in an extreme form, is the nature of basic contemporary political struggle: the struggle over appearing and disappearing. Reactionary governments in the so-called democracies no longer argue over ideology:

they simply find ways of making oppositional voices inaudible, of making their speakers invisible. This stretches all the way from actual political disappearances to the mythologization of political opponents to the statistical manipulations through which Subjects are denied their "official" existence. The radical critic must begin to attend to this question as well as to the more usual business of ideological demystification.

To do this, however, the critic must attend to the political importance of time. It used to be the case that all forms of political analysis would base themselves upon a geopolitical terrain: arguments would be easily waged and understood over the relation between the civic and the rural, between the civic center and the suburb, between the centrality of a cathedral and the marginalization of a prison in urban planning. This basis remains important, but one must add to it the implications of the political philosophy of André Gorz. Gorz is aware that changes in technology have had a drastic effect on one of the founding conditions of modern political existence: employment and labor. Whereas Marxism found the laboring body to be the medium between the Subject of consciousness and an "other" objective environment that had to be negotiated or controlled and manipulated for human happiness, a post-Marxism begins to find it less possible to organize political thought around labor in a culture where it is becoming expressly redundant. The obvious response to this is the ostensibly democratic one of redistribution of labor.[13]

Gorz is clear on this issue: redistribution of labor implies a drastic reduction in the number of hours people will spend in conventional forms of employment. The effect of this is a reconsideration of the political in terms not of the organization of space but rather of the organization of time. The source for such a philosophy is, of course, still the Marxist source: chapter 10 of volume 1 of *Capital,* in which Marx analyzes the working day. Gorz enables a form of thinking that differentiates times within the aim of the emancipation of time itself. An agreed upon—and significantly reduced—number of hours might be spent in work during a lifetime, producing more time for what Illich might think of as "convivial" tasks and for what Gorz clearly identifies as the production of autonomy and community for the Subject. It is important that the free time thus made is not in turn colonized by the "leisure merchants," for this would be tantamount to a denial of autonomy for the Subject; the aim of the philosophy is precisely such autonomy in the form of freedom. Gorz suggests that the time might be used for pursuing forms of bricolage or community enterprises whose content is explicitly cultural. But *cultural* here does not mean simply "related to the arts"; rather, it means something closer to its etymological signification, pertaining to the "growth," the development of *Bildung* of the Subject. Hence, culture becomes "ordinary," in Raymond Williams's terms; and the ordinary itself becomes extraordinary to the extent that it is not already prescribed according to

the banal logic of eight hours of work (in the city), eight hours of sleep (in bed), and eight hours of consumption of the products of the leisure merchants (in the privatized space of the suburban home). The ordinary becomes extraordinary precisely because it is not already accounted for in the governing political system, because it is genuinely autonomous.

This brings me to what might be called the central aspect of the political under the sign of the postmodern mood: the "event" itself. I shall conclude the present argument by exploring the possible meaning of the political fallout of the stress on the event; and I shall begin from a brief consideration of some of the truisms of postmodernism.

The postmodern is inimical to metanarratives, as we all have learned to rehearse. The great stories of emancipation cannot be subscribed to with any degree of comfort. What lies behind this, of course, is the Lyotardian suspicion of a Universal History and of all forms of what I shall term "homomonomania" associated with such a grand totalizing project. By my composite neologism, I mean a form of thinking that delights in the reduction of all alterity to identity and in the reduction of all forms of multiplicity and plurality to a level of abstraction in which the differences can be eradicated under some single structural and abstract form: theory. Theory, thus understood, is consonant with "determining judgement," a form of judgment that, according to Kant in the Third Critique, enables judgments and decisions to be made in conformity with a rule or regulatory system. The terms of the system within which a judgment is made predetermine the kind of decision that is possible. While such judgment might be appropriate in certain circumstances, it is not necessarily appropriate for all. For Kant, what he called "reflective judgement" was that form of judgment that was more appropriate in aesthetic matters, in which there are no prescriptive rules determining what constitutes, for example, the "beautiful." Modernity is that mode of thinking in which the determining has triumphed over the reflective; the postmodernist is she or he who, following Adorno and Horkheimer, distrusts the regulatory and predetermining homologization of all forms of thinking under one rationality that arrogates to itself a normative status. For Lyotard, a rehabilitation of reflective judgment is important; he claims an analogy between the forms of judgment possible between, on the one hand, aesthetic matters and, on the other, political matters.

In reflective judgment, there is a high degree of unpredictability. Such unpredictability arises because the reflective judge is she or he who "works without rules in order to formulate the rules of what will have been done" once the judgment is made (Lyotard, *Postmodern Condition* 81). Judgment is always inevitable: even to remain silent in the face of a statement, proposition, or dilemma is to make a tacit judgment about it. We must judge the state of affairs, the given, with which we are presented at any instant; but the postmodernist has no rules according to which to make

that judgment. That is, we can have no theory that will subtend the "correct" judgment or mode of action. In brief, we can have no political program. It is precisely such a program that we are looking for. In this case, the judgment we make will be of the nature of an event: it is not a happenstance that can take its predetermined place within some grander system or narrative; rather, it is the unpreprogrammed, the unforeseen that is neither aleatory nor predetermined. The event is a happening that irrupts into history and thus produces time as that condition of which Serres speaks: time not as some simple linear series of points but as a lived multiple experience in which different histories coincide and coalesce, sometimes in contradictory fashion.

Yet a political problem surely exists: how can we ensure the possibility of justice if we cannot predetermine the results or terms of our judging? For the postmodernist, this is primarily an ethical demand, as opposed to a political determinant of action. I must judge, certainly; but, most importantly, *I* must judge. This means that the "I" must constitute itself, invent itself in and through the act of judging; and I have no model that will ensure the outcome. There is here a profound risk to the Subject, whose political task is the search for justice. Yet such justice can never be static, can never be formalized as some programmatic series of "rights" or "cases": insofar as the act of judging must be an event—and insofar as the act of judging has any historical and political existence at all—it must be done as the demand for judgment arises, and that demand is constant.

What the "I" searches for, thus, is an autonomous historical being, or an ontology, in which an "event" will take place and in which justice will have been the outcome. The modern priority—of the psychopolitical health of the Subject—is replaced by the postmodern priority of an enactment or production of justice in and through which the Subject will be constituted necessarily as a social rather than as an individual being. The postmodern, in attending to the political, rehabilitates the "thinginess" of the world, its alterity or objectal status, not through the realization of any narratological history but rather through the enactment of events. All such events are predicated upon acts of judging in which the Subject is fully and firmly implicated. But insofar as the postmodern wishes to call into question the prioritization of the determining over the reflective judgment, such judging is itself the search for justice. The postmodern political is the search for the just event, that is, for the historical event as such and for the just within such an eventuality.

NOTES

1. See Lawson.

2. According to Michel Serres (76–77), this is always a theological view of time.

3. See Benjamin (244) for the now classic warning about the dangers inherent in the aestheticization of the political. But see also Jean-François Lyotard, *Peregrinations*, in which he says that an "analogy," and *only* an analogy between the aesthetic and the political, is at stake. This is important in countering the typical misrepresentations of the Lyotardian political position so current among leftist criticism.

4. See Laclau and Mouffe.

5. See Bourdieu, especially part 1.

6. For a different perspective on the same problem, deriving from the philosophy of desire, see Lyotard, *Economie libidinale*.

7. For an explication of the notion of "linking"—the necessity of basing a politics upon the ways in which one responds to a given "phrase"—see Lyotard, *The Differend*.

8. This argument depends upon a collocation of Baudrillard's texts, *De la séduction* and *Les stratégies fatales*.

9. The translation is as follows: "Take the example of a recent make of motorcar: it comprises a diverse ensemble of scientific and technical answers to problems of different ages; and one could date it bit by bit; one component was invented at the start of the century, another about ten years ago, and the Carnot cycle is almost two hundred years old. Not to mention the fact that the wheel takes us back to the neolothic age."

10. See Kristeva. The argument depends upon a kind of Bergsonism made currently available via the work of Gilles Deleuze.

11. Virilio, *Vitesse et politique*.

12. Homi K. Bhabha, *Location of Culture*, offers a way of rethinking the entire problematic of postcolonialism in relation to a space-logic contaminated by a temporality that disrupts its easy formulation. In this respect he differs from, for example, Said in his dealings with the practical necessities of the Palestinian question.

13. Gorz, *Farewell to the Working Class* and *Critique of Economic Reason*.

WORKS CITED

Baudrillard, Jean. *De la séduction*. Paris: Denoel, 1979.

———. *Les stratégies fatales*. Paris: Grasset, 1983.

———. *Simulations*. Trans. Paul Foss, Paul Patton, and Philip Beitchman. New York: Semiotext(e), 1983.

Benjamin, Walter. "The Work of Art in the Age of Mechanical Reproduction." In *Illuminations*, ed. Hannah Arendt, trans. Harry Zohn. London: Fontana, 1973. 219–53.

Bhabha, Homi K. *Location of Culture*. London: Routledge, 1994.

Bourdieu, Pierre. *Distinction*. Trans. Richard Nice. London and New York: Routledge, 1984.

Gorz, André. *Critique of Economic Reason*. London: Verso, 1988.

————. *Farewell to the Working Class*. Trans. Mike Sonenscher. London: Pluto, 1982.

Jameson, Fredric. *The Political Unconscious*. London: Methuen, 1981.

Kristeva, Julia. *Le temps sensible*. Paris: Gallimard, 1994.

Laclau, Ernesto, and Chantal Mouffe. *Hegemony and Socialist Strategy*. London and New York: Verso, 1985.

Lawson, Hilary. *Reflexivity: The Postmodern Paradox*. London: Hutchinson, 1985.

Lyotard, Jean-François. *The Differend*. Trans. Georges van den Abbeele. Manchester, U.K.: Manchester University Press, 1988.

————. *Economie libidinale*. Paris: Minuit, 1974.

————. *Peregrinations*. New York: Columbia University Press, 1988.

————. *The Postmodern Condition*. Trans. Geoff Bennington and Brian Massumi. Manchester, U.K.: Manchester University Press, 1984.

Parrinder, Patrick. *The Failure of Theory*. London: Harvester, 1988.

Said, Edward W. *The World, the Text, the Critic*. London: Faber, 1983.

Serres, Michel. *Eclaircissements: Entretiens avec Bruno Latour*. Paris: Flammarion, 1994.

Virilio, Paul. *L'Horizon négatif*. Paris: Galilée, 1984.

————. *Vitesse et politique*. Paris: Galilée, 1977.

Postmodern Education
in the Age of Border Youth

Henry A. Giroux

Postmodernism, if it is about anything, is about the prospect that the promises of the modern age are no longer believable because there is evidence that for the vast majority of people worldwide there is no realistic reason to vest hope in any version of the idea that the world is good and getting better. . . . Postmodernism, therefore, is about a question. What is to be made of the world-concern that preoccupies people outside the cloisters of privilege who believe the world is not what it used to be? . . . [H]ow much of what is called by this name is properly joined to so much of what is said in the wider world of human suffering about how things may have changed.

—Lemert, *Postmodernism Is Not What You Think* xii–xiii

For many theorists occupying various positions on the political spectrum, the current historical moment signals less a need to come to grips with the new forms of knowledge, experiences, and conditions that constitute postmodernism than a need to write its obituary. The signs of exhaustion are in part measured by the fact that postmodernism

has gripped two generations of intellectuals who have pondered endlessly over its meaning and its implications as a "social condition and cultural movement" (Jencks 10). The "postmodern debate" has spurned little consensus and a great deal of confusion and animosity. The themes are, by now, well known: master narratives and traditions of knowledge grounded in first principles are spurned; philosophical principles of canonicity and the notion of the sacred have become suspect; epistemic certainty and the fixed boundaries of academic knowledge have been challenged by a "war on totality" and a disavowal of all encompassing, single worldviews; the rigid distinctions between high and low culture have been rejected by the insistence that the products of the so-called mass culture, popular, and folk art forms are proper objects of study; the Enlightenment correspondence between history and progress and the modernist faith in rationality, science, and freedom have incurred a deep-rooted skepticism; the fixed and unified identity of the humanist subject has been replaced by a call for narrative space that is pluralized and fluid; and, finally, though far from complete, history is spurned as a unilinear process that moves the West progressively toward a final realization of freedom.[1]

While these and other issues have become central to the postmodern debate, they are connected through the challenges and provocations they provide to modernity's conception of history, agency, representation, culture, and the responsibility of intellectuals. The postmodern challenge not only constitutes a diverse body of cultural criticism, but it must also be seen as a contextual discourse that has challenged specific disciplinary boundaries in such fields as literary studies, geography, education, architecture, feminism, performance art, anthropology, and sociology.[2] Given postmodernism's broad theoretical reach, its political anarchism, and its challenge to "legislating" intellectuals, it is not surprising that there has been a growing movement on the part of diverse critics to distance themselves from it.

While postmodernism may have been elevated to the height of fashion hype in both academic journals and the popular press in North America during the last twenty years, it is clear that a more sinister and reactionary mood has emerged, constituting something of a backlash. Of course, postmodernism did become something of a fashion trend, but such events are short-lived and rarely take any subject seriously. Still, the power of fashion and commodification should not be underestimated in terms of the cloudy residue of irrelevance and misunderstanding such practices bestow on an issue. But there is more at stake in the recent debates on postmodernism than the effects of fashion and commodification; the often essentialized terms in which critiques of postmodernism have been framed suggest something more onerous. In the excessive rhetorical flourishes that dismiss postmodernism as reactionary nihilism, fad, or simply a new form of consumerism, there appears a deep-seated anti-intellectualism, one that

lends credence to the notion that theory is an academic luxury and has little to do with concrete political practice. Anti-intellectualism aside, the postmodern backlash also points to a crisis in the way in which the project of modernity attempts to appropriate, prescribe, and accommodate issues of difference and indeterminacy.

Much of the criticism that now so blithely dismisses postmodernism appears trapped in what Zygmunt Bauman refers to as modernist "utopias that served as beacons for the long march to the rule of reason [that] visualized a world without margins, leftovers, the unaccounted for—without dissidents and rebels" (xi). Against the indeterminacy, fragmentation, and skepticism of the postmodern era, the master narratives of modernism, particularly Marxism and liberalism, have been undermined as oppositional discourses. One consequence is that "a whole generation of postwar intellectuals have experienced an identity crisis. . . . What results is a mood of mourning and melancholia" (Mercer 424).

The legacy of essentialism and orthodoxy seems to be reasserting itself on the part of left intellectuals who reject postmodernism, along with what they call the "cultural turn" in progressive politics, as a serious mode of social criticism and practical politics.[3] It can also be seen in the refusal on the part of intellectuals to acknowledge the wide-ranging processes of social and cultural transformation taken up in postmodern discourses that are appropriate to grasping the contemporary experiences of youth and the proliferation of forms of diversity within an age of declining authority, economic uncertainty, the proliferation of electronic-mediated technologies, and the extension of what I call consumer pedagogy into almost every aspect of youth culture (Giroux, *Channel Surfing*).

In the following discussion, I want to shift the terms of the debate in which postmodernism is usually engaged, especially by its more recent critics. In doing so, I want to argue that postmodernism as a site of "conflicting forces and divergent tendencies" (Patton 89) becomes useful pedagogically when it provides elements of an oppositional discourse for understanding and responding to the changing cultural and educational shift affecting youth in North America. A resistant or political postmodernism seems invaluable in helping educators and others address the changing conditions of knowledge production in the context of mass electronic media and the role these new technologies are playing as critical socializing agencies in redefining both the locations and the meaning of pedagogy.

My concern with expanding the way educators and cultural workers understand the political reach and power of pedagogy as it positions youth within a postmodern culture suggests that postmodernism is to be neither romanticized nor casually dismissed. On the contrary, I believe that postmodernism is a fundamentally important discourse that needs to be mined critically in order to help educators understand the modernist nature of public schooling in North America.[4] It is also useful f-

educators to comprehend how the changing conditions of identity formation within a virtual economy of visual media are producing a new generation of youth between the borders of a modernist world of certainty and order, informed by the culture of the West and its technology of print, and a postmodernist world of hybridized identities, mass migrations, local cultural practices, and pluralized public spaces. But before I develop the critical relationship between postmodern discourse and the promise of pedagogy and its relationship to border youth, I want to comment further on the recent backlash against postmodernism and why I believe it reproduces rather than constructively addresses some of the pedagogical and political problems affecting contemporary schools and youth.

WELCOME TO THE POSTMODERN BACKLASH

While conservatives such as Daniel Bell and his cohorts may see in postmodernism the worst expression of the radical legacy of the 1960s, an increasing number of radical critics view postmodernism as the cause of a wide range of theoretical excesses and political injustices. For example, the British cultural critic John Clarke argues that the hyperreality of postmodernism wrongly celebrates and depoliticizes the new informational technologies and encourages metropolitan intellectuals to proclaim the end of everything in order to commit themselves to nothing (especially the materialist problems of the masses).[5] Dean MacCannell goes further and argues that "postmodern writing [is] an expression of soft fascism" (187). Feminist theorist Susan Bordo dismisses postmodernism as just another form of "stylish nihilism" and castigates its supporters for constructing a "world in which language swallows up everything" (291). For orthodox left critics such as Todd Gitlin, postmodernism is just another form of identitarian/cultural politics that undermines the possibilities of a unified movement rooted in a materialism based on objective analysis of class. The nature of the backlash has become so prevalent in North America that the status of popular criticism and reporting seems to necessitate proclaiming that postmodernism is "dead." Hence, comments ranging from the editorial pages of *The New York Times* to popular texts such as *13thGen* to popular academic magazines such as *The Chronicle of Higher Education* alert the general public in no uncertain terms that it is no longer fashionable to utter the "p" word.

Of course, more serious critiques have appeared from the likes of Jurgen Habermas, Perry Anderson, David Harvey, Terry Eagleton, and Linda Nicholson and Steven Seidman, but the current backlash has a different intellectual quality to it, a kind of reductionism that is both disturbing and irresponsible in its refusal to engage postmodernism in any kind of dialogical, theoretical debate.[6] Many of these left critics often assume the moral high ground and muster their theoretical machinery within binary

divisions that create postmodern fictions, on the one side, and politically correct, materialist freedom fighters, on the other. One consequence of this approach is that any attempt to engage the value and importance of postmodern discourses critically is sacrificed to the cold winter winds of orthodoxy and intellectual parochialism. I am not suggesting that all critics of postmodernism fall prey to such a position, nor am I suggesting that concerns about the relationship between modernity and postmodernity, the status of ethics, the crisis of representation and subjectivity, or the political relevance of postmodern discourses should not be problematized. But viewing postmodernism as a terrain to be contested suggests theoretical caution rather than reckless abandonment or casual dismissal.

What is often missing from these contentious critiques is the recognition that, because postmodernism does not operate under any absolute sign, it might be more productive to reject any arguments that position postmodernism within an essentialized politics, an either/or set of strategies. A more productive encounter would attempt, instead, to understand how postmodernism's central insights illuminate how power is produced and circulated through cultural practices that mobilize multiple relations of subordination.

Rather than being proclaimed as the end of reason, postmodernism can be critically analyzed for how successfully it interrogates the limits of the project of modernist rationality and its universal claims to progress, happiness, and freedom. Instead of assuming that postmodernism has vacated the terrain of values, it seems more useful to address how postmodernism accounts for how values are constructed historically and relationally and how they might be addressed as the basis or "precondition of a politically engaged critique" (Butler, "Contingent Foundations" 6–7). In a similar fashion, instead of claiming that postmodernism's critique of the essentialist subject denies a theory of subjectivity, it seems more productive to examine how its claims about the contingent character of identity, constructed in a multiplicity of social relations and discourses, redefine and expand the possibility of critical and political agency. One example of this type of inquiry comes from Judith Butler, who argues that acknowledging that "the subject is constituted is not [the same as claiming] that it is determined; on the contrary, the constituted character of the subject is the very precondition of its agency" ("Contingent Foundations" 13). The now familiar argument that postmodernism substitutes representations for reality indicates less an insight than a reductionism that refuses to engage critically the ways in which postmodern theories of representation work to analyze the constitutive nature of meaning, or the ways in which appeals to the universal, objective, unified, and transcendent caricaturize, demean, and domesticate difference (Butler, "Merely Cultural").

A postmodern politics of representation might be better served through an attempt to understand how power is mobilized in cultural terms, how

images are used on a national and local scale to create a representational politics that is reorienting traditional notions of space and time. A postmodern discourse could also be evaluated through the pedagogical consequences of its call to expand the meaning of literacy by broadening "the range of texts we read, and . . . the ways in which we read them" (Berube 75). The fact is that mass media, especially popular culture, is where the pedagogy and learning take place for most young people; as the primary pedagogical medium, it cannot be ignored. The issue is not whether such media simply perpetuates dominant power relations but how youth and others experience the culture of the media differently or how media is "experienced differently by different individuals" (Tomlinson 40). Whereas postmodernism pluralizes the meaning of culture, modernism firmly situates it theoretically in apparatuses of power. It is precisely in this dialectical interplay between difference and power that postmodernism and modernism inform each other rather than cancel each other out. The dialectical nature of the relationship that postmodernism has to modernism warrants a theoretical moratorium on critiques that affirm or negate postmodernism on the basis of whether it represents a break from modernism. The value of postmodernism lies elsewhere.

Acknowledging both the reactionary and progressive moments in postmodernism, antiessentialist cultural work might take up the challenge of "writing the political back into the postmodern" (Ebert 291), while simultaneously radicalizing the political legacy of modernism in order to promote a new vision of radical democracy in a postmodern world. One challenge in the debate over postmodernism is whether its more progressive elements can further our understanding of how power works, how social identities are mediated and struggled over, and how the changing conditions of the global economy and the new informational technologies can be articulated to meet the challenges posed by progressive cultural workers and the new social movements.

One issue critical educators might consider is appropriating postmodernism as part of a broader pedagogical project that reasserts the primacy of the political while simultaneously engaging the most progressive aspects of modernism. In this context, postmodernism becomes relevant to the extent that it becomes part of a broader political project in which the relationship between modernism and postmodernism becomes dialectical, dialogic, and critical.

In the following discussion, I want to illuminate and to analyze some of the tensions between schools as modernist institutions and the fractured conditions of a postmodern culture of youth along with the problems they pose for critical educators. First, there is the challenge to understand the modernist nature of existing schooling and its refusal to relinquish a view of knowledge, culture, and order that undermines the possibility for constructing a radical democratic project in which a shared

conception of citizenship simultaneously challenges growing regimes of oppression and struggles for the conditions needed to construct a multiracial and multicultural democracy. Second, there is a need for cultural workers to address the emergence of a new generation of youth who are increasingly constructed within postmodern economic and cultural conditions that are almost entirely ignored by the schools. Third, there is the challenge to critically appropriate those elements of a postmodern pedagogy that might be useful for educating youth to be the subjects of history in a world that is increasingly diminishing the possibilities for radical democracy and global peace.

MODERNIST SCHOOLS AND POSTMODERN CONDITIONS

Wedded to the language of order, certainty, and mastery, public schools are facing a veritable sea change in the demographic, social, and cultural composition of the United States for which they are radically unprepared. As thoroughly modernist institutions, public schools have long relied upon moral, political, and social technologies that legitimate an abiding faith in the Cartesian tradition of rationality, progress, and history. The consequences are well known. Knowledge and authority in the school curricula are organized not to eliminate differences but to regulate them through cultural and social divisions of labor. Class, racial, and gender differences are either ignored in school curricula or are subordinated to the imperatives of a history and culture that is linear and uniform. Within the discourse of modernism, knowledge draws its boundaries almost exclusively from a European model of culture and civilization and connects learning to the mastery of autonomous and specialized bodies of knowledge. Informed by modernist traditions, schooling abets those political and intellectual technologies associated with what Foucault terms the "governmentalizing" of the social order. The result is a pedagogical apparatus regulated by a practice of ordering that views "contingency as an enemy and order as a task" (Bauman xi). The practice of ordering, licensing, and regulating that structures public schooling is predicated on a fear of racial and cultural differences and indeterminacy. The effects reach deep into the structure of public schooling: there is an epistemic arrogance and faith in certainty that sanctions pedagogical practices and public spheres in which cultural differences are viewed as threatening; knowledge becomes positioned in the curricula as an object of mastery and control; the individual student is privileged as a unique source of agency irrespective of iniquitous relations of power; the technology and culture of the book is treated as the embodiment of modernist high learning and as the only legitimate object of pedagogy.

While the logic of public schooling may be utterly modernist, it is neither monolithic nor homogeneous. But at the same time, the dominant

features of public schooling are characterized by a modernist project that has increasingly come to rely upon instrumental reason and the standardization of curricula. In part, this can be seen in the regulation of class, racial, and gender differences through rigid forms of testing, sorting, and tracking. The rule of reason also reveals its Western cultural legacy in a highly centered curriculum that more often than not privileges the histories, experiences, and cultural capital of largely white, middle-class students. Most recently, the instrumentalist nature of modernist schooling can be seen in the growing corporatism of public education and in the increasing vocationalism of higher education in the United States. Moreover, as I have implied earlier, the modernist nature of public schooling is evident in the refusal of educators to incorporate popular culture into the curricula or to take account of the new electronically mediated informational systems in the postmodern age that are generating massively new socializing contexts for contemporary youth.

The emerging conditions of indeterminacy and hybridity that the public schools face but continue to ignore can be seen in a number of elements that characterize what I loosely call postmodern culture. First, the United States is experiencing a new wave of immigration that, by the end of this century, may exceed in volume and importance the last wave at the turn of the twentieth century. Key geographic areas within the country—chiefly large metropolitan regions of the Northeast and Southwest, including California—and major public institutions, especially those of social welfare and education, are grappling with new populations that bring with them new needs. In 1940, 70 percent of immigrants came from Europe, but in 1999 only 15 percent come from Europe while 44 percent come from Latin America and 37 percent come from Asia. National identity can no longer be written through the lens of cultural uniformity or be enforced through the discourse of assimilation. A new postmodern culture has emerged that is marked by specificity, difference, plurality, and multiple narratives.

Second, the sense of possibility that has informed the American Dream of material well-being and social mobility is no longer matched by a social order willing to sustain such dreams, especially for those who are considered marginal to such a society. In the last two decades, the American economy has mostly benefitted the rich while real incomes for low- and middle-income groups have declined. At the present historical conjuncture, the current financial crisis in Asia, Latin America, and Russia suggests that there will be an increase in the expansion of service-economy jobs and an increase in the number of companies that are downsizing and cutting labor costs in order to adapt to the new global downturn.

Not only are full-time jobs drying up, but there has also been a surge in the "number of Americans—perhaps as many as 37 million—[who] are employed in something other than full-time permanent positions" (Jost 633). These so-called contingent workers are "paid less than full-time workers

and often get no health benefits, no pensions and no paid holidays, sick days or vacations" (Jost 628). In spite of the economic boom of the 1990s, diminishing expectations have become a way of life for youth all over North America. *Maclean's Magazine* reports that, in Canada, "[p]eople ages 15 to 24 are currently facing unemployment rates of more than 20 percent, well above the national average of 10.8 percent" (Blythe 35). For most contemporary youth, the promise of economic and social mobility no longer warrants the legitimating claims it held for earlier generations of young people. The signs of despair among this generation are everywhere. Surveys strongly suggest that contemporary youth from diverse classes, races, ethnicities, and cultures "believe it will be much harder for them to get ahead than it was for their parents—and are overwhelmingly pessimistic about the long-term fate of their generation and nation" (Howe and Strauss 16).

Clinging to the modernist script that technological growth necessitates progress, educators refuse to give up the long-held assumption that school credentials provide the best route to economic security and class mobility. While such a truth may have been relevant to the industrializing era, it is no longer sustainable within the post-Fordist economy of the West. New economic conditions call into question the efficacy of mass schooling in providing the "well-trained" labor force that employers required in the past. In light of these shifts, it seems imperative that educators and other cultural workers reexamine the mission of the schools (Aronowitz and Difazio, 1994).

Rather than accept the modernist assumption that schools should train students for specific labor tasks, it makes more sense in the present historical moment to educate students to theorize differently about the meaning of work in a postmodern world. Indeterminacy rather than order should become the guiding principle of a pedagogy in which multiple views, possibilities, and differences are opened up as part of an attempt to read the future contingently rather than from the perspective of a master narrative that assumes, not problematizes, specific notions of work, progress, and agency. Under such circumstances, schools need to redefine curricula within a postmodern conception of culture linked to the diverse and changing global conditions that necessitate new forms of literacy, a vastly expanded understanding of how power works within cultural apparatuses, and a keener sense of how the existing generation of youth are being produced within a society in which mass media plays a decisive if not unparalleled role in constructing multiple and diverse social identities. As Stanley Aronowitz and I have pointed out,

> Few efforts are being made to rethink the entire curriculum in the light of the new migration and immigration, much less develop entirely different pedagogies. In secondary schools and community colleges, for example, students still study "subjects"—social studies, math, science, English and

"foreign" languages. Some schools have "added" courses in the history and culture of Asian, Latin American and Caribbean societies, but have little thought of transforming the entire humanities and social studies curricula in the light of the cultural transformations of the school. Nor are serious efforts being made to integrate the sciences with social studies and the humanities; hence, science and math are still being deployed as sorting devises in most schools rather than seen as crucial markers of a genuinely innovative approach to learning. *(Education Still Under Siege 6)*

As modernist institutions, public schools have been unable to open up the possibility of thinking through the indeterminate character of the economy, knowledge, culture, and identity. Hence, it has become difficult, if not impossible, for such institutions to understand how social identities are fashioned and struggled over within political and technological conditions that have produced a crisis in the ways culture is organized in the West.

BORDER YOUTH AND POSTMODERN CULTURE

The programmed instability and transitoriness characteristically widespread among a generation of eighteen- to twenty-five-year-old border youth are inextricably rooted in a larger set of postmodern cultural conditions informed by the following assumptions: a general loss of faith in the modernist narratives of work and emancipation; the recognition that the indeterminacy of the future warrants confronting and living in the immediacy of experience; an acknowledgment that homelessness as a condition of randomness has replaced the security, if not the misrepresentation, of the home as a source of comfort and security; and an experience of time and space as compressed and fragmented within a world of images that increasingly undermine the dialectic of authenticity and universalism. For border youth, plurality and contingency, whether mediated through the media or through the dislocations spurned by the economic system, the rise of new social movements, and the crisis of representation have resulted in a world with few secure psychological, economic, or intellectual markers. This is a world in which one is condemned to wander across, within, and between multiple borders and spaces marked by excess, otherness, difference, and a dislocating notion of meaning and attention. The modernist world of certainty and order has given way to a planet on which hip-hop and rap condense time and space into what Paul Virilio calls "speed space." No longer belonging to any one place or location, youth increasingly inhabit shifting cultural and social spheres marked by a plurality of languages and cultures.

Communities have been refigured when space and time mutate into multiple and overlapping cyberspace networks. Youth talk to each other over electronic bulletin boards in coffeehouses. Cafes and other public

salons, once the refuge of beatniks, hippies, and other cultural radicals, have given way to members of the hacker culture. They reorder their imaginations through connections to virtual reality technologies and lose themselves in images that wage a war on traditional meaning by reducing all forms of understanding to random-access spectacles.

In pointing to these new cultural formations, I am not endorsing a Frankfurt School dismissal of mass or popular culture in the postmodern age. On the contrary, I believe that the new electronic technologies with their proliferation of multiple stories and open-ended forms of interaction have altered not only the context for the production of subjectivities but also the manner in which people "take in information and entertainment" (Parkes 54). Values no longer emerge from the modernist pedagogy of foundationalism and universal truths or from traditional narratives based on fixed identities and with their requisite structure of closure. For many youths, meaning is in rout, media has become a substitute for experience, and what constitutes understanding is grounded in a decentered and diasporic world of difference, displacement, and exchanges.

I will take up the concept of border youth through a general analysis of some recent films that have attempted to portray the plight of young people within the conditions of a postmodern culture. I will focus on four films: *River's Edge* (1986), *My Own Private Idaho* (1991), *Slacker* (1991), and *Kids* (1995). All of these films point to some of the economic and social conditions at work in the formation of youth, but they often do so within a narrative that combines a politics of despair with a fairly sophisticated depiction of the sensibilities and moods of a generation of youth. The challenge for critical educators is to employ a critical pedagogy that would cancel out the worst dimensions of postmodern cultural criticism while appropriating some of its more radical aspects. At the same time, there is the issue of constructing a politics and project of pedagogy that would create the conditions for social agency and institutionalized change among postmodern youth.

For many postmodern youth, showing up for adulthood at the fin de siècle means pulling back on hope and trying to put off the future rather than taking up the modernist challenge of trying to shape it. Postmodern cultural criticism has captured much of the ennui among youth and has made clear that "[w]hat used to be the pessimism of a radical fringe is now the shared assumption of a generation" (Anshaw 27). Postmodern cultural criticism has helped to alert educators and others to the fault lines marking a generation, regardless of race or class, that seems neither motivated by nostalgia for some lost conservative vision of America nor at home in the New World Order paved with the promises of the expanding electronic information highway. For most commentators, youth have become "strange," "alien," and disconnected from the real world. For instance, in Gus Van Sant's film, *My Own Private Idaho*, the main character, Mike, who

hustles his sexual wares for money, is a dreamer lost in fractured memories of a mother who deserted him as a child. Caught between flashbacks of Mom shown in 8mm color and the video world of motley street hustlers and their clients, Mike moves through his existence by falling asleep in times of stress only to awake in different geographic and spatial locations. What holds Mike's psychic and geographic travels together is the metaphor of sleep, the dream of escape, and the ultimate realization that even memories cannot fuel hope for the future. Mike becomes a metaphor for an entire generation forced to sell themselves in a world with no hope, a generation that aspires to nothing, works at degrading McJobs, and lives in a world in which chance and randomness rather than struggle, community, and solidarity drive their fate.

A more disturbing picture of youth can be found in *River's Edge*. Teenage anomie and drugged apathy are given painful expression in the depiction of a group of working-class youth who are casually told by John, one of their friends, that he has strangled his girlfriend, another of the group's members, and left her nude body on the riverbank. The group at different times visit the site to view and probe the dead body of the girl. Seemingly unable to grasp the significance of the event, the youths initially hold off in informing anyone of the murder and with different degrees of concern initially try to protect John, the teenage sociopath, from being caught by the police. The youths in *River's Edge* drift through a world of broken families, of blaring rock music, of schooling marked by dead time, and of general indifference to life. Decentered and fragmented, they view death as they view life itself—as merely a spectacle, a matter of style rather than substance. In one sense, these youth share the quality of being "asleep" that is depicted in *My Own Private Idaho*. But what is more disturbing in *River's Edge* is that lost innocence gives way not merely to teenage myopia but to a culture in which human life is experienced as a voyeuristic seduction, a video game, good for passing time and diverting oneself from the pain of the moment. Despair and indifference cancel out the language of ethical discriminations and social responsibility while elevating the immediacy of pleasure to the defining moment of agency. In *River's Edge*, history as social memory is reassembled through vignettes of 1960s types portrayed either as burned-out bikers or as the ex-radical-turned-teacher whose moralizing relegates politics to simply cheap opportunism. Exchanges among the young people in *River's Edge* appear as projections of a generation waiting either to fall asleep or to commit suicide. After talking about how he murdered his girlfriend, John blurts out, "You do shit, it's done, and then you die." Pleasure, violence, and death, in this case, reassert how a generation of youth takes seriously the dictum that life imitates art or how life is shaped within a violent culture of images in which, as another character states, "It might be easier being dead," to which her boyfriend, a Wayne's World–type, replies, "Bullshit, you couldn't

get stoned anymore." *River's Edge* and *My Own Private Idaho* reveal the seamy and dark side of a youth culture while employing the Hollywood mixture of fascination and horror to titillate the audiences drawn to these films. Employing the postmodern aesthetic of revulsion, locality, randomness, and senselessness, youth in these films appear to be constructed outside of a broader cultural and economic landscape. They become visible only through visceral expressions of psychotic behavior or through the brooding experience of a self-imposed comatose alienation.

One of the more celebrated youth films of the 1990s is Richard Linklater's *Slacker*. A decidedly low-budget film, *Slacker* attempts in both form and content to capture the sentiments of a twenty-something generation of white youth who reject most of the values of the Reagan–Bush era but have a difficult time imagining what an alternative might look like. Distinctly nonlinear in its format, *Slacker* takes place in a twenty-four-hour time frame in the college town of Austin, Texas. Borrowing its antinarrative structure from films such as Luis Bunuel's *Phantom of Liberty* and Max Ophlus's *La Rhonde, Slacker* is loosely organized around brief episodes in the lives of a variety of characters, none of whom are connected to each other except that each provides the pretext to lead the audience to the next character in the film. Sweeping through bookstores, coffee shops, auto-parts yards, bedrooms, and nightclubs, *Slacker* focuses on a disparate group of young people who possess little hope in the future and who drift from job to job speaking a hybrid argot of bohemian intensities and new age–pop cult babble.

The film portrays a host of young people randomly moving from one place to the next, border crossers with no sense of where they have come from or where they are going. In this world of multiple realities, "schizophrenia emerges as the psychic norm of late capitalism" (Hebdige 88). Characters work in bands with the name "Ultimate Loser," they talk about being forcibly put in hospitals by their parents, and one neopunker attempts to sell a Madonna pap smear to two acquaintances she meets in the street: "Check it out, I know it's kind of disgusting, but it's like sort of getting down to the real Madonna." This is a world in which language is wedded to an odd mix of nostalgia, popcorn philosophy, and MTV babble. Talk is organized around comments such as "I don't know . . . I've traveled . . . and when you get back you can't tell whether it really happened to you or if you just saw it on TV." Alienation is driven inward and emerges in comments such as "I feel stuck." Irony overshadows a refusal to imagine any kind of collective struggle. Reality seems too despairing to care about. This is humorously captured in one instance by a young man who suggests, "You know how the slogan goes, workers of the world, unite? We say workers of the world, relax." People talk but appear disconnected from themselves and each other; lives traverse each other with no sense of community or connection.

There is a pronounced sense in *Slacker* of youth caught in the throes of

new information technologies that both contain their aspirations and at the same time hold out the promise of some sense of agency. At rare moments in the films, the political paralysis of solipsistic refusal is offset by instances in which some characters recognize the importance of the image as a vehicle for cultural production, as a representational apparatus that can not only make certain experiences available but can also be used to produce alternative realities and social practices.

The power of the image is present in the way the camera follows characters throughout the film, at once stalking them and confining them to a gaze that is both constraining and incidental. In one scene, a young man appears in a video apartment surrounded by televisions he claims he has had on for years. He points out that he has invented a game called "Video Virus" in which through the use of a special technology he can push a button and insert himself into any screen and perform any one of a number of actions. When asked by another character what this is about, he answers, "Well, we all know the psychic powers of the televised image. But we need to capitalize on it and make it work for us instead of working for it." This theme is taken up in two other scenes. In one short clip, a history graduate student shoots the video camera he is using to film himself, indicating a self-consciousness about the power of the image and an ability to control it at the same time. In another scene, with which the film concludes, a group of people in a car, all equipped with their Super 8 cameras, drive up to a large hill and throw their cameras into a canyon. The film ends with the images being recorded by the cameras as they cascade to the bottom of the cliff in what suggests a moment of release and liberation.

One of the most controversial films to appear about teenage sexuality and youth was *Kids,* which was directed by Larry Clark in 1995 from a script written by nineteen-year-old Harmony Korine. Most of the characters in the documentary-like film are nonactors and skateboarding friends of Korine. The film opens with a close-up of a teenage boy and girl loudly kissing each other. The image is crucial both aesthetically and politically. Aesthetically, the camera focuses on open mouths, tongues working overtime, a sucking noise highlighting the exchange of saliva—the scene is raw, rubbing against the notion of teenage sex as "a scaled down version of adult couplings, glamorized and stylized."[7] And it seems to go on forever, positioning the audience as voyeurs watching sex explode between kids who look too young to be acting on their own passions. In a voiceover, Telly (Leo Fitzpatrick), the fifteen-year-old known to his friends as the Virgin Surgeon, says, "Virgins. I love 'em." After seducing a young blond virgin in her bedroom, Telly bolts from the Manhattan brownstone and joins his friend Casper (Justin Pierce), who has been waiting for him. Telly provides an account of his conquest in intimate detail, and so begins Clark's rendition of urban teenage youth in the 1990s.

After Telly's initial seduction, he and Casper head out to wander

through the streets of Manhattan. Along the way, they knock off a forty-ounce bottle of beer, urinate in public, jump over subway turnstiles, and steal some fruit from a Korean grocer. They end up at a friend's apartment, where they do drugs, talk sex, and watch skateboarding movies. The scene becomes more violent as Telly and his friends end up at Washington Square Park, where they smoke some more dope, insult two gays who walk by, and viciously beat with their skateboards a black youth with whom Casper gets into an argument. After stealing some money from Telly's mother, the youths break into the local YMCA for a swim. The day's activities culminate in a night of excessive drinking and drugs at a party given by a kid whose parents are out of town. The party degenerates into a haze of narcotized and drunken bodies, hands plunging randomly into crotches. Telly scores his second virgin. In the meantime, Jennie (Chloe Sevigny) appears at the party looking for Telly to inform him that she has tested positive for the HIV virus, but she is too drugged to prevent him from infecting another young girl. Too numb to do anything, she falls asleep on a couch. In a grotesque and perverse reversal of the fairy-tale plot, Clarke's Sleeping Beauty, Jennie, is not awakened with a kiss and the promise of living happily ever after. Rather, she suffers the brutal humiliation of a rape by Casper and will awaken to the nightmare reality of her eventual death and potentially his as well. The scene ends with Casper looking directly into the camera and asking, "Jesus Christ, what happened?"

Irresponsible sex is transformed into lethal violence as it becomes clear that Jennie contracted the HIV virus from Telly, who now emerges as the infector, the ultimate antihero of American culture in the age devastated by AIDS. If Telly's story is one of sexual conquest, Jennie's is one of tragedy and powerlessness in the face of a ruthless urban youth culture that celebrates reckless sexuality and violence while reducing young girls to one of two sexist stereotypes: they are either sexual objects to be taken up and put down at will or they are sex-crazed and on the make. When the girls come together in the film, they either sit around talking about oral sex, titillating the guys or each other, or they get set up to be exploited, as in the case of Darcy, Telly's last sexual conquest, to become another AIDS statistic.

As for the younger generation of preteens, their future is foreshadowed as the camera focuses on a quartet of dope-smoking eleven-year-old African-American boys who watch the older kids drink and drug themselves into a stupor at the party. The future they will inherit holds no positive role models or encouraging signs of hope. For even younger girls, there is the ominous and disturbing message that they will soon become sexual trophies for the predatory male buffoons who stalk them in the dangerous space of the city. Michael Atkinson captures this sentiment in noting that the camera "lingers on a stepside moptop 3 year-old girl as if to grimly intone, it's only a matter of time" (27). Passivity and helplessness become the privileged modes of behavior as the girls in the film follow the lead of the

male characters, silently observe their expressions of brutality, and plead tearfully when they become the objects of such violence. Predatory sexuality permeates the ruthless world of misogynist teenage males filled with a sense of themselves and their desire to prey on young girls who wait passively to be pulled into a ritual of seduction and possibly death.

Floating on the surface of a dead-end cynicism, Clark's film refuses to probe the places in which identity resides for the urban youth he represents. The teenagers in *Kids* are portrayed as if they live in a historical, political, and cultural vacuum. Lacking any depth, memories, or histories, Clark's teenagers are drawn in personal and stylized terms. For example, he provides no larger context for understanding the cultural, social, and institutional forces working on the lives of these urban teenagers. In this severely decontextualized perspective, it is almost impossible to understand the absence of adults in the film, the at-risk sexuality, the rabid homophobia, or the random violence practiced by these teenagers. Representing teen life as if it existed outside of the forces of history, of the dominant culture, or of the powerful influence of dominant institutions too easily resonates with a dominant, conservative ideology that blames the "psychological instability" of poor—especially poor black—urban youth for the social decay, poverty, and endless disruptions that influence the everyday lives of these kids. Not unlike the Calvin Klein Jeans advertising campaign, Clark's narrative about youth plays on dominant fears about the loss of moral authority while reinforcing images of demonization, racism, and sexual license through which adults can blame youth for existing social problems and can be titillated at the same time.

Clark's realism is too easily used under the pretext of insightful historical and social consideration to transform the jolting and real experiences of the teenagers he represents into raw, celebratory, and stylized evocations of shock and transgression. Failing to come to grips with considerations of politics, power, and ideology, Clark offers neither serious questions regarding how the viewer can account for the simultaneous aggression and powerlessness portrayed by teenagers in *Kids* nor resistance to the brutality and limited options that define their lives. Lacking depth and detail, the teenagers who inhabit Clark's film are one-dimensional to the point of caricature. Clark's attempt to let the film speak for itself results in a stylized aesthetic of violence that renders the reality of violence voyeuristic, spectacular, and utterly personal rather than social and political. *Kids* avoids a central pedagogical lesson in dealing with any segment of teenage culture: unsafe sexual practices, violence, and drug use are learned behaviors that society seems to be going all out to teach. Similarly, Clark seems unacquainted with the notion that any serious portrayal of teens in this culture begins by questioning established social relations and configurations of power. In the end, pathology and ignorance become the basis for defining the identity and agency of urban youth in Clark's world

of casual violence, rampart nihilism, and incorrigible depravity. While Clark has been quick to defend his film as a cautionary tale about safe sex as well as an indictment of adults who either do not understand teenagers or are simply not around to provide guidance for them, he fails to understand—or at least to represent—that it is precisely adult society with its celebration of market values, its market moralities, and its attack on civil society that undermines the social safety net for children. Within the postmodern culture depicted in these films, there are no master narratives at work, no epic modernist dreams, nor is there any element of social agency that accompanies the individualized sense of dropping out, of self-consciously courting chaos and uncertainty.

In many respects, these movies present a culture of white youth who appear overwhelmed by "the danger and wonder of future technologies, the banality of consumption, the thrill of brand names, [and] the difficulty of sex in alienated relationships" (Kopkind 183). The significance of these films rests, in part, in their attempt to capture the sense of powerlessness that increasingly cuts across race, class, and generations. But what is missing from these films—as well as from the various books, articles, and reportage concerning the often-called "Nowhere Generation," "Generation X," "13thGen," or "Slackers"—is any sense of the larger political and social conditions in which youth are being framed. What in fact should be seen as a social commentary about "dead-end capitalism" emerges simply as a celebration of refusal that is dressed up in a rhetoric of aesthetics, realism, style, fashion, and solipsistic protests. Within this type of commentary, postmodern criticism is useful but limited because of its often theoretical inability to take up the relationship between identity and power, biography and the commodification of everyday life, or the limits of agency in a post-Fordist economy as part of a broader project of possibility linked to issues of history, struggle, and transformation. The contours of this type of criticism are captured in a comment by the late Andrew Kopkind, a keen observer of slacker culture:

> The domestic and economic relationships that have created the new consciousness are not likely to improve in the few years left in this century, or in the years of the next, when the young slackers will be middle-agers. The choices for young people will be increasingly constricted. In a few years, a steady job at a mall outlet or a food chain may be all that's left for the majority of college graduates. Life is more and more like a lottery—life is a lottery—with nothing but the luck of the draw determining whether you get a recording contract, get your screenplay produced, or get a job with your M.B.A. Slacking is thus a rational response to casino capitalism, the randomization of success, and the utter arbitrariness of power. If no talent is still enough, why bother to hone your skills? If it is impossible to find a good job, why not slack out and enjoy life? (187)

The pedagogical challenge represented by the emergence of a postmodern generation of youth has not been lost on advertisers and market research analysts. According to a 1992 Roper Organization, Inc. study, the current generation of eighteeen- to twenty-nine-year-olds has an annual buying power of $125 billion. Addressing the interests and tastes of this generation, "McDonald's, for instance, has introduced hip-hop music and images to promote burgers and fries, ditto Coca-Cola, with its frenetic commercials touting Coca-Cola Classic" (Hollingsworth 30). Companies such as Benetton and Reebok have followed suit in their attempts to mobilize the desires, identities, and buying patterns of a new generation of youth. What appears as a dire expression of the postmodern condition to some theorists becomes for others a challenge to invent new market strategies for corporate interests. In this scenario, youth may be experiencing the conditions of postmodernism, but corporate advertisers are attempting to theorize a pedagogy of consumption as part of a new way of appropriating postmodern differences. What educators need to do is to make the pedagogical more political by addressing both the conditions under which they are teaching and the conditions of learning for a generation that is experiencing life in a way that is vastly different from the representations offered in modernist versions of schooling. The emergence of the electronic media coupled with a diminishing faith in the power of human agency have undermined the traditional visions of schooling and the meaning of pedagogy. The language of lesson plans and upward mobility and the forms of teacher authority on which it was based have been radically delegitimated by the recognition that culture and power are central to the authority/knowledge relationship. Modernism's faith in the past has given way to a future in which traditional markers no longer make sense.

POSTMODERN EDUCATION

In this section, I want to develop the thesis that postmodern discourses offer the promise, but not the solution, for alerting educators to a new generation of border youth. Indications of the conditions and characteristics that define such youth are far from uniform or unanimous. But the daunting fear of essentializing the category of youth should not deter educators and cultural critics from addressing the effects on a current generation of young people who appear hostage to the vicissitudes of a changing economic order with its legacy of diminished hopes, on the one hand, and a world of schizoid images, proliferating public spaces, and increasing fragmentation, uncertainty, and randomness that structures postmodern daily life, on the other. Central to this issue is whether educators are dealing with a new kind of student forged within organizing principles shaped by the intersection of the electronic image, popular culture, and a dire sense of indeterminacy. Differences aside, the concept of border youth

represents less a distinct class, membership, or social group than a referent for naming and understanding the emergence of a set of conditions, translations, border crossings, attitudes, and dystopian sensibilities among youth that cuts across race and class and that represents a fairly new phenomenon. In this scenario, the experiences of contemporary Western youth in the late modern world are being ordered around coordinates that structure the experiences of everyday life outside of the unified principles and maps of certainty that offered up comfortable and secure representations to previous generations. Youth increasingly rely less on the maps of modernism to construct and to affirm their identities; instead, they are faced with the task of finding their way through a decentered cultural landscape no longer caught in the grip of a technology of print, of closed narrative structures, or of the certitude of a secure economic future. The new emerging technologies that construct and position youth represent interactive terrains that cut across "language and culture, without narrative requirements, without character complexities. . . . Narrative complexity [has given] way to design complexity; story [has given] way to a sensory environment" (Parkes 50).

A postmodern pedagogy must address the shifting attitudes, representations, and desires of this new generation of youth being produced within the current historical, economic, and cultural juncture. For example, the terms of identity and the production of new maps of meaning must be understood within new hybridized cultural practices inscribed in relations of power that intersect differently with race, class, gender, and sexual orientation. But such differences must be understood not only in terms of the context of their struggles but also through a shared language of resistance that points to a project of hope and possibility. This is where the legacy of a critical modernism becomes valuable in that it reminds us of the importance of the language of public life, of democratic struggle, and of the imperatives of liberty, equality, and justice.

Educators need to understand how different identities among youth are being produced in spheres generally ignored by schools. Included here would be an analysis of how pedagogy works to produce, to circulate, and to confirm particular forms of knowledge and desires in those diverse public and popular spheres where sounds, images, print, and electronic culture attempt to harness meaning for and against the possibility of expanding social justice and human dignity. Shopping malls, street communities, video halls, coffee shops, television culture, and other elements of popular culture must become serious objects of school knowledge. But more is at stake here than an ethnography of those public spheres in which individual and social identities are constructed and struggled over. More important is the need to fashion a language of ethics and politics that serves to discriminate between relations that do violence and those that promote diverse and democratic public cultures through which youth and others can understand their problems and concerns as part of a larger effort to

interrogate and to disrupt the dominant narratives of national identity, economic privilege, and individual empowerment.

Pedagogy must redefine its relationship to modernist forms of culture, privilege, and canonicity, and must serve as a vehicle of translation and cross-fertilization. Pedagogy as a critical cultural practice needs to open up new institutional spaces in which students can experience and define what it means to be cultural producers capable of both reading different texts and producing them, of moving in and out of theoretical discourses but never losing sight of the need to theorize for themselves. Moreover, if critical educators are to move beyond the postmodern prophets of hyper-reality, politics must not be exclusively fashioned to plug into the new electronically mediated community. The struggle for power is not merely about expanding the range of texts that constitute the politics of representation; it is also about struggling within and against those institutions that wield economic, cultural, and political power so as to undermine and suppress democratic relations.

It is becoming increasingly fashionable to argue for a postmodern pedagogy in which it is important to recognize that "[o]ne chief effect of electronic hypertext lies in the way it challenges now conventional assumptions about teachers, learners, and the institutions they inhabit" (Landow 120). As important as this concern is for refiguring the nature of the relationship between authority and knowledge and the pedagogical conditions necessary for decentering the curriculum and for opening up new pedagogical spaces, it does not go far enough, and it runs the risk of degenerating into a another hyped-up methodological fix.

Postmodern pedagogy must be more sensitive to how teachers and students negotiate both texts and identities, but it must do so through a political project that articulates its own authority within a critical understanding of how the self recognizes others as subjects rather than as objects of history. In other words, postmodern pedagogy must address how power is written on, within, and between different groups as part of a broader effort to reimagine schools as democratic public spheres. Authority in this instance is linked to auto-critique and becomes a political and ethical practice through which students become accountable to themselves and others. By making the political project of schooling primary, educators can define and debate the parameters through which communities of difference—defined by relations of representation and reception within overlapping and transnational systems of information, exchange, and distribution—can address what it means to be educated as a practice of empowerment. In this instance, schools can be rethought as public spheres, as borderlands of crossing and travel (Clifford 246–47), actively engaged in producing new forms of democratic community organized as sites of translation, negotiation, and resistance.

What is also needed by postmodern educators is a more specific

understanding of how affect and ideology mutually construct the knowledge, resistances, and sense of identity that students negotiate as they work through dominant and rupturing narratives, attempting in different ways to secure particular forms of authority. Fabienne Worth is right in castigating postmodern educators for undervaluing the problematic nature of the relationship between "desire and the critical enterprise" (8). A postmodern pedagogy needs to address how the issue of authority can be linked to democratic processes in the classroom that do not promote pedagogical terrorism and yet still offer representations, histories, and experiences that allow students to critically address the construction of their own subjectivities as they simultaneously engage in an ongoing "process of negotiation between the self and other" (Worth 26).

The conditions and problems of contemporary border youth may be postmodern, but they will have to be engaged through a willingness to interrogate the world of public politics while at the same time recognizing the limits of postmodernism's more useful insights. In part, this means rendering postmodernism more political by appropriating modernity's call for a better world while abandoning its linear narratives of Western history, unified culture, disciplinary order, and technological progress. In this case, the pedagogical importance of uncertainty and indeterminacy can be rethought through a modernist notion of the dreamworld in which youth and others can shape, without the benefit of master narratives, the conditions for producing new ways of learning, engaging, and positing the possibilities for social struggle and solidarity. Radical educators can subscribe neither to an apocalyptic emptiness nor to a politics of refusal that celebrates the immediacy of experience over the more profound dynamic of social memory and moral outrage forged within and against conditions of exploitation, oppression, and the abuse of power. Postmodern pedagogy needs to confront history as more than simulacrum and to confront ethics as something other than the casualty of incommensurable language games. Postmodern educators need to take a stand without standing still, to engage their own politics as public intellectuals without essentializing the ethical referents to address human suffering.

In addition, a postmodern pedagogy needs to go beyond a call for refiguring the curriculum so as to include new informational technologies; instead, it needs to assert a politics that makes the relationship among authority, ethics, and power central to a pedagogy that expands rather than closes down the possibilities of a radical democratic society. Within this discourse, images do not dissolve reality into simply another text; on the contrary, representations become central to revealing the structures of power relations at work in the public, schools, society, and the larger global order. Difference does not succumb to fashion in this logic (another touch of ethnicity); instead, difference becomes a marker of struggle in an ongoing movement toward a shared conception of justice and a radicalization of the social order.

NOTES

1. For a particularly succinct examination of the postmodernism challenge to a modernist conception of history, see Vattimo, especially chapter one.

2. A number of excellent readers have appeared that provide readings in postmodernism that cut across a variety of fields. Some of the more recent examples include Jencks; Natioli and Hutcheon; Docherty; and Nicholson and Seidman.

3. See, for instance, Todd Gitlin; Michael Tomasky; Jim Sleeper; Barbara Epstein, Richard Flacks, and Marcy Darnovsky; and Richard Rorty.

4. I have taken this issue up in great detail in Giroux 1988; 1992; 1996; and 1997.

5. See, especially, chapter 2. Clarke's analysis has little to do with a complex reading of postmodernism but is instead a defensive reaction of his own refusal to take seriously a postmodern critique of the modernist elements in Marxist theories.

6. Needless to say, one can find a great deal of theoretical material that refuses to dismiss postmodern discourses so easily and in doing so performs a theoretical service in unraveling its progressive from its reactionary tendencies. Early examples of this work can be found in Foster; Hebdige; Vattimo; Ross; Hutcheon; Collins; and Connor. More recent examples include Nicholson; Lasch; Chambers; Aronowitz and Giroux; Best and Kellner; Denzin; Owens; Nicholson and Seidman; and Fraser.

7. Trip Gabriel, "Think You Had a Bad Adolescence?" *New York Times* 31 July 1995: C1.

WORKS CITED

Anderson, Perry. "Modernity and Revolution." *New Left Review* 144 (1984): 96–113.

Anshaw, Carol. "Days of Whine and Poses." *The Village Voice* 37 (10 November 1992): 25–27.

Aronowitz, Stanley, and William Defazio. *The Jobless Future*. Minneapolis: University of Minnesota Press, 1994.

Aronowitz, Stanley, and Henry A. Giroux. *Education Still Under Siege*. 2nd ed. Westport, Conn.: Bergin and Garvey, 1993.

———. *Postmodern Education*. Minneapolis: University of Minnesota Press, 1991.

Atkinson, Michael. "Skateboard Jungle." *The Village Voice* 37 (12 September 1992): 64–67.

Bauman, Zygmunt. *Intimations of Postmodernity*. New York: Routledge, 1992.

Bell, Daniel. *The Cultural Contradictions of Capitalism*. New York: Basic Books, 1976.

Berube, Michael. "Exigencies of Value." *The Minnesota Review* 39 (1992/1993): 63–87.

Best, Stephen, and Douglas Kellner. *Postmodern Theory*. New York: Guilford Press, 1990.

Bishop, Katherine. "The Electronic Coffeehouse." *New York Times* 2 August 1992, sec. "The Street": 3.

Blythe, Scott. "Generation Xed." *Maclean's* 106.31 (August 1993): 35.

Bordo, Susan. *Unbearable Weight: Feminism, Western Culture, and the Body*. Berkeley: University of California Press, 1993.

Butler, Judith. "Contingent Foundations: Feminism and the Question of Postmodernism." In *Feminists Theorize the Political*, ed. Judith Butler and Joan Scott. New York: Routledge, 1992. 3–21.

———. "Merely Cultural." *Social Text* 52–53 (Fall/Winter 1997): 266–77.

Chambers, Iain. *Border Dialogues*. New York: Routledge, 1990.

Clarke, John. *New Times and Old Enemies: Essays on Cultural Studies and America*. New York: Harper Collins, 1991.

Clifford, James. *Routes: Travel and Translation in the Late Twentieth Century*. Cambridge, Mass.: Harvard University Press, 1997.

Collins, Jim. *Uncommon Cultures*. New York: Routledge, 1989.

Connor, Steven. *Postmodernist Culture*. Cambridge, Mass.: Blackwell, 1989.

Denzin, Norman. *Images of a Postmodern Society*. Newbury Park, U.K.: Sage, 1991.

Docherty, Thomas, ed. *Postmodernism: A Reader*. New York: Columbia University Press, 1993.

Eagleton, Terry. *The Illusions of Postmodernism*. Oxford: Basil Blackwell, 1996.

Ebert, Teresa. "Writing in the Political: Resistance (Post)modernism." *Legal Studies Forum* 15.4 (1991): 291–303.

Epstein, Barbara, Richard Flacks, and Marcy Darnovsky, eds. *Cultural Politics and Social Movements*. Philadelphia, Pa.: Temple University Press, 1995.

Foster, Hal, ed. *Postmodern Culture*. London: Pluto Press, 1985.

Fraser, Nancy. *Justice Interruptus: Critical Reflections on the 'Postsocialist' Condition*. New York: Routledge, 1997.

Giroux, Henry. *Border Crossings*. New York: Routledge, 1992.

———. *Channel Surfing: Racism, the Media, and the Destruction of Today's Youth*. New York: Routledge, 1998.

———. *Disturbing Pleasures: Learning Popular Culture*. New York: Routledge, 1994.

———. *Fugitive Cultures*. New York: Routledge, 1996.

———. *Schooling and the Struggle for Public Life*. Minneapolis: University of Minnesota Press, 1988.

Gitlin, Todd. *Twilight of Our Common Dreams: Why America is Wracked by Culture Wars*. New York: Metropolitan Books, 1995.

Green, Bill, and Chris Bigum. "Aliens in the Classroom." *Australian Journal of Education* (in press).

Habermas, Jurgen. *The Philosophical Discourse of Modernity*. Cambridge, Mass.: MIT Press, 1978.

Harvey, David. *The Conditions of Postmodernity*. Cambridge, Mass.: Basil Blackwell, 1989.

Hebdige, Dick. *Hiding in the Light*. New York: Routledge, 1988.

Hollingsworth, Pierce. "The New Generation Gaps: Graying Boomers, Golden Agers, and Generation X." *Food Technology* 47.10 (October 1993): 30.

Howe, Neil, and Bill Strauss. *13th Gen: Abort, Retry, Ignore, Fail?* New York: Vantage Books, 1993.

Hunter, Ian. *Culture and Government: The Emergence of Literary Education*. London: Macmillan, 1988.

Hutcheon, Linda. *The Poetics of Postmodernism*. New York: Routledge, 1988.

Jencks, Charles. "The Postmodern Agenda." In *The Postmodern Reader,* ed. Charles Jencks. New York: St. Martin's Press, 1992. 10–39.

Jost, Kenneth. "Downward Mobility." *Congressional Quarterly Researcher* 3.27 (23 July 1993): 627–44.

Kopkind, Andrew. "Slacking Toward Bethlehem." *Grand Street* 44 (1992): 177–88.

Landow, George. *Hypertext: The Convergence of Contemporary Critical Theory and Technology*. Baltimore, Md.: Johns Hopkins University Press, 1992.

Lasch, Scott. *Sociology of Postmodernism*. New York: Routledge, 1990.

Lemert, Charles. *Postmodernism Is Not What You Think*. Cambridge, Mass.: Basil Blackwell, 1997.

MacCannell, Dean. *Empty Meeting*. New York: Routledge, 1992.

Mercer, Kobena. "'1968': Periodizing Politics and Identity." In *Cultural Studies,* ed. Lawrence Grossberg, Cary Nelson, and Paula Treichler. New York: Routledge, 1992. 438–49.

Natioli, Joseph, and Linda Hutcheon, eds. *A Postmodern Reader*. Albany: State University of New York Press, 1993.

Nicholson, Linda, ed. *Feminism/Postmodernism*. New York: Routledge, 1990.

Nicholson, Linda, and Steven Seidman, eds. *Social Postmodernism*. New York: Routledge, 1995.

Owens, Craig. *Beyond Recognition: Representation, Power, and Culture*. Edited by Scott Bryson et al. Berkeley: University of California Press, 1992.

Parkes, Walter. "Random Access, Remote Control: The Evolution of Story Telling." *Omni* (January 1994): 48–54, 90–91.

Patton, Paul. "Giving up the Ghost: Postmodernism and Anti-Nihilism." In *It's a Sin,* ed. Lawrence Grossberg et al. Sydney: Power Publications, 1988. 88–95.

Rorty, Richard. *Achieving Our Country: Leftist Thought in Twentieth-Century America*. Cambridge, Mass: Harvard University Press, 1998.

Ross, Andrew, ed. *Universal Abandon? The Politics of Postmodernism*. Minneapolis: University of Minnesota Press, 1988.

Sleeper, Jim. *The Closest of Strangers*. New York: W. W. Norton, 1990.

Smart, Barry. *Modern Conditions, Postmodern Controversies*. New York: Routledge, 1992.

———. "Theory and Analysis After Foucault." *Culture and Society* 8 (1991): 144–45.

Tomasky, Michael. *Left for Dead: The Life, Death and Possible Resurrection of Progressive Politics in America*. New York: Free Press, 1996.

Tomlinson, John. *Cultural Imperialism*. Baltimore, Md.: Johns Hopkins University Press, 1991.

Vattimo, Gianni. *The Transparent Society*. Baltimore, Md.: Johns Hopkins University Press, 1992.

Virilio, Paul. *Lost Dimension*. Trans. Daniel Moshenberg. New York: Semiotext(e), 1991.

Willinsky, John. "Postmodern Literacy: A Primer." *Interchange* 22.4 (1991): 56–76.

Worth, Fabienne. "Postmodern Pedagogy in the Multicultural Classroom: For Inappropriate Teachers and Imperfect Strangers." *Cultural Critique* 25 (Fall 1993): 5–32.

Postmodern
Art and Technoculture

Transaesthetics

Margot Lovejoy

Living in the postmodern conditions of the interim between one century's end and the beginning of the new, we confront a greatly revised cultural context brought about by major technological advances. Today's crisis in art is far more profound than the one that took place at the beginning of the last century when photography and cinematography shattered existing traditions of representation. Today's universal digital technologies deeply affect new conditions for communication—the way art is produced, disseminated, and valued. They shift totally the very paradigm of cognition and representation under which we have been operating since the Renaissance.[1]

Fundamental to the understanding of the impact of technology on cultural change is the work of cultural critic Walter Benjamin, who, in his significant 1935 essay "The Work of Art in the Age of Mechanical Reproduction" (widely disseminated in translation by the early seventies), brought into a key position for the first time critical awareness of the relationship between art and technology. His assessment creates an important framework for understanding how widespread integrated changes in technological conditions can

affect the collective consciousness and trigger important changes in cultural development.

Using photography as a prime example of the relationship between major changes in technological conditions and the formation of culture, Benjamin argues that the very invention of photographic processes from 1850 essentially undermined the existing function of art, not only because it could provide visual reportage but also because it threatened the "aura" and value of the original, the handmade object that relied on the specialized skills of the artist. Benjamin understood that once a camera records images or events unique to a particular place and time, a disruption of privacy takes place. A loss of original magic, spirit, authenticity, or aura occurs. Uniqueness is destroyed.

Photography was not simply a visual medium but a means of reproduction for making endless copies from a single original, an aspect that Benjamin acknowledged as the major factor affecting art in its relation to the new age of mechanical reproduction. The copying processes of photography undermined the marketplace value of the original, threatening the very foundations of the existing art establishment that were based on the aura of "unique works of original genius" created by hand skills of individual "great masters." Rather than using photography directly as a medium for their work, painters of the 1880s and 1890s began to move away from their preoccupation with forms of illusion and realism and moved toward attitudes that led to abstraction and formalism. Photography acted as a catalyst for the establishment of a modern theology of a pure high art, a canon still deeply embedded in our consciousness.

According to Benjamin, photographic reproduction and the cinema raised social questions about the role of the artist, about the audience for art, and about art as communication rather than art as object, thus bringing into focus the social function of art as opposed to its commodity value. The copying of an artwork increases its currency in the public consciousness. Art that is enlarged, reduced, and printed in different forms such as postcards or billboards and is widely disseminated reaches an expanded audience beyond the confines of art institutions and the gallery system. As a consequence, the cultural sphere is broadened, enriched, and democratized. Paradoxically, this added exposure increases the value of the original. However, when artworks are seen in many different contexts removed from their original time periods and settings, their meanings change. They begin to mean something else and to fragment into new sets of fresh associations.

Photography came to be associated with the wrenching excesses of the Machine Age. As a result of its potential to threaten the existing role of the artist and to challenge established canons and institutions of art, photography's full development as a medium and its acceptance as a viable fine art form were suppressed until the questions implicit to it

became an important means for deconstructing modernism.

Benjamin was the first to study mass culture as a focus of philosophic analysis. In his essay "The Author as Producer," he anticipated the current crisis of identity and the loss of moral authority of the author/artist. His interdisciplinary thinking anticipated the interwoven, layered structuring of associations and observations that has come to be understood as the postmodern. However, it is clear from Benjamin's writing, particularly the "Arcades Project,"[2] that while he understood the potentially positive influence of technology on art and culture, he was also aware of the major losses incurred by its advances.

His work has influenced contemporary cultural critics and theorists from various sources who have gone beyond him to provide the most illuminating commentary on current representation issues vis-à-vis mass media and major new technological advances in the digital realm: Baudrillard on simulacra, simulation, and the hyperreal; Barthes and Foucault on intertextuality and interactivity; and Derrida and the feminist movement on deconstruction. Their contemporary theoretical understandings, furthering those of Benjamin, are useful tools for probing the postmodern and its relationship to technological advance. It is interesting to note that some of these theoretical concepts closely correspond to the structure and functioning of electronic media tools themselves.[3]

While technological advances of the Industrial Revolution and the impact of new imaging technologies on the arts beginning in 1850 modernized seeing and catalyzed a general cultural move to what was termed the modern period—characterized in the arts by tendencies toward abstraction—by the 1930s "Modernism" came to refer to a special institutionalized movement, an aesthetic understanding of art. This concept was shaped by the systemic critical writings of Clement Greenberg in essays he published between the 1930s and 1960s. Greenberg argued that art practice conformed to immaculate, linear laws of progression that were verifiable and objective. He favored an understanding of art as pure form, a formalist stance that excluded any literary or theatrical references or descriptions and that shut out the real world as subject matter.

Postmodernism is a shift to an essentially broader territory where the suppression of social and cultural influence is no longer possible. The defining moment in the visual arts, when the shift to postmodernism began, was in the late fifties, when architectural forms of representation began to be radically revised away from pure formalist tendencies of "Moderism" and "International Style" toward the more vernacular.[4] The aloofness of the steel curtain walls with their purity and rationality seemed out of synch with the tumultuous sixties characterized by the Vietnam War, which heightened the major personal and political change taking place. New technological conditions, including electronic communication networks such as television, deeply invaded private space, creating a new

kind of cultural infrastructure. Postindustrial capitalism based on electronic technologies under development from the fifties and sixties ushered in a new kind of "information society," a "society of the spectacle." Television acted as the crucible for a postmodern consciousness by challenging our concepts of space, simultaneity, and individuality. The very structure of television is a postmodern one where equal value is asserted between all the elements, including the advertisements.[5] One of the first effects of television on the mind is the "marked mitigation of the distinction between public and private consciousness. A manifestation of this is an increasingly altered sense of ourselves as we become more media dominated; our tele-selves become our real selves. We lose our private selves in publicity."[6]

With the invasion of television into the American living room, the boundaries between high art and popular culture began to shift when a younger group of artists began to demonstrate the direct connections between art and an increasingly technologized consumer society. The work of these pop-movement artists—Roy Lichtenstein, James Rosenquist, Andy Warhol, Robert Rauschenberg, Jasper Johns, and Claes Oldenberg, among many others, including British artists Eduardo Paolozzi and Richard Hamilton—was inspired by the theories and example of European avant-gardist Marcel Duchamp.[7]

While the European avant-garde was more political in its opposition to the status quo and to technological conditions, the American pop movement was avant-garde in its adoption of industrial technologies for making work. When Andy Warhol began silk-screening photo images directly onto his canvasses in 1962, pop artists began the appropriation of mass culture by using photomechanical technologies to reproduce images directly into the field of painting. In so doing, they bypassed the social implications of photography raised by Benjamin. Although many photographers such as Stieglitz and Steichen asserted photography as a fine art medium, it was not until after its reproductive technology was brought directly into the field of painting by pop artists, more than one hundred years after its invention, that it was accepted into the canon as a fine art medium like any other.

More than any other of the pop artists, Warhol fused the method and style of industrial production as part of his overall aesthetic. His serial repetition of images was a commentary on mechanical reproduction itself. Warhol called his studio "The Factory" and declared, "If I paint this way, it's because I want to be a machine" (Wheeler 150). His works, particularly his Brillo box constructions, are an unequivocal acknowledgment of the impact of media to register decisively and coolly the terrifying emptiness and terrible loss implied by consumer culture. He registers the impact of postmodern simulacra in the "cold deadpan stare of the late self-portraits with their look of insatiable, inarticulate yearning for the unrecoverable" (Wheeler 312).

Avant-garde movements in the sixties and seventies moved in

opposition to the still-dominant modernist aesthetic toward an expanded dematerialized view of art that refused the object: Earth Art, Fluxus, Performance, Conceptual Art, and work that incorporated the new electronic media tools, especially video and the computer. The incorporation of mass culture and photographic reproduction methods into the fine arts by the pop movement, in tandem with the use in the arts of new forms of electronic representation, marks the moment of a major crisis for representation.

Ironically, once photography was accepted into the fine arts canon, all the issues denied for so long under the rubric of modernism became the very focus of it, the very means of deconstructing it. The deconstruction of the fine arts canon began through widespread use of tools of critical theory—particularly concerning the issues brought out earlier by Walter Benjamin (concerning aura, identity, the copy and the original, death of the author, originality and genius)—along with poststructuralism, psychoanalysis, and feminist theory.

Photography engages every postmodern critical or theoretical issue. Authorship, uniqueness, subjectivity, and appropriation are endemic to its very process:

> Issues devolving on the simulacrum (authenticity versus artificiality), the stereotype, and the social and sexual positioning of the viewing subject are central to the production and functioning of advertising and other mass-media forms of photography. Postmodernist photographic activity may deal with any or all of these elements and it is worth noting, too, that even work constructed by the hand . . . is frequently predicated on the photographic image. (Solomon-Godeau 80)

The deconstruction process, particularly by feminists, raised consciousness regarding the marginalization of certain artists not only because of gender but also because of race or class. Artists such as Sherrie Levine and Barbara Kruger began to use theoretical issues as the very subject matter of their work. Levine questioned the value of an original by completely appropriating the work of another artist and calling it her own. Kruger's work commented on identity, appropriation, the copy and the original, and the concept of the artist as genius.

Many postmodern artists in the 1980s and 1990s appropriated found imagery in their work as a strategy to seek new meanings by changing the context in which an image is seen. In the process, they have mounted a critique of the conventions of art history challenging the modernist notion that "original" and "uniqueness" rightfully dominate in assigning value to art. Some of the strategies they pursued were appropriation or quotation of preexisting historical images, texts, forms, and styles. Mass-media influences (originating in 1960s pop imagery) were brought into a new, more political forum. Artists in the eighties used photography and

appropriated commercial images from comics and media along with collage and an effluvia of found materials. However, the new pop differed in its implicit critique of commercial culture by unmasking the "manipulative nature of the message-bearing images fed . . . through various media and designed to keep us consuming goods, goods produced solely to be consumed. The result is not only an appropriation of that imagery but also an appropriation of the power of that imagery" (Frank and McKenzie 90).[8]

Ironically, the formal, self-referential modernist aesthetic of fine art photography—handmade prints with their own claims of an acknowledged particular object presence or aura—has essentially separated photography from the more expanded postmodern view of it, as expressed by Walter Benjamin. As seen against his view of photography as a powerful means of mass communication with a social function that dominates the culture of everyday life—in forms such as photomechanical reproduction, cinema, and television—the medium became trapped in the meshes of a confining system that controlled canonical notions of what representation is.

An example of artwork using theory as subject matter is Sherrie Levine's extreme use of appropriation. Her critique of the market system involves rephotographing and thus appropriating in their entirety the works of other well-known artists (such as Walker Evans, Alexander Rodchenko, and Piet Mondrian) and signing the fabricated copies as her own. Like those of Duchamp and Warhol before her, this outstandingly radical neo-dadaist body of work has created a sensation, forcibly bringing the issue of the copy and the original into focus.[9]

Barbara Kruger's work offers a further illustration of these major tendencies in art and their relationship to technology. She raises ironic questions about representation in relation to social constructs. She uses the copy and appropriation as the major site for her theoretically based work. Her strategy is to reproduce found images from mechanically produced sources and to add texts to them so that they function effectively as an active commentary. This forcefully raises issues about female presence so long excluded by the patriarchy. Kruger's media-conscious work is at the intersection of mass media/mass culture in its nexus with high art, especially through her engagement with the copy and the politics of art. Her work is confrontational, agitational, and is aimed at destroying a certain order of representation: the glorification of the original that up until now has been all male.

Both of these artists reveal in their work the tension between the high value that the arts have placed on object value (aura) and the postmodern emphasis on the primacy of mediated images and signs and of immateriality. These acts of appropriation and repetition indicate a kind of cultural exhaustion that has important shock value because they dramatically bring into focus major issues that normally lie below the surface, issues that need to be questioned.

In "The Death of the Author," Barthes asserts that the author (or artist)

is never the source and site of meaning and that meaning is never invented or locked in. A work exists in a "multi-dimensional space in which a variety of writings, none of them original, blend and clash. The text is a tissue of quotations drawn from the innumerable centers of culture." The artist/author is no longer the only container for feelings, impressions, and passions, but he is rather "this immense dictionary from which he draws a writing (image) that can know no halt: life never does more than imitate the book, and the book itself is only a tissue of signs, an imitation that is lost, infinitely deferred" (Barthes 146–47).[10]

The debate about this position and the aesthetic attitudes that grew out of the influence of theory were extremely important as strategizing tools for artists during the seventies and eighties. Generally they led to appropriation, parody, and pastiche as critical imaging methods. As we have seen, the unmediated appropriation exemplified by Levine's works has a transgressional political edge. Appropriation can be seen pessimistically as merely looking backward, or it can be seen as an act of renewal through its provision of the context of history on current affairs. As pastiche, it can be a hybrid hodgepodge of imitations of dead styles, recalling the past, memory, and history with satirical intention. It can be referred to as a kind of radical eclecticism in which various styles or subsystems are used to create a new synthesis. Similarly, parody can be employed in different ways as a strategy. The work of neo-Expressionist artists could be seen as a satirical quotation of older work, but it could also be seen as an effort on the part of contemporary German artists after the war to find new ground as a generation seeking a place to begin again.

Deconstructive strategies opened the way to alternative representations that involve social and cultural issues as a major context in the way ideas can be presented. The feminist movement that evolved as a result of the dramatic social change of the sixties contested the modernist canon with its formalist criticism in ways that profoundly ruptured art's social position and practice. Using the deconstructive strategies concerning the rhetoricity of texts first developed by Paul De Man, in combination with the theories of Walter Benjamin and Roland Barthes, feminist artists unearthed very different views related to history. They questioned the male-dominated litany of aesthetic values, of artistic criteria, and of art-historical practices. Suppressed and marginalized for so long by the dominant power structure, they began to interrogate profoundly and to alter the subject matter for art and the way art is practiced and positioned. By introducing into their work feminist content through the use of innovative new materials and techniques, they brought into the field of representation new views of gender, of identity, and of the body as subject matter, and they dismantled, as we have seen, traditional notions of originality and authorship. With their fresh outlook they created new forms of mixed media exploration such as the body art of Hannah Wilke, the performance

work of Carolee Schneemann, and the video installations of Adrian Piper.

Definitions of postmodernism vary because the term is applied to many fields. It is characterized by the impact of mediated images on perception; by the deconstruction of the major canons and narratives that have up until now formed Western thought; and by the development of a visual culture, superseding one that relied mainly on the word and transmitted by electronic technologies that have consciousness-controlling capacity. The very pervasiveness of media technologies in modern society creates a new set of questions calling for new theories of the relationship between language, behavior, and belief, and between material reality and its cultural representation. Baudrillard speaks about the veritable bombardment of images and signs as causing an inward collapse of meaning where mass-media feedback dominates reality. Is there any absolute knowledge when there is no longer an authentic message, when there is only the absolute dominion of information as digitized memory storage banks? The constant melting down of forms causes a kind of "hyperreality," a loss of meaning due to the neutralization of difference and of opposition, that dissolves all claims to universal truth.

Culturally, postmodernism is characterized by major change: from the concept of a single Eurocentric cultural stream dominated by white male privilege to one that recognizes diverse identities and voices interacting in a complex web of ideological and behaviorist associations. Eurocentric thought assumed a centered, authoritative voice based on a single world-view, structured through domination and transformation of subjected cultures. This attitude now seems outdated in the face of a globalized, transnational information economy. Even the process of analysis itself is suspect and subject to deconstruction, a factor that has led to uncomfortable "correctness" issues in relation to the overthrow of traditional Western systems of thought, as they have been practiced up to now in intellectual and critical communities to reveal their darker underside.

The computer has made possible a break with the kind of representation we have followed since the Renaissance. It has the capability of combining sound, text, and image within a single database. Images no longer reside in the visual field but rather exist in the database of the computer as an accumulation of data, without physical substance. Their existence as information does not necessarily lead to the production of a material art object unless the artist makes a conscious decision to translate it into one that can maintain a physical presence within a perceptual field. To see an image, the data about its structure of lights and darks must be called up for display. Not only is it a dematerialized image, but it is also one that can be destabilized and constantly invaded, changed, and manipulated interactively by a viewer through software commands.

George Landow, in *Hypertext: The Convergence of Contemporary Critical Theory and Technology*, demonstrates that in the computer we have an

actual, functional convergence of technology with critical theory. The computer's very technological structure illustrates the ideas of Benjamin, Foucault, and Barthes, who earlier theorized the "death of the author." It happens immaterially and interactively, via the computer's operating system. The destabilization of a single text to one of many associations in a weblike intertextuality takes place in the linked network of digital references that are nonsequential and nonlinear in the data space of the computer.

This possibility for intervention and interaction challenges notions of a discrete work of art, one that is authored by the artist alone. An interactive work is one that may, for example, use branching systems and networks for creating connective links and nodes. The artist who decides to work with technology now assumes a different role in relationship to his work, one similar to a systems designer, and the work takes a different route in relationship to the viewer who participates in the work's ultimate unfolding and meaning.

Electronic CD-ROM is an example of how the experience of reading and of looking at visual images has changed and ultimately how the new technologies are changing the nature of what is seen and what is read. It calls for a new way of viewing that is based on visual icons. A computer provides the possibility for interaction by allowing for the branching out of visual or textual material to present choices to the viewer through a series of document blocks linked to different pathways. The computer creates interconnected webs of information. It is able to link various kinds of image files and other types of documents, to network them, and to create paths and nodes connecting them. CD-ROM multimedia implies visual or textual material or sound with possible electronic linkages that can be manipulated and rearranged at the viewer's command.

Roland Barthes considers such media a metaphor for the postmodern. In the ideal work,

> the networks are many and interact, without any one of them being able to surpass the rest; . . . it has no beginning; it is reversible; we gain access to it by several entrances, none of which can be authoritatively declared to be the main one; the codes it mobilizes extend *as far as the eye can reach*, they are indeterminable. . . ; the systems of meaning can take over this absolutely plural text, but their number is never closed, based as it is on the infinity of language. (*S/Z*, 5–6)

Multimedia interactivity undermines the concept of centrality and the notion of an individual discrete work such as the familiar narrative form. However, it also creates a less powerful but more democratic condition that implies a society of dialogues in which no one discourse or ideology dominates. For example, interactivity changes the relationship between artist and viewer. The viewer must choose between options to receive a

single message from the many. Electronic nonsequential viewing affects how art is produced and how it is accessed by the viewer. Interactivity deeply entwines the functions of viewer and artist. In so doing, the artist's role changes. This convergence transforms what had been two very different identities of the artist and the viewer. Art solicits from the viewer not simply reception but also an independent construction of meaning. By interactively participating, the viewer derives power parallel with that of the artist: to choose one's own path and discover one's own insights through the interactive work. The artist, in designing the work as a collaborative piece meant for interaction, chooses subservience to the viewer. The romantic sense of self as a single artist/creator is then subsumed by the self now merely a node in an information network. This contributes to the loss of the single voice in favor of a democratic dialogue.

Interactive viewing is completely different from linear activity. Benjamin differentiates between simple viewing and viewing multiple edited versions of the same image in movement: "The painter maintains in his work a natural distance from reality while the cameraman penetrates deeply into its web. . . . That of the painter is a total (or linear) one, that of the cameraman consists of multiple fragments which are assembled under a new law" ("Work of Art," 233–34). Interactive multimedia work permits creation of a new kind of viewing that may take the form of an interactive synthesis of animation and sound. In effect, watching television provides an everyday interactive *experience:* Imagine television as a web of image blocks from which we draw our own meanings while we zap our way through the day's programming choices. Works originally conceived as CD-ROM or interactive installations include those of Bill Seaman, Agnes Hegedus, and Miroslaw Rogala. These works electronically link blocks of images or of electronic functions to each other or to other video segments mixed with still images, animations, and sound.

In his 1981 essay "Simulacra and Simulations," Baudrillard articulates simulacra as a

> generation by models of a real without origin or reality: a hyperreal. . . . The real is produced from miniaturized units, from matrices, memory bank, and command models—and with these it can be reproduced an indefinite number of times. It no longer has to be rational, since it is no longer measured against some ideal or negative instance. It is nothing more than operational. In fact, since it is no longer enveloped by an imaginary, it is no longer real at all. It is hyperreal—the product of an irradiating synthesis of combinatory models in hyperspace without atmosphere. (Baudrillard 187)

The new virtual reality three-dimensional environments are only representations of human knowledge—the sum of our human knowledge about any one subject, such as a bird or a human body. We can create models of

objects and animate them to move around in virtual space using millions of polygons and ultrasophisticated programming, as in the work of Catherine Ikam. However, these simulated objects tend to have no "otherness," no mysteriousness, no autonomous life.

"Les Immateriaux," a 1985 exhibition curated by Lyotard at the Pompidou Center in Paris, was a demonstration of the states of artificiality and synthetic "nonmateriality" that grow out of instabilities and changes inherent in the postindustrial society—a "disappearance of the object" in favor of its completely artificial facsimile, in effect, the "primacy of the model over the real, and of the conceived over the perceived" (Linker 105). The simulacrum becomes for both Lyotard and Baudrillard an emblem of the opposition between the modern concept of mastery and control of production and its postmodern antithesis in which matter can be organized in new machines that may have the edge on certain aspects of the mind and hand. The relation between mind and matter is no longer that between a willful subject and an inert object. It becomes decentered, split, and interactive. The postmodern realization that "the truth is, there is no one truth" has been usurped by an electronic one that feeds on itself, self-multiplies, and can exist concurrently in computer memory and in cyberspace on the Internet.

Unprecedented forms of communication are occurring globally as a result of interactive computer communications on the World Wide Web. As one user stated, "Getting information off the Internet is like taking a drink from a fire hydrant." The metaphor of the Internet as a highway fits, like Jack Kerouac's *On the Road:* from a tight little community out onto a wide open road. Everybody's out there; it's not a small elite system. Already, virtual communities have created a Net culture where dialogue and exchange take place on-line. Research results and writings are shared.

Artists are now creating works for the Internet as a new aspect of representation: art as communication. The accessibility of an on-line, electronically produced artwork is synonymous with it being transmitted and disseminated like television. However, unlike television, it is an interactive, participatory medium. It can be accessed as part of an electronic network in which the outcome is a kind of sharing and messages-in-circuit impulse. Such accessibility changes the work itself because it must be created with a broader audience in mind. An on-line gallery offers a much larger audience than that possible with conventional exhibitions. In a way, art on the Internet becomes an aspect of what we could call public art, with all the constraints and freedoms to communicate within a wider sphere. Viewers also become collaborators in an interactive dialogue, leaving notes and comments at the site of the exhibition or printing out sections of images or texts.

Communications technologies provide increased opportunities for global cooperative projects where there can be a sharing of ideas and

artwork with others, thus advancing the possibilities for cross-cultural exchange. For example, artists in five different countries collaborate on a drawing that is faxed and embellished at sites in each country; participants in a global on-line electronic mail conference are invited to share views about on-line artworks; and international links between sites allow for intercultural dialogue and artistic invention.

The effect of technology is to expand the possibility for cultural growth and exchange. Fueled by market concerns, its evolution is breathtakingly fast. It is creating major social and cultural upheavals comparable to the social and cultural dislocation of the Machine Age. Its possibilities for providing a wider global forum for art are today contrasted with a repressive system of control we understand in reference to commercial television. Questions surface that still have no answers. How will artists function in the new cyber-environment? What role will art play in the evolving architecture of the electronic landscape? What kinds of cultural institutions will exist? What kinds of education will artists need?

Each artistic field has widened beyond the idea of a received canon and has begun to lose its particular relevance and character. In the visual arts, there is a convergence of the disciplines—music, dance, theater, film—and a merging of technical production. Parallel to the shift in art brought about by photography is the current shift being propelled by electronic media toward anonymity/collaboration and transience/multiplicity. This kind of technological production surpasses the modernist narrative of the individual artist struggling to transform a particular physical medium. Uniqueness, permanence, and transcendence have given way in film and video. The invasion of electronic media into every phase of our existence creates deep schisms that force a reconsideration of representation for electronic tools and that make it possible to rethink existing artistic forms and to invent new ones.

The need for art has expanded since the sixties due to the democratizing influence of electronic media. In the late twentieth century, no culture is untouched by mass culture. People everywhere are increasingly receiving similar commercial and cultural influences. International corporations are promoting the breakdown of local culture, but they are also creating communications that could lead to a more global one. While this change has many dangers, the democratization of culture through new electronic communication networks offers the challenge of immediacy and the possibility for public interaction in creating an art that could contribute to fresh forms of cultural development. We have come a long way from McLuhan's 1960s ideal of the world as a global village. The perspective is there, but it is skewed by the knowledge we possess concerning the dangers inherent in new technologies.

All the major ideas and movements of the modern period from the early 1900s—abstraction and cubism, constructivism, dadaism, and

expressionism—have all been restated through neo-dadaism, neo-constructivism, and neo-expressionism. In the 1980s and 1990s there has been a replay of mainstream movements from the fifties and sixties, including neo-minimalist, neo-pop, and neo-conceptualist. This has occurred with slight progressions and extensions but with no real new break in the field of perception or in systems of meaning that offer a serious challenge to traditional notions of representation. Technologized seeing and forms of representation have now, however, passed well beyond photography and cinema to embrace the radically new aspects of electronic representation opened up by television, video, globalized electronic communications, and digital technologies that have the power to create structures that produce "virtual" images and possibilities for interactive forms of communication. As representation, these media have been largely marginalized by the mainstream until recently, similar to the earlier example of photography, even though the social and economic implications of their use have strongly affected cultural conditions since the early sixties.

New York Times critic Michael Brenson comments on the postmodern shift that has taken place since the fifties: art can now "be conceptual, photographic, figurative, or expressive. It [can] mirror and engage the mass media, particularly the visual media like television and film. It [can] have mythical, personal, and social subject matter. . . . It [has] something to say about the giddy excitement and awful conflicts of late twentieth-century life." Will the unprecedented technological conditions of our times allow for the emergence of transaesthetic forms and ideas that will have wide significance? The politics of the new cybernetic world we have entered may work to impose limits to the freedom offered by digital technologies. However, many contemporary artists address the need for aesthetic experience that is felt more deeply than ever before by a larger number of people as they strive to situate themselves in the complexity of the electronic age. Works of art can only be helpful in understanding living social relations if they are structurally in tune with the creative energy of our time.

NOTES

1. See Lovejoy.
2. See Buck-Morss.
3. See Landow.
4. See Venturi and Scott-Brown.
5. It is as if our continual stimulation by the programmed fusion of old movies, soap operas, depictions of family life, news, scenes of war, and historical documentaries has contributed to a state in which artificial representations of reality become dominant features—an obstacle to direct personal meaning and significance.
6. Willoughby Sharp, quoted in Loeffler 32.

7. Seen in today's context, Duchamp's ideas, building on those of Walter Benjamin about appropriation, have gained fresh impetus by bringing up issues of the copy and the original and of the privileging of the object. Duchamp's readymades set an important precedent because they recontextualized and reoriented art away from its own identity as a form (as in minimalism or abstract expressionism) toward the kind of instability and undecidability of postmodernism with its questions about authorship, originality, and genius.

8. Also, the methods used by artists such as Keith Haring, Kenny Scharf, Rodney Alan Greenblatt, and Jeff Koons to convey their messages make use of the same mannerism, exaggeration, and sense of easy fun mixed with wrenching disjuncture that characterize television itself. While sixties pop established an equation between aesthetic appreciation and commodity consumption of images, and as a result was more accessible to the public, the work had a "disinterested" nonpolitical subjectivity to it that in effect refashioned the images, abstracted them, and effectively detached them from the context of their social relations. The reincarnation of pop, however, is socially aware and uses incongruous, out-of-context imagery of all kinds to make its point. This new work apes the energy and the glitzy, unabashed directness of commercial advertising, television, and magazine styles, but it has its own political agenda.

9. Levine's use of other artists' work to question the copy and the original recalls the issues raised by Duchamp when he exhibited in a gallery his readymades—objects not only made by machines but also produced industrially as multiples of an object. Duchamp pointed out that the meaning and value of art is a constructed product of the mind and that changing the context of an object could create a new meaning for it and could enable it to be seen in a different perspective.

10. Also, Foucault wrote about representation in *The Order of Things* and in "What is an Author?"

WORKS CITED

Barthes, Roland. "The Death of the Author." In *Image-Music-Text,* trans. Stephen Heath. New York: Hill and Wang, 1977. 142–48.

———. "From Work to Text." In *Image-Music-Text,* trans. Stephen Heath. New York: Hill and Wang, 1977. 155–64.

———. *S/Z.* Trans. Richard Miller. New York: Hill and Wang, 1974.

Baudrillard, Jean. *Selected Writings.* Ed. Mark Poster. Stanford, Calif.: Stanford University Press, 1988.

Benjamin, Walter. "The Author as Producer." In *Art After Modernism: Rethinking Representation,* ed. Brian Wallis. New York and Boston: New Museum of Contemporary Art and David R. Godine, Publisher, Inc., 1984. 297–309.

———. "The Work of Art in the Age of Mechanical Reproduction." In *Illuminations,* trans. Harry Zohn. New York: Schocken Books, 1978. 217–51.

Brenson, Michael. "Is Neo-Expressionism an Idea Whose Time Has Passed?" *New York Times* 5 January 1986, sec. 2.

Buck-Morss, Susan. *The Dialectics of Seeing: Walter Benjamin and the Arcades Project.* Cambridge, Mass.: MIT Press, 1991.

Frank, Peter, and Michael McKenzie, *New, Used, and Improved: Art of the Eighties.* New York: Abbeville Press, 1987.

Kruger, Barbara. "Incorrect." In *Remote Control: Power, Cultures, and the World of Appearances.* Cambridge, Mass.: MIT Press, 1993. 220–21.

Landow, George. *Hypertext: The Convergence of Contemporary Critical Theory and Technology.* Baltimore, Md.: Johns Hopkins University Press, 1992.

Linker, Kate. "A Reflection on Postmodernism." *Artforum* 24, 1 (Sept. 1985): 104–5.

Loeffler, Carl. "Towards a TV Art Criticism." *Art Com* 22:6.2 (1983): 32.

Lovejoy, Margot. *Postmodern Currents: Art and Artists in the Age of Electronic Media.* 2nd ed. Upper Saddle River, N.J.: Prentice Hall, 1997.

Solomon-Godeau, Abigail. "Photography after Art Photography." In *Art After Modernism: Rethinking Representation,* ed. Brian Wallis. New York and Boston: New Museum of Contemporary Art and David R. Godine, Publisher, Inc., 1984. 75–86.

Venturi, Robert, and Denise Scott-Brown. *Learning from Las Vegas: The Forgotton Symbolism of Architectural Form.* Cambidge, Mass.: MIT Press, 1977.

Wheeler, Daniel. *Art Since Mid-Century: 1945 to the Present.* Englewood Cliffs, N.J.: Prentice Hall/Vendome Press, 1991.

Hyperaesthetics

Theorizing in Real-Time about Digital Cultures

Peter Lunenfeld

NOSTALGIA FOR THE FUTURE

Infinitely tiny partitions of time contain the equivalent of what used to be contained in the infinite greatness of historical time. (Paul Virilio, quoted in Sans 57)

suffer from nostalgia for the future. I am one of those people who works with computers, a ubiquitous trade within the information economy. I find myself missing systems, softwares, tools, and products before they are even gone. I miss them because I know that the ever-redoubling speed of digital technologies will render them obsolete memories in the blink of my too human eye. If I do not prepare myself emotionally for their absence even before the moment of their release, I will be less able to adjust to the immediate future that will regard them either as detritus or charming anachronisms. Only nostalgia for the future allows me the mental space to confront the convergence of digital technologies and cultural production.

THE FUTURE/PRESENT

An enthusiastic respect for the word "future," and for all that it conceals is to be ranked among the most ingenuous ideologies. (Duhamel xii)

Remember future shock: the new boldly announces itself, cuts through the quotidian fog, and forces you to confront tomorrow. It is already tomorrow, however, and the future does not shock—it simply exists alongside the present. Grammarians speak of the future perfect tense, which indicates an action that begins in the past or the present and will be completed later. Example: "The snow *will have melted* before you arrive." Explanation: Melting of snow *has begun, is continuing,* and *will soon be completed.* There is need for a similar term to describe the contemporary moment—no longer simply the present, but rather a future/present, a phenomenological equivalent to the future perfect tense. Example: "In the future/present, digital post-production techniques *will have become obsolete* by the time you learn them." Explanation: The technologies *have been developed, are being refined,* and *will soon outstrip* your expertise.

That the cycles of development, maturation, and decay of future/present environments are ever accelerating has been noted by others too numerous to mention. In fact, the blossoming of metacommentary—in books, journals, magazines, newsgroups, listserves, and Web sites—is itself an aspect of this speedup. This explosion of discourse indicates that, if we are to wrest meaning from contemporary experience, we must deal with the future/present ubiquity of the computer.

The cybernetic realm metastasizes faster than cancer, and classical aesthetics is not the diagnostic tool it once was. Yet who said the culture is more pathological now than it has ever been? It is not. Etymologically speaking, to diagnose is to distinguish, and distinguishing the one from the other—*a* from *b,* apples from oranges—is the basic function of cognition. Once we distinguish a technoculture and its future/present from that which preceded it, however, we need to move beyond the usual tools of contemporary critical theory. Methodologically sophisticated as this theory has become, it remains imbricated in analogue systems. As constituted over the past three or four decades, "contemporary" critical theory has proved itself only partially competent to account for these new digital objects and electronic systems. A critical reading of the technoculture must involve more than the facile overlay of well-worn vocabularies and paradigms onto new objects of investigation. Three representative strategies for confronting the future/present have developed, each with its own temporal orientation. The first invokes the past to battle the present, reinvigorating the machine-breaking ideology of the Luddites. The second races frantically to keep pace with the present, manifesting itself in an almost hysterical neologizing. The third looks forward, deploying a discourse that mimes the structures and concerns of science fiction. I conclude the essay with a fourth alternative, a hyperaesthetic that encourages a hybrid temporality, a real-time approach that cycles through the past, present, and future to think with and through the technoculture.

NEO-LUDDITES

All technologies should be assumed guilty until proven innocent. (Mander 43)

There are those in our culture who do not suffer from what Allucquère Rosanne Stone refers to as *cyborg envy:* "the desire to cross the human/machine boundary" that computer technologies and their interfaces seem to promise ("Will the Real Body" 108).[1] Studies such as *War in the Age of Intelligent Machines* (De Landa), *Cyborg Worlds: The Military Information Society* (Levidow and Robins), and *The Closed World: Computers and the Politics of Discourse in Cold War America* (Edwards) offer compelling arguments that the new cybernetic technologies are far too dependent on their roots in the military's obsession with C³I (Command, Control, Communications, and Intelligence) to be seen as entirely beneficent. Yet as cautionary as these critiques are, they do not go as far as others. In deference to the Luddites, those early-nineteenth-century bands of English mechanics and their supporters who set themselves to devastate the manufacturing machinery in England's midlands and north, we can call the furthest wing of technocritique neo-luddite.[2] Neo-luddite thought approaches the manifestations of digital culture as phenomena that must be examined with the focus firmly on the past—looking at historical, and even prehistorical, models of a more "humane" relationship among the environment, culture, and technology. The neo-luddites do more than risk the approbation of the technophiles; they court it. Author and provocateur Kirkpatrick Sale has gone as far as smashing computers with sledgehammers during public lectures.[3]

When impassioned ex-advertising executive turned ecological think-tank director Jerry Mander maintains "the importance of the negative view," he is expressing an exhaustion with the prosocial rhetoric of the twentieth century's technology boosters. Philosopher Langdon Winner succinctly asks the question, "What kind of world are we building here?" (18). Though there is no catechism for the neo-luddites, they could agree that the ills of the future/present can only be solved by paying attention to the lessons of the past. There are groups not always willing to accept the label of neo-luddite—ranging from Earth First! (the radical environmentalist group) to the *Processed World* collective (publishers of a magazine about the horrors and boredom of the electronic workplace)—that find themselves in sympathy with this perspective on the past.[4]

Critical theorist Andrew Ross, by no means a Luddite, neo- or otherwise, posits that the "high-speed technological fascination that is characteristic of the postmodern condition can be read . . . as a celebratory capitulation by intellectuals to the new information technologies" (99). For those who adhere to this reading, the effect of the move to the digital merely atomizes, accelerates, and renders instantly accessible the violent, racist, sexist,

consumerist, and antienvironmental excesses of postindustrial capitalism. If so, who needs it? What is the point of theorizing that which deserves merely scathing condemnation?

The hard-line neo-luddite stance offers a critique of an expansionist, consumption-oriented technology from a conservationist, pacifist point of view, often inspired by the philosophies of aboriginal peoples. Attempts to apply the neo-luddite approach to the aesthetics of digital arts and media tend to situate computer-inflected arts as handmaidens to the ubiquitous entertainment industries of postindustrial capitalism. Poet and essayist William Irwin Thompson positions the citizenry of the technoculture as the "electropeasantry in the state of Entertainment" (31). In *Generation X,* a novel far more interesting than the marketing label it became, Douglas Coupland is less concerned with technopolitics, which he labels "bread and circuits" (80), than in post–baby boomers and their numbed personae. The technocultures have ever-expanding borders, and their endless engorgement contributes to what he has termed "option paralysis: the tendency when given unlimited choices, to make none" (139).

Yet we must make choices, especially if we reject Mander's complete skepticism about new technologies. The question becomes, how do we reason or feel our way vis-à-vis the technoculture without relying too heavily on a perspective focused on the past? Digital cultures tend to have embryonic and oddly amalgamated politics.[5] They profess on some levels to being inclusive and open to divergent voices—the digital democracy of the electronic meeting house so central to wired populism (Ross Perot's quixotic 1992 presidential campaign was the first major manifestation of this particular delusion in North American politics). Digitizing a culture is a cash-intensive proposition that dramatically demonstrates the split between rich and poor, North and South. Regardless of the growing presence of women and people of color on-line, there is still a poor enunciation of gender consciousness, and questions of race are often elided in the airy discourses of technopositivism. Whole swaths of these cultures still maintain their gnostic and nerdy insularity, with experts happily plying their trades for whomever buys them equipment and rents their time. As powerful as the neo-luddites' positions can be, their central arguments almost preclude their abilities to address the very audience that most needs to hear them: technophiles who could broaden their conception of who they are, of what they do, and of how they could strive for so much more.

LEXICOGRAPHERS OF THE FUTURE/PRESENT

Rasterbator—A compulsive digital manipulator. A Photoshop abuser. (*Wired*'s "Jargon Watch")[6]

To enter a community and practice its crafts, an individual must learn to speak a specific language. The editor of *The New Hacker's Dictionary* writes of the computer community's "almost unique combination of the . . . enjoyment of language-play with the discrimination of educated and powerful intelligence" to account for the prodigious rate at which it coins new words, acronyms, and slang to describe and comment on the systems it creates and utilizes (Raymond 3).[7] Critical discourse's adoption of the hackers' penchant for neology is evident throughout the myriad academic journals and conferences that are springing up to confront the technoculture. The venerable *South Atlantic Quarterly,* founded in 1901, published an issue almost one century later titled "Flame Wars," with essays such as "Compu-sex: Erotica for Cybernauts."[8] In the acronymic triads of the humanities—such as CAA (the College Art Association), SPE (the Society for Photographic Education), MLA (the Modern Language Association), and SCS (the Society for Cinema Studies)—panels and papers bulge with references not merely to cyberspace and cyberpunk (the direct descendants of Norbert Weiner's "cybernetics") but also to their distaff cousins: cybersex, cyberfunk, cyberbunk, cypherpunk, cyburbia, et cetera, or perhaps, ad nauseam. This *neologorrhea*—to coin a phrase—is a response to the foreshortening of the horizon of new technologies.[9]

Neologizing is neither new nor intrinsically bad, of course, and as Thomas Jefferson noted, "Necessity obliges us to neologize."[10] But as the future/present barrels along, the critical community can too quickly follow the lead of developers and hackers by continually refashioning the language to account for the novelties it confronts. This accounts for the neologizers' fascination with the immediate present. These scholars are in a breakneck race to enunciate the moment. Yet one of the features of the future/present is that novelties—and the vocabularies that grow with them—have ever-quickening half-lives before they turn into either constituents of the general culture or painfully anachronistic clichés. Less than a decade after the release of William Gibson's *Neuromancer,* the term "cyberpunk" was already beginning to feel creaky. When a movement makes the cover of *Time* magazine, it is usually over, and so here entered into evidence is the magazine's cover blurb for 8 February 1993: "Cyberpunk: Virtual sex, smart drugs and synthetic rock'n'roll! A futuristic subculture erupts from the electronic underground." This typically exploitative feature—which could have borne the alternate title "Are Cyberpunks a Danger to Your Kids?: A Time Warner Guide for Parents"—served to foreground the problems of chasing furiously after the present.

Each successive digital technology that catches the mass media's attention adheres to the same cycle of hype followed by a backlash of fearmongering. From the explosion of desktop personal computing, to virtual reality, to the Internet and the World Wide Web, excitement quickly morphs into hysteria. The elevation of pedophilic Web-meisters to the

threat level of agents of international communism in the 1950s and of rogue terrorists in the 1970s is evidence less of the damage done by the pedophile gone digital than of a national security apparatus in the West searching for reasons to exist in a post-'89 world.[11] This kind of excess is proof that hysterical neologizing is not enough. There must be more than mere naming: care must be taken to develop a process for contextualizing the new words and concepts generated in and by the future/present.

VAPOR THEORISTS VERSUS DIGITAL DIALECTICIANS

Media philosophy attempts to move beyond existing institutions to imagine and fashion possibilities that *might be*. (Taylor and Saarinen 20)

The foreshortened horizon of new technologies also generates a parallax of critical vision. The position of the critic with regard to the culture is always in flux. Driven by both the market and the laboratory, technomediated culture is constantly mutating, leading cultural critics such as R. L. Rutsky to observe that we do not read science fiction so much as we live it. Rutsky maintains that it is a conceit to imagine that we are capable of stepping outside of the future/present to comment on it from a "stable" position. He follows the lead of Donna Haraway, who has suggested that we make the best of this and metaphorize our present condition "in a kind of science fictional move . . . imagining possible worlds."[12] All this talk of imagining announces that the temporal focus of the science-fictionalized discourse of the technoculture is the future. But is this the best strategy? Must we adopt a science-fictionalized discourse to critique a science-fictionalized world? The danger here is that the critic can be too easily drawn into a ever-escalating cycle of conjecture and unsubstantiated speculation, which generally sorts out into odd combinations of utopian longings, dystopian warnings, and technomysticism. Are scholars to critique the material conditions of the future/present or to weave the phantasmic?

The computer industry respects a hierarchy of realisms: there are the market-proven products on the shelves at your local electronics superstore, and there are new releases to be purchased only by the brave; there are beta packages out with testers and alpha versions that are not even allowed out of the developer's lab. Furthest out is vaporware, that most ineffable of all products, which is to be sold only to exceedingly gullible venture capitalists. Are critics to follow suit, offering a brand of dialectical immaterialism— a vapor theory of ruminations unsupported by material underpinnings?

This is certainly not to say that science-fictionalized discourse should be banned but rather to say that too many theorists are modeling their methods after works such as Haraway's brilliantly speculative "Cyborg Manifesto" without acknowledging that the insights contained within her work grow from a long-standing inquiry into the material history of

science and its practices. In *Future Hype: The Tyranny of Prophesy*, Max Dublin refers to sociologist Daniel Bell's particularly offensive notion that just as historians create "retrospective history," futurologists are writing "prospective histories." Dublin creates a savage image of a "time-telescope" first focused on the past, then mechanically flipped around "one hundred and eighty degrees" to the future (101). My complaint about the science-fictionalized discourse of contemporary theory is that serious investigations into the technocultures should be scrupulously differentiated from the wretched excesses of professional futurists. Those who contemplate the future/present should ground their insights in the constraints of practice, speculating *after* thorough investigations, not *before*.

Subsuming the neologizing and science-fictionalized discourse to the investigation of the production, consumption, and use of computer-inflected media technologies is a strategy that I have elsewhere defined as the "digital dialectic."[13] Digital dialecticians will educate themselves in the ways of these new technologies, thinking not only of their theoretical potentials but also of their practical limitations. Here, for example, is critic and curator Timothy Druckery, who in calling for a new approach to interactive art forms also requires a thorough investigation of the modes of production and dissemination of this work: "A model of interactivity will have to include an assessment of the fragmentation of knowledge, a reformulated concept of identity within discourse as well as the creation of media to manage information dispersal, and a refigured model for access and distribution" (127). Also in line with a digital dialectic is the work of N. Katherine Hayles, whose book, *How We Became Posthuman*, situates her theses about virtuality within a scrupulously researched account of information theory as it relates to cybernetic technologies.

Some areas of discourse, especially those about virtual reality, seem entirely removed from any conception, much less comprehension, of computer graphics technologies. Why discuss economizing the use of graphics primitives or the intricacies of interface design when you can wax rhapsodic about the mechanisms of virtual sex? It is one thing when a figure such as the founder of pioneering virtual technologies corporation VPL, Jaron Lanier, crafts a public persona both gnomic and visionary. After all, he had a start-up company he needed to hype. It is quite another thing when a theorist such as Anne Friedberg discusses the complete dissolution of gender through the adoption of virtual identities, as though this were technically feasible or even likely to move beyond mere masquerade.[14]

Mark Pesce's mystic excesses on behalf of the utopian potential of Virtual Reality Modeling Language (VRML)—which included launching the software with a technopagan ceremony/rave he called the Cyber-Samhain—are understandable and even refreshing coming from VRML's co-creator.[15] Yet, too often, otherwise interesting thinkers allow their discussions about the impact of the Internet and the World Wide Web to

spiral into airy theosophizing about Teilhardian noospheres and Gaian consciousness.[16] For example, Pierre Lévy concludes his book *Collective Intelligence: Mankind's Emerging World in Cyberspace* by dismissing anyone who questions how realistic a prospect it is that a world brain machine will come into being. "The process has begun and we do not yet know, within the context of its overall movement, what limits it will shift or how far it will shift them. Its ultimate finality will be to place the reigns of the great ontological and noetic machine in the hands of the human species considered as hypercortex" (250). As Erik Davis ably counters in his book *Techgnosis,* "the notion that computer networks are booting up the mind of the planet is not a technoscientific scenario at all, however much the language of complex systems or artificial intelligence may help us get a handle on the Internet's explosive, out of control growth or its mindlike properties" (297–98).

The danger of vapor theorizing is not simply that it often mutates into technomysticism but, more importantly, that it can lead even exceptionally able thinkers into a hype-driven discourse that dates incredibly quickly. Williams College's Mark C. Taylor and the University of Helsinki's Esa Saarinen basked in the mediasphere's attentions for the requisite fifteen minutes when they conducted an educational experiment in 1992. They co-taught students in America and Finland, linking their classrooms together by computer networks as well as by phone, fax, and video transmission. Two years later they published their on-line discourses in a very highly designed volume entitled *Imagologies: Media Philosophy.* Taylor and Saarinen demand that we move beyond what exists in order to create what "might be," eliding rigorous investigations of what "was" and what "is." In the end, just about nobody but Marshall McLuhan regularly succeeded with this gambit, and, truth be told, McLuhan's observations, or "probes," as he called them, failed at least as often as they succeeded. No less than the neo-luddites and the hysterical neologizers need to, those who practice a science-fictionalized discourse about the technocultures need to readjust their temporal focus.

HYPERAESTHETICS IN REAL-TIME

> When a poetic structure attains a certain degree of concentration or social recognition, the amount of commentary it will carry is infinite. (Frye 88)

Traditionally, the study of aesthetics has been the study of stable forms. In literature, the ancient genres of the epic, the lyric, and the dramatic still generate debate. The discourse around art has concentrated on the concrete object: painting, sculpture, and architecture. The advent of the computer, however, has destabilized these formations, blurring categories and boundaries. Artist, theorist, and long-time director of the Austrian

exhibition/conference Ars Electronica, Peter Weibel has described a categorical error that many make in their critiques of technocultural work: aesthetics of the static are being applied to dynamic arts.[17] The neo-luddites focus on the past; the neologizers on the present; the science fictionalizers on the future. A dynamic object, however, requires constant recalibrations in focus, a shifting between three temporalities. Hyperaesthetics requires theorization in real-time.

In computer graphics, one of the grails is to create three-dimensional systems in which any changes to a model will be reflected immediately without the wait for a new object or scene to be rendered. The more complex the three-dimensional structures, the more difficult it is to create and to refine them in real-time. Real-time theory does not posit a prelapsarian past like neo-luddism; it eschews the hype-mongering of hysterical neologizing, and it condenses vapor theory into a discourse grounded in the constraints of production. Real-time theory strives for balance while maintaining passions both positive and negative. The question becomes, then, how is real-time theory to be encouraged, and where can it be found?

It is one of the glories of the Internet that for all its fabled, and often failed, hype, it can nurture new forms of discourse and production. The development of bulletin boards, chat rooms, and Web sites have added a dimension of instantaneity to the discussion and critique of digital culture that printed texts for the most part lack. In academic publishing, the twin requirements of peer review (books and articles go through lengthy vetting by anonymous reviewers) and disciplinarity (the idea that literary scholars should talk about literature to other literary scholars) tend to slow down and to calcify the discussion of contemporary culture. In contrast, more immediate print media such as magazines and the even quicker, dirtier 'zines often do not profess a strong interest in developing much more than an instantly reactive model of consumption and response, eschewing a longer project of developing sustained critical and theoretical discussion.[18]

The obvious solution to the bottleneck of print would appear to be the Web, which so famously makes everyone with access to it their own publisher. In the abstract, it should be the new medium most open to the development of a hyperaesthetic. But while Web pages and electronic 'zines flourish, they are too often like flowers in the desert, popping up, lasting for a short time, and then dying or going dormant until the next rains. In other words, these sites are closely modeled on magazines and journals, a model that their publishers have difficulties maintaining after launch. Even should the site's content change on a regular basis, there is the problem of informing readers and getting them to return.

Usenet, a technology that predates the Web and continues to prosper on the Internet, would seem to offer the solution to the problems outlined above. On usenet, people read and post to newsgroups, which are usually

organized around themes or interests. As interesting as these newsgroups are, however, one still has to seek them out (using either a dedicated newsreader or a newsreading functionality built into a Web browser). To use an analogy from the world of print, reading a Web page or a posting to a newsgroup is like buying a single copy of a magazine. To enter into the community of readers of that particular publication, the reader has to make the conscious and regular choice to return to the newsstand.

What all magazine publishers are looking for, of course, is an escape from the "cover-driven" business of single-issue sales. Publishers want subscriptions to ensure a stable readership, and (in the ideal) readers subscribe because they do not want to miss the publication's ongoing conversation and because they want know that something they care enough about to commit their eyes and thoughts to will arrive regularly.

Listserves, humble as they may be, solve these problems and are the best hope for theory in real-time. Listserves are electronic mailing lists to which users subscribe. Subscribers post written comments that are then automatically distributed to all the other subscribers. This structure can be open or moderated by listserve managers who monitor postings to screen out spam and messages that they deem inappropriate to the list's mission. Discussions build over time in a contained, though often expanding, community, as subscribers' mailboxes fill (sometimes hourly) with the latest posts. Readers turn into writers with the touch of a reply button: commenting, challenging, diverging, and sometimes combining all three in the same post.

Push media—which stream unchosen (and often unwanted) materials to an Internet user's desktop—were hyped as a revolutionary way to "move seamlessly between media you steer (interactive) and media that steer you (passive)," as a now infamous cover story in *Wired* put it. The problem with this process was that it felt more like television than anything else, and the self-styled digiterati were quick to revile a return to "broadcast," regardless of the magazine's boosterism.[19] Listserves, in contrast, have proved to be push media that people actually want.

There are listserves about everything from Barbie-doll collecting to avant-garde filmmaking to community organizing. Howard Rheingold has defined these curious hybrids of community, publication, and dialogue as a sort of "invisible college" (264). Three lists that have contributed to the dissemination, reception, and strengthening of real-time theory through the 1990s are The Thing, Rhizome, and <nettime>.[20] From the start, these lists determined to be more than simply places to post notices and to engage in electronic chat. These lists serve as collaborative text filters for the contributions of their regular posters, who compose a formidable, international collection of theorists, artists, and intellectuals.

Jordan Crandell, an artist based in New York who has developed his own listserves, writes of how these lists resist "the market boosterism of

the 'digital revolution,'" attempting "to forge a new kind of media criticism from informed positions deeply embedded within the networks" and fostering "groupware" collaborations among their dispersed communities (20). These lists have featured long-running threads on the development of hybrid net-based forms of English, manifestos on the technopolitics of the Zapatista movement, disquisitions on the aesthetics of net.art, and a hodgepodge of whatever their subscribers find interesting. Subscribers regularly post work they have written for other venues, but it never feels like repurposed shovelware (that bane of the commercial software business in which preexisting "content" is shoveled into new media) or like resumé building (as with the republication of so many academic articles).

With listserves, there is also the pleasure/terror of not having full confidence that those who have signed their names to something are the people they claim to be, shifting theory into the raw material of detective fiction. But the reality of identity is not always the most important issue, such as when someone claiming to be the conceptual artist Jeff Koons posted the following letter to <nettime>. I include both the post by "Koons" and my response to give a flavor of how theory in real-time emerges:[21]

Dear List,
I've been following this list for a while now in complete and utter astonishment.
I'm sure all posts are incredibly interesting but is there actually anyone reading all this?
Or are you just trying to build a Borgesian library?
Yours truly,
Jeff.

[My response]:
The recent spate of falsely attributed postings to this and other lists makes me gun shy about responding to this particular post, but I'm willing to adopt nomenclature from the music world—The Artist Formerly Known As Prince (TAFKAP)—and refer to the author (or authors) of this post as The Artist Assumed To Be Koons (TAATBeK). TAATBeK raises the point that <nettime> generates quite a bit of text, and wonders if I/we/you actually read any of these missives.
<nettime> is push media, and TAATBeK seems to feel that push media like listserves carry with them the impression that everything should (must?) be read. For TAATBeK, email thus retains something of the urgency of a phone call (with all but the most egregious spams having at least a slight pull on one's time and attention).
Would TAATBeK ask this same question about a printed magazine or a journal? I think not. . . . The assumption I make with <nettime> is that some pieces are interesting enough to read carefully, some get a quick skim, and a

large percentage get deleted after the first paragraph or even at the Subject line. This is exactly how I treat print (doesn't TAATBeK read Artforum the same way?). The major difference is that <nettime> posts do not come all at once (though many lists, including Rhizome, do digests that mimic their print forebears exactly).

All told, I prefer this kind of dedicated push media to webzines and e-journals, which I dutifully investigate, bookmark, and then ignore. In the end, <nettime> serves as a refuge for long arguments and sophisticated discourse, two forms that most other media have long since abandoned, and I like the list's mix of focus and breadth, constancy and surprise. But then again, I'm both an academic and a text addict, so my innocence is sullied (and anyway, I'd be first in line for a Borgesian Library Card).22

Listserves depend not only on the relentless energies of their moderators but also on the interest of their subscribers. Most of the best hyperaesthetic listserves maintain archives so that interested parties can thread through their postings, but the question of how the extraordinary explosion of thoughtful commentary on new media generated in these venues will survive is an open question. When these lists finally come to their entropic ends, will their archives simply atrophy, shedding bits until nothing is left of once vibrant debates and polemics? What happens to their particular real-time piquancy when they are archived, especially when bound into the no-time/all-time flavor of the book? There are no answers to these questions, though it is probably a good thing that the bulk of any era's discussions disappear. The future deserves its opportunity to cycle through temporalities, fabricating its own theories in real-time about the past, our present.

NOTES

1. See also Stone, *The War Between Technology.*

2. Chellis Glendinning resurrected the ghost of Ned Ludd in order to drive a critique of the technoculture in "Notes Towards a Neo-Luddite Manifesto." Kirkpatrick Sale offers a partisan history, with a contemporary moral, in *Rebels Against the Future.* Other works include those by Theodore Roszak, Clifford Stoll, Sven Birkerts, and Bill McKibben.

3. The Luddites have had an appeal for science fiction authors. In his classic eco-dynastic saga, *Dune,* Frank Herbert created the Butlerian Jihad—a crusade far in the future against computers and thinking machines that spawns the commandment "Thou Shalt not make a machine in the image of the human mind" (521). There is even more explicit reference to Ned Ludd in William Gibson and Bruce Sterling's *The Difference Engine.* It is a prime example of "steampunk" science fiction, a movement that looks to create alternate, fictionalized histories for the nineteenth

century's Industrial Revolution. "The Luddites are dead as cold ashes. Oh, we marched and ranted for the rights of labor and such. . . . But Lord Charles Babbage made blueprints while we made pamphlets. And his blueprints built this world" (22). Their other historical reference in this passage is to Charles Babbage, a polymath nineteenth-century inventor who created calculating machines, including the programmable "Difference Engine." He is considered the great ancestral figure of computing.

4. Carlsson.

5. See Lunenfeld, "Commodity Camaraderie."

6. This word's root is the computer's display technology of the "raster grid."

7. For an analysis of the spread of these new words from the laboratory outward to the general culture, see Barry.

8. Mark Dery, ed. This issue was later packaged as a book: *Flame Wars: The Discourse of Cyberculture,* ed. Mark Dery (Durham, N.C.: Duke University Press, 1994).

9. I am hardly preaching from a position of grace; after all, the title of this essay incorporates the word "hyperaesthetics."

10. Jefferson's comment is the motto of *The Barnhart Dictionary Companion: A Quarterly of New Words,* an idiosyncratic and fascinating resource published by Miriam Webster, Inc.

11. This demonization is not restricted to North America, by any means. See Blissett, a stridently antistatist tract that includes a discussion of Italian antichild pornography laws and Internet censorship. Portions of the text have been translated as "Let The Children . . . Pedophilia as a Pretext for a Witch Hunt" and are available on-line at <www.geocities.com/Area51/Rampart/6812/ramp2.html>.

12. See R. L. Rutsky, "TechnoMondo," a paper presented at the Society for Cinema Studies, New Orleans, 1993, portions of which have been incorporated into his book *High Techne;* and Donna Haraway, "Cyborg Manifesto," in *Simians, Cyborgs, and Women,* 149–81.

13. Lunenfeld, *The Digital Dialectic.*

14. "Virtual reality is two-way, interactive. It allows for interspecial, cybernetic, intergendered interactions: you can be a Weimaraner, a vacuum cleaner, a trumpet, a table. Previous 'identity bound' positions of race, class, ethnicity, age, and gender can be technologically transmuted. In virtual reality . . . men can be women, women can be men, and so forth" (Friedberg 145).

15. "The myth of spirit ends in the gathering of conscious life into unified being; that word we know today as Web. In the inevitable collision of these endpoints, a new teleology emerges, where being and doing collapse into a unified expression of will. For, at the end of time, all forces must converge" (Pesce).

16. For more of this Teilhardian strain of vapor theory, see Cobb.

17. See Weibel.

18. These descriptions are generalities, of course, as academic presses do regularly publish timely and free-flowing work on new media, and magazines such as *Mute,* which is published in London, do offer systematic readings of digital culture.

19. *Wired* 5.03 (March 1997): 12.

20. Subscription information is available at each list's Web site/archive: <www.thing.netthing.at>, <www.rhizome.org>, <www.desk.nl /~nettime>.

21. Media activists Geert Lovink from Holland and Pit Schultz from Germany founded <nettime> as "an attempt to formulate an international, networked discourse, which promotes neither the dominant euphoria (in order to sell some product), nor to continue the cynical pessimism, spread by journalists and intellectuals working in the 'old' media, who can still make general statements without any deeper knowledge on the specific communication aspects of the so-called 'new' media" (from the <nettime> archive home page: <www.factory.org/nettime>).

22. This correspondence can be found at <www.factory.org/nettime>.

WORKS CITED

Barry, John A. *Technobabble*. Cambridge, Mass.: MIT Press, 1991.

Birkerts, Sven. *The Gutenberg Elegies: The Fate of Reading in an Electronic Age*. Boston: Faber and Faber, 1994.

Blissett, Luther. *Lasciate che i bimbi. Pedofilia: Pretesto per la caccia alle streghe*. Rome: Castelvecchi Edizioni, 1997.

Carlsson, Chris, ed. *Bad Attitude: The Processed World Anthology*. New York: Verso, 1990.

Cobb, Jennifer J. *CyberGrace: The Search for God in the Digital World*. New York: Crown, 1998.

Coupland, Douglas. *Generation X: Tales for an Accelerated Culture*. New York: St. Martin's Press, 1991.

Crandell, Jordan. "Hot List." *Artforum* 36.7 (March 1998): 20.

Davis, Erik. *Techgnosis: Myth, Magic, and Mysticism in the Age of Information*. New York: Harmony Books, 1998.

De Landa, Manuel. *War in the Age of Intelligent Machines*. New York: Zone Books, 1991.

Dery, Mark, ed. "Flame Wars: The Discourses of Cyberculture." Special issue of *South Atlantic Quarterly* 92.4 (Fall 1993).

Druckery, Timothy. "Feedback to Immersion: Machine Culture to Neuromachines/Modernity to Postmodernity." *Computer Graphics: Visual Proceedings*. Annual Conference Series. New York: The Association for Computing Machinery, Inc., 1993.

Dublin, Max. *Future Hype: The Tyranny of Prophesy*. New York: Plume/Penguin, 1992.

Duhamel, Georges. *America: The Menace, Scenes of the Life of the Future.* Trans. Charles M. Thompson. Boston: Houghton Mifflin, 1931.

Edwards, Paul N. *The Closed World: Computers and the Politics of Discourse in Cold War America.* Cambridge, Mass.: MIT Press, 1996.

Friedberg, Anne. *Window Shopping: Cinema and the Postmodern.* Berkeley: University of California Press, 1993.

Frye, Northrop. *The Anatomy of Criticism: Four Essays.* New York: Athenaeum, 1970.

Gibson, William, and Bruce Sterling. *The Difference Engine.* New York: Bantam Books, 1991.

Glendinning, Chellis. "Notes Towards a Neo-Luddite Manifesto" *Utne Reader* 38 (March/April 1990): 50–53.

Haraway, Donna. "A Cyborg Manifesto: Science, Technology, and Techno-Feminism in the Late Twentieth Century." In *Simians, Cyborgs, and Women: The Reinvention of Nature.* New York: Routledge, 1991. 149–81.

Hayles, N. Katherine. *How We Became Posthuman: Virtual Bodies in Cybernetics, Literature, and Informatics.* Chicago, Ill.: University of Chicago Press, 1998.

Herbert, Frank. *Dune.* 1965. New York: Ace Books, 1987.

"Jargon Watch." *Wired* 2.04 (April 1994).

Kelly, Kevin, and Gary Wolf. "Kill Your Browser." *Wired* 5.03 (March 1997): 12–23.

Levidow, Les, and Kevin Robins, eds. *Cyborg Worlds: The Military Information Society.* London: Free Association Books, 1989.

Lévy, Pierre. *Collective Intelligence: Mankind's Emerging World in Cyberspace.* Trans. Robert Bononno. New York: Plenum Press, 1997.

Lunenfeld, Peter. "Commodity Camaraderie and the TechnoVolksgiest." *Frame-Work* 6.2 (Summer 1993): 7–13.

———, ed. *The Digital Dialectic: New Essays on New Media.* Cambridge, Mass.: MIT Press, 1999.

Mander, Jerry. *In the Absence of the Sacred: The Failure of Technology and the Survival of the Indian Nations.* San Francisco: Sierra Club Books, 1991.

McKibben, Bill. *The Age of Missing Information.* New York: Plume, 1993.

Pesce, Mark. "*Ontos* and *Techne*." <www.hyperreal.org/~mpesce/oant.html>, 1997.

Raymond, Eric, ed. *The New Hacker's Dictionary.* 3rd ed. Cambridge, Mass.: MIT Press, 1996.

Rheingold, Howard. *The Virtual Community: Homesteading on the Electronic Frontier.* New York: HarperPerennial, 1993.

Ross, Andrew. *Strange Weather: Culture, Science and Technology in the Age of Limits.* New York: Verso, 1991.

Roszak, Theodore. *The Cult of Information: A Neo-Luddite Treatise on High Tech, Artificial Intelligence, and the True Art of Thinking.* 2nd ed.

Berkeley: University of California Press, 1994.

Rutsky, R. L. *High Techne: Technology and Art in Modernity and Beyond.* Minneapolis: University of Minnesota Press, 1999. [Includes portions of "Techno-Mondo" (1993)].

Sale, Kirkpatrick. *Rebels Against the Future: The Luddites and Their War on the Industrial Revolution: Lessons for the Computer Age.* Reading, Mass.: Addison-Wesley, 1995.

Sans, Jérôme. "Interview with Paul Virilio." *Flash Art* 138 (January/February 1988): 57–61.

Stoll, Clifford. *Silicon Snake Oil: Second Thoughts on the Information Highway.* New York: Doubleday, 1995.

Stone, Allucquère Rosanne. *The War Between Technology and Desire at the End of the Twentieth Century.* Cambridge, Mass.: MIT Press, 1995.

———. "Will the Real Body Please Stand Up." In *Cyberspace: First Steps,* ed. Michael Benedikt. Cambridge, Mass.: MIT Press, 1991.

Taylor, Mark C., and Esa Saarinen. *Imagologies: Media Philosophy.* New York: Routledge, 1994.

Thompson, William Irwin. *The American Replacement of Nature.* New York: Doubleday, 1991.

Weibel, Peter. *Transformationen Der Techno-Äesthetiek.* Digitaler Schein, Suhramp, 1991.

Winner, Langdon. "Artifacts/Ideas and Political Culture." *Whole Earth Review* 73 (Winter 1991): 18–24.

If Only Mother Nature Could Sue Wordsworth for Copyright Infringement

Wendy Griesdorf

The more all-embracing the crisis of contemporary society, the more that the in-
dividual aspects of the latter confront one another in rigid opposition, so the
more the creative reveals itself as the merest form of variant, with contradiction
for its father and imitation as its mother.

W. Benjamin, "A Short History of Photography"

T he crisis of the real, the crisis of the original, the crisis of contemporary society: each is a signal of postmodern culture that recognizes the paradox that Western culture values art for its originality even though many of these "original" works themselves originate from a long tradition of artistic precursors.[1] Much of the beauty of Milton's *Paradise Lost,* for instance, is its ability to reference its own cultural antecedents of epic poetry and biblical prose. This irony that original art may be nothing more than art that *owes its origin* to an earlier time consumes certain forms and expressions of postmodern art. As Derrida

summarizes, we cannot help but to find it "unthinkable and intolerable that what has the name *origin* should be no more than a point situated within the system of supplementarity" (243).

For the postmodern artist, the power of the original transmutes into the power of the intertext. The postmodern audience becomes witness to something new that contains *within its textual space* testimony that this newness is old, that the new is both the origin of its own time and a copy of a former time. When art turns inward toward itself, the concept of the original dissolves beneath the massive weight of the copy. Such a reconceptualization of art finds little refuge in the United States copyright laws, which are founded on the concepts of originality, creativity, and authorship. Artists who operate within the epistemological changes inherent in postmodernism risk becoming victims of an outdated legal doctrine.

Such is the case with Jeff Koons, a postmodern artist who plays with the crisis of the original by creating "original" art whose artistic antecedents emerge not from history but rather from contemporary society. His work belongs to a type of practice known as *appropriation art,* which typically "borrows" objects from everyday culture (such as a toilet) and incorporates these objects into an original form. Essentially these artists spin the concept of the originality on its head by creating original works from unoriginal objects. Koons's "Banality Show," an exhibition of these works in 1988, functioned for one critic "as a probe into the *spirit* of the present moment" (Danto 282).

However, these cultural objects, objects that "are too submerged even to be classed as kitsch," belong somewhere to someone (Danto 280). One of those someones sued Koons in 1991 when he found out what Koons was doing. The case that followed (unfortunately for Koons) demonstrates the sluggish reluctance of the aesthetic status quo to recognize the message and the art of the postmodern movement. It is not surprising what followed.

THE CASE

The facts surrounding *Rogers v. Koons*[2] present themselves as straightforward. The plaintiff, Rogers, is a professional photographer who was commissioned by his friend to make a portrait of the friend, his wife, and their new litter of eight puppies. Rogers entitled the photograph "Puppies," which was subsequently published by a local newspaper and then exhibited with Rogers's other works in a gallery. In 1984 Rogers licensed "Puppies" to a postcard company.

The defendant, Koons, is a popular artist and sculptor who purchased one of these postcards in a gift shop. He constructed a sculpture from the image of the photograph, painted the puppies blue, and carved daisies in the woman's ears. Koons entitled the sculpture "String of Puppies" and exhibited it in his 1988 "Banality Show." He made two other copies, which

he sold to collectors. When Rogers learned of the sculpture, he sued Koons for copyright infringement and won. Koons appealed and lost again.[3]

THE JUDGMENT

The trial judgment is short and presents itself almost as straightforwardly as the facts of the case. The trial judge, Mr. Justice Haight, concludes first that Koons infringed on Rogers's photograph and second that Koons, because of his substantial use of the photographic image, could not support a fair use defense.

There are, however, areas of the judgment that beckon a closer reading. Justice Haight employs several value-laden terms that point to a predisposition favoring Rogers and an impatience toward Koons. He describes Rogers's work as "a charming photograph"[4] while he criticizes Koons's sculpture for being "sullied"[5] with commercial considerations. Certain issues that would appear relevant to Koons's position are mentioned only cursorily. It is not difficult to discern that the judgment is less concerned with the current nature of art than it is with the market implications for the plaintiff.

Much of the judgment focuses on Koons's fair use defense. This is a defense available to a copyright defendant who, although recognizing that he has infringed on the plaintiff's copyright, argues that he has done so for some larger (usually social) purpose. This defense is often invoked when a work is copied for educational or news-reporting purposes and is codified in the American Copyright Act at 17 U.S.C.S. § 107:

> Notwithstanding the provision of section 106, the fair use of a copyrighted work . . . for purposes such as criticism, comment, news reporting, teaching (including multiple copies for classroom use), scholarship, or research, is not an infringement of copyright. In determining whether the use made of a work in any particular case is a fair use the factors to be considered shall include—
>
> (1) the purposes and character of the use, including whether such use is of a commercial nature or is for nonprofit educational purposes;
>
> (2) the nature of the copyrighted work;
>
> (3) the amount and substantiality of the portion used in relation to the copyrighted work as a whole; and
>
> (4) the effect of the use upon the potential market for or value of the copyrighted work.

Even though Justice Haight reminds us that the fair use doctrine is an equitable rule designed to avoid instances that would "stifle the very creativity which that [copyright] law is designed to foster,"[6] the doctrine is nonetheless presented from a surprisingly conservative perspective. Justice Haight first adopts the view that Koons's work is commercial enterprise

and not a form of art without considering whether the sculptures really are commercial endeavors. Granted two of the sculptures were eventually sold to private collectors, the primary characterization of the first sculpture was noncommercial, as Koons himself stated: "the subject for the show would be Banality but the message would be a spiritual one. And while being uplifting, the work also would be [sic] critical commentary of conspicuous consumption, greed, and self indulgence."[7]

Then, in an awkward line of reasoning, Justice Haight concludes that Koons's sculpture competes with Rogers's photograph in the market. This is a particularly important point because if the infringing work cuts into the original work's market, then the infringer loses his ability to rely on the fair use defense. Justice Haight concludes here that any *possible* effect that Koons's sculpture may have on that market is sufficient reason to disqualify the fair use defense rather than more finely analyzing whether Koons's sculpture has a demonstrable effect on Rogers's potential market. In my opinion, the *possibility* of impact in a market is too broad a test and risks prohibiting art forms from developing intertextually. Instead, it should be the plaintiff's burden to establish that the defendant's work has damaged an actual or potential market (that is, probable rather than possible). This practice would align more closely with the legal principles as stated by the U.S. Supreme Court:

> [A] use that has no demonstrable effect upon the potential market for, or the value of, the copyrighted work need not be prohibited in order to protect the author's incentive to create. The prohibition of such noncommercial uses would merely inhibit access to ideas without any countervailing benefit.[8]

From the facts described in the trial judgment, there appears to be no evidence that Koons's sculptures would have any real impact on Rogers's market. It seems unlikely that any one of the owners of Koons's sculptures would be more or less inclined to purchase a print, engraving, or even sculpture of Rogers's "Puppies" (given the artists' different artistic styles). Moreover, this line of reasoning does not even begin to consider the argument that Koons's work is a critical commentary of Rogers's art, an argument that would position the sculpture as a parody and would therefore place it into an entirely different market than the photograph.

PARODY

There is little space in the trial judgment given to the second and third factors of the fair use doctrine, which is unfortunate since they could have been convenient opportunities to consider parody as a fair use defense. Instead, both factors are dismissed as invalid defenses for Koons by brief remarks first that the fair use defense is less likely to be allowed with fiction

(which Rogers's work is erroneously categorized as, given that it was a picture of real people with a new litter of real puppies) and second that, because Koons represented the entire photograph as opposed to one aspect of it, he cannot rely on a substantiality argument.

The absence of discussion in the trial judgment on the relationship of parody to copyright law is surprising since parody is listed as an example of fair use in § 107 Interpretive Notes and Decisions. Cases on parody are rich with material and apply directly to Koons in that they recognize parody as a distinct art form that is valuable to our culture and that should be protected by copyright laws. As early as 1964, the court acknowledged that "parody and satire *are* deserving of substantial freedom—both as entertainment and as a form of social and literary criticism."[9]

The difficulty with parodies from a legal perspective is that they often require a substantial taking of the original work in order to be effective. Essential to a successful case of parody or satire is the court's appreciation of the value of the parody's critical comment and, more importantly, that the parodying artist maintains a separate perspective (and consequently separate market) apart from the parodied artist's work. This is a difficult line of reasoning for a court to appreciate, especially if its primary focus is to inquire into the substantial "taking" by the infringing artist of the original work. However, such a shift in the court's view of parody would allow parodies to be more fairly adjudicated on objective market grounds since, as some academics observe, "few valid attempts at parody are commercial substitutes for the originals."[10]

A successful fair use parody defense would also require the court to recognize parody as a *productive* rather than a *reproductive* use.[11] As Chafee succinctly wrote, "the world goes ahead because each of us builds on the work of our predecessors. A dwarf standing on the shoulders of a giant can see farther than the giant himself."[12] Jeff Koons perceives (and renders) the image of a couple holding eight puppies from an entirely different—perhaps antithetical—perspective than that of Art Rogers. Whereas Rogers saw a "charming" image, Koons saw a photographer partaking of "conspicuous consumption, greed, and self indulgence." Koons was not so much reproducing the image in Rogers's photograph as he was producing commentary about that image. Perhaps it is from coloring the puppies blue, perhaps it is in the overly artificial expressions on the couple's faces or in the daisy earrings, *or maybe it is in the fact of re(-)presentation alone:* Koons's sculpture assumes a distinct critical space separate and apart from Rogers's photograph.

It is difficult to discern whether it is Mr. Justice Haight's judgment alone that assumes such an unfavorable position toward Koons or whether it is systemic within all of copyright law that the Koons of the art world will necessarily fail in the legal world. It is not uncommon to find scholars who criticize copyright law for inhibiting the work of artists it claims to protect.[13] Despite the U.S. Constitution's boasting of its power

"to promote the progress of Science and the Useful Art,"[14] Koons's courtroom failure attests to a deadlocking friction between the goal of copyright and the practice of its regulatory laws.

IF FOUCAULT WERE THE JUDGE

What exactly is Koons's art? And how does it—apart from copyright law—impact or play with Rogers's photograph? A study of the positions these two works hold in the theoretical practice of the plastic arts will assist us in understanding the peculiar relationship between Koons's sculpture and Rogers's photograph and may even shed light on how the law should view what is going on.

A glimpse into the ontology of sculpture reveals that the function of sculpture has always been more than aesthetic, that is, more than a mere duplication of the world outside. Andre Bazin, in "The Ontology of the Photographic Image," traces the development of plastic arts in ancient Egyptian culture and observes that sculpture began as a human attempt to represent life in the face of death. Terra cotta statuettes depicting the mummified bodies of the dead attempted "the preservation of life by a representation of life" (Bazin 11).[15] This was the method early culture used to defend itself against the threatening and destructive elements of death and time. Copying the subject was homage, a tribute to its worthiness never to be forgotten, and icons sprang up everywhere with the aim to eternalize and immortalize their subjects.

Walter Benjamin parallels Bazin's observations in his discussion of the cult value of art. For him, a cult value of art diametrically opposes both qualitatively and quantitatively an exhibition value of art. He argues that, while at one time the function of art was to serve in rituals and for religious purposes, the easy reproducibility of photography (and film) has shifted art away from its original cult experience to this exhibition value. Whereas sculpture primarily retains its cult value, Benjamin observes, "in photography, the exhibition value begins to displace cult value all along the line" (Benjamin, "Work" 682). Because photography did not originate from religion or ritual, it never shared the same developmental history as the other plastic arts and therefore never had a cult value attached to it.

As the exhibition value of a representation increases, the authenticity and authority of the original decreases. This depreciation of the original by its representation ruptures what Benjamin refers to as the "aura" of the original.[16] It is this "prizing of the object from its shell" that collapses the aura of the original and prepares its representation for mass consumption (Benjamin, "Short History" 21). When the masses become the market for such exhibitory and mechanically reproduced art, economic and political factors inevitably control its production. Objects that were once available only to an elite few (as in rituals) can now be reproduced and easily disseminated to the public.

Koons's sculpture critiques this destruction of the aura of which Benjamin speaks. Koons plays with and parodies the historical function of sculpture, a function of immortalizing and eternalizing, by turning this function toward a photograph, which, by its very nature, never had any cult value. He ritualizes something that never participated in any form of ritual, thereby ironically restoring an aura to an object that never had one. Koons removes the photographic image from the realm of mass consumer production and fixes it in eternal time, albeit momentarily (and ironically in a show titled Banality), in the same way that terra cotta mummies immortalized the image of their dead subjects.

Such parodic ritualization is only possible in a culture obsessed with its own subjectivity. Benjamin and more explicitly Michel Foucault are united in their assertion that modern culture is the first culture with an overwhelming subjective world picture in which man becomes "entrapped within his own self-referential gaze."[17] For Foucault, subjectivity emerges when language, which had been perceived in earlier centuries as a neutral and transparent access to thought, folds in on itself and acquires its own density. The artist in this modern episteme (as he coins the term) is obsessed with the fact that before there is representation, there must be a subject who can represent. Because all representation is contingent on the a priori existence of a representer (or speaker), the modern artist can no longer escape his own image. For Foucault, language thickens in the modern episteme to such an extent that it becomes, in its opacity, more potent in its form as object than in its function as representation. Man emerges as the "enslaved sovereign," caught inside his own critical gaze, in the "ambiguous position as an object of knowledge and as a subject that knows" (Foucault 312). Suspicion (verging on paranoia) over the neutrality of language leads the modern artist to question "who is speaking" and to reply, "the word itself—not the meaning of the word, but its enigmatic and precarious being" (Foucault 305).

Koons's sculpture is a product of an epistemology whose supreme self-consciousness forces the artist into an intense myopia. Identical to those who write reviews of art (and incidentally, who receive protection under the fair use doctrine), Koons employs his artistic medium to comment on the products of his own culture. His art can be seen as the epitome of man critiquing his own position in his self-created material world; his sculpture is precisely the language of man caught gazing at himself.

Art Rogers's photograph is an instance of kitsch culture that opens itself up to anyone who analyzes popular culture. It belongs to the language of kitsch, and those who critique any aspect of kitsch culture inevitably comment on all of kitsch. The pathetic sentimentality of the image captured by Rogers's photograph and the materialization of that image when Rogers licensed it to a postcard company were captured by Koons not with words but in a sculpture with daisy earrings and blue puppies. That Koons placed

the sculpture in a show entitled "Banality Show" attests to the fact that Koons was borrowing one aspect of kitsch culture in order to critique it all. One could even argue that Rogers's photograph epitomizes *all* that is kitsch, since "kitsch is the epitome of all that is spurious . . . [and] pretends to demand nothing of its customers except their money—not even their time" (Greenberg 10).

There is one counterargument, however, that must be addressed. It returns us to the second factor in the fair use defense and involves questioning whether Koons was justified in representing the entire image in Rogers's photograph. Because reviewers of books rarely, if ever, reproduce the entire text in their review, some might suggest, as Justice Haight concluded, that Koons's total replication of Rogers's photograph violates a fair use defense. This argument, however, has little support, given the structural nature of a photograph. Even though photography is a form of language, theorists do not regard it as language akin to the written word. Texts, sentences, and words can all be broken down into components, or units, and can be analyzed in such units. The letter "s," for instance, when placed on the end of a noun, signifies plural (car; cars) and when placed on the end of a verb, signifies third person singular (I run; she runs). Signification emerges in language when these units are placed together to form a whole signifying structure.

Photography does not operate this way.[18] A photograph is regarded as an analogon; that is, an entire photograph presents itself as one single unit and cannot be broken down into smaller signifying units. In this way, a photograph operates at the level of the sentence: a picture of a car denotes "This is a car." Connotations may arise from this denotative level, not from parts or aspects of the photographic image but rather from the whole analogon in its entirety. A picture of a car may connote "luxury" or "materialism," but in order to arrive at this connotative level, one must first employ the whole analogon.

Roland Barthes warns that the photographic image desperately attempts to conceal its connotative level by continually asserting its natural connection to reality. The camera appears "to shoot" reality *without comment,* without the intervention of the human political hand. Barthes considers this effort of the photographic image to be the "naturalization of the cultural" and argues that the photographic image is continuously burdened with connotation and always requires deciphering (Barthes 15). Otherwise, the various messages contained within the photographic image would remain inaccessible to critique. Thus Koons's only access to the connotative level of Rogers's image is through a total representation of photograph: in order to represent the connotative level of material consumption embedded within Rogers's photograph, Koons first had to reproduce the entire image.

There are two arguments operating here as critical justifications of Koons's sculpture. The first is that Rogers's photograph is an eligible *subject* of representation, given modern culture's subjectivity and man's

enigmatic position as both the speaking subject and the object of that speech. The second argument is that Rogers's photograph is an eligible *object* of representation for Koons's art because it is a product of kitsch culture and should be available for representation in the same way that any object may be used as an object of representation. These arguments are not unrelated since, in a culture caught in a self-critical gaze, objects that are produced out of that culture's landscape will invite more commentary than the natural landscape of the outside world. Nonetheless, Koons could defend his sculpture from either of these epistemological arguments: either that his work arises from man's subjective self-reflexivity or that objects of kitsch culture are of the same order as any object found in a modern landscape. Wordsworth chose to represent daffodils—Koons chose a postcard. Mother nature did not complain—neither should Rogers.

In either case, parody is undoubtedly the operative mode in Koons's representation, and it is furthermore the parody emblematic of postmodern culture. It is the parody that "makes obedience and transgression equivalent, and that is the most serious crime, since it *cancels out the difference upon which the law is based*" (Baudrillard 40). Just as Koons's sculpture criticizes and rejects the consumerist values embedded in Rogers's photograph, it also, as a statue, absorbs and ironically consecrates those values. By choosing to represent his critical commentary in the form of a sculpture, Koons automatically invokes the ritualistic aspects inherent in sculpture's ontology. His intertextual energy is aimed "not to destroy the past; in fact to parody is both to enshrine the past and to question it. And this, once again, is the postmodern paradox" (Hutcheon 126).

Whatever it is that Koons's art communicates, *it is in the fact of copying* that that communication is channeled. Had Koons invented the puppies and people on his own and had he not represented an image already found elsewhere, his sculpture would be of an entirely different artistic order than it is now. Intertextuality, the act of weaving an old text into a new context, maintains a double function: just as the original text enhances the signification of the new context, the new context also sets the original text into a novel set of relations. The audience of Koons's sculpture will never "reread" Rogers's photograph in the same way. No audience of Koons's "vision of an aesthetic hell" will ever wander through a gift shop without feeling something akin to Danto's nightmare: "there was a figure of a man smiling with intolerable benignity at an armful of blue puppies that haunts me like a bad dream" (Danto 281). American copyright law fails to understand this point and instead imposes constraining laws on Koons that lack the flexibility necessary to recognize the recent changes within artistic practice. What copyright law must learn is that, without artists such as Rogers out there for artists/critics such as Koons to appropriate, one could argue that postmodern art has little reason to speak. Silence should never be the product of any law.

NOTES

1. This essay is based on a paper written in 1991. Since then, new cases on copyright have been passed down, including an appeal to the trial decision in *Rogers v. Koons*. Therefore, read this essay with the caveat that the legal citations should be cautiously, if at all, relied upon.

2. (1990) 751 F. Supp. 474 (S.D.N.Y.).

3. This paper was written before the appeal was passed down and, consequently, does not discuss the appellate judgment. For those interested, the appeal may be found at (1992) 960 F.2d 301.

4. *Supra,* note 2 at 475.

5. *Supra,* note 2 at 479.

6. *Supra,* note 2 at 479, citing *Stewart v. Abend* (1990) 110 St.Ct. 1750 at 1768.

7. *Supra,* note 2 at 475–76.

8. *Sony Corporation of America v. Universal City Studios* (1984) 104 St.Ct. 744 at 793 (1984).

9. *Berlin v. E.C. Publications, Inc.* (1964) 329 F.2d 541 (2d Cir.). See Nimmer, *Nimmer on the Law of Copyright* (1990) § 13.05[C] at 13–90.7. Please note that the appeal discusses parody extensively.

10. "The Parody Defense to Copyright Infringement: Productive Fair Use after *Betamax*" (1984) 97 Harvard Law Review Notes 1395 at 1410.

11. This differentiation between productive and reproductive uses is advanced by the editors of the Harvard Notes, *ibid.* at 1407–1409, who, when analyzing *Sony Corporation of America,* contend that parody is not a reproducing of an original work but rather a producing of a new work.

12. Chafee, *Reflections on the Law of Copyright* (1945) 45 Columbia Law Review 503 at 511.

13. See D. Vaver, "Intellectual Property Today: Of Myths and Para-doxes" (1990) 69 Canadian Bar Review 98; V. Proter, "The Copyright Designs and Patents Act 1988" (1989) 16 Journal of Law & Sociology 340; and B. Kaplan, *An Unhurried View of Copyright* (New York: Columbia University Press, 1967).

14. Article I § 8 cl. 8.

15. Bazin notes how mummification was the primary source of a symbolic preservation of life but fell prey too often to the sacrilege of pillage. Therefore, statuettes were placed by the mummy "as substitute mummies which might replace the bodies if these were destroyed" (9).

16. By aura, Benjamin is referring to "a peculiar web of space and time: the unique manifestation of a distance, however near it may be" ("Short History" 20). The resulting effect of an aura is uniqueness and permanence—both of which are destroyed by the camera's quest to bring everything it perceives "close spatially and humanly" ("Work" 680).

17. Even though both men describe modern culture in similar ways,

modernity begins, for each, at different chronological points: for Benjamin, it begins in the early nineteenth century with the invention of the camera, and for Foucault, it begins in the late eighteenth century with the writings of Immanuel Kant.

18. This is the theoretical position put forward by Roland Barthes in his various texts on semiotics, language, and photography (see *Elements of Semiology* [New York: Hill and Wang, 1968]; *The Responsibility of Forms;* and *Camera Lucida* [New York: Noonday Press, 1981]). For the most part, semioticians and theorists follow this line of reasoning that the photograph is an analogon. However, Umberto Eco argues contrariwise. He regards the photograph and filmic image as a digital image—that is, as being composed of smaller units, like language, that can be broken down and analyzed at the denotative level. But these are precisely the elements that Barthes attributes to the connotative level of the image (such as angle of the camera, content of the image, frame of the shot, color, etc.). The difficulty with Eco's view is that few can agree on what these digital elements are and on how they operate in a structuralist scheme.

WORKS CITED

Barthes, Roland. "The Photographic Message." In *The Responsibility of Forms*. New York: Hill & Wang, 1985. 3–20.

Baudrillard, Jean. *Simulations*. Trans. Paul Foss, Paul Patton, and Philip Beitchman. New York: Semiotext(e), 1983.

Bazin, Andre. "The Ontology of the Photographic Image." In *Film Theory and Criticism,* ed. Gerald Mast and Marshall Cohen. New York: Oxford, 1985. 24–31.

Benjamin, Walter. "The Work of Art in the Age of Mechanical Reproduction." In *Film Theory and Criticism,* ed. Gerald Mast and Marshall Cohen. New York: Oxford, 1985. 669–94.

Danto, A. "The Whitney Biennial, 1989." In *Encounters & Reflections: Art in the Historical Present*. New York: Farrer, Straus, Giroux, 1990. 279–85.

Derrida, Jacques. *Of Grammatology*. Trans. G. Spivak. Baltimore, Md.: Johns Hopkins University Press, 1976.

Foucault, Michel. *The Order of Things*. New York: Vintage Books, 1973.

Greenberg, Clement. "Avant-Garde and Kitsch." In *Art and Culture: Critical Essays*. New York: Beacon Press, 1961.

Hutcheon, Linda. *A Poetics of Postmodernism*. New York: Routledge Press, 1988.

Postmodern
Architecture

Post-Modern Architecture and Time Fusion

Charles Jencks

mong the several ills that modern architecture suffered during its brief reign as the dominant mode of building in the West—from the late 1920s to the early 1960s—was the loss of historical consciousness. This was a self-inflicted condition, as is well known, due to the strictures of such architects as Walter Gropius, who wished to ban the teaching of architectural history from the Bauhaus. Le Corbusier proclaimed, "[T]he styles are a lie," and any modern architect who was caught dropping a historical reminiscence was condemned as a pasticheur, reactionary, or something far worse. History was put on the Index.

Modern architects, like several devout sectarians before them, simply believed that they were following "the right method"—just solving problems according to dispassionate reason—and that the plurality of styles and all the clutter of memories and associations that came with them were unfortunate bric-a-brac that had to be swept away if one were to create with a fresh mind. For modern architects, as opposed to architects in most ages, traditions were fetters, not the preconditions for innovation. History weighed down

like a heavy burden, a constraining yoke, as historicism became the socially accepted substitute for creative thought. Reacting against this notion, modernists put rational design method in the place of tradition (the free use of models and paradigms), thus hoping to naturalize the architectural sign and to make it transparent, functional, and necessary. Their flight beyond culture in this sense differed from mainstream modernist practice in the 1920s, which was—in the guise of Joyce, Eliot, Yeats, or Heidegger and the Existentialists—critical of mass production and mass culture. Architects, by contrast, had to become ultramodern in transcending the status quo, and this meant convincing themselves that design could be, like mathematics, acultural and ahistorical. The result of this doctrine soon became apparent: an abstract architecture, shorn of location in place and time, an architecture of amnesia or what Norman Mailer called in the 1960s "empty landscapes of psychosis."

Is this an overstatement? Perhaps, but it comes a bit too close to the truth for comfort, especially when one examines the average modern housing estate in London, Brasilia, Chandigarh, or La Defense in Paris—or on the outskirts of Moscow and on every capital city in the world. These barren tracts of development, with their abstract machines for getting lost in, have suffered the equivalent of a cultural lobotomy. They are simply the cheapest way to house the poor, and modernist doctrine has played an important, if not determinant, role in this incarceration process. Of course, the loss of historical consciousness is not the key factor—economic and cultural considerations are—but it is one significant influence.

Such factors—incommensurable as they are—as the notion of the tabula rasa, the architectural clean slate; bombs of negative planning legislations, called "planning blight"; the treatment of the city as a problem of statistics, or simple functional separation; the questions of abstraction and the machine aesthetic; and the problem of massive development and land speculation came together to create the modernist cityscape of the 1950s and 1960s. It was not a pretty sight.

In this essay I will discuss the five main stages of architectural postmodernism, from 1960 to the present, and will focus on the question of historical consciousness and the different ways it was partly reincorporated into the mainstream discourse.[1] I should emphasize that this focus is a vast reduction in the post-modern architectural agenda, which extends from such areas as pluralism—architecture as a complex language—to ecological, technological, and political issues.

Inevitably the first stage of post-modernism, from 1960 to 1972, was a reaction against the destruction of the historical city. Jane Jacobs wrote the first attack on modernism and the manifesto of the nascent movement in 1961, entitled *The Death and Life of Great American Cities*. Here she very clearly states a principle of what was later to become the "Post-Modern sciences of complexity" when she pointed out, in conclusion, that the

city is not only a statistical problem of "simplicity" or "disorganised complexity" but also one of "organised complexity" like those of the life sciences (428-32). In this first period of post-modernism, driven by the counterculture and its myriad battalions—"advocacy planners," feminists, black power enthusiasts, minorities of all types—modernism was seen as representing the power structure, a bland, commercialized middle class and bureaucracy. Accusations came from all quarters: corporate America had built the downtown in a modernist mode, Walter Gropius had sold out the integrity of the Bauhaus and designed a squat, clichéd headquarters for the Pan Am corporation, and so much modern art had degenerated into a smug backdrop of a *genre-de-vie*. Again, these characterizations, while polemical, are uncomfortably close to the truth.

In 1966 Robert Venturi wrote the second manifesto of the fledgling movement, *Complexity and Contradiction in Architecture;* from then on different architectural histories—and in particular the Mannerist, Baroque, and Edwardian periods—were open for influence of contemporary work. Historical consciousness returned to help the architect solve many kinds of problems, among them the contrary pressures exerted by the interior

(fig.1) Robert Venturi and Denise Scott Brown, *Medical Research Building,* UCLA, Los Angeles, 1989–1992. Modifying the surrounding medical building type—a tall, flat, brick box with loft space—the Venturis made a virtue of its flatness by exaggerating the window-wall plane, introduced subtle ornamental rhythms, and inflected the building at its corner and base for contextual reasons.

function of a building and the exterior urban landscape. Venturi showed how such architects as Borromini and Lutyens had successfully resolved these often contradictory forces, leading to buildings that are full of surprise, ambiguity, and wit. The negative side of this approach only became apparent in the 1980s, when too many buildings were smothered with too many witty allusions, but Venturi and his wife, Denise Scott Brown, carried out their program of a complex and contradictory architecture with restraint and appropriateness. Ornament, allusion, and geometrical innovations were given a contextual relevance (figure 1).

The second period of post-modernism, from 1972 to 1978, was a pluralist period in which a series of styles and approaches reigned, ranging from the ad hoc assemblage method of Lucien Kroll to the radical eclecticism of James Stirling. In the Stuttgart Museum addition of 1977, he juxtaposed several different styles, or "language games," as Lyotard might call them: classicism, modernism, vernacular, and high-tech. In this, the first "masterpiece" of post-modernism (not the AT&T building, as proclaimed by Paul Goldberger), the styles are not resolved as a synthetic totality but rather are placed in opposition and tension with others (figure 2). The "tensed field"

(fig.2) James Stirling and Michael Wilford, *Die Neue Staatsgalerie*, Stuttgart, 1977–1984. Languages of architecture, appropriate and jarring, are played against each other to heighten the perception of difference and architecture as language. Here the modernist naturalization of the architectural sign is reversed as it is proven again to be contingent, arbitrary, and related to cultural context.

of juxtaposed styles created the meaning of the building, and that meaning was the new episteme of pluralism. In effect, the building represented the fragmentation of taste cultures, with conflict and enjoyable difference becoming the subject of the architecture. My writings, naming post-modernism in 1975 and defining this pluralism, may also have helped catalyze the second stage, but who can describe their own contribution?

The third stage, from 1978 to 1985, saw post-modernism go public, professional, and corporate. In becoming successful it took on many of the problems that beset modernism—above all, overproduction, inflation, and what is called "quick-build." Massive $2 billion buildings were designed, as usual with leviathans, on the back of an envelope. Even Stirling did a conceptual sketch of Stuttgart on the back of his airplane ticket. Cesar Pelli is no doubt the master of this restricted genre—most evident at the fifty-story Canary Wharf Tower in London's Docklands, a building that had, under construction, a velocity of one story per week and that, finished, makes pleasing proportional rectangles out of a commission that is now fashionable to deplore. (The rectangles are more pleasing the farther one is away from them because of problems of parallax.)

Less speedy and more thoughtful post-modern classical structures were built around the world, epitomizing the embrace of the corporate and civic worlds. These buildings are probably too well known to need summary. Suffice it to say that some of the lasting achievements of the third stage of post-modernism are evident at IBA in Berlin, the international building exhibition that lasted throughout the 1980s and employed some of the best post-modern architects, among them Charles Moore, Aldo Rossi, Matthias Ungers, and Robert Krier. The lessons of history drawn upon at IBA concerned not only previous classical periods but also the historical typology of the city, its streets, its squares, its contained open space, and its common language. All of this was absorbed at IBA, which was certainly the best urbanism built in the 1980s (with the district renewal system of Barcelona a close second).

The city as a historical palimpsest, and as a collage of different symbol systems, is also apparent in Gae Aulenti's conversion of the Gare d'Orsay in Paris. Here she yokes together these quite opposite building types, and their collision has a mad, positive logic. The first is the old 1907 railroad terminus, the second is the medieval cathedral, and the third is the contemporary museum. These are combined as a single, dramatic narrative to explain the nineteenth-century art it contains (figure 3). The avant-garde art is placed in the left aisle rooms, while the central nave, where the trains entered in the past, culminates first at the transept, where one comment is made by a painting titled *Romans of the Decadence,* and then next at the high altar, where the Paris Opera—the ultimate spectacle of the nineteenth century—is placed under a shroud. Resonant in its symbolism, this old station is now a double-barreled comment on the new role of art

(fig.3) Gae Aulenti and Act, *Musee d'Orsay, conversion,* Paris, 1980–1986. The train shed, symbol of nineteenth-century power and materialism, meets thirteenth-century cathedral layout in a twentieth-century temple to the contradictions of nineteenth-century art. Diverse time frames and building types are merged and contested in this double-voiced discourse.

today: it has become a substitute form of religion, while the new museums, which underwent inflationary growth in the 1980s, have been forced to become temples. Inasmuch as the new religion showed more faith in the art market than in culture in general, Gae Aulenti's ironic collision of types is meant both to enhance and to undermine this fact. Double coding is as prevalent a method in post-modern architecture as it is in post-modern literature.

The fourth stage of post-modernism, starting at about 1985, was also concerned with historical precedents and meanings when it reacted to the third stage. Instead of the huge corporate structure expressed as a single volume, the overlarge office was now broken up into "small blocks" that were expressed in many articulations.

Jane Jacobs recommended small-block planning in the sixties, Leon Krier did likewise in the seventies, and, by the late eighties, James Stirling, Hiroshi Hara, Kisho Kurokawa, and Antoine Predock (among many others) were looking to historical precedent for breaking up architectural volumes into discrete and grammatical units. Seventeenth- and eighteenth-century cities were consulted, including a study of the perimeter blocks of

Naples; and the coherent juxtapositions of small classical units in ancient Greece were very persuasively demonstrated in the seductive drawings of Leon Krier, who by the late 1980s was very much in the Traditionalist camp with Prince Charles and was the main theorist behind the new town of Seaside, Florida. So the past could, once again, help the present out of a blind alley.

Furthermore, post-modernists reacted against the overstated symbolism of such things as Michael Graves's Swans at Disneyworld by adopting a more abstract representation, an allusive and enigmatic symbolism. This was most evident in Kisho Kurokawa's Hiroshima Museum of Contemporary Art, which alluded to many previous eras of Japanese and Western architecture as well as to the recent destruction of Hiroshima. In the sense that modern technology and warfare produced the bomb and destroyed Hiroshima, their erasure is the ultimate modernist attack on time and memory. While Kurokawa's building alludes to this past, it also signifies the future with veiled hints of a spacecraft and high-tech equipment (figure 4). His Hiroshima museum manages to tie different periods and

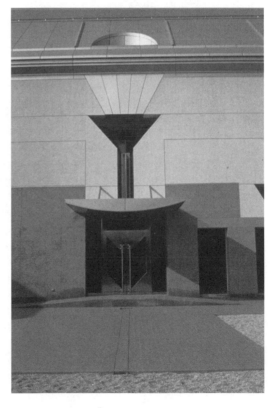

(fig.4) Kisho Kurokawa, *Museum of Contemporary Art*, Hiroshima, Japan, 1988–1989. This building marks the fusion of the past (Edo stonework), the recent past (the burned scorch marks are incorporated), the present (white tile), and the future (aluminium space imagery). This fusion, opposed to the usual post-modern method of violent juxtaposition, is seamless, harmonious, and peaceful. It reflects, no doubt, Buddhist attitudes toward reconciling irreconcilable discourses.

cultures together through this understated allusion. In a city that was totally devastated by the ultimate product of modernism, in a city that has literally suffered urban amnesia, Kurokawa has designed a healing amalgam of time: the cracked stone base alludes to Edo Culture and represents the past. The center of the building, with its white tile, is reminiscent of modern structures, and the aluminum top has many overtones of the future, including space travel. In many more ways the building binds historical periods together and in this sense becomes a clear alternative to the timeless, abstract modernism that continues today in its "late" and "neo" forms. The contrasts are obvious.

The fifth stage, or distinguishable movement, of post-modern architecture started in the early 1990s and presents yet other ways of dealing with time and cultural pluralism. One way is through the broad architectural movement I discuss in *The Architecture of the Jumping Universe,* based on complexity theory, that sees time as the great constructor, the great builder, whether of DNA complexity or of architectural complexity. One aspect of this movement is framed under the guise of the folding theory, which stems from Deleuze and his writings on *Le Pli.* Greg Lynn and Jeffrey Kipnis, among many younger architects, and Peter Eisenmann and Daniel Libeskind, among a few older ones, have seen a way beyond collage and juxtaposition. Finding the oppositional methods of Stirling at Stuttgart and the ironies of Venturi in London too confrontational, they have fashioned a method of folding in difference. Here variety and pluralism are allowed but are subsumed into a changing, supple, continuous whole. As Kipnis argues, it is coherent and congruent yet still, in part, inclusive of difference.

The recent work of Frank Gehry epitomizes both the folding and complexity theories without explicitly being based on either. Gehry is aware of the writings on both and respects them, but he is led more by his intuitive concerns. Nonetheless, his New Guggenheim Museum in Bilbao characterizes the supple, pliant, moving quality of the one and the notions of self-organizing systems and a fractal order of the other. The all-over titanium panels of the museum repeat endlessly as they fold into self-similar, fractal shapes of natural forms: the two most obvious are flower petals and the shimmering water of the Nervion River into which the building springs (figure 5). Into these continuously changing curves many types of space are poured—Gehry's pluralism is typological more than semantic. The interior galleries run the gamut through all the types: spaces that are long, thin, white, curved, and high; spaces that are small, squashed, square, colored, and low; and both abstract spaces and art-specific rooms. Furthermore, the hills, streets, and river of Bilbao are very much pulled into the museum and celebrated, with both glimpsed views and vast, sixty-foot-high, tilted and warped windows. The building is strongly tied into the site. It slides under an existing highway to one side,

and then with its surface and color acknowledges the trains and the rail-road station to the other. Following the fourth stage of post-modern architecture, which also reacts against explicit symbolism, all of these references are understated and oblique, but they are definitely to be found by those who care to look. Basques may find the implied art and culture too American, too bombastic, or too hegemonic, but they appreciate the way Gehry has implicitly responded to the site and the preexisting industrial landscape to create a building that resuscitates a dying rust-belt city. If ever post-modernization existed as a tertiary and quaternary industry replacing secondary manufacturing, it is here. The cultural industry has, through this and other creations, revived Bilbao's economy and thus has created new links across time that would have surprised the modernists and materialists.

For Karl Marx, as for many modernists, history was an intolerable burden that weighed down on the present; creative action was impossible.

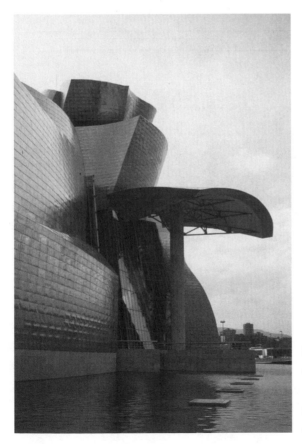

(fig.5) Frank Gehry, *New Guggenheim Bilbao,* 1993–1997. This building represents the architecture of complexity and folding.

For Henry Ford, the quintessential modernist, history was "bunk" and a "scrap heap" on which to throw obsolescent bodies, outmoded concepts—or old Model Ts. For Isaac Newton, as for the classicists, history was timeless, eternal, that is, nonhistorical. For Le Corbusier and Mies van der Rohe, historical consciousness was irreversibly broken, and the "great tradition" had ended with nineteenth-century eclecticism, or what they considered to be false consciousness. The new city was thus to be a tabula rasa on which one could inscribe totally new and functional ideas. This kind of thinking, if not finished today, is at least a curiosity. Even the new modernists and deconstructionists consciously revive their chosen history and acknowledge that creativity must exist within a socially constructed reality. So the worldviews of post-modernists and these others, while very different, at least meet on one point: most architects now support a historical understanding of their place in space and time—the necessary coordinates of urban action.

Post-modernists, as we have seen, have developed different attitudes

(fig.6) Frank Gehry, *Chiat/Day/Mojo Headquarters,* Venice, California, 1985–1991. This work represents a high point of post-modern heteroarchitecture, which includes so many discourses in its interior workspace and exterior treatment as to make James Joyce read like a purist. The supreme crossing of categories is the office-village layout under the preexisting warehouses at the back, spaces that merge the vernacular street with the public realm, church, and home.

toward the past, and in summary I will underline four: With James Stirling and Robert Venturi there are the juxtapositions of historical codes and the conflict, confrontation, or nonresolution of a dialectic between several codes and tastes of the users. With Charles Moore, at the Piazza d'Italia, for instance, there is the inclusive parody that accommodates different tastes and epochs, with an irony that has become too easily plastered over much of the commercial environment. With Gae Aulenti at the Musée d'Orsay there is the ironic weaving together of past and present, and with Kurokawa there is the symbiosis of past, present, and future as autonomous, but peacefully coexisting, realms. The urban work of Frank Gehry is a compilation of many of these positions. For instance, his advertising agency headquarters building is, like Stirling's work, a bricolage of opposite discourses; like Venturi's and Moore's, an ironic but easy-going incorporation of pop icons; like Aulenti's, a reuse of old typologies (the warehouse); and, like Kurokawa's, in part, a seamless vernacular web (figure 6). The heteroglottic aspects of post-modern fiction find their equivalent in his carnivalesque sense of *everything*.

From a theoretical position, post-modernists accept the evolutionary paradigm; that is, they conceive everything as radically historical, with the time and cultural dimension clearly featured. The big bang theory of the universe, with its attendant evolutionary metaphysics, was formulated in the 1960s, in the first period of post-modernism, and recently a self-styled "post-darwinism" has started to dominate discussion. Ilya Prigogine's *Order Out of Chaos* shows the metaphysics of the post-Newtonian position, where time has entered radically into all equations—the arrow of time, along with the arrow of entropy. The creation of sudden new order out of chaos, the metaphysics of self-organizing systems, dominates the current post-modern worldview.

With respect to architecture, there is no question that historical reference roots a building in space and time and gives it greater resonance, allowing our feelings and understanding to grasp a place and structure. Who today would deny this truth, particularly its enduring pleasure? It does, however, often become, in a commercial culture, reductive and nostalgic, failed historical reference rather than creative pastiche, the one-liner of Michael Graves's Swans.

In the end, historical reference and understanding are only two of many dimensions essential to architecture. They are on a par with the usual Vitruvian triad of form, function, and technic, but they are no more or less significant. Historical consciousness is just one dimension that may look more significant today because for fifty years it had been successfully repressed. Yet in this century there has been another possibility, as the minority tradition within literary modernism shows, a tradition concerning history expressed occasionally by T. S. Eliot, particularly the well-known paradox with which he starts *The Four Quartets:*

Time present and time past
Are both perhaps present in time future
And time future contained in time past.

Here we are close to the post-modern science of Prigogine and the meta-physics of David Bohm—his idea of the "implicate order" that enfolds time and quantum events. While I will not presume to explicate it, the architectural implications of this concept are represented by the symbiotic architecture of Kisho Kurokawa at Hiroshima and of the heteroarchitecture of Frank Gehry in Los Angeles: time fused, bound, embedded, and breaking out.

NOTES

1. Charles Jencks's hyphenated spelling of "post-modernism" reflects his view that "Post-*Modernism*" means the continuations of Modernism *and* its transcendence, a double activity that acknowledges our complex relationship to the preceeding paradigm and world view ("Post-Modern Agenda," 11).

WORKS CITED

Bohm, David. *Wholeness and the Implicate Order*. London: Routledge and Kegan Paul, 1980.
Jacobs, Jane. *The Death and Life of Great American Cities*. New York: Vintage Books, 1961.
Jencks, Charles. *The Architecture of the Jumping Universe*. London and New York: Academy Editions/John Wiley, 1997.
———. "The Post-Modern Agenda." In *The Post-Modern Reader,* ed. Charles Jencks. London and New York: Academy/St. Martin's, 1992. 10–39.
Kipnis, Jeffrey. "Towards a New Architecture." *Architectural Design* 63, 3/4 (1993): 41–49.
Le Corbusier. *Towards a New Architecture*. London, 1927.
Prigogine, Ilya, and Isabelle Stengers. *Order Out of Chaos: Man's New Dialogue with Nature*. New York: Bantam Books, 1984.
Venturi, Robert. *Complexity and Contradiction in Architecture*. Museum of Modern Art Papers on Architecture. New York: Museum of Modern Art, 1966.

Postmodern
Media and Performance

"Old Tools," Not "New Noise"

Opera's Postmodern Moment

Linda Hutcheon

mong the performance art-forms flourishing to-
day, none would seem more distant from a post-
modernist sensibility than opera" (Lindenberger
28). With those words, Herbert Lindenberger be-
gins his groundbreaking article "From Opera to
Postmodernity." And yet this "exotic and irra-
tional entertainment," to use Dr. Johnson's terms,
is, nonetheless, experiencing a revival that may
herald a return to its earlier historical position as
popular, accessible, indeed, "democratic" the-
ater—though its locus and institutional frame
have expanded significantly. Thanks to film and
televised productions, not to mention advances
in video and aural recording technology, opera
can now enter the home with an ease only
dreamt of by the first listeners of the *Metropoli-
tan's Saturday Afternoon at the Opera* radio broad-
casts. Opera houses around the world are moving
from being museums of the past to becoming
showplaces for the new—for revisionary, icono-
clastic productions and even for new operas. The

camera close-up and the performing conventions of film have created audience expectations of a new dramatic realism in performances too, and so are born a new look and a style of stage acting. If anything, it would be this conjunction of new creation, reinterpretation, and technology that might make possible the postmodern moment of opera. But, perhaps even more than in other art forms, this is not an unproblematic moment.

A word of caution is in order from the start: the use of the word "postmodern" here must be conditioned by the fact that, unlike architecture or even literature, opera has had no particularly dominant "modernist" form to which to respond. Thus, operatic "postmodernism" will exist more by stylistic and ideological analogy with other art forms than by precise art-historical parallel. Indeed, it is less the modernist period than the period from Mozart to Puccini—from the late eighteenth and to the early twentieth centuries—that forms the powerful and persistent canon to be addressed in opera. As Peter Conrad puts it, "Throughout the twentieth century, opera adheres to a past it rewrites but can never reject" (216). Those short, difficult, and austere modern operas by Schoenberg/Pappenheim[1] (Erwartung), Stravinsky/Cocteau (Oedipus Rex), Bartók/Balázs (Bluebeard's Castle), and Poulenc/Cocteau (La Voix Humaine) are, as Lindenberger notes, peripheral to the standard repertoire. Longer works have persisted but are not exactly central to the canon: Stravinsky/Auden's The Rake's Progress—with its parodic play with eighteenth-century music and painting—would almost qualify, as we shall see, as postmodern.[2] It is the general view of modern music as being difficult and serious—and, since Schoenberg, not traditionally melodic—that has worked against modernist opera becoming as popular and accessible as the nineteenth-century repertoire, in particular.

The performed operatic text, however, has been given new life by its reinterpretation and reshaping at the hands of a new generation of stage directors, whose often brash and fearless historicizing and politicizing maneuvers have been seen as "efforts to save opera by minimalizing, pauperizing or sullying it—by a variety of desecrations" (Conrad 278). Peter Sellars's much publicized (and televised) parodic resetting of Mozart's three Da Ponte operas—Don Giovanni, Così fan tutte, and Le Nozze di Figaro—with all their class politics, in the contemporary multiracial United States brought a new audience to opera, even as it perhaps alienated another. In other words, what has become a directorial commonplace in the last decades for Shakespearian productions, for example, has been seen as radical and iconoclastic in operatic circles: Sellars's work has been called "a powerful assault on performance tradition" (MacDonald 707). Former East German director Harry Kupfer updated Gluck's eighteenth-century Orfeo ed Euridice to the present, and when his Orfeo sings his "classic" operatic parts, he dons a tuxedo jacket over his jeans and sweatshirt and sings with a libretto in hand. Kupfer's penchant for reflexive productions means that he will have Händel appear in his own opera, Giustino, as a composer-ex-machina, with

the singers performing in the final scene with parodic marionettes of their characters. In this way, what might look, to an audience today, like the artifice of a puppet-show plot is here laid bare for what it is: precisely that. Through self-consciousness, Kupfer recodes the opera and its possible appeal for us today. In his "green" version of *Der Ring des Nibelungen* at Bayreuth (1988–1992), he used this reflexive recoding technique to bring out those aspects of the libretti of Wagner's cycle of music dramas that might make them meaningful to current audiences, with their worries about the ecology and nuclear arms proliferation. It is not that Wagner's operas transcend time to speak to us today, as might be argued within a humanist tradition; such productions simply acknowledge the postmodern realization that any meaning we give to them today is necessarily historicized through our current frames of reference. In their paradoxically critical yet implicated way, these postmodern productions allow the canon—Wagner, Mozart, Verdi—to persist, they but give it new and different significance.

Reflexivity, parody, and this kind of rehistoricizing of meaning are the field markings of the postmodern in operatic productions. Here, as in other postmodernist art forms, "style itself [is emphasized] as a way of coming to terms with the traditions of the past as well as the discursive and ideological conflicts in the present" (Collins 138–39). Hans-Jürgen Syberberg's 1982 film of Wagner's *Parsifal* illustrates the contention that this work, as with all of Wagner's work, cannot be viewed—after the Nazi use and abuse of it—as anything other than "the assemblage of all its past and present incarnations and appropriations" (Collins 140). Less contentiously, when Ingmar Bergman filmed Mozart's *Die Zauberflöte* in 1974 on a studio mock-up of Drottningholm Castle's courtly eighteenth-century stage, his reflexive camera went backstage—to show the artifice and to reveal the everyday reality of the performers—before turning its attention to the audience, cataloging its various responses. Still other filmmakers have used opera as a kind of play-within-a-play to postmodern, parodic ends: Suzanne Osten's *The Mozart Brothers* is a film about a fictional Swedish opera company's attempt to put on an iconoclastic (postmodern) version of Mozart's *Don Giovanni,* an attempt that itself reflexively and ingeniously enacts the plot of the opera.

To this familiar parodic/reflexive/rehistoricizing mixture, Lindenberger has added other characteristics that a postmodern *opera* rather than *production* might manifest. The first is an urge to test the boundaries between opera's traditional "high" art status and popular culture (41), which can be seen in his example—John Adams/Alice Goodman's *Nixon in China* (1987), with its recent and familiar historical subject and its American big band–inspired music—or perhaps in Michael Nyman's *The Man Who Mistook His Wife for a Hat* (1986), whose music's "unexpected metrical shifts and harmonic angularities" have been said to suggest "a curious conjunction between Stravinsky and rock and roll" (Morreau 638). Philip Glass's

operatic reworkings of Cocteau's films *Orphée,* in 1992, and, a few years later, *La Belle et la Bête* are perhaps even better examples.

Another typical postmodern characteristic of opera, for Lindenberger, would be a desire to rupture the union of word and music that defines the genre (41), as in Philip Glass's *Einstein on the Beach* (1976), where the text—made up of bits of news clips, songs, ads, and clichés—is not made relevant to either the music or any narrative line. Examples of another order might be *Eight Songs for a Mad King* (1969) or *Miss Donnithorne's Maggot* (1974), two pieces by Peter Maxwell Davies/Randolph Stow that were written for "extended voice" in which all parts of the human sound spectrum interact with parodic echoings of earlier, more "normal" music and do so in the context of the libretto's exploration of what the "normal" consider to be "mad."

Lindenberger also believes that postmodern opera would have to attempt to provoke audiences out of either identification or passivity (41). But to provoke an audience without losing it is no mean trick, given that the economics of grand opera, at least, work against the taking of too large risks. Once again, in opera, as in other art forms, postmodernism's parodic play with or even critique of conventions, traditions, and styles must remain in a sense complicitous: its radicality is always going to be constrained by its desire to speak to an audience with expectations formed by the operatic tradition. This, of course, is where parody comes in handy, as we shall see shortly. More radical—and less immediately accessible—avant-garde works such as John Cage's *Europeras* (1987, 1991, 1992), Luciano Berio/Italo Calvino's *La Vera Storia* (1982), or Robert Wilson's *the CIVIL warS* (1984) have been called postmodern by some (Birringer 175) but seem to me a continuation of that "difficult" modernist tradition, going one step beyond Schoenberg and Berg into multimedia, nonnarrative, nonmimetic explorations of both the institutions of music/opera and the "architecturalization" of the performing body. While there are obvious analogies here to what could be called the postmodern, as there are in those moves toward ritualization in such works as R. Murray Schafer's *The Alchemical Theatre of Hermes Trismegistos* (1992) or Karlheinz Stockhausen's *Donnerstag aus Licht* (1981), the question of relative accessibility—or of complicity, to use the more negatively coded term—remains for me the distinction between the modern and the postmodern in opera. Opera is an art form that has persisted in its appeal as *staged* sung drama, despite the escalating costs of production that might have been expected to kill it off by now: to hire a conductor, a director, an orchestra, a chorus, soloists, a stage crew, designers and producers of sets and costumes, lighting technicians, and many others, you have to be sure that people will actually attend your live performances. (The filming of some staged operas would change the economics somewhat today, but not entirely and not for most companies.)

To be parodic and reflexive in opera is not, contrary to expectation, to be inaccessible; the reason is that opera has been, from the start, "drama *about* music, not just accompanied by it" (Conrad 13). From Monteverdi/Striggio's *Orfeo* (1607) to Wagner's *Die Meistersinger von Nürnberg* (1868) to, as we shall see, Corigliano/Hoffman's *The Ghosts of Versailles* (1991), some version of the artist/singer/musician/composer figure has been at the center of many operatic narratives. With realistic or "veristic" opera in the late nineteenth century came what has been referred to as opera's need to justify itself by choosing artists as protagonists, for only they would be "at home in the shoddy artificiality of the theater" (Conrad 194): Floria Tosca is an opera singer because "only a temperamental soprano can in all conscience be permitted to behave operatically" (Conrad 8). Out of the political and aesthetic crises of early-twentieth-century Germany came a kind of historical allegorical form of artist-opera that could be called, by analogy, the *Künstleroper:* Hans Pfitzner's *Palestrina* (1917), Paul Hindemith's *Mathis der Maler* (1938), and, a little later, Schoenberg's *Moses und Aron* (1957) (see Bokina).

The metamusical dimension is, to some, the very essence of opera (Cone 125). But within opera narratives, characters frequently sing realistic songs, such as toasts *(brindisi)* and love serenades, as if "they do not *hear* the music that is the ambient fluid of their music-drowned world" (Abbate 119). Opera's rather bizarre illusion is that the characters are unaware they are singing and that therefore the music emanates from some nonstage source and communicates to the audience alone. But against this illusion operates an equally strong urge toward reflexivity—from the romantic artist-figure of Wagner's *Tannhäuser* (1845, 1861) to the opera-within-an-opera of Leoncavallo's *Pagliacci* (1892) or Strauss/Hofmannsthal's *Ariadne auf Naxos* (1916) and on through Ravel/Colette's *L'Enfant et les sortilèges* (1925), a parodic romp through the history of opera in the playful animation (and vocalization) of the objects in a child's room and garden.

More complex versions of operatic reflexivity can be seen in Strauss/Krauss's 1942 *Capriccio: Konversationsstück für Musik,* an opera about the theory of operatic form that responds to Mozart/Stephanie's 1786 *Der Schauspieldirektor: Komödie mit Musik* by replacing the competitive sopranos with a composer and poet who compete for the same woman's love by debating the relative importance to opera of music and words. Possible subjects for operas discussed include those of Strauss's own earlier operas, duly cited to parodic ends by the orchestra. At the other end of the scale—of mood and impact—is the reflexive structure of Berg's *Lulu:* the palindromic form of the music (with the second half repeating the first in reverse) is echoed in the silent film interlude called for by the libretto to show the story of Lulu's arrest, trial, and imprisonment in the first half, which then reverses itself to show her switch in prison with the

Countess Geschwitz and her subsequent escape. The prologue also frames the opera in the reflexive trope of a circus: the Animal Trainer invites us to view his menagerie of beasts—the wild ones, not the domesticated ones in the opera house audience. Lulu herself is a dancer; Alwa is a composer, who wonders at one point whether people would believe any opera he wrote about the absurd life of Lulu.[3] Musically Berg parodies formal conventions—such as arias and recitatives—but in such a way that he can invoke their traditional power while still contesting their possible reification through ironic recontextualizing; for instance, Isolde's heterosexual love for Tristan in Wagner's "Liebestod" here becomes the Countess Geschwitz's dying devotion to Lulu.

It would be no exaggeration to say that opera, from the start, has been reflexive. Likewise, parodies (as ironic reworkings rather than ridicule) have accompanied popular operas for centuries.[4] The writing of parodic operas in and for themselves (rather than in tandem with a specific parodied opera) does seem to have increased in frequency over the years to the point that it has been said that "[o]pera in the twentieth century is preoccupied with its history, wondering if it's an art whose time has run out" (Conrad 226). That negative evaluation from a critic, however, needs countering with the experience of a composer. John Adams, whose music resonates with citations of and references to the work of others, puts forward a more positive view: "My attitude towards creation is one of incorporating in my compositions everything I've learned and experienced of the past. I've never received any powerful creative energy from the idea of turning my back on the past." His analogy for what he does is the work of postmodern architect Philip Johnson: both worked to the limits of modernism and then tried to develop "a new language that resonates with the past."[5]

From the point of view of the audience, the use of parodic references by postmodern architecture or music can work to counter the austerity of modernism's formalism and aesthetic autonomy and, therefore, can actually increase accessibility. This might be especially true in opera, where parody has become almost a convention. As Peter Rabinowitz has noted,

> [b]orrowing itself, of course, is hardly new: one need only recall the plagiarism and self-plagiarism of the baroque or the operatic potpourris of the Romantic virtuosi. But not until this century has the listener's *awareness* of the interplay between "new" and "borrowed" material . . . become a significant determinant of aesthetic effect in large numbers of musical compositions. (193)

That we are hearing borrowed music in a new context—as well as watching a borrowed (or parodied) narrative—gives initial meaning to a new opera like *The Ghosts of Versailles,* which is based in part on the third "Figaro" play by Beaumarchais, *L'Autre Tartuffe ou La Mère coupable.* The first two French plays had yielded Rossini/Sterbini's *Il Barbiere di Siviglia* (1816)

and Mozart/Da Ponte's *Le Nozze di Figaro* (1786), and both John Corigliano's music and William M. Hoffman's libretto pay due homage to their predecessors, thus drawing on their audience's potential knowledge of these two familiar operas of the canonical repertoire.

A review of the premier of *The Ghosts of Versailles* (1991) at the Metropolitan Opera in New York claimed that this new work restored the fun and excitement of the past to opera and did so "partly by stripping away the barnacles of accrued tradition, partly by making a big joke of them" (Feingold 89). On the contrary, I would argue that the work relies heavily on the audience's knowledge of that very tradition, ironizing it only somewhat but mostly drawing on its continuing power and on the audience's remembered pleasure in a way parallel to postmodern architecture's parodic recalling of the classical tradition or to postmodern fiction's playing with realist as well as modernist narrative conventions. The same review went on to assert that the composer and librettist had invented "something new and distinctively American: a huge melting-pot mélange of styles, events, and ideas that suggests a vaudeville show or a *Ziegfield Follies* as often as it does a traditional operatic drama or comedy" (Feingold 89). But what is even more clear than the "Americanness" of this opera is its "postmodernness": its parodic, reflexive rehistoricizing of the traditions and conventions of opera. Called *A Grand Opera Buffa*, *The Ghosts of Versailles* depends on its audience's recognition of the paradoxical (portmanteau) generic mix of "grand opera" and "opera buffa"—the ironic recognition that an opera commissioned by the Met (with its 3,800-seat capacity) was not going to be an ordinary, cozy "opera buffa" like Mozart's *Le Nozze di Figaro,* the bourgeois, comic alternative to the aristocratic classicism of "opera seria." Indeed, this new opera made full use—through over forty featured roles, a large chorus, elaborate stage sets and costumes, and both a pit and a stage orchestra—of the full institutional facilities and resources of nineteenth-century grand opera that the Met often seems to exist to perform. And perhaps its postmodern complicity—and accessibility—can be traced through its critical and commercial success, despite what might seem like real difficulties.

For instance, *The Ghosts of Versailles* manages to be even more complex in narrative structure than the earlier two operatic adaptations of Beaumarchais's plays had been. It exists on three experiential planes, so to speak. The first is the frame world, a ghost world: the time is the present; the place is Versailles; the characters are the ghosts of Louis XVI, Marie Antoinette, and their court, and the playwright Beaumarchais, who, in order to entertain the queen with whom he is in love, writes an "opera buffa" called *A Figaro for Antonia*—a parodic echoing of the music of Mozart and Rossini that makes it "unthreatening to most listeners," as one reviewer tellingly put it (Keller 23).[6] This opera-within-an-opera is played a bit more realistically than the stylized and defamiliarized special-effect

world of the ghosts. Nevertheless, these two planes merge in act 2, scene 2, when Figaro, the character, refuses to stick to his creator's text and therefore to help the historical Marie Antoinette escape the scaffold. Beaumarchais enters his opera's fictional world to right matters; then the ghostly Marie Antoinette brings Figaro into her world so that she can argue against his harsh evaluation of her. In order to change his mind, she asks Beaumarchais to show Figaro her actual (and, here, future) fate at the hands of the Revolutionary Tribunal. We then enter the third world: the historical streets of Paris in 1793, during the Terror. At the end, the three planes overlap as the historical Marie Antoinette is executed, the cast of the "opera buffa" plot escapes Paris in a balloon, and the ghosts of Beaumarchais and his beloved "Antonia" (as he familiarly calls her) walk off into the fictional gardens of Aguas Frescas, the home of the Almaviva family in the "Figaro" plays and operas.

The complex plot of Beaumarchais's play *La Mère coupable* continued the narrative of his earlier two plays about the trials of courtship and marriage of the Spanish Count and Countess Almaviva. In this play, the mutual love of the illegitimate children of both partners is threatened by the hypocritical, lying, manipulative Bégearss. Set in Paris at the end of 1790, the Revolution is present (the Almavivas can no longer be addressed by their noble titles) but is not a major plot force. Hoffman's libretto departs from this by setting the action in Paris in 1793, at the height of the Reign of Terror. Bégearss is still a dangerous hypocrite, but this time he is also a spy for the Revolution and, as we shall see, is parodically portrayed according to yet another set of conventions, those of the melodramatic villain.

All three narrative planes are presented as the sites of reflexive self-consciousness. The ghost courtiers complain about how boring they find opera, an art that in their day was said to offer "an imposing and pretentious world, consistently sublime in tone, pompous and even soporific to some, and essentially humourless" (Johnson 1387). One of them even enters in full (and anachronistic) Walküre gear to denounce the proceedings at hand: "This is not opera! Wagner is opera!!" (39). Louis XVI laments the plot complexity: "I couldn't follow the last act of *The Marriage of Figaro* and this is even worse" (18). Hoffman is careful not to rely on his audience's memory too much: he has his Beaumarchais fill in the earlier plot details for the courtiers and for us. The intermission between acts 1 and 2 is the same for the theater audience of *The Ghosts of Versailles* and for the ghost audience of *A Figaro for Antonia,* who return to their seats less quickly and obediently than the others. Then again, as Hoffman's historicizing humor underlines, our convention of silent watching in a darkened hall is post-Wagnerian and too recent for the eighteenth-century ghosts to be expected to know about.

With structural echoes of Woody Allen's *The Purple Rose of Cairo,* Beaumarchais is driven to enter his own fictional world when Figaro

improvises, calling his ghost creator's beloved, Marie Antoinette, a "spoiled, arrogant, decadent" (44) vampire and vulture. In response to her outrage and to his own shock at this independence ("Singers have no minds" [43]), Beaumarchais attempts to force Figaro to obey him and to participate in a plot to change history and to help Marie Antoinette escape her death at the guillotine. Beaumarchais shows himself to his terrified characters, identifying himself as a "ghost," to the music of the Commendatore's ghost in Mozart/Da Ponte's *Don Giovanni*. In the Met production, holding out a finger to touch Figaro's—in a visual parody of Michelangelo's Sistine Chapel creation of Adam by God—he identifies himself further: "I am your creator" (52).

In addition to *Ghosts*'s clear musical and narrative parodies of the earlier Beaumarchais-inspired operas,[7] the villain Bégearss's outrageous "Aria to the Worm"—suggested by Arrigo Boito's poem *Il Re Orso*—is a parodic, evil credo worthy of Verdi/Boito's Iago in their *Otello*. The choice of the worm as the metaphoric analogue might well be an operatic allusion not only to Wagner's dragon *(Wurm)* in *Siegfried* (1876) but to Wurm, the adviser to the devious and corrupt aristocrat in Verdi/Cammarano's *Luisa Miller* (1849), a character also directly involved in marriage trickery. Any opera set in the time of the French Revolution and with this particular plot potentially recalls a rich set of intertexts:[8] Giordano/Illica's *Andrea Chénier* (1896), about the indictment and death of a poet and his beloved at the hands of the Revolutionary Tribunal; von Einem/Blacher's *Dantons Tod* (1947); Benjamin/Cliffe's *A Tale of Two Cities* (1957); Poulenc/Bernanos's *Les Dialogues des Carmélites* (1957); and Eaton/Creagh's *Danton and Robespierre* (1978). Puccini even began an opera about Marie Antoinette's imprisonment, trial, and execution (see Greenfeld 182) but decided that the French Revolution was already an "over-exploited" subject (Ashbrook 97).[9]

This turbulent period in history saw the revival and great success of the "rescue opera" genre, one whose politics were useful for revolutionary purposes. Cherubini/Bouilly's *Les Deux Journées* (1800), about the escape of an aristocratic couple from political danger through class benevolence and egalitarianism (Arblaster 48), is typical of the genre. *The Ghosts of Versailles* ends with the death of the historical Marie Antoinette but also with the rescue of the Almaviva household from revolutionary Paris and the shared spectral love of Beaumarchais and his Antonia. But what is striking about this postmodern opera is that not only does it recall the rescue opera genre and all those grand operas on historical and political themes—from Auber/Scribe-Delavigne's *La Muette de Portici* (1828) to Verdi/Piave's *Simon Boccanegra* (1857)—but it equally obviously draws on popular cultural intertexts. Corigliano, who wrote the score for Ken Russell's film *Altered States*, here also uses a cinematic musical technique of "cross-fading" to unite structurally the interconnecting levels of action (Keller 23). When

the ghostly Beaumarchais tells the spirit of Marie Antoinette that he will help her escape her historical fate and that they will live forever in the New World, in Philadelphia, the ghost of Louis XVI sardonically interjects: "If you call that living" (42), thereby recalling W. C. Fields's own epitaph: "On the whole, I'd rather be in Philadelphia."[10]

Popular television and film culture today is also the current home of melodrama, that radically polarized form of dramatic confrontation and purgation that was born in the aftermath of the French Revolution. Originally, as defined by Rousseau to describe his *Pygmalion* (1770), melodrama sought new emotional expressivity through the use of music combined with monologue and pantomime. The historical flourishing of this particular form in France in the postrevolutionary years[11] might have been one of its attractions for Hoffman and Corigliano, who, as contemporary opera creators, might also have been trying to find a form with democratic appeal in which to write about the same period in history and about the death of French royalty. Peter Brooks, in *The Melodramatic Imagination,* has argued that melodrama illustrates and contributes to the epistemological moment of the Revolution, one that

> symbolically, and really, marks the final liquidation of the traditional Sacred and its representative institutions (Church and Monarch), the shattering of the myth of Christendom, the dissolution of an organic and hierarchically cohesive society, and the invalidation of the literary forms—tragedy, comedy of manners—that depended on such a society. (15)

It is tempting to draw a parallel between the apocalyptic discourse that has formed and informed current discussions of postmodernity and Brooks's articulation of this revolutionary moment. The difference, however, might be that today the stage (musical or dramatic) is infrequently the scene of the "escape" into the radical "excess" of melodrama, with its "mode of heightened dramatization" (Brooks ix), its hyperbolic extravagance and concentrated intensity, and most of all its "moral manichaeism" (5) through a polarization of ethical forces into good and bad; rather, the site for this escape today is likely television drama (including soap opera) and certain genres of Hollywood film. But it is with the self-conscious awareness of melodramatic entertainment as escape that Hoffman locates his melodrama specifically within the eighteenth-century reflexive and parodic opera-within-an-opera, *A Figaro for Antonia*—Beaumarchais's attempt to distract and to entertain Marie Antoinette.

Brooks points out that the "affective structure" of a form like melodrama, with its grandiose emotional states and vivid self-dramatizations, has much in common with the experience of dreams (35). It is perhaps not coincidental that critics have noted the importance of a kind of dream-logic, with elements of nightmare, to the effect of the spectral

frame of *The Ghosts of Versailles* (Kerner 83): the ghostly courtiers are rest-less, and Marie Antoinette is traumatized, reliving over and over the terror of her trial and death. Dream and nightmare conflate as fiction and his-tory also meet in the reenactment of that terror at the end of the opera. So many of the conventional staples of melodramatic narrative are invoked in *Ghosts* that they become a major intertextual point of reference: against all historical evidence, Marie Antoinette is turned into the very image of persecuted innocence, wandering into the typical garden of innocence that Aguas Frescas has come to symbolize; the topos of the interrupted fête frames Bégearss's seeming triumph; the melodramatic public hearing that restores right is both evoked and ironized in the Revolutionary Tri-bunal trial of Marie Antoinette (Brooks 20–31).[12] In almost every scene, spectacular stage effects also recall those of melodrama (46). The melodra-matic bag of narrative tricks—mysteries of parentage, disguised identities, secret plots, occult powers—also makes its way into *Ghosts* but appears un-der the sign of irony.

In the narrative of *A Figaro for Antonia*, as in melodrama, the characters have no psychological depth; but whereas Brooks argues that in melo-drama this is because the characters stand for pure psychic signs—Father, Daughter, Persecutor (35–36)—in the new opera, these very roles are ironized: part of the plot involves trying either to figure out or to hide the complex parentage of a daughter and a son. The Persecutor, as in Beau-marchais's play, masquerades as Protector and successfully fools everyone but Figaro. Moral epithets typical of melodrama ("That man is a saint" [26]) are attached to Bégearss, the hypocritical friend/enemy. Parodying the melodramatic villain—"a swarthy, cape-enveloped man with a deep voice" (Brooks 17)—Corigliano and Hoffman cast Bégearss as a character tenor and make enormous demands on the upper range of his voice.[13] The histrionic acting style demanded of melodramatic villains as the expres-sionistic externalizations of their evil and excess (Brooks 47) would seem to have guided director Colin Graham's conception of Graham Clark's Bégearss in the Met production. This is fitting for a character introduced by Beaumarchais within the opera as the villain of the piece, one who himself openly admits he "can't wait to betray Almaviva" (21): "It's true: I'm low, base, vile. But don't they know the king of beasts is the worm?" (22). His "Aria of the Worm," with its defiant "Long live the worm" re-frain, functions as the self-revealing soliloquy of melodrama: "it is the vil-lain who most fully articulates the stark monochrome of his moral charac-ter, his polarized position in the scheme of things" (Brooks 38). An active force, even the motor of the plot, Bégearss is the pure villain, reducing in-nocence to powerlessness through his incitement of the dangerous mob of Parisian women who are loud in their determination to have Marie An-toinette's head.

The setting of the opera in the context of the French Revolution,

however, is what makes *The Ghosts of Versailles* the operatic equivalent of what has been called postmodern "historiographic metafiction" (Hutcheon)—reflexive, parodic, and contesting of the given narratives of history. The appearance of characters based on (and named as) actual people on stage is nothing new to opera, of course. Hoffman's Beaumarchais does bear some resemblance to the actual, historical personage who wrote those plays and at least one libretto,[14] who was a secret agent for Louis XV and Louis XVI,[15] and who was "a radical, but also an opportunist and an entrepreneur" (Arblaster 23). But in the opera, his antiaristocratic sentiments seem to turn against him, for he falls in love with no less than the former Queen of France.[16]

The operatic ghost of Beaumarchais tries not only to cheer Marie Antoinette up but also to save her from her historical fate, to show her history "as it should have been" (15). He is stopped from doing so only by Marie Antoinette herself. The librettist of *Ghosts,* however, could be said to have changed history in another sense. Whether the change was motivated by a feminist-inspired rewriting of history or simply sentimentality, the woman that most historical accounts have presented as a frivolous, extravagant, imprudent queen who contributed to the popular unrest of the Revolution is here revisioned as a sympathetic victim of villainous evil and mob persecution. Her first aria in the opera juxtaposes her happy memories of Versailles (sung to a haunting chromatic theme, "Once there was a golden bird") with her relived terror of her trial and execution (spoken harshly in *Sprechgesang,* reminiscent of Berg's *Lulu*—another ambiguous tale of female as victim/victimizer). The historical prerevolutionary "Affair of the Diamond Necklace," which was used to discredit the monarchy through accusations of Marie Antoinette's moral impropriety with a churchman, gets recoded into its rather more innocent sale to finance the rescue and escape of the imprisoned queen.

As she watches *A Figaro for Antonia,*[17] Marie Antoinette identifies with the victimized young daughter, recalling her own arrival in Paris, lonely and homesick at age fourteen. Beaumarchais reminds her, "Oh, how the people loved you" (24), setting up the contrast with the Bégearss-instigated mob that will demand her head. She is obviously tempted by Beaumarchais's offer to risk his soul to change history for her but warns him, "It's dangerous to change history" (41). To this Louis XVI responds with irony, "It's *only* an opera" (41). This single exchange, with its mixing of the historical and the reflexive, is emblematic of the historiographic metaoperatic postmodernism of *Ghosts* as a whole. Nevertheless, although Louis's humorous asides undercut Marie Antoinette's histrionic desire to live again ("Excessive in life, excessive in death" (42), he mutters), she remains touching in her vulnerability, both to the audience and to Figaro, whom she manages to convince to save her from mob (in)justice and an unfair trial. Her decision in the end not to be rescued, not to have history

rewritten for her, but to accept her historical destiny is attributed to her realization that Beaumarchais's love and art offer a way out of suffering in endless night through forgiveness as the only way to freedom. Melodrama's plot ending of virtue rewarded and order restored is thus simultaneously invoked and "made strange": reward comes, but only in the next world. By the end, what seems to look less like a feminist revisioning and more like a sentimental, nostalgic conclusion may well be the most complicitous aspect of this postmodern opera. Its critical and even commercial success might well be the result of this sentimental rewriting of history two hundred years after the fact. No one, to my knowledge, responded to this work as a feminist statement.[18] One critic called the score "so fertile, so warmly tuneful, often so atonally wild, and just as often so disarmingly dizzy that you don't have time to worry about dramatic motivation and other proprieties" (Kerner 83). This is perhaps true, but, as with all postmodern works, the means of providing such access warrant some attention, if not always worry.[19]

This question of accessibility, important also to the selling of novels and to the designing of buildings, is crucial to an expensive art like opera. This economic reality is what, I think, most hampers any radical potential of postmodernism in this art form. Lindenberger's final evaluation of what constitutes the postmodern is more extreme and avant-garde than my own, and his view of the operatic may be different than mine: "To the extent that the term 'postmodern' challenges most everything we associate with opera from the performing personnel to the role of consuming audience, any operatic work that rigorously pursues a postmodern program must seek its audience, if it can, outside the opera house" (46–47). There is no doubt that postmodern opera—by either of our definitions—is taking place outside the opera house: in small theaters (Nic Gotham/Anne-Marie MacDonald's *Nigredo Hotel* [1992], a marriage of Hitchcock's *Psycho* to Jung's psychology, or James Rolfe/George Elliott Clarke's resetting of Shelley's Roman *The Cenci* in early slave-owning North America in *Beatrice Chancy* [1998]) and at academic conferences (John Beckwith/James Reaney's *"In the Middle of Ordinary Noise . . .": an auditory masque* [1992], on the life and work of literary theorist Northrop Frye).

As the popularity of *The Ghosts of Versailles* shows, however, the postmodern may even be glimpsed in what one wag called the Metropolitan Opera Museum. Both Sellars's updating of Mozart—an act that reveals less a "radical commitment to the work's universality" (MacDonald 707) than a historicizing interpretation in line with current cultural norms—and the new filmic "realism" of recent (often filmed) productions might have been read as conservative moves, had they occurred in another art form. But in opera, where acceptance of a norm of artifice and convention has long guided audience expectation, new stagings and new operas too can play with a long history of parody and reflexivity while introducing a historical

dimension that may be less radical than inevitable. This is clearly not the "new noise" that Jacques Attali sees coming, one that "can neither be expressed nor understood using the old tools" (133). It is, rather, through those very "old tools" that canny (commercial) complicity can and does coexist with critical revisioning in opera's postmodern moment.

NOTES

1. Admittedly, this double name–referencing is awkward and untraditional. Throughout this article, however, the first name will refer to the composer of the music and the second to the librettist. This is a literary critic's perhaps futile attempt to restore to the writer of the operatic text some sort of recognition in the face of musicology's seeming reverence for the composer alone. Where only one name appears, the composer has been responsible for the libretto as well.

2. Modernist literary texts—especially those of Thomas Mann—have been made into operas that could be seen as both modern (Benjamin Britten/Myfanwy Piper's *Death in Venice*) and postmodern (Harry Somers/Rod Anderson's *Mario and the Magician*). In Mann's novel, *Doktor Faustus*, Adrian Leverkühn writes a modern opera on *Love's Labour's Lost* that parodies nineteenth-century opera: parody, argues Leverkühn, is central to modern art, thereby articulating and illustrating Mann's own belief and practice.

3. Nicholas Muni's production for the Canadian Opera Company reflexively worked with this remark and kept Alwa present on stage always—sitting in a director's chair, playing with a model of the stage action.

4. Parodies of popular operas performed at the Paris Opera in the eighteenth century played at the theaters of the Parisian fairgrounds, the Théâtre des Italiens, and the Théâtre de la Foire (see Johnson 1388).

5. These two citations are from John Adams's interview with Jonathan Cott in 1985, printed in the notes to the Nonesuch CD recording of *Harmonielehre*, whose very title invokes Schoenberg's 1910 study of harmony, which he dedicated to Mahler.

6. Figaro's first aria is a parodic reworking of and homage to Rossini/Sterbini's "Largo al factotum" aria in *Il Barbiere di Siviglia;* among the Mozartian echoes are those in the Aguas Frescas memories of the Countess about Cherubino and in the scene at the Turkish ambassador's party, where nineteenth-century "Turkomania" (a.k.a. orientalism) and Mozart/Stephanie's *Die Entführung aus dem Serail* are both signaled and mocked through the singer Samira's comic complaining cavatina, partly sung in Turkish.

7. In order to aid its audience's memory, the Met scheduled both *Le Nozze di Figaro* and *Il Barbiere di Siviglia* in the same season as *Ghosts*.

8. See Noiray 366–71 on the many operas about the French

Revolution written and performed in Paris at the time and on the changes in content and tone from 1790 to 1794. Not many of these operas have become part of the repertoire, however. Many were propagandistic but, as Noiray points out, the Revolution represents one of the strongest moments in French music (378).

9. This has not stopped contemporary directors from resituating operas set in other periods in the tense and dramatically suggestive time of the Revolution, of course. Frank Corsaro moved Prokofiev/Gozzi's *L'Amour des Trois Oranges* from 1761 to 1789, where it reflexively took place in a Paris street theater (Conrad 294).

10. In the Met production, Beaumarchais complains that he loves a woman who "cares for me" and then pauses before adding "not." This seems a patent allusion to the irony mark for a world that does not understand irony, the "not" made famous by the film *Wayne's World*.

11. Opera also flourished in these years and became not an expensive and exclusive form of "museum culture" but a popular and increasingly bourgeois form of live entertainment (see Arblaster 45). From performing one new opera a week before the Revolution, Paris theaters doubled or tripled their production with the opening of new houses and the end of royal "privilege" to determine what would be put on stage. See Noiray for complete details.

12. Hoffman's use of the language of historical record for the trial scene could be read as a comment on melodrama as well. As Brooks says, "Like the oratory of the revolution, melodrama from its inception takes as its concern and raison d'être the location, expression, and imposition of basic ethical and psychic truths" (15).

13. By making Beaumarchais, the lover, a bass-baritone, they inverted the tradition of the tenor as hero/lover but set up a tension: baritones who fall in love in opera are often dangerous and will be punished in the end (Dumas 90).

14. His libretto to Salieri's music for *Tarare* was political in theme: egalitarian, anticlerical, contesting abuses of power (see Spinelli 1333). *Tarare* is also described by critics as aiming at a fusion of the tragic, the fantastic, and the comic, which is not a bad description of *The Ghosts of Versailles* (see Noiray 363).

15. Louis XVI hired Beaumarchais to go to London to stop a libelous text about Marie Antoinette from being published; given that he almost succeeded, in history, as in operatic fiction, he was almost her savior.

16. The historical Beaumarchais's play *Le Mariage de Figaro,* with its attack on the aristocratic *droit de seigneur* and its elevation of merit—goodness and cleverness—over rank, had been banned by Louis XVI, though he did let the first play, *Le Barbier de Séville*, be put on at the theater at the petit Trianon at Versailles, with Marie Antoinette playing the heroine and directed by the playwright.

17. As mentioned earlier, Beaumarchais refers to Marie Antoinette by the affectionate Antonia, much to Louis XVI's irritation, but there is also an operatic echo here of the sacrificial Antonia in Offenbach/Barbier's *Les Contes d'Hoffmann,* who dies in order to sing. The librettist's name—Hoffman—may not be utterly without relevance in this postmodern play with names.

18. Until recently, there has been surprisingly little feminist response to opera in general, as many critics have recently noted. See, however, the important works of Clément and McClary and now a host of young scholars.

19. See Felsin 11 on the use of mass-media representations within postmodern visual art as a means of providing (positive) access.

WORKS CITED

Abbate, Carolyn. *Unsung Voices: Opera and Musical Narrative in the Nineteenth Century.* Princeton, N.J.: Princeton University Press, 1991.

Arblaster, Anthony. *Viva la Liberta! Politics in Opera.* London and New York: Verso, 1992.

Ashbrook, William. *The Operas of Puccini.* Oxford: Oxford University Press, 1985.

Attali, Jacques. *Noise: The Political Economy of Music.* Trans. Brian Massumi. Minneapolis: University of Minnesota Press, 1985.

Beaumarchais, Pierre-Augustin Caron de. *L'Autre Tartuffe ou la Mère Coupable.* Paris: Gallimard, 1966.

Birringer, Johannes. *Theatre, Theory, Postmodernism.* Bloomington: Indiana University Press, 1991.

Bokina, John. "Resignation, Retreat, and Impotence: The Aesthetics and Politics of the Modern German Artist-Opera." *Cultural Critique* 9 (Spring 1988): 157–95.

Brooks, Peter. *The Melodramatic Imagination: Balzac, Henry James, Melodrama, and the Mode of Excess.* New Haven, Conn.: Yale University Press, 1976.

Clément, Catherine. *Opera, or the Undoing of Women.* Trans. Betsy Wing. London: Virago, 1989.

Collins, Jim. *Uncommon Cultures: Popular Culture and Post-Modernism.* London and New York: Routledge, 1989.

Cone, Edward. *Music, A View from Delft: Selected Essays.* Ed. Robert P. Morgan. Chicago, Ill.: University of Chicago Press, 1989.

Conrad, Peter. *A Song of Love and Death: The Meaning of Opera.* New York: Poseidon, 1987.

Corigliano, John, and William M. Hoffman. *The Ghosts of Versailles: A Grand Opera Buffa in Two Acts.* Milwaukee, Wis.: Schirmer, 1991.

Dumas, Jean. "Le Mélodrame, carrefour des ambitions symboliques."

Esperienze Letterarie 7.1 (1982): 82–93.

Feingold, Michael. "Haunting Premises." *Village Voice* 37 (14 January 1992): 89.

Felsin, Nina. "No Laughing Matter." Catalog to *No Laughing Matter* exhibition. New York: Independent Curators, 1991. 7–11.

Greenfeld, Howard. *Puccini: A Biography*. New York: Putnam's Sons, 1980.

Hutcheon, Linda. *A Poetics of Postmodernism: History, Theory, Fiction*. London and New York: Routledge, 1988.

Johnson, Neal. "Opera Parodies in Eighteenth-Century France." *Studies on Voltaire and the Eighteenth Century* 265 (1989): 1386–90.

Keller, James M. "John Corigliano's *Ghosts of Versailles:* A Spirit of American Opera Revisits the Met." *Musical America* 111.6 (1991): 20–24.

Kerner, Leighton. "The Spirits of 1793." *Village Voice* 37 (7 January 1992): 83.

Lindenberger, Herbert. "From Opera to Postmodernity: On Genre, Style, Institutions." In *Postmodern Genres,* ed. Marjorie Perloff. Norman: Oklahoma University Press, 1989. 28–53.

MacDonald, Heather. "On Peter Sellars." *Partisan Review* 48.4 (1991): 707–12.

McClary, Susan. *Feminine Endings: Music, Gender, and Sexuality*. Minneapolis: University of Minnesota Press, 1991.

Morreau, Annette. "Michael Nyman." In vol. 3 of *The New Grove Dictionary of Opera,* ed. Stanley Sadie. London: Macmillan, 1992. 637–38.

Murray, David. *"Capriccio."* In vol. 3 of *The New Grove Dictionary of Opera,* ed. Stanley Sadie. London: Macmillan, 1992. 721–23.

Noiray, Michel. "L'Opéra de la Révolution (1790–1794): un 'tapage de chien'?" In *La Carmagnole des muses: l'homme de lettres et l'artiste dans la Révolution,* ed. Jean-Claude Bonnet. Paris: Armand Colin, 1988. 359–79.

Rabinowitz, Peter J. "Fictional Music: Toward a Theory of Listening." In *Theories of Reading, Looking, and Listening,* ed. Harry R. Garvin. Lewisburg, Pa.: Bucknell University Press, 1981. 193–208.

Sadie, Stanley, ed. *The New Grove Dictionary of Opera*. 4 vols. London: Macmillan, 1992.

Spinelli, Donald C. "Beaumarchais's Opera *Tarare:* Ideas and Music in the Eighteenth Century." *Studies on Voltaire and the Eighteenth Century* 265 (1989): 1333–34.

Channel Surfing

Postmodernism on Television

Glenn Hendler

C hannel surfing, zapping, grazing: flicking from station to station, program to program, constructing my own plural text, intended by nobody. What could be more postmodern? So, remote control in hand, I search for the postmodern on television. Much to my surprise, however, I discover that postmodernity is over, at least according to the network with the greatest claim to authority on the subject: MTV. The late-night half-hour show called *Postmodern MTV*, which in the late 1980s showcased the ever-shifting avant-garde of pop music, was canceled in the early 1990s. The cutting edge—defined as that which had not yet made it onto the network's regular playlist or which was unlikely ever to get there—ranged in style, sound, and vision from the enigmatic imagery and jangly guitar sound of the critically and later popularly acclaimed group REM to the harsher rhythms and violently surreal videos of Ministry and Front 242. *Postmodern MTV* generally catered to the same market served by college radio, and with

the massive success of REM, with the successive waves of self-consciously "alternative" bands such as Nirvana and Nine Inch Nails, and, finally, with a chain of radio stations that advertise themselves as "the alternative," the market for such sounds has been recognized, developed, and expanded. However, the show's cancellation implies that the word "postmodern" no longer describes either the music or its market.[1]

Flicking to another channel, I find a place where postmodernism has not happened yet: *Nick at Nite*. In an evening time slot that overlaps with that of *Postmodern MTV* and its successors, the cable channel Nickelodeon broadcasts reruns of "television classics" such as *The Dick Van Dyke Show, Dragnet, Superman,* and *The Mary Tyler Moore Show*. One promotional campaign for this package of shows consists of a set of slyly self-ironizing ads touting the channel's role in "preserving our television heritage," promoting the genius of its chairman of the board, Dick Van Dyke himself, and, most pertinently and amusingly, advertising itself with a phrase that would be derided as jargon if used in an academic essay: "Pre-postmodern television." *Nick at Nite* tells its viewers that it is a "safe haven" from the "stock docudrama and made-for-TV mayhem" of contemporary television: "No bad guys, no scary guys. The worst that can happen is Lucy'll get fired—again!" The network concludes its ads by proclaiming that it is "dedicated to better living through television."

The two cable channels thus seem to take diametrically opposed attitudes toward postmodernism.[2] Whereas MTV promotes its programming as postmodern, Nickelodeon sees itself as virtually premodern. *Postmodern MTV* clearly embraced its idea of the postmodern as a critical "alternative" to more mainstream music and images; the show and its VJs consistently presented their version of alternative music with a hipper-than-thou attitude, though they did not hesitate each night to preview and to promote the very different-looking heavy-metal show that followed, "Headbangers' Ball."[3] *Nick at Nite,* in contrast, stands in opposition to a vaguely defined postmodernity by nostalgically locating itself temporally prior to it.[4]

Postmodern MTV and *Nick at Nite* put the word "postmodern" regularly on television and therefore probably represent the most visible uses of the term in popular culture. Between MTV's positive valuation of the word and Nickelodeon's desire to send us back in time to escape it can be seen a variety of ways of thinking about not only postmodernism's place on television but also the place of television—and mass culture as a whole—in postmodernity.[5] This essay examines how postmodernism can be defined in and in relation to mass culture, and at the same time it explores mass culture's responses to the postmodern condition. Throughout the essay, most of my examples will be drawn from the recent history of television, in part because television is the dominant popular medium of the late twentieth century and in part because the attitudes of postmodernist theorists toward the medium have varied so widely and revealingly.

When some cultural critics flick from channel to channel, they find no postmodernism at all. Linda Hutcheon, for instance, sees a vast wasteland of conventional genres, realism, and commercialism with none of the ironic, parodic ambivalence that is, by her account, characteristic of post-modernism. "Most television," she writes, "in its *unproblematized* reliance on realist narrative and transparent representational conventions, is pure commodified complicity, without the critique needed to define the post-modern paradox" (10). For Hutcheon postmodernism is defined in terms of both stylistic traits and political attitude. In form and style, a postmodern text "takes the form of self-conscious, self-contradictory, self-undermining statement" (1). Postmodernism is, then, similar to modernism, with its "self-referentiality, irony, ambiguity, and parody" (15) but is taken further, made more ambiguous and, importantly, more deeply politically ambivalent. Hutcheon characterizes postmodern art and literature as a form of "complicitous critique"; they take a critical stance toward contemporary culture and dominant ideology without claiming for themselves that "critical distance" that is essential to modernist art and literature. "Postmodernism's irony is one that rejects the resolving urge of modernism toward closure or at least distance" (99). Hutcheon would agree with *Nick at Nite* that television is typically "pre-postmodern" because it is dominated by sitcoms and dramas that follow old forms and conventions without either criticism or irony.

As an account of some important tendencies in literature and art of the past few decades, Hutcheon's definition has proved useful and influential. As well, her characterization of television accords with the seemingly universal sense that "there's nothing good on TV." But like most criteria of judgment taken from the analysis of "high culture"—the realist or modernist novel, poetry, serious theater, painting, sculpture, and so on—her definition proves more confusing than enlightening when applied to mass-cultural forms such as television. First, unlike these other forms, television never had a period that could plausibly be called "modernist." Certainly the early years of television included a degree of the formal experimentation that is characteristic of modernism, but modernism has always been characterized by its insistence on distancing itself from "popular" and "mass" taste, a distance that Andreas Huyssen has called "The Great Divide." Commercial television has never had the luxury, or the desire, to set up such a divide; the networks almost always work to create and to address a mass audience.[6]

Perhaps more importantly, careful analysis of television in terms of the history and codes of representation of popular culture, as opposed to those of high culture, reveals that it is typically pervaded by "self-conscious, self-contradictory, self-undermining statement." Of course, much television does rely on "realist narrative and transparent representational conventions." Prime-time programming as well as other fictional shows such as

soap operas and police dramas tend to follow familiar genre conventions, and only rarely does narrative fictional television resort to modernist distancing techniques of "baring the device," deliberately making viewers aware of the artificiality of what they are viewing by letting them see the equipment or by having actors directly address the camera (remember *Moonlighting?*). But mainstream television is constantly being criticized for being too self-absorbed, too self-conscious and self-undermining. Think, for instance, of the television reporting of the 1992 and 1996 presidential campaigns, in which the lead story was typically about a poll commissioned by the networks or CNN and in which it seemed that more time was spent analyzing the media coverage than discussing the issues and the positions of the candidates. I can think of no more apt example of "complicitous critique" than the sight of Larry King and Ross Perot jointly opining that the media spends too much time analyzing the personal quirks of the candidates and not enough time on the problems of the nation, unless it is a panel of pundits bemoaning the way coverage of Monica Lewinsky is distracting the public and the president from more important issues.

Hutcheon also argues, quite pertinently, that "postmodernism reveals a desire to understand present culture as the product of previous representations" (58). *Postmodern MTV* and *Nick at Nite* are equally exemplary of television's compulsive tendency to do exactly that, to represent history as a series of images constructed into a narrative. As Ann Kaplan notes in her analysis of postmodernism and MTV, rock videos tend to deploy a postmodern pastiche of images from past popular culture, including older films, magazine images, and familiar documentary footage of fifties rock and roll, John F. Kennedy, and civil rights demonstrations. In a different way, *Nick at Nite* tells its baby-boomer viewers that the older shows it broadcasts are what made them the adults they are today, that the present can in fact be understood "as the product of previous representations." Despite its claim to pre-postmodernity, the package of programs taken together with its promos can easily be seen as postmodern.

It is even possible to characterize both programs as television's counterparts to what Hutcheon describes as the quintessentially postmodern literary genre, "historiographic metafiction," or "fictionalized history with a parodic twist" (53). *Nick at Nite*'s self-promotion patently exhibits an irony toward its shows that nonetheless claims no modernist "distance" from them, for instance, when clips from the various shows are edited to make it seem as if Mary Tyler Moore, Jack Webb, and George Reeves are having a conversation about their intention to tune in that evening. MTV videos have from the start displayed a similar "parodic twist." Queen and David Bowie's 1981 duet "Under Pressure," a song about a wide range of contemporary problems, concludes with self-consciously ironic, but somehow still sincere, lyrics about the redeeming power of love, referred to as "such an old-fashioned word." The video, made entirely of familiar,

mostly documentary images edited rhythmically together, pairs this re-
demptive moment of the song with the famous footage of the 1972 de-
molition of the modernist Pruitt-Igoe building—an event Charles Jencks
designates as the death of modern architecture—but played backwards, as
if the dynamite were instantaneously creating a building out of a pile of
rubble (Jencks 9). One can read the video as expressing, like *Nick at Nite,* a
desire for a pre-postmodern moment with less "pressure" or as a self-
ironizing, self-contradictory, self-undermining statement. In either case,
its attitude toward history as a series of representations and its implied
"complicitous critique" make the video an example of postmodern televi-
sion, even in Hutcheon's own terms.

Hutcheon's comments in *The Politics of Postmodernism* are meant to ap-
ply to "most television," not all, and thus to identify certain programs, or
certain videos, as containing the features she designates postmodern
would be perfectly acceptable to her. That kind of differentiation between
different shows, or kinds of television, has been typical of the way many
television critics have used the concept of postmodernism. Two mid-1980s
television events—the expansion of MTV into every U.S. cable market and
the 1985 debut of the stylish cop show *Miami Vice*—precipitated a flurry of
articles in academic journals about the new postmodern television.[7] Such
discussions recurred once again in the early 1990s, but this time in more
popular magazines and newspapers; the favored examples at that point
were the sitcom *Seinfeld* and HBO's talk-show parody *The Larry Sanders
Show* (both, as of this writing, have recently stopped producing new
episodes). It is worth looking at both moments in the history of discourse
about television, for despite the differences between the academic and the
popular uses of the term "postmodern," each makes clear that there are
problems with the desire to differentiate postmodern television on the ba-
sis of specific themes and styles of particular shows.

A 1986 article by Peter Wollen concisely sets out the reasons why MTV
seemed a likely place to find postmodernism on the television dial. Music
videos blur the distinctions between genres as well as between different
media, "combining elements of live musical performance, film and TV to
produce a kind of mini-operetta, or, to put it another way, an animated
record sleeve . . . a miniature 'total work-of-art', to use Wagner's phrase"
(168). Like that of postmodern art, MTV's relation to earlier mass-cultural
forms, including photography, film, and television, is characterized by
"eclecticism and historicism . . . appropriation, simulation, and replica-
tion. It plunders the image-bank and the word-hoard for the material of
parody, pastiche and, in extreme cases, plagiarism" (168).

Most importantly, Wollen argues, music videos break down the bound-
aries that had previously separated popular television from video art.
Technological, formal, and stylistic innovation in the video medium had
been the province of the "art film" and of artists producing for museum

and art gallery installations, but MTV brought these styles and techniques into the living rooms of middle America. Music videos casually and routinely violate the conventions set up by Hollywood cinema and largely followed by narrative television, including the editing style known as the continuity system and a style of camera work designed to make spectators feel as if they were watching an unmediated reality, the centrality of a single protagonist with whom they are meant to identify, a narrative flow structured by easily comprehensible causes and effects, and a location in a consistent story-world. Watch MTV for ten minutes—its jumpy, rapid, and very noticeable editing and handheld camera, its highly condensed and fragmented three-minute narratives lacking heroes, villains, or even causally related events—and you will have seen most of the technical rules of classical Hollywood cinema thrown out the window.[8]

Modernist art and culture were also predicated on the violation of established conventions; music video could be seen as a popularization of modernism's call to "make it new" and to make the familiar seem strange. But, again, modernism's impulse toward innovation was set against two backdrops: that of an official, academic art—what Peter Bürger calls "institution art"—and a mass culture portrayed as stultifying, depoliticized, meaningless, vulgar, and "effeminate" (Huyssen). MTV gleefully appropriates imagery and styles from institution art, the historical avant-garde, and mass culture—the videos of the Nine Inch Nails song "Closer" or David Bowie's "The Hearts Filthy Lesson," with their juxtapositions of Dada and Surrealism with references to early cinema, are cases in point—and yet unapologetically locates itself in the latter realm. The oppositions that made modernism possible simply no longer apply.

Wollen's allusion to Wagnerian opera suggests an analogy to another interaction between high and mass culture: the history of the opera audience in the United States. Lawrence Levine has discussed the way Italian opera was first imported as a popular art form; indeed, the first mass-cultural celebrity in the United States was the Swedish operatic soprano Jenny Lind, whose triumphant tour in the 1850s was managed by the circus promoter P. T. Barnum and was attended by huge, rowdy crowds of enthusiastic listeners of all economic classes. By the early twentieth century, though, opera was an elite institution that catered almost exclusively to quiet, well-dressed, bourgeois audiences. Through changes in the way it was presented and marketed, it came to be considered a form of high art. The postmodern circle is closed on Malcolm McLaren's 1984 album "Fans," which Wollen describes as a "'bricolaged' mix of opera *(Carmen, Madame Butterfly)*, rap, and self-referential material from McLaren himself," who made his name as a fashion promoter as well as the man who presented the Sex Pistols to the world (169). When an aria from *Madame Butterfly* becomes a dance club hit, it is evident that Huyssen's "Great Divide" separating modernist notions of high art from mass culture has become quite narrow indeed.

Similar claims have been made for the stylistic postmodernism of *Miami Vice* and for many of the same reasons. Its producer, Michael Mann, made explicit the show's formal similarities to MTV *and* its relationship to modernism and the historical avant-garde when he told *Rolling Stone* that MTV and *Miami Vice* are "cousins" whose "common ancestor . . . is the concept of sound as counterpoint to visual images that was formulated by the revolutionary Soviet Filmmaker Sergei Eisenstein in the late 1930s" (Benedek 62). Eisenstein pioneered a film technique he called "montage," often described as a critical alternative to the "invisible style" of classical Hollywood cinema. The Soviet director meant for his jarring juxtapositions and disjunctive construction of cinematic space to produce a revolutionary spectator, making Mann's claim that *Miami Vice* and MTV are Eisenstein's successors at least mildly implausible. But what makes Mann's account of his show seem postmodern is his confidence that he can appropriate aesthetically radical forms without risking the incorporation of their radical political origins.

Stylistically, as several scholarly articles argued when the show was in its heyday, *Miami Vice* was a textbook example of postmodern pastiche, indiscriminately recombining elements not only of Eisenstein but also of *film noir,* art deco, advertising, and rock video into a narrative structure that was at its core not all that different from the 1970s series *Starsky and Hutch.* Other writers have argued that *Miami Vice*'s postmodernism extends beyond its visual style and use of rock music. In an article comparing the series to car commercials, Todd Gitlin makes a parallel between the program's emphasis on surface and style and the depthlessness of the male characters, concluding that their "studied blankness of tone" shows that they "partake of that 'waning of affect' which Fredric Jameson rightly identifies as one of the hallmarks of postmodern culture" (156–57). Andrew Ross convincingly analyzes a whole postmodern ideology of masculinity developed in the show, one in which the instability of the two men's individual histories and identities is resolved through the interethnic bond between them (see Ross, "Miami Vice").

These claims bear comparison with those made in the early 1990s for programs such as *Seinfeld* and *The Larry Sanders Show.* In discussing MTV and *Miami Vice,* critics seemed to wish to locate a stylistic avant-garde within television, to identify certain shows' formal techniques as especially innovative and/or comparable to the formal techniques of postmodern literature and art. As well, the claim was made that a show like *Miami Vice* or certain rock videos reflected, or expressed, a new sensibility or an ideological shift.[9] The postmodernity of the newer shows seems to consist less in any stylistic commonality among them than in their almost claustrophobic self-reflexivity, their obsessive concern with the television medium itself, and their self-awareness of their commercial status. The earlier programs were undoubtedly self-reflexive in sometimes similar

ways. *Miami Vice* included celebrity appearances, sometimes by the very rock stars—Glenn Frey, Phil Collins, Iggy Pop—who were singing on the soundtrack, though they usually played villains thoroughly integrated into the story-world. Also appearing as versions of themselves were public figures ranging from Lee Iaccocca to G. Gordon Liddy. As Ann Kaplan points out, many rock videos are similarly self-reflexive, often incorporating some reference to the making of the video into the text; for instance, in Phil Collins's "Don't Lose My Number," the singer rejects a variety of clichéd formats for his song's video. The difference may be in what critics are noticing and writing about, though it is possible that the critics are registering an increasingly open and foregrounded self-reflexivity. The opening credits sequence of *The Simpsons,* which concludes with the family members leaping simultaneously onto their couch to watch television, is perhaps emblematic of the 1990s version of postmodern television, especially on those occasions when it is followed immediately by an animated *Simpsons* advertisement for a Butterfinger candy bar, an ad that, we might imagine, the Simpsons themselves are watching. The fact that one mid-1990s promo for *The Simpsons* advertised it as "nouveau postmodern comedy for the masses" underscores its makers' self-conscious relation to such a definition of postmodernism.

The popular press repeatedly marked as "postmodern" a plot arc on the NBC sitcom *Seinfeld* in which the main character—a stand-up comic named Jerry Seinfeld played by the stand-up comic Jerry Seinfeld—approaches NBC with an idea for a sitcom involving himself and his friends. The fitting punch line to this self-ironizing *mise-en-abyme* is that, when asked what the series was to be about, the characters reply with great conviction in their originality, "Nothing. It's about nothing." If *Seinfeld* was postmodern, it was so in a way unlike MTV, *Miami Vice,* or *Max Headroom.* In terms of visual style it was quite conventional for its genre, and although its writing is generally considered above average in wit, it was less moralistic than most network fare, and its humor was aimed at a more educated and upscale audience than, say, *Married with Children;* nonetheless it relied heavily on one-liners and cleverly titillating gags that pushed toward, but not beyond, the borders of good taste and network standards (the celebrated "master of my domain" episode, about masturbation, is a case in point). Its performers act in the broad, exaggerated style of most sitcoms. In short, when writers refer to *Seinfeld*'s postmodernism, they are claiming that it deals with postmodern themes, not that it takes a postmodern form.

The other show to be consistently deemed postmodern by everyone from the Toronto *Globe and Mail* to *TV Guide* was *The Larry Sanders Show.*[10] This show starred Garry Shandling as a talk show host in competition with David Letterman, Arsenio Hall, and Jay Leno. As the camera follows Sanders through his preparations for the talk show and through its

filming, he meets and interviews "real" celebrities who appear "as themselves" on the show or, rather, on both the "real" show and the fictional "show" (when a description requires that many scare quotes, you can be pretty sure you are entering the realm of the postmodern). The show thus consists of a plausibly realistic talk show in conjunction with a fictional drama, usually revolving around Sanders's notably difficult personality. One episode, for instance, dealt with his response to a polled "focus group" that did not like his attitude and his attempts to compensate by being pleasant to his staff and his guest that day, Richard Simmons.

Stylistically *The Larry Sanders Show* is quite unusual, often resorting to a hand-held documentary camera style reminiscent of direct cinema and looking generally rougher than most network television.[11] Its self-reflexivity and focus on the television medium itself are also more unrelenting than that of *Seinfeld*. Whereas television was a theme on *Seinfeld*, it was an essential part of the premise of *Larry Sanders*. And the show's blurring of fiction and reality was emphasized even more when, in early 1993, Garry Shandling was considered as a replacement for David Letterman on NBC's *Late Night*.

Still, the postmodernism of *Seinfeld* and *Larry Sanders* seems to consist mostly in their thematic self-referentiality. If so, one could reasonably ask what makes these programs more postmodern than one of the progenitors of literary modernism. Gustave Flaubert's *Madame Bovary* is, after all, about a woman whose characteristic activity is the reading of novels, and he infamously announced his own desire to write "a book about nothing." Self-referentiality, irony, a "self-consciousness, self-contradictory, self-undermining" stance, and even a flat, affectless tone are not new phenomena in themselves; all can be located in modernism and perhaps in earlier popular culture as well.

In my view, to find postmodernism on television, we have to go beyond the either/or dichotomy, the idea that some individual shows are postmodern and some are not. Little is gained by an argument that concludes that *Miami Vice* is postmodern but *Hill Street Blues* is not; that Madonna videos are but Paula Abdul's are not; that David Letterman is but Johnny Carson is not (we are still not sure about Jay Leno, but Conan O'Brien's previous career as a writer for *The Simpsons* gives him impeccably postmodern credentials). Aside from its inevitable subjectivity, this approach has several problems. First, it reestablishes the modernist distinction between mainstream and artistic culture and may even lead to a revival of the notion of the avant-garde as a privileged cutting edge of social change. Such categories may usefully register differences between certain mass-cultural texts, but when the lines are all drawn within the boundaries of mass culture, postmodernism can become just another label for what appeals to a particular target audience. As John Ellis argues, *Twin Peaks,* another series hyped as "postmodern," turned out to be little more

than a genre hybrid, extending soap opera's "habitual lack of narrative closure" to "a murder mystery narrative" and throwing in "a few running gags and tag lines ('damn fine cup of coffee'), the staple of every successful long-running comedy." Ultimately, the cultural effect of the series was to "give the impression that the TV audience divides along traditional lines of material and educational privilege into the culturally sophisticated and the culturally naive," those who "got" the joke and those who did not (275–76). Perhaps postmodernism on television is nothing more than television aimed at a yuppie audience and reflecting that audience's sensibility, but if so, we ought to come up with a less grandiose name for it.[12]

More problematically, to draw such a line within television depends upon an ability to analyze discrete, distinguishable styles, genres, and texts, to make the kinds of distinctions that much of postmodernism—*and television as a medium*—breaks down. Especially in such countries as the United States, where most television broadcasting is a for-profit operation funded by the sales of commercial time, television is not really made up of separate texts. It is, as Raymond Williams argues in *Television: Technology and Cultural Form,* characterized by "flow," by almost imperceptible transitions between programs, ads, and self-promotions. Many media theorists claim that the object of television analysis cannot be the individual text, because such texts do not exist in isolation; their meaning is always structured by the other texts that are juxtaposed with them, that interrupt them and permeate them. Whether they refer to it as "the television supertext" (Browne) or, more commonly, "the televisual apparatus," these critics argue that what we watch are not television programs but portions of a never-ending flow of images, sounds, and meaning coming from our television sets.

That we can and often do say, "I sat around and watched TV last night," without specifying particular shows, is evidence that this perspective has a great deal of experiential validity. Even when we do say, "I watched *The X-Files* last night," we most likely mean that we also watched a set of commercials, possibly a newsbreak, and a promo for another Fox series, or else we flicked the remote during the ads to watch a rock video, to check out a sports story, or to get an update on the latest "trial of the century" or political scandal. If we are to identify the postmodernity of television, perhaps we should stop flipping from channel to channel looking for the perfect postmodern program and begin to look at the surface of television, at the screen itself, at the medium and not just its messages.

Jean Baudrillard is the theorist who has been most influential on those who want to look at television in this way, and even though he seldom uses the word "postmodern" himself, his views of the new "universe of communication" have been almost universally seen as postmodern. For Baudrillard, television's postmodernity is an essential, ontological quality of the technological medium itself. The television image always makes a

claim to transparency and immediacy; even when we are aware that a program is prerecorded, television provides a sense of "hereness" and "nowness" that, Baudrillard argues, eliminates any reference to the outside world. The screen itself represents a flattening out of the world, producing the postmodern perception that all events, performances, signs, and images are nothing but representations—or, in Baudrillard's key term, *simulations,* representations whose only referent is other representations. The events depicted on the screen are happening in our living room; their "reality" is in our private space, and according to Baudrillard this simulation of reality has replaced any sense of a public sphere, of an outside that would be any different from the inside. Kaplan's synopsis of Baudrillard is concise and clear on this point: "Television, with its decentered address, its flattening out of things into a network or system, the parts of which all rely on each other, and which is endless, unbounded, unframed, seems to embody the new universe" (44).

Baudrillard's account of "hypersimulation" and "the ecstasy of communication" has struck a chord not only with television analysts but also with postmodern artists, filmmakers, and writers, and his description of the experience of television is seductive and convincing. But his theories have been persuasively criticized as well. Few if any of the characteristics Baudrillard attributes to television can plausibly be said to be essential to the medium itself or to be even universally and equally true. Television's almost exclusive location in private, domestic spaces, for instance, was not inevitable; indeed, many of its early creators envisioned that it would be shown in theaters, like films. That we watch television in private rather than public places (with the notable exceptions of waiting rooms and bars), that it is less a mass medium than it is an individual and familial one, is the result of a set of marketing decisions made beginning in the 1940s by the corporations who produced the sets and the programs.[13]

Even the sense that television is a never-ending network of signs rather than a series of discrete texts—the idea of total flow—is the result of a particular configuration of economic factors, has not always been true, and is not equally true everywhere. Indeed, Raymond Williams coined the term "flow" to describe his experience of American television after being accustomed to British broadcasting, which tended to reserve commercials, where they existed, to the intervals between programs and marked the transition with a clear symbol, such as the BBC logo. In the United States, many early television programs were underwritten by a single corporate sponsor; thus the advertisements' relation to the show was clear and unambiguous. It was only later that the seemingly random series of commercials with which we are now familiar became the norm.

Broadcasters have a clear and straightforward interest in maintaining television's "total flow"; it holds viewers in their place, thereby ensuring a larger audience. Williams's often quoted personal anecdote introducing

the idea of flow illustrates this point amusingly, even if his experience is affected by his exhaustion and his being attuned to British televisual conventions, which "had not prepared me for the characteristic American sequence." He continues:

> One night in Miami, still dazed from a week on an Atlantic liner, I began watching a film and at first had some difficulty in adjusting to a much greater frequency of commercial 'breaks'. Yet this was a minor problem compared to what eventually happened. Two other films, which were due to be shown on the same channel on other nights, began to be inserted as trailers. A crime in San Francisco (the subject of the original film) began to operate in an extraordinary counterpoint not only with the deodorant and cereal commercials but with a romance in Paris and the eruption of a prehistoric monster who laid waste New York. . . . I can still not be sure what I took from that whole flow. I believe I registered some incidents as happening in the wrong film, and some characters in the commercial as involved in the film episodes, in what came to seem—for all the occasional bizarre disparities—a single irresponsible flow of images and feelings. (*Television*, 91–92)

For Baudrillard, this would be a typically postmodern experience, in which distinctions between texts, as well as between texts and commodities and between text and reality, become entirely irrelevant. For the broadcaster, though, the televisual flow had its desired effect: Williams did not change the channel.

To argue that such techniques have an economic basis—that they serve the interests of broadcasters—is not necessarily to undermine the claim that the televisual apparatus is postmodern. Indeed, if postmodernism is, as Fredric Jameson has argued, the "cultural logic of late capitalism," and if those cultural forms most closely tied to the economy—his example is architecture—will evince postmodernity most clearly, then one could argue that all commercial television, in its direct and openly avowed link to the sphere of economic exchange, is postmodern. Television's postmodernity would consist in its conscious knowledge of its status as a commodity and a purveyor of commodities. Self-promotion is an explicit case of such a postmodernity, as is the flow between ads and shows. The characteristics of television that can be called postmodern may then be strategies of audience address: subtle, clever, and often effective ways of keeping the viewer watching.

Nick at Nite's self-promotion and the *Simpsons* credit sequence are two already mentioned moments that could be cited in support of this characterization of television. Another such moment, one that demonstrates the self-promotional character of postmodern televisual flow, was in the 1992–1993 season when *The Jackie Thomas Show,* about an obnoxious television personality, was introduced. It is common industry practice to

debut a new show immediately following a long-established one or "ham-mocked" between two successful series. The evening the show was intro-duced, the hit show *Roseanne* concluded with the characters played by Roseanne Arnold and John Goodman seated in front of their television set. Roseanne suggests to her fictional husband that they watch this new show that she's heard is great; they exchange a couple of one-liners about its star and flick their remote. Subsequently, the credit sequence for *The Jackie Thomas Show* appeared on our television screens. Adding to the self-reflex-ivity of this moment, and to the sense of televisual flow, was the fact that any reader of a mass-market magazine such as *People* or *TV Guide* was aware that the new show starred Tom Arnold, Roseanne's then real-life husband, that Roseanne Arnold was the show's executive producer, and even that she had been publicly criticized for overly aggressively and nepo-tistically promoting the show to the network. Watching that moment, laughing at the clever conceit while my remote control was seemingly ren-dered powerless by the simulated one on the screen, I felt a bit like Williams arriving in America, unprepared for the speed and complexity of that evening's television flow. And I did not change the channel either.

As this example indicates, flow is at least as much a category of *recep-tion* as it is a category of the text or the apparatus. In other words, it refers to a way of experiencing television, not just of making or presenting it. Perhaps television's postmodernity lies not only in the text itself, nor in the "supertext," but also in the ways it is watched, in its individual viewer or its infinitely various audience. One of the most influential and accessi-ble schools of thought about television, that associated with the Univer-sity of Birmingham Centre for Contemporary Cultural Studies, claims that most cultural analysis pays far too much attention to the text and its pro-ducers, while virtually ignoring the television audience. Building on con-cepts from the Birmingham school, John Fiske begins his chapter on tele-vision from a postmodernist view of television texts but quickly focuses on the uses to which audiences put those texts. Television, he asserts, does not just break down distinctions between genres, between past and present, between image and reality; above all it dissolves the categories of "text" and "audience":

> There is no such thing as "the television audience," defined as an empirically accessible object, for there can be no meaningful categories beyond its boundaries—what on earth is "not the television audience"? . . . Similarly, the television text, or program, is no unified whole delivering the same mes-sage in the same way to all its "audience." ("Moments," 56)

Fiske goes beyond the idea of "total flow," the point that the boundaries between texts are unmarked and ultimately irrelevant, for even that con-cept presumes that, however confusing, complex, and contradictory the

televisual flow, its meaning is there on the screen for a viewer to try to decode. For Fiske, meaning is a process, not a product, better described with the abstract term "textuality" than with the concrete nouns "text" and "audience."

> The textuality of television, the intertextuality of the process of making sense and pleasure from it, can only occur when people bring their different histories and subjectivities to the viewing process. There is no text, there is no audience, there are only the processes of viewing. ("Moments," 57)

In this view, television viewing is not the passive, stupefying activity it is usually portrayed to be. Quite the opposite is true; it is an active appropriation of images. Audiences have what Fiske calls "semiotic power," the ability to make the images on the screen "their own" in ways that the producers and broadcasters never intended or imagined. To support this claim he cites empirical studies of female soap opera viewers who "rewrite" the scripts in their heads, of Russian Jews in Israel who see *Dallas* as "capitalism criticizing itself," and of homeless Native Americans who enjoy old Westerns on television, whose "pleasure peaks at the moment of the Indian's triumph, when they have taken the homestead or the wagon train, so at that moment they switch off the set, before the inevitable white restoration and retribution" ("Postmodernism," 63). We should not see these as misreadings of the dominant meanings of the images on the screen; they are, Fiske claims, only exaggerated and therefore exemplary cases of what we all do when we watch television. Every act of viewing is a "guerilla tactic" against the totalizing and constraining "strategies" of top-down culture. We are always bringing our personal and cultural histories to the television and always transforming the images we are given in ways that make them meaningful and pleasurable to us. "Popular culture is less a culture of art-objects and images, and more a set of cultural practices by which art is imbricated into the routines and conditions of everyday life" ("Postmodernism," 62).

In Fiske's view, every television viewer is engaged in the acts of appropriation and dehistoricizing pastiche that are characteristic of the postmodern artist or writer. We rearrange the images we confront, refunctioning their meanings to suit ourselves. As Fiske admits in the context of a critique of Baudrillard's postmodernism, this vision of the "semiotic democracy" of television is predicated on a postmodern view of television, and indeed on social experience in general, as textuality. "Postmodern theory" can help explain "how signs are not tied to their conditions of production nor to their dominant conventions of use" as well as "how it is that subordinated people can exercise their social agency in the cultural sphere by making their contextually relevant meanings out of the signs produced and distributed by the dominant Other" ("Postmodernism," 65).

Audience-oriented theories such as Fiske's are also postmodern in that they counter the tendency in literary studies and other analyses of culture to place the source of meaning either in the text itself or in the author's intentions, a tendency rooted in the aestheticism of high modernism and the New Criticism that came out of it.

As I sit with my remote control, Fiske's attribution of productive power to my act of viewing has a lot of appeal. I like the idea that I am being offered a wide selection of programs from which to choose because the television networks cannot quite predict what "the people" will want, and the idea that each program presents not a single meaning but a "menu" from which to choose and to recombine at will. But certain moments of television that I have experienced raise the question of whether Fiske's theories are not a matter of what he chooses to emphasize. One day in the mid-1980s, like millions of Americans, I switched on C-Span to watch the first day of Oliver North's testimony in what came to be known as the Iran/Contra hearings. I brought to this act of viewing a history that positioned me as, among other things, antagonistic toward the Reagan administration, and I watched with increasing glee as I saw what I thought was the self-destruction of that regime, the Republican party, and the legitimacy of interventionist foreign policy in general. I called my roommate in to watch with me, and we agreed not only that North was confessing to incredible crimes but that anyone could see the man was malevolent, not to mention stark raving mad. Of course, most viewers did not seem to agree with me; by the next day the word in the media was that North was being idolized as an upstanding American hero and that his testimony marked a turn in public opinion toward excusing the administration's crimes in Iran and Nicaragua.

How can we interpret such a moment? It would, of course, be too easy to resort to a reference to external and objective reality to say that the general public was duped into thinking it saw something other than what was really there on the screen. Given that my own response was about perception, not reality—about the "fact" that anyone would recognize North's true nature—such a non-postmodern truth-claim could more easily be made in the other direction: *I*, not the general public, misread the text. But in relation to Fiske's framework, what is remarkable about this moment is not my act of "misreading" but rather the fact that by most accounts a huge, almost monolithic bloc of the mass audience interpreted this text in the same way, as the emergence of a national hero whose patriotic acts had been constrained by mere legality and who was now at risk of being scapegoated for his heroism. In other words, the plots of *Rambo* and *Dirty Harry* had, as they did so often in the 1980s, overdetermined the dominant response to a televised public political act.

The postmodernity of my account of this moment should be clear: the genres of action film and Congressional hearing are blurred, and the

distinction between representation and reality is virtually effaced. It should also serve to demonstrate that Fiske's model of "semiotic democracy" applies better to fictional texts, where the ideological stakes are lower, than it does to television's depiction and mediation of potentially destabilizing crises. At such moments, the political and economic imperatives of the corporate basis of the televisual apparatus can sometimes work together to manufacture ideological consent and to minimize the effectivity of the postmodern audience's guerilla tactics.

The most cogent fact about commercial television's relation to its audience is not the plurality of meanings that can be made from its texts. There is nothing particular to television about this plurality; as Fiske himself says, "all texts are polysemic" ("Moments," 59). What is more remarkable is the relative singularity of the meaning of the television audience: the audience is a commodity to be sold to advertisers. The television networks are not in the business of selling programs to audiences; we get those "for free," as it were, or pay cable corporations to provide these to us. The programs are only the tools the networks use to produce audiences that can then be marketed to the highest bidder, at prices determined by quantity (measured by the Nielson ratings) as well as quality (judged in terms of viewers' disposable incomes). As an NBC researcher candidly told the television scholar Ien Ang, everything they do is aimed toward "'delivering audiences to the advertisers'" (ix).

No analysis of television can be entirely convincing if it does not take into account this rather brutal economic fact. Fiske tries to produce an analytic separation of economics and meaning by distinguishing "a financial economy within which wealth circulates, and a cultural economy within which meanings and pleasures circulate, and the relationship between them is not as deterministic as some theorists have proposed" ("Moments," 59). As a counterweight to the bogeyman of economic determinism, this distinction has heuristic value, but Fiske uses the following tortuous argument to claim that the distinction exists in reality:

> In the financial economy television is programs and advertisements, not textuality. A program is a commodity produced and then sold to distributors. In distribution its role changes and it becomes not a commodity, but a producer, and what it produces is a new commodity, the audience which is then, in its turn, sold as a commodity to advertisers. The ramifications of this financial economy are fascinating, but they are not the topic of this paper. I wish to concentrate on the cultural economy.

> Here the role shift undergone by the program in the financial economy—that from commodity to producer—is now undergone by the audience, whom I left as a commodity sold to the advertiser. But in the cultural economy the audience rejects its role as commodity and becomes a producer, a

producer of meanings and pleasures, and at this moment stops being "an au-
dience" and becomes different materializations of the process that we call
"viewing television." ("Moments," 59)

The television most often designated postmodern tells us quite force-
fully that self-promotion and commodification are part of the text itself,
that we cannot bracket the economics of its production and distribution
in trying to understand what it means. One clear example of this phe-
nomenon comes from film, not television: the moment in Steven Spiel-
berg's *Jurassic Park* when the camera pans over the gift shop in the diegetic
Jurassic Park to reveal a sampling of the "tie-in" products for the movie
Jurassic Park available at a store near you. Similarly, every rock video is in
part an advertisement for itself, the single, the album, the group or artist,
and the record company. That advertising is an important part of the
meaning of the text is signaled by the inclusion of that very information
at the beginning and end of every broadcast of the video on MTV; promo-
tion, a call to consumption, literally frames the text. MTV doubles the
commodification of the audience, selling it to the record companies (or
trading it for the right to show the video) and to the advertisers.

Why, then, should the audience have to "reject" its commodity status
in order to produce "meanings and pleasures"? One of the commodities
MTV sells *is* textuality, the source of the meanings and pleasures that spec-
tators seem perfectly capable of both producing and consuming (this dis-
tinction, central to Fiske, seems so pre-postmodern). As the NBC re-
searcher told Ang, "'industry people are much more inclined to see the
audience as active than critics who worry so much about the effects of
television from an outside perspective. We just can't afford to sit back and
think of the audience as a passive bunch that takes anything they're
served'" (ix). In short, the active, productive spectator Fiske portrays is
precisely what the television industry produces and sells to advertisers.

Again, pointing to the economic basis of television's textuality does not
make it any less postmodern. If postmodern textuality and postmodern
strategies of address are required to produce an affluent viewing public to
be sold to advertisers, then the networks will be happy to oblige. Nor need
we limit ourselves to the bleakest visions of postmodernism as dehuman-
izing capitalist commodification in order to make the term useful for an
understanding of television. Such visions are predicated on conceptions of
the relationship between audience and text that, as Fiske would agree,
badly need rethinking. It is not too much of an oversimplification to say
that modernism—I am tempted to say "pre-postmodernism" so as to in-
clude most conceptions of textuality since the Enlightenment—addresses
its audience in putatively universal terms. To use a term from Lyotard's
Postmodern Condition, such an address to an audience is based in a liberal
humanist "metanarrative," a story about the essential core of identity that

all people supposedly share. That core has been conceived in significantly different ways: as an ability to think rationally and critically; as a capacity to appreciate the beautiful things in life; as a belief in equality and justice; as the possession of a certain configuration of (Oedipal, hetero-) sexual desires; as an ability to sympathize with the suffering of others. The pre-postmodernist text casts its net to catch that fundamental humanity; an example might be the way the U.S. Constitution begins by citing as its authorization and addressee "We, the People." As Lyotard says, the postmodern condition is characterized by an "incredulity toward metanarratives" (xxiv), a skepticism that has its most important source in the realization that stories about such transcendental subjects as "the people" have tended structurally to exclude large numbers of people.

The postmodernity of television lies in its recognition of this "incredulity" and in the way television incorporates it into its strategies of audience address. To be sure, television sometimes addresses its viewers universally. Like mass culture has done since at least the nineteenth-century sentimental novel, TV movies of the week work to enlist an emotional sympathy that, these movies presume, everyone feels for a sick child or an abused woman. And television casts its net more widely than the humanist metanarrative characteristic of realism and modernism alike. Even if, as Raymond Williams points out, the concept of "the mass audience" for television is a misnomer because television is not consumed *en masse,* commercial television almost always aims for a mass*ive* audience. But it is precisely the massiveness of the audience that makes all the difference. In order to address such an obviously and extremely diverse set of audiences, television has two choices. It can proliferate channels and programs, replacing broadcasting with "narrowcasting." Alternatively, the industry can incorporate into single texts or "supertexts" a multiplicity of addresses to a multiplicity of audiences, deliberately producing the kinds of polysemic textuality and meaning-producing audiences that Fiske valorizes.

The first option, "narrowcasting" and the evolution of increasingly subtle ways of "targeting" specific audiences, is an important new development and has grabbed the lion's share of attention in media studies. Some even argue that the future of the mass audience is its dissolution into a postmodern plurality of audiences identified by racial, national, regional, and economic identity. It is worth noting, however, that a study commissioned by the major networks comes to the conclusion that to go much further in that direction will lead to diminishing profit margins (Neuman). Commercial television's primary strategy has been the second option, and as Ang's NBC researcher makes clear, it went that way out of a sense that it was economically efficient, not out of an aesthetic commitment to postmodern textuality or a desire to promote political pluralism. Whatever the reasons, such a strategy has the potential to produce contradictory, even antagonistic, forms of audience address. Much of the time

these potential contradictions can be ignored; one person can watch *Dallas* as a sign that money can't buy happiness, another can see it as a spur toward conspicuous consumption, and these interpretations need not ever come into conflict. But there are times when television's conflicting forms of audience address can help produce and shape real social conflict in the public sphere.[14] I want to conclude with a brief discussion of one such moment as a way of demonstrating the intersection of television's postmodernity with postmodern politics.

The coverage of the Clarence Thomas/Anita Hill hearings before the Senate Judiciary Committee may seem an unlikely place to look for postmodernism on television. After all, the hearings were essentially a news event, and news and related genres such as talk shows are not usually the best examples of postmodern pastiche. Nor were they the kind of television that viewers were likely to graze by with their remote controls; a massive television audience seems to have been spellbound by the spectacle that unexpectedly unfolded on their screens in the days following October 11, 1991. Nonetheless, the various televisual textualizations of the events of that weekend—their representation and the ways audiences made choices from their "menu" of meanings—are a fitting place to conclude our search for postmodern television.

That weekend it was impossible not to notice that different people were seeing different things in the same televisual texts. Television itself tried to contain the multiplicity of social conflicts raised by Hill's accusations of sexual harassment by portraying the whole affair as a kind of special-interest group mud-wrestling match, pitting "women" against "blacks" (and thereby, as Nancy Fraser has pointed out, "disappearing" Anita Hill herself as a black woman).[15] Then the opinion polls, which so often serve to fix the identities and opinions of such groups in the public mind, began to come in and threw a small wrench into the works: the majority of women, for instance, seemed to believe Thomas, not Hill. Within a few days, though, the whole affair had, in the eyes of television, been subsumed into a cynical populist interpretation that incorporated all "special interests" into a general public united in its skepticism about the fitness of the white males on the Judiciary Committee to judge anything. The metanarrative of justice and representative democracy that was supposed to preside over the confirmation process had patently failed to win anyone's allegiance, and even the senators themselves were put in the position of denouncing "the process" for having victimized both Thomas and Hill.

Replacing the obviously discredited political metanarrative, and vying for the allegiance of "the general public" (here, virtually identical to "the television audience"), were a set of smaller narratives, each based in the raced and gendered identity of their protagonists. Some of these stories were told by the principals in the drama themselves; even before the allegations of sexual harassment were leaked to the press, Thomas had

demonstrated his skill at portraying himself as the hero of a Horatio Alger, rags-to-riches story. Once the conflict erupted, Thomas was able to parlay this role into victim status; he represented himself as the object of a "high-tech lynching" masterminded by white liberal and feminist intellectuals. Hill's professional status—and, oddly, her gender—"whitened" her; only Thomas was able to use the category of race to his advantage.[16]

Many of the analyses of the hearings have pointed out that one reason Thomas won, however temporarily,[17] the battle for the hearts and minds of the television audience was that there were more such narratives available for a black man than for a black woman and that the sexist and even racist stereotypes reinforced in popular narrative since at least *The Birth of a Nation* worked, ironically, in his favor.[18] Televisual codes of gender and genre served a similar ideological function; it is doubtful that the contradictory representations of Hill as both erotomaniac and prude, as spurned heterosexual and angry lesbian feminist, would have passed so unnoticed if it were not for the similarly contradictory representations of women everywhere on television, from nighttime soaps to cop shows.

The postmodern multiplicity of these representations, like that of television in general, is sometimes capable of producing a relatively monolithic—though logically incoherent—ideology and a relatively unified political subject position for viewers to occupy, even if within a couple of years polls showed that that position had broken down and most Americans believed Hill's version of events. Viewing only the breakdown as postmodern while ignoring the moment of apparent coherence—the moment that, after all, allowed the Senate to confirm Thomas to the Court—arbitrarily divides the act of viewing television into two parts that are neither ideologically nor experientially separable. Such a division leaves those of us who want to understand television as a postmodern phenomenon as bewildered as I was at the public response to the Oliver North hearings. We need definitions of postmodernism and of television viewing that account for the ways both of them simultaneously open up and close down the possibility of critical, active, and democratic participation in the production of meaning, the meaning of a fictional narrative or of a political debate.

In the aftermath of the Thomas/Hill hearings, a model for such a political understanding of postmodernism and television appeared in another unlikely place: in an episode of *Designing Women*. Two weeks after Thomas's confirmation, the half-hour sitcom was devoted to the characters' response to the television coverage of the hearings.[19] Two of the four major female characters—made up, oddly but somehow appropriately, to look like Bette Davis and Joan Crawford in *Whatever Happened to Baby Jane?*—wear T-shirts saying "I Believe Anita Hill," while the shirts of the other two read simply "She's Lying." The four of them gather around their television to watch a condensed version of the hearings, figuring our own position as television viewers of the political process. That position is

uncannily doubled by the local television film crew filming their reactions "live" under the rubric of "Atlanta women's response to the hearings," and each is separately interviewed for her opinions.[20] Aside from a brief set-up explaining the Davis and Crawford costumes as part of an amateur production of *Baby Jane,* the entire episode consists of excerpts from the hearings being commented on sarcastically and often perceptively by the four white women and their black male employee, Anthony; even the two conservative women get in some good jabs about the irony of Ted Kennedy sitting in judgment on a case of sexual harassment.

Despite the show's apparent pluralism and numerical evenhandedness, the views of its producers—Harry Thomason and Linda Bloodworth-Thomason, now famous as friends and advisors to the Clintons—are clearly and unambiguously pro-Hill. Hill's supporters are, along with Anthony, the characters of longest standing on the show, who get most of the funniest and most pointed lines, and the episode ends with a freeze-frame of Hill's face, looking tired but heroic, deeply ironically juxtaposed with George Bush's praise of Thomas at his nomination ceremony.

Hilarious and yet quite moving, this pastiche of news footage framed by a fictional sitcom premise that contains a fictional news show (as well as, more than most sitcoms, loudly enthusiastic responses from the studio audience) is as complexly self-reflexive, genre-bending, ironic, and self-contradictory as a postmodern theorist could desire and represents a multiplicity of possible audience responses in dialogue and conflict with one another. As much as any half hour of television I have seen, it exemplifies both the potential and the limitations of postmodernism on television. Its postmodernity, I would argue, consists not so much in its self-conscious reflexivity as in the tension between the various things it is trying to do, ideologically, economically, and textually. *Designing Women* addresses viewers in what is simultaneously a "mass" audience and a "targeted" audience; it was in 1991 one of the top ten shows on the air, and it was broadcast on Monday night, CBS's "women's night," along with other programs aimed primarily at women *(Murphy Brown* and *The Trials of Rosie O'Neill).* Each of these shows, in deference to the demographic CBS was trying to reach, took a liberal, somewhat feminist approach to the personal and political issues they insistently address, and at least the first two were for quite a long time successful in holding their core audiences, preventing them from changing channels. If these economic interests were not being met by these shows, *Designing Women's* postmodern polemic would never have reached our living rooms.

The network's attempt to target a specific but sufficiently large portion of the mass audience led to an explicit address to "women," conceived of here as white, liberal feminists who believed Anita Hill. However, given the polling data available at the time, this was not merely a case of preaching to the converted; most white women who were asked did not believe

Anita Hill, nor would they identify themselves as feminists. Indeed, one of the characters on the show points out both of these facts. *Designing Women* was not just trying to *reach* a previously existing audience; it was doing what television does all the time: trying to *produce* an audience. If in doing so the show used postmodern textual strategies and postmodern techniques of audience address, or it addressed a political issue from a progressive perspective, it in no way contradicts the fact that the show also did so in order to sell its audience to advertisers.

In our search for the postmodern on television, we began by looking at the shows, then at the medium, and then at the audience itself. If the word "postmodern" can usefully be used to talk about television, it is, in my view, as a way of describing the relationship between all three in the context of a profit-driven commercial television industry. In a pre-postmodern view of popular culture, what *Designing Women* did would have been a contradiction. The show used self-reflexive, ironic techniques to address a collective social and political subject—white feminist women— and simultaneously identified that group as a target for advertising and prospective consumption. The most self-conscious entertainment television and the most contested political crises depicted on television both tell us that this apparent contradiction is not much of a problem anymore, that television can address us as active subjects and as consumers at the same time. It is not postmodern theory that has deconstructed the oppositions between activity and passivity, production and consumption, entertainment and advertising, fiction and reality; television has done all that, and theories of mass culture are just beginning to account for the implications of the postmodernity of television.

NOTES

1. The apparent successor to *Postmodern MTV*, called *Alternative Nation,* addressed the subset of teenagers and twentysomethings who identified themselves with the next fashionable word, "alternative." Now that term, too, is obsolete, and there is no single show on the schedule identifying an "alternative" market based on a particular aesthetic. The long-running show *120 Minutes* shows the videos that might have appeared on the earlier programs.

2. It is interesting to note that both Nickelodeon and MTV were in their early years parts of the same media conglomerate, Time Warner. For an account of the effect of Warner/Amex's sale of MTV to Viacom International on the channel's programming, see Goodwin 136–39.

3. In the late 1980s, the heyday of *Postmodern MTV*, metal was generally seen to be significantly different from, even antithetical to, "alternative" music, much as in the late 1970s punk and metal were addressed to different youth subcultures. The rise to prominence of the Seattle grunge

scene and other bands such as Jane's Addiction blurred many of these boundaries. For a look at the way these differences worked before the 1990s, see Penelope Spheeris's documentaries *The Decline of Western Civilization* and *The Decline of Western Civilization, Part II-The Metal Years*. For a more academic discussion of the punk and metal sensibilities, see Grossberg, "The Politics of Youth Culture."

4. However cleverly ironic its self-promotional campaign appears, *Nick at Nite* does not seem to register the ironies of portraying a show such as *Mary Tyler Moore* as an escape from social problems, when in its day it was touted as closer to "reality" than most other sitcoms. In its second season, CBS placed *The Mary Tyler Moore Show* in the hour following the somewhat controversial and socially relevant comedies *All in the Family* and *M*A*S*H*. Although it was less explicitly political than the other two shows, its treatment of a single, professional woman provoked some controversy in the early 1970s. See Feuer 7. Nor does the network see anything ironic about placing *Dragnet* in opposition to current cop shows when, however quaint and campy it looks now, it clearly set the precedent for the recent wave of crime reenactment programs.

5. This is not the place to enter into the debate over whether such cultural forms as television are better referred to as "mass culture" or "popular culture." The first term emphasizes the mass-produced nature of television and differentiates it historically from a popular culture produced *by* the people. Those critics who emphasize the productivity of the television consumer use the term "popular culture." Although I think "mass culture" better expresses the importance of the historical shift from earlier precapitalist and preindustrial cultural forms, in this chapter I use either term depending on which of the two critical camps is under discussion and whether I am emphasizing the production or the consumption of culture.

6. These comments obviously apply most forcefully in the North American context, where commercial television has been dominant for decades. In such a situation, even public broadcasters such as PBS and the CBC are under pressure to compete with private broadcasters. European and other countries that have a stronger public service tradition on television, or for that matter fully state-funded and controlled networks, include television that is not solely motivated by the necessity of drawing a mass audience. See, for instance, Ang's comparison among the American, British, and Dutch industries.

7. The other series from this period to be consistently called postmodern was *Max Headroom*, but since it was short-lived and its few episodes are not often rebroadcast, I chose to focus on two potentially more familiar texts.

8. Kaplan's *Rocking Around the Clock* is the most extensive and detailed analysis of MTV's postmodernism and is especially good on comparing its techniques to classical Hollywood forms. Goodwin cogently

criticizes the use of a postmodern paradigm as well as the overdependence on analogies to cinema for the understanding of MTV.

9. This kind of argument is most recently and interestingly made in Lawrence Grossberg's *We Gotta Get Out of This Place,* which focuses on the shifts in affective/political sensibility expressed in popular music in the 1980s.

10. See, for instance, Lacey.

11. The fact that the show is produced for and broadcast by HBO means as well that network standards do not apply; thus there are no restrictions on the characters' use of language that would normally be censored.

12. Pfeil argues that postmodernism is a class-specific phenomenon, representing the sensibility of the now culturally hegemonic professional/managerial class.

13. On the problems with calling television a "mass" medium, see Williams, *Television,* 23–24, and Williams, *Keywords,* 192–97. On the marketing of television as a family activity, see Spigel.

14. For an accessible discussion in these terms of that much-maligned genre, the made-for-TV movie, see Rapping.

15. Fraser's article in *Critical Inquiry* is essential for understanding what was at stake in those hearings, as are several of the pieces in Morrison.

16. Again, see Fraser.

17. Recent public opinion polls indicate that more people later came to believe Hill than did at the time of the hearings. David Brock's sensationalistic and reprehensible book *The Real Anita Hill,* funded by the right-wing Olin Foundation, was one attempt by the right to win back the ideological and affective hegemony they saw slipping from their grasp.

18. See Painter; Lubiano.

19. Andrew Ross briefly discusses this episode in "The Private Parts of Justice."

20. The irony of interviewing four white businesswomen as a way of representing the opinions of "women" in a majority black city goes largely unnoticed in this show, though the eloquent statements of the black male character in the room seem at moments to try to register this omission.

WORKS CITED

Ang, Ien. *Desperately Seeking the Audience.* New York: Routledge, 1991.

Baudrillard, Jean. *The Ecstasy of Communication.* Ed. Sylvere Lotringer. Trans. Bernard Schutze and Caroline Schutze. New York: Semiotext(e), 1988.

———. *Simulations.* Trans. Paul Foss, Paul Patton, and Philip Beitchman. New York: Semiotext(e), 1983.

Benedek, Emily. "Inside Miami Vice: Sex and Drugs and Rock & Roll Ambush Prime Time TV." *Rolling Stone* 28 March 1985: 56–62, 125.

Brock, David. *The Real Anita Hill: The Untold Story*. New York: Free Press, 1993.

Browne, Nick. "The Political Economy of the Television (Super)Text." In *Television: The Critical View*, ed. Horace Newcombe. 1976. 4th ed. New York: Oxford University Press, 1987. 585–99.

Bürger, Peter. *Theory of the Avant-Garde*. Trans. Michael Shaw. Minneapolis: University of Minnesota Press, 1984.

Ellis, John. *Visible Fictions: Cinema, Television, Video*. 1982. Rev. ed. London: Routledge, 1992.

Feuer, Jane. "MTM Enterprises: An Overview." In *MTM: "Quality Television,"* ed. Jane Feuer, Paul Kerr, and Tise Vahimagi. London: British Film Institute, 1984. 1–31.

Fiske, John. "Moments of Television: Neither the Text nor the Audience." In *Remote Control: Television, Audiences, and Cultural Power*, ed. Ellen Seiter et al. 1989. London: Routledge, 1991. 56–78.

———. "Postmodernism and Television." In *Mass Media and Society*, ed. James Curran and Michael Gurevitch. London: Edward Arnold, 1991. 55–67.

Fraser, Nancy. "Sex, Lies, and the Public Sphere: Some Reflections on the Confirmation of Clarence Thomas." *Critical Inquiry* 18.3 (1992): 595–612.

Gitlin, Todd. "Car Commercials and Miami Vice: 'We Build Excitement'." In *Watching Television*, ed. Todd Gitlin. New York: Pantheon, 1986. 136–61.

Goodwin, Andrew. *Dancing in the Distraction Factory: Music Television and Popular Culture*. Minneapolis: University of Minnesota Press, 1992.

Grossberg, Lawrence. "The Politics of Youth Culture: Some Observations on Rock and Roll in American Culture." *Social Text* (Winter 1983–84): 104–26.

———. *We Gotta Get Out of This Place: Popular Conservatism and Postmodern Culture*. New York: Routledge, 1992.

Hutcheon, Linda. *The Politics of Postmodernism*. London: Routledge, 1989.

Huyssen, Andreas. *After the Great Divide: Modernism, Mass Culture, Postmodernism*. Bloomington: Indiana University Press, 1986.

Jameson, Fredric. *Postmodernism, or, The Cultural Logic of Late Capitalism*. Durham, N.C.: Duke University Press, 1991.

Jencks, Charles. *The Language of Post-Modern Architecture*. 4th ed. London: Academy Editions, 1984.

Kaplan, E. Ann. *Rocking Around the Clock: Music Television, Postmodernism, and Consumer Culture*. New York: Routledge, 1987.

Lacey, Liam. "What Is Going On?" *The Globe and Mail* 4 February 1993: C1–2.

Levine, Lawrence. *Highbrow/Lowbrow: The Emergence of Cultural Hierarchy in America*. Cambridge, Mass.: Harvard University Press, 1988.

Lubiano, Wahneema. "Black Ladies, Welfare Queens, and State Minstrels: Ideological War by Narrative Means." In *Race-ing Justice, En-gendering Power: Essays on Anita Hill, Clarence Thomas, and the Construction of Social Reality*, ed. Toni Morrison. New York: Pantheon, 1992. 323–63.

Lyotard, Jean-François. *The Postmodern Condition: A Report on Knowledge*. Trans. Geoff Bennington and Brian Massumi. Minneapolis: University of Minnesota Press, 1984.

Morrison, Toni, ed. *Race-ing Justice, En-gendering Power: Essays on Anita Hill, Clarence Thomas, and the Construction of Social Reality*. New York: Pantheon, 1992.

Neuman, W. Russell. *The Future of the Mass Audience*. Cambridge: Cambridge University Press, 1991.

Painter, Nell Irvin. "Hill, Thomas, and the Use of Racial Stereotype." In *Race-ing Justice, En-gendering Power: Essays on Anita Hill, Clarence Thomas, and the Construction of Social Reality*, ed. Toni Morrison. New York: Pantheon, 1992. 200–214.

Pfeil, Fred. "Making Flippy-Floppy: Postmodernism and the Baby-Boom PMC." In *The Year Left*, ed. Mike Davis. London: Verso, 1985. 263–95.

Rapping, Elayne. *The Movie of the Week: Private Stories, Public Events*. Minneapolis: University of Minnesota Press, 1992.

Ross, Andrew. "Miami Vice: Selling In." *Communication* 9 (1987): 305–34.

———. "The Private Parts of Justice." In *Race-ing Justice, En-gendering Power: Essays on Anita Hill, Clarence Thomas, and the Construction of Social Reality*, ed. Toni Morrison. New York: Pantheon, 1992. 40–60.

Spigel, Lynn. "Television in the Family Circle: The Popular Reception of a New Medium." In *Logics of Television: Essays in Cultural Criticism*, ed. Patricia Mellencamp. Bloomington: Indiana University Press, 1990. 73–97.

Williams, Raymond. *Keywords: A Vocabulary of Culture and Society*. 1976. New York: Oxford University Press, 1983.

———. *Television: Technology and Cultural Form*. 1974. New York: Schocken, 1975.

Wollen, Peter. "Ways of Thinking about Music Video (and Post-Modernism)." *Critical Quarterly* 28.1, 2 (1986): 167–70.

Postmodern Literature

Difficult Times

Manifesto for a Postmodern Literary History

Bill Readings

We hear a lot of talk about the politics of postmodernism. And curiously enough, a lot of this talk goes on in literature departments. I want to suggest that this reaction is the product, at least in part, of a neurotic repression of anxiety. For the subject that is covered up is the question of postmodernism's impact on literary history. As Timothy Bahti has demonstrated, the institutional being of literary studies is inextricably bound up with the historicization of literature, which alone makes it capable of being critically studied as the expression of the symbolic life of nation states (3–69). Of course, we have known moments when the historicity of literature has been rejected: structuralism and the American New Criticism are perhaps the most visible examples. But the opposition of historicism to the flat-out rejection of historicity has continued to structure this debate. This is hardly surprising given that, since Schleiermacher, literature has been entrusted with the task of reconciling immediate aesthetic experience and historical tradition.

Up to now, reactions to postmodernism have tended to fall within the terms of this debate. On the one hand, left-wing historicists, conscious of having recently slain the New Critical and structuralist dragons, have accused postmodernism of forgetting history, which for any good Marxist is the same thing as forgetting politics.[1] On the other hand, those trained in traditional literary history have greeted the postmodern as another historical period, liable to produce endless dissertations on the subject of whether such and such an author is modern or postmodern.[2] In this sense, we can say that where postmodernism has not been simply refused as marking an end of history, it has been understood in a purely additive sense. In other words, the postmodern has taken its place as a historical category alongside those of medieval, renaissance, and modern. And scholars have concerned themselves with determining the classification of particular texts. I do not deny that the postmodern may have formal features; I merely want to insist that these features should be tied to a temporal problematic, not to the attitude of a subject, be it ironic, parodic, communitarian, or cynical.[3]

I have called this essay a manifesto because I want to suggest that the postmodern—and here I follow Lyotard—is not simply another historical period but moreover a challenge to both the model of historical periodization and the notion of texts as objects that occur within a continuous historical progression. I will argue that postmodernism is first and foremost a challenge to this model of literary historicity, a rethinking of temporality. The postmodern marks a temporal aporia, a gap in the thinking of time that is constitutive of the modernist conception of time as succession or progress.

Modernist history, as a critical field or science, has its grounds in the establishment of a discrete break or cut between a past (the time about which the historian writes) and a present (the time of writing). The modernist historian differs from the medieval chronicler in that "he" is not simply an appendix to the story "he" writes but also the absolutely privileged and secure site that grounds the possibility of the story. Where the chronicler is in metonymic relation to the past, the modernist historian stands in paradigmatic opposition to the panoply of the past. On the one side is the present: modernity, the ahistorical moment of overview from which causal patterns become apparent. On the other side is the past: a history that surrenders itself to the gaze of modernity. Postmodernity intervenes not as the overcoming of modernity but as a troubling of the division that founds the security of modernity as a present over and against the past.

Postmodernism, that is, is not simply a more immediate present in which anything goes: the surrender of the past to the purely present act of inscription (what is said about the past now). In fact, modernist history is merely an alibi for modernism's dream of self-presence. Postmodernism is rather the insistence that the "it" or id of historical difference uncannily haunts the "now" of the historian's discourse. Postmodernism

inhabits neither the distant past nor the distance of the present: neither nostalgia nor theory will redeem us, will provide an alibi for authoritative discourse.

One form of the insurgence of the historical "it"—which we might with the greatest caution indicate as a parallel to the Freudian unconscious in its troubling of the modernist dream of subjective historical consciousness—is anachronism, anachronism that is no longer considered as a falsehood but is thought of as the mark of the unaccountable necessity on which every modernist act of historical accounting is based.[4] An example here would be the epistemological vertigo of all narrative of time travel, from H. G. Wells to *Bill and Ted's Excellent Adventure*: the narrative convention underlying modernist history—that it is possible to come to terms with the past by consciously inhabiting it—once it has been exposed as such, produces interminable contamination. That is, the problem of all time-travel narratives is Heisenbergian: how to avoid changing the past by the very fact of observing it. To acknowledge this paradox is to upset the modernist claim to legitimacy, based on the metaphoric distancing of the knowing subject from the paratactic succession of historical phrases. Postmodernism asks: How long must it take to arrest time and make it an object of knowledge? What metonymic linking of phrases establishes the silent detachment of the observer's distanced survey?

These questions will not be answered by a revised or more perspicacious modernist history. They require the abandonment of the binary opposition between nostalgia and theory, between historical object and historicist subject. This is something Paul de Man has laid out for us in "Literary History and Literary Modernity," where he follows Nietzsche in pointing out that the desire to forget the past is only the sign that the lesson of the past (that it is necessary to be modern) has been learned (147–48).

WHAT ARE THE IMPLICATIONS FOR LITERARY HISTORY?

History, as presented by the modern institution that is the university, still bears an uncanny resemblance to the ages of man. Since at least Cicero, the course that runs from youth to old age via middle age has held the personal, the natural, the political, and the historical within a harmonious balance. The organic unity of the *cursus aetatis* has provided a series of analogies whose *ratio* has supported the name of man and the humanities in general. What we call the humanities have relied upon this analogy in order to claim a fit or appropriate, a timely, thought. Against this, postmodernism offers a thought that is "out of season" or untimely in its recognition of the infantile babbling within adult reason. And this "presence of the past" cannot itself be recovered for subjective consciousness as a second order "take" on reason; it is not reducible to a subjective attitude of irony, critique, or playful dialogue. In this sense, postmodernism

requires a rethinking of the temporality of literature that is closer to the temporality of psychoanalysis, of *Nachträglichkeit* and uncanny return.

Let me be clear. I am not claiming that postmodernism is the age of psychoanalysis. I am saying that postmodernism shares the temporality that Freud released in his most antisystematic and most authentically psychoanalytic moments. Postmodernism, that is, thinks the grip of tradition as not simply the starting place from and against which the literary or critical subject must assert his or her modernity. The tradition can be neither inhabited (it is past, it is not completely present) nor abandoned (it is not completely past). The tradition haunts. The failure of traditional literary historians has always been to believe that they can live out the role of the living dead that literature imposes. Hence, the apologists for cultural literacy, such as E. D. Hirsch, are prepared to reduce the discipline for which they make grand redemptive claims to a mere list of key works, just to have something to hold onto. As Marvell put it, "the grave's fine and private place / But none, I think, do there embrace" (51). Literature is entombed so that it may be reduced to an object of present consciousness, so that it can stay in the grave, lest it walk and threaten the lucid rationality of our daylight. In this context, postmodernism presents itself neither as an appeal to history nor as the end of history but as a chance for history, finally. This chance, this risk, will demand of us a new literacy, one that is at odds with the logic of expertise, of disciplinary competence. This is why postmodernism is not simply the project for a fully annotated edition of *Finnegans Wake,* the better to comprehend Joyce's genius.

To take seriously the way literature ghosts itself is very difficult. It offers the chance of a literary history that is actually literary, that does not simply submit literature to a historical metanarrative that literature must be *read* as coming from an elsewhere that cannot be pinned down within a cognitive schema such as proposed by Saint Augustine. That is, the terms of that reading cannot be legitimated by an appeal to a metanarrative of historical progress. Reading will have to become a work, not a recognition or a hermeneutics. Reading is an impossible profession, like pedagogy, government, or psychoanalysis. And this is not the grounds either of despair (the last resort of the modernist as scoundrel) or of relativism (the negative modernism that proposes the grand narrative of a subject so detached and transcendent as to be totally *ind*ifferent to events).

Such reading does not so much turn its ear to hear the past as it borrows ears from the past in the attempt to hear the present, which is to say that it is a hearing of the past in the present tense of writing. Given that the past as other is a structural condition of language (we acquire language from elsewhere and can only speculate *a posteriori*, in language, about that elsewhere), the possibility of an autonomous mastery, a subjective appropriation of language as mere instrument of consciousness, is radically disbarred. No amount of hermeneutic reworking will join up the ends of the

web of language, marked as it is by a radical temporal difference that undermines subjective self-presence.

A postmodern history, like literature, becomes the site that evokes the feeling that something cannot be said, that time undermines consciousness. It is marked by figures that undermine the instrumentality of language (tropes of address) or by effects that undermine the self-presence of consciousness (sublimity, enthusiasm). It is, I believe, what Adorno sought to address in denying the possibility that poetry could be written after Auschwitz ("Cultural Criticism," 34). This means not that nothing can be said about the past but that all such saying must be fissured by the acknowledgment that the past cannot be spoken, cannot be made into the object of a subjective representation. Such is the effect of a genocide that exceeds both historical conscious and collective atonement. Genocide cannot be the matter of history; it must be remembered as *unspeakable*. And postmodernism, if it is anything, is the driving of this wedge between the work of memory and the act of historical representation.

It is perhaps unsurprising that this sense of memory is threatening to North Americans, inhabitants of a society founded on the genocidal subjugation of the past to the future promise of the realization of the fully self-conscious subject of republican democracy. Such a sense of history imposes an urgent ethical obligation to a past that cannot be mastered in present representation. It forces me, as a white in North America, to accept responsibility for acts of genocide and enslavement I did not commit. My responsibility is anachronistic, as it were. Yet it is a responsibility nonetheless, for it reminds me that I do not stand apart from the history on which I gaze, that I am not capable of overcoming the weight of the past through an act of subjective understanding that might ensure my autonomy as a human being.

A postmodern literary history begins with the sense that the artwork cannot simply be an object *within* history or an object *with* a history. Rather, the art object makes a claim on what remains of us; it intervenes as memory. As Walter Benjamin says when unpacking his library, "every passion borders on the chaotic, but the collector's passion borders on the chaos of memories" (60). A history in which memory becomes passion, where historical vision is rendered opaque by passion, is a history organized by what Benjamin calls "tactical instinct," as opposed to the strategic vision of theoretical man. Benjamin's apparent praise of private book ownership is actually a recognition that in the private collection it becomes most apparent that memory is not an object of ownership but that the memory owns the subject: it is not that objects come alive in the owner but that he lives in them (67). Hence, "inheritance is the soundest way of acquiring a collection" precisely because it reminds us that these are never our memories: they always come to us from elsewhere (Benjamin 66). We do not possess the memories that we own: they are not our own.

To put it another way, memory is inhuman. This is why postmodern history will have been at least in part a history of the body, a history of the body as a memory that is never an object of rational consciousness but is structured by the tics or addictions against which modernity warned us. The history of the body is heteronomous, the history of an enslavement to a memory of practices and affects from which no rational enlightenment can liberate us, a history of inhuman neuroses that forbid autonomy—neuroses that do not speak the language of human reason, that are *in-fans*, infantile. Gender is one such neurosis. A postmodern literary history will turn out to have been a history of how bodies, as bundles of unhistorical memory, which is to say, passionate and chaotic memory, elude the discourse of reason that attempts to represent them.

That the humanities have difficulty in dealing with an art and a history whose temporality has become inhuman is perhaps hardly surprising. Herein lies the source of all those laments for what poststructuralism and postmodernism are doing to the songs of the academy. The study of what we used to call the humanities has become historical in the rigorous sense, a reading that attends to the event and refuses to put it to rest as part of an objective historical representation (a world) or a subjective historical understanding (a knowledge). Thus history names a sense of the irrepresentable, a demand we must hear and must not drown with the sound of our own voices, with claims to represent history as the property of a subject. History becomes the uncanny, the foreignness at home, a stranger in the house of modernity to which we owe an obligation that precedes our understanding, precedes our knowledge of the stranger within us.

NOTES

1. On this point, see Jameson; Callinicos.
2. See, for example, McHale; Hassan.
3. For further discussions of these issues, see Hutcheon; Elam; and Lyotard.
4. For a further discussion of postmodern and anachronism, see Elam.

WORKS CITED

Adorno, Theodor W. "Cultural Criticism." In *Prisms,* trans. Samuel and Shierry Webber. Cambridge, Mass.: MIT Press, 1990. 19–34.

———. "Trying to Understand *Endgame.*" In *Notes to Literature,* ed. Rolf Tiedemann, trans. Shierry Nicholsen. New York: Columbia University Press, 1992. 241–75.

Bahti, Timothy. *Allegories of History: Literary Historiography after Hegel.* Baltimore, Md.: Johns Hopkins University Press, 1992.

Benjamin, Walter. "Unpacking My Library." In *Illuminations,* ed. Hannah Arendt, trans. Harry Zohn. New York: Harcourt and Brace, 1968. 59–68.

Callinicos, Alex. *Against Postmodernism: A Marxist Critique*. Cambridge: Polity Press in association with Basil Blackwell, Oxford, 1989.

de Man, Paul. "Literary History and Literary Modernity." In *Blindness and Insight: Essays in the Rhetoric of Contemporary Criticism*. Minneapolis: University of Minnesota Press, 1983. 142–65.

Elam, Diane. *Romancing the Postmodern*. London and New York: Routledge, 1992.

Hassan, Ihab. *The Dismemberment of Orpheus: Toward a Postmodern Literature*. New York: Oxford University Press, 1971.

Hirsch, E. D. *Cultural Literacy: What Every American Needs to Know*. Boston, Mass.: Houghton Mifflin, 1987.

Hutcheon, Linda. *The Poetics of Postmodernism: History, Theory, Fiction*. London and New York: Routledge, 1988.

————. *The Politics of Postmodernism*. London and New York: Routledge, 1989.

Jameson, Fredric. *Postmodernism, or, The Cultural Logic of Late Capitalism*. Durham, N.C.: Duke University Press, 1991.

Lyotard, Jean-François. *The Postmodern Condition: A Report on Knowledge*. Trans. Geoff Bennington and Brian Massumi. Minneapolis: University of Minnesota Press, 1984.

Marvell, Andrew. "To His Coy Mistress." In *The Complete English Poems*, ed. Elizabeth Story Donno. Harmondsworth: Penguin, 1978. 50–51.

McHale, Brian. *Constructing Postmodernism*. London and New York: Routledge, 1992.

To the Beat of a Different Conundrum

Postmodern Science and Literature

Susan Strehle

R eaders of this volume of essays will quickly gather that "postmodern" refers to change; whatever form they take, the assumptions implicit in postmodern thought are different, at a basic level, from the assumptions of previous eras. How one thinks about the previous and current states and explains the changes in the fabric of our beliefs, lifestyles, politics, questions, and ways of thinking will depend upon the path one takes into the postmodern; but all of the paths converge in an altered state. Whether the difference appears as progress or decline, and whether the relation to what precedes postmodernism is one of anxiety, contempt, or acceptance, the postmodern announces the arrival of difference.

While we prepare to lay about with the axe-like term "postmodern," we might as well begin by agreeing with theorists who deplore its backward-looking qualities—the sense it conveys of our times as a "post-"script to something earlier, an era that had already arrived at "modern."

Modern, we can learn from the dictionary, comes from Latin roots meaning "exactly" or "to the measure"; things modern are modish, a la mode, upscale, updated, just now, the right fit. In this light, "postmodern" takes on connotations of used, run down, stretched out, past the era of harmonious accord between the times and the things produced by or designed for them. Alternatively, "postmodern" could suggest a time beyond caring about fit, fashion, and newness. But the recent work of cultural theorists and critics, an important and original group of "postmodern" thinkers, shows that each culture constructs only to its own measure; every time can only invent what fits.[1] Every era is "modern" in that sense, and "postmodern" is a logical impossibility—a conundrum, if you will. Conundrums, while the dictionary remains open, are riddles or problems having no clear solution—their only answer is conjectural.

Conundrums are central to postmodern thought; they approach the essence of "postmodernism." To begin to map my own pathway in, some notion that the mysteries of life had solutions—in animistic superstitions, in God and the church, in enlightenment rationality, in positivistic science, in the progress of social agendas, in the ordering power of art—appears to me to characterize previous collective modes of thought. The belief, instead, that uncertainty is basic and fundamental, that some problems cannot be solved, that knowers always enter into and shape what they can know, appears distinctively characteristic of postmodernism.[2] Because this belief is articulated most clearly within the domain of science, I begin there. It permeates the rest of postmodern thought, including that of artists and writers who help make uncertainty part of the general currency of exchange. In the second part of this essay, I turn to Canadian fiction writer Margaret Atwood to show how science and literature intersect in exploring the terrain of the unsolvable. Atwood's recent story "The Age of Lead" offers a rich meditation on the uncertainties of our age, when the consequences you suffer result from "things you didn't even know you'd done." Meditating on scientific, historical, and human mysteries, this story reflects postmodernism's attention to the beat of a different conundrum.

CONUNDRUMS IN POSTMODERN SCIENCE

Conundrums typify the changed way postmodern science looks at reality. Classical science—including then-radical de-centering sciences such as the astronomy of Copernicus, the physics of Newton, and the biology of Darwin—understood the world as rational and solvable; what scientists didn't know today they would learn tomorrow. Scientific activity was objective, and its very detachment from the realms of personal and emotional investment gave it superior access to truth. In contrast, postmodern science sees reality as unsolvable and its own activities as limited by a

radical uncertainty built into the interaction between the observer and the system under observation. Scientists inescapably bring the assumptions of the paradigm constructed by their scientific and cultural community to bear on the questions they ask and the phenomena they perceive.[3] Far from having absolute, objective knowledge of definable systems, scientists form conjectures and demonstrate them through thought-experiments. Rather than pinning reality down, science acknowledges mystery.

Physics, the science devoted to nonliving reality, provides an especially pronounced measure of the change in paradigms. Postmodern physics is distinguished from its predecessors by a different term: it is called "new physics" to distinguish it from classical or Newtonian physics. The extent to which relativity theory, quantum theory, and wave mechanics revolutionized previous concepts of reality deserves emphasis. In *The Philosophical Impact of Contemporary Physics,* Milič Čapek defines in strong language the "astonishment" generated by the way postmodern concepts transform classical physics:

> There is hardly any similarity between the "matter" of modern physics and the traditional material substance of the classical period, and this is true in varying degrees of other concepts as well. . . . It is true that the effect of [relativity, quantum theory, and wave mechanics] on the imagination of physicists, philosophers, and even laymen was truly shattering; the contrast between the new theories and the appealing clarity of classical concepts was sharp and shocking. (xi)

Similar assessments, with a frequent invocation of the term "revolution," appear throughout studies of the new physics—one of them, revealingly, titled *Dismantling the Universe.*[4]

The complex story of the revolution in physics has been frequently told, with different emphases, by various historians and philosophers of science.[5] A condensed version of this story will place in sharp relief those assumptions of the new physics that have exerted a profound influence on contemporary culture and have shaped the way postmodernism emerges at other sites. Postmodern science, culture, and literature join in seeing the external world as discontinuous, acausal, energetic, relative, complex, and chaotic, and the observer's relation to it as subjective and uncertain. Each of these terms reflects a major transformation of the assumptions basic to the Newtonian paradigm. For a follower of Newton, reality was above all orderly, shaped in predictable ways by the presence of absolute space, time, and motion, and science proceeded through an objective methodology to determine the causal laws governing the continuous operations of an essentially material world. Science projected an attainable certainty in its attempts to uncover the deterministic and therefore clearly identifiable relations among the properties of nature.

Nature was complicated in its manifestations but simple in its essence.

After the "revolutionary" new theories of relativity and quantum mechanics had been assimilated (between, roughly, 1905 and 1930), a changed understanding emerged. For a follower of Einstein, Planck, Heisenberg, and Bohr, space, time, and motion are relative and interrelated, and no privileged frame of reference remains to enable the determination of scientific results. At the subatomic level, reality is discontinuous or quantized; particles make quantum leaps from one energy state to another. Subatomic reality *is* energy, rather than matter, for particles whose position and velocity can't be determined cannot be said to "exist" as things. Their behavior is indeterminate, not predictable by causal laws, but only describable by the laws of statistics. Limited by the uncertainty principle to incomplete knowledge, science acknowledges the subjectivity generating its choice of focus and its inventions of theoretical models. Reality is chaotic and complex, and its multiplicity can't be resolved into simpler forms of order.

The first disruption of the classical physicist's worldview occurred in an era considered modernist rather than post: in 1905, when Albert Einstein published one paper advancing the special theory of relativity and another arguing that light sometimes behaves as particles—the assumption basic to quantum theory. The scientific impact of these papers was enormous; they began the series of radical changes in paradigm that led to postmodernism. The special theory of relativity assumes that the velocity of light is constant, regardless of whether its source is moving relative to the observer or not. Light does not propagate in waves through the ether envisioned by classical physics, and therefore the concept of this stationary medium could be abandoned. More importantly, Einstein theorizes that measurements are relative to their frames of reference, so that a measuring instrument changes depending on its motion. A clock on a speeding rocket runs more slowly than a clock on earth, and an accelerating measuring rod contracts to become shorter than an earthbound rod. This hypothesis explains why the speed of light remains the same for both the observer moving slowly through space on earth and the observer moving rapidly on a rocket. Each observer would see no change in the measuring instruments, which would appear entirely normal. In part, this is because the speeding observer too would contract and slow down.

Another implication of the special theory of relativity is that "simultaneity" does not exist for events separated in space. Simultaneity is relative to the observer's frame of reference; one observer might perceive events as happening simultaneously, but others in different states of motion could see either of the two as previous. None of these observers is right, because no absolute or privileged frame of reference exists.

An accelerating body increases in mass for an earthbound observer, though from the reference frame of the speeding body earth also appears

to be growing heavier. Einstein's famous equation describing this process, E=mc², suggests that mass or matter contains energy, while energy has mass. This idea—perhaps the best-known conundrum of the new physics—radically alters the notion of matter in classical physics, creating a newly energized and dynamic version of the solid stuff basic to classical and common sense notions of reality. Seen in relation to the energy it contains, matter ceases to be distinct and absolute; it becomes, itself, relative.

A similar transformation brings time and space, previously seen as separate and absolute, into relativistic relation. In order to posit a standard against which experimental results could be verified in classical physics, Newton defined an absolute time flowing equably, without relation to anything external. The mechanistic or "clockwork" model of the universe that emerged inevitably from this hypothesis eliminated temporality, as Čapek points out: "time in the sense of genuine succession has no place in the consistent necessitarian scheme" (140). Einstein reintroduces temporality by showing that it is relative to the observer's position and momentum in space—Einstein terms their relative relation a space-time continuum. Rather than spatializing time, Capek argues, the notion of a continuum actually "dynamizes" space (384). Time becomes a fourth dimension, a coordinate that joins the three spatial dimensions to form a mathematically definable continuum.

The general theory of relativity (1916) extends its inquiry from bodies in uniform motion to bodies in accelerating motion and thus defines the effects of gravitational fields. Gravity curves the space-time continuum, Einstein argues, and changes the geometry of space and time. Gravity itself is not the product of matter exerting its pull through empty space; rather, gravitational fields define space-time, and, where they become intense, they constitute matter. Space, time, and matter are not discrete entities but rather interacting aspects of the curved gravitational field. Reality behaves as if its physical elements—space, time, matter, energy, gravitation, inertia—are not separate or isolated, as they were in Newtonian mechanics, but rather as if these elements function, and can be understood, only in a network of relational interdependence.

Einstein spent much of the rest of his life attempting to refute implications other physicists derived from his theories. A believer to the end, despite disturbing evidence to the contrary, that "God does not play dice with the world," Einstein retained his faith in the existence of a causal order in the objective world and in the possibility of a unified field theory that would establish universal scientific truth. Quantum theory led, however, in the opposite direction. Relying on Einstein's vision of interconnected phenomena, observed from involved, unprivileged, always relative frames of reference, drawing even on his 1905 argument for the emission of light in particular units, quantum theory grew to dismay—and finally to override the objections of—its reluctant sire.

Quantum theory originated with another unwilling revolutionary, Max Planck, who theorized in 1900 that light is emitted in packets or quanta. Since light had been understood as waves for two centuries, and conclusive evidence had accumulated supporting its wavelike nature, Planck's quantum theory presented a major conceptual challenge to the framework of classical physics. But Planck could explain the phenomena of blackbody radiation in no other way: light is emitted in discrete whole units, never in fractions as the wave theory would predict.

Einstein proposed in 1905 that light was made up of particles, thus explaining Planck's experimental results. Particles, emitted in wholes rather than fractions, make Planck's quantum theory logical. Arthur Compton's experiments with X rays confirmed Einstein's hypothesis in 1923, for Compton showed that X rays passed through paraffin not only scattered but also changed their wavelengths, giving up energy in the collision of particles as quantum theory predicts.

The problem remained, or rather became newly pressing, that light had been seen as waves because it behaves demonstrably in wavelike patterns. Paradoxically, light has a dual nature as both wave and particle. The attempt to resolve this conundrum by bringing its two terms into alignment, or discovering some unifying relation between them, has occupied physicists ever since. One of the earliest of these attempts was Louis de Broglie's doctoral dissertation, submitted in 1924, suggesting that particles behave as waves. Responding to Niels Bohr's theory (1913) that electrons revolve around the nucleus of atoms in orbits or shells, jumping outward to another shell when energy is introduced and emitting this energy in the form of a quantity of light when it returns to the lower shell, de Broglie hypothesized that electrons behave as light does—as both particle and wave. Matter, he said, has waves that correspond to it; the greater a particle's momentum, the shorter its matter wave. Experiments with electron diffraction, passing a beam of electrons through a very small space, confirm de Broglie's theory: the beam diffracts just as light does. The conundrum becomes more intricate: light, made of waves, behaves as particles, and electronic particles behave as waves.

Erwin Schrödinger advanced the theory in 1926 that electrons are not particles at all, but standing waves, which are also quantized. Schrödinger developed a wave mechanics to describe mathematically the possible shapes of standing waves, and the mathematical values have been confirmed experimentally. At the same time, Werner Heisenberg advanced a matrix mechanics that, though it proceeds from different assumptions about subatomic processes, gives the same confirmable mathematical results. While Schrödinger envisioned electrons as spread out over their wave patterns in a cloud, Heisenberg assumes that physicists must abandon perceptual models of atomic processes and work with observable states at the beginning and end of experiments; these he correlated in mathematical

tables of matrices. Continuous waves in Schrödinger's wave mechanics and discontinuous, unlocalized particles in Heisenberg's matrix mechanics, electrons appear democratically to confirm both irreconcilable theories.

Max Born suggested a way to resolve the paradox: he argued that electrons are particles whose wave function represents the probability that they are located at a particular place. Born assumes that the position and velocity of the subatomic particle cannot be defined; its behavior cannot be understood as causally determined but only predicted by the laws of statistics.

Heisenberg's uncertainty principle (1927) establishes the conundrum as a law of nature, for it posits a radical indeterminacy in scientific knowledge of the subatomic realm. Scientists cannot measure accurately both the position and the velocity of subatomic particles. Using light energy to measure position alters the velocity of particles; in measuring velocity, without altering the energy level of the system, one cannot determine position. No improved technology will ever remove this fundamental uncertainty from scientific knowledge, for basic to it is the recognition that the observer changes—disturbs—the system under study. While classical physics assumed that reality proceeds on its independent course, following immutable laws of causality, and objective scientists watch and predict its course, Heisenberg's principle recognizes that subatomic reality changes with observation—and, even more radically, is constituted by the choices the observer makes from an involved vantage. Heisenberg emphasizes the subjective interaction of the scientist with those aspects of nature he or she chooses to observe: "Science no longer confronts nature as an objective observer, but sees itself as an actor in this interplay between man and nature" (*Physicist's Conception*, 29). When the scientist, for centuries a figure typifying neutrality, distance, and passive observation, becomes an actor in the interplay, caught up in the same process of interpretation as the artist and the historian, we have arrived at a postmodern understanding of science.

Heisenberg's principle has other implications disruptive of the Newtonian worldview. If scientists cannot determine position and velocity, they cannot apply Newton's laws of motion in the subatomic realm. They cannot predict the course of electrons they cannot measure, nor can they construct causal models explaining why reality behaves as it does. As Gary Zukav puts it, "The whole idea of a causal universe is undermined by the uncertainty principle" (135).[6] Moreover, a particle without a determinable position and velocity cannot be located as a "thing" in space or time, and the "reality" that scientists study loses the solidity of matter *(res)* to take on the energetic quality of acts *(acta)*.

Accepting the indeterminacy of the wave-particle duality of light generates Niels Bohr's principle of complementarity (1927). Known as the Copenhagen interpretation of quantum theory, complementarity sees irreconcilable and mutually exclusive concepts—both particle and wave—as necessary to understand subatomic reality, which behaves according to

both opposite principles. In Bohr's view, "an independent reality in the ordinary physical sense can neither be ascribed to the phenomena nor to the agencies of observation" (54). Rather, the interactions between scientists and nature construct a necessarily double or complementary view of subatomic processes. Resolution of the paradox—or restoration of Newtonian clarity—cannot occur. Tolerating ambiguity while using the conundrum as a springboard for new theoretical creations has become the distinctive gift of the postmodern scientist.

More recent developments in physics within the last thirty years have not resolved paradoxes, restored certainty, or unified the theoretical field; rather, they have formulated new and highly productive means of describing the intricate order of chaos and complexity. Itself a dramatic new conundrum, chaos theory studies a variety of intricate patterns—found in cloud movements, cotton prices, the eye movements of schizophrenics—and finds them regular, obedient to discernible laws, and therefore meaningful. James Gleick, the writer who brought chaos to the popular imagination in 1987, writes that it has opened new territory for physics:

> The most passionate advocates of the new science go so far as to say that twentieth-century science will be remembered for just three things: relativity, quantum mechanics, and chaos. Chaos, they contend, has become the century's third great revolution in the physical sciences. Like the first two revolutions, chaos cuts away at the tenets of Newton's physics. As one physicist put it, "Relativity eliminated the Newtonian illusion of absolute space and time; quantum theory eliminated the Newtonian dream of a controllable measurement process; and chaos eliminates the Laplacian fantasy of deterministic predictability." (5–6)

While it has roused as much skepticism as fascination in the scientific community, chaos theory has applications in virtually every scientific discipline, from mathematics to chemistry to medicine. Studying the patterned motions of nonlinear systems, it theorizes about the overarching order within highly complex data, including the human and physical universe.

The set of chaotic patterns discernible in nature is jagged and recursive. Developed in 1975, Benoit Mandelbrot's fractal geometry explores rough, irregular shapes, such as the coastline of Britain, to take one example developed by Mandelbrot. Fractal geometry, says Gleick, "is a geometry of the pitted, pocked, and broken up, the twisted, tangled, and intertwined. The understanding of nature's complexity awaited a suspicion that the complexity was not just random, not just accident" (94). Mandelbrot found qualities of self-similarity, replication of jagged patterns in smaller and smaller scales, pattern within pattern. The concept of "strange attractors," named by David Ruelle and Floris Takens in 1971, helped explain the deep structures found within seemingly patternless systems. Studying

nonlinear systems in the mid-1970s, Mitchell Feigenbaum found a similar recursive and self-referential quality whereby patterns replicate across various scales. Feigenbaum's theory describes the numerical recursion of patterns on varying scales in complex systems.

A related movement in recent science has been called complexity; both related to and different from chaos theory, it sees itself as drawing on and going further than chaos, especially in its focus on the underlying mechanisms that lead systems toward self-generated organization.[7] Brought to the general public by writer M. Mitchell Waldrop in 1992, the science of complexity studies complex nonlinear systems characterized by spontaneous self-organization, by adaptation, and by dynamic balance at what Waldrop calls "the edge of chaos" (11–12). Drawing on the work in irreversible thermodynamics of Ilya Prigogine, who won the Nobel Prize in 1977, a group of researchers in fields ranging from economics to physics to artificial intelligence founded a think tank called the Santa Fe Institute in 1983. According to Waldrop, the various members of the group have begun the latest highly significant revolution in science:

> they all share the vision of an underlying unity, a common theoretical framework for complexity that would illuminate nature and humankind alike. They believe that they have in hand the mathematical tools to create such a framework, drawing from the past twenty years of intellectual ferment in such fields as neural networks, ecology, artificial intelligence, and chaos theory. They believe that their application of these ideas is allowing them to understand the spontaneous, self-organizing dynamics of the world in a way that no one ever has before—with the potential for immense impact on the conduct of economics, business and even politics. They believe that they are forging the first rigorous alternative to the kind of linear, reductionist thinking that has dominated science since the time of Newton. . . . They believe they are creating . . . "the sciences of the twenty-first century." (12–13)

The sense of the revolutionary character of this new set of theories is again dramatically clear in the language Waldrop uses to summarize these beliefs.

The alternative to linearity has particular importance in both chaos and complexity. Traditional science tended to focus on linear systems, in part because their ordered precision satisfied the assumptions of classical scientists and in part because the mathematics was possible to do by hand. With increasing use of computers in the 1950s and 1960s, nonlinear equations became far easier to solve, and with this the exploration of nonlinear systems took off. The web of connections among distant phenomena, the development of major changes out of small initial events, and the evolution of patterns of increasing complexity are all analyzed only through nonlinear equations. Life itself—including the development

of postmodern science—is not linear and does not unfold in a single direction where every event contributes to one final sum that equals precisely the total of each part. Linear narration always leaves conflict and multiplicity out in the interest of clarity and resolution. Postmodernism, with its respect for the conundrum, gives new scope and emphasis to nonlinearity in science and in literature.

As this summary suggests, the new physics has reimagined reality, replacing the predictable laws that send a marble rolling down a slope in classical physics with a set of questions about how complex systems adapt and organize in the face of multiple changes. For the new group of scientists, postmodern reality has the qualities of a conundrum. It may be described as relative, discontinuous, energetic, statistical, subjective, chaotic, complex, and uncertain. The general conception of the change in reality extends beyond physics, into psychology (where Lacan and others shift the emphasis from material causes of disorder to energetic processes of relation in language), philosophy (where Foucault and others replace absolutist concepts of people and events with relativistic notions of forms of representation and discourse), and literary theory (where Derrida and others see interpretation not as the penetration of certain truth but as an encounter with the duplicitous undecideability of texts). Like any significant change in paradigms, the latest one has rattled windows in every house on the block.

CONUNDRUMS IN POSTMODERN LITERATURE

Readers of this volume may come to the subject of postmodern science as nonspecialists, bringing backgrounds in arts, culture, and cuisine to this section of the text. Such readers will wonder about linkages, transfer, influence: how do insights from the specialized domain of postmodern science get out? Who translates findings about X-ray diffraction and theories of complementarity into forms accessible to the artistic imagination? Through what alchemy do they become commanding metaphors for groups of writers and readers? And how do we recognize the traces of postmodern science in other, allied postmodernisms springing to life around us?

For students of the intersections between science and literature, these different ways of knowing reality appear to inhabit the same territory and to speak of similar uncertainties in different languages. The connections between them tend to occur at the level of ideas and assumptions and to be indirect but significant. The postmodern scientific theories to which I've referred are not so specialized that only physicists discuss them; even children who don't understand it know Einstein's famous formula for the relation between energy and mass. Media coverage has helped place some new physical theories in general use, and the large numbers and financial success of books on the new science demonstrate popular interest in these

theories. Canadian fiction writer Alice Munro describes the way private in-
dividuals come to share the most progressive notions afloat in their cul-
ture: "It's as if tendencies that seem most deeply rooted in our minds,
most private and singular, have come in as spores on the prevailing wind,
looking for any likely place to land, any welcome" (23). Writers may, by
nature, provide a culture's most welcoming grounds for such spores.

Margaret Atwood has certainly read widely about the new physics and
has demonstrated interest in the conundrums of our age. In *Cat's Eye*
(1989), Atwood's brief acknowledgment indicates her reading of popular-
ized accounts of the new physics: "The physics and cosmology sideswiped
herein are indebted to Paul Davies, Carl Sagan, John Gribbin, and Stephen
W. Hawking, for their entrancing books on these subjects, and to my
nephew, David Atwood, for his enlightening remarks about strings."[8]
Throughout that novel, new physical concepts are voiced by the narrator's
brother Stephen (named, perhaps, for Hawking), who tells his sister about
the expanding universe, the curvature of space-time, and the intertwined
nature of matter and energy. A famous physicist in his mature years,
Stephen delivers a lecture on "The First Picoseconds and the Quest for a
Unified Field Theory" that echoes John Gribbin's *Genesis: The Origins of
Man and the Universe*.[9]

A story Atwood wrote around the same time as *Cat's Eye* provides a re-
markable illustration of the ways in which scientific conundrums emerge
in and enrich postmodern literary texts. The story, titled "The Age of
Lead," appears in Atwood's collection, *Wilderness Tips* (1991).[10] The story
counterpoints two narratives: on television, a man dead for a hundred and
fifty years is exhumed from arctic ice; Jane, watching the report, remem-
bers her friend Vincent, who died less than a year ago. The narrator, a
third-person limited narrator who stands for, but is detached from, Jane,
compares the two dead men throughout the narrative, highlighting the
constant parallels between the two strands of the story. The two doomed
dead men—one thawed on screen and looking alive, the other evoked by
memory as a living presence—are surrounded by ice and "wintry" light
(160). They have identical "white thin feet," bare of socks (154, 160).
More to the point, each death is a medical and scientific mystery, a conun-
drum in its own right. Both men appear to have ingested poisons from
their environment that, while hidden from the men and undetected by
their doctors, nonetheless trigger their deaths. While scientists are able to
identify the poison that helped kill the earlier dead man, they can neither
identify nor treat the "mutated virus that didn't even have a name yet"
(160) that operates in the present to kill Vincent. Both strands of the story
are about postmodern scientific knowledge—and its limitations. The story
reflects a perilous uncertainty; what you don't know will kill you.

To highlight the central importance of uncertainty in "The Age of
Lead," Atwood focuses one of the two intertwined strands of narrative on

the current scientific study of a famous historical mystery, the Franklin ex-
pedition. The frozen man was John Torrington, a member of the expedi-
tion led by Sir John Franklin in 1845 to find the Northwest Passage to In-
dia; the entire crew died. Mystery surrounds this episode of British
colonial history: 129 men perished, leaving skeletal remains over a large
area and tales of cannibalism among the Inuit.[11] The mission left with
every chance of success: two sound and well-equipped ships, the *Terror*
and the *Erebus,* carried experienced arctic sailors and a food supply, includ-
ing tinned meats and soups, calculated to last three years. They spent the
first winter (1845–46) icebound near Beechey Island, where three sailors
(including John Torrington, age twenty, the first to die, on January 1,
1846) were buried. The next summer they sailed southwest to King
William Island, where the ships were beset (locked in by ice) in September
1846. They stayed onboard the ships until April 1848, at which point they
abandoned the ships and began an overland march to the south. They
died, some in groups and some alone, in places on King William Island
and the Adelaide Peninsula. Aside from one very brief note written in
April 1848 as they began the southern march, no record survives.

Theoretical accounts of the disaster have been generated ever since;
though starvation, scurvy, arctic winters, frostbite, bears, and wolves pro-
vide enough causes of death, questions remain about why the men left the
ships, why their guns did not secure enough food, why some tins of food
were left unopened, and why they were found in areas of King William Is-
land not leading toward their goal, the Back's Fish River. While Atwood's
interest in the Franklin expedition can be traced both earlier and later
than 1987,[12] the story she tells in "The Age of Lead" is shaped in that year
by the publication of a scientific explanation (with photographs, includ-
ing several of the exhumed bodies): *Frozen in Time: The Fate of the Franklin
Expedition,* by Owen Beattie and John Geiger.[13] Beattie, a physical anthro-
pologist who is an expert in forensic pathology, suspected that Torrington
had died from lead poisoning, which causes physical and neurological
problems that range from anorexia, weakness, and fatigue to irritability
and paranoia. Beattie performed autopsies on all three permafrosted bod-
ies, whose preserved soft tissue would provide a far clearer measure than
the bones of unburied crewmen of the lead ingested during their last
years. The lead levels in all three bodies were extremely high, especially in
the hair. Beattie concludes that the canning process, in which tin cans
were sealed with a bead of lead solder down both the inside and outside
seams, led to the poisoning of the officers and crew: "It is sadly ironic that
Franklin's mighty expedition, . . . carrying all the tools that early industry
and innovation could offer, should have been mortally wounded by one
of them" (162).

"The Age of Lead" makes its commentary on science primarily through
the medical doctors—important more for their absence than for their

opinions—who treat both Vincent and John Torrington and through the nameless "scientists" who exhume and study the latter. Science does not appear as a source of clear and certain knowledge in either context. Although there were two doctors present on each ship of the expedition, the doctor is unable to help John Torrington. As Jane imagines it,

> Down in the hold, surrounded by the creaking of the wooden hull and the stale odors of men far too long enclosed, John Torrington lies dying. He must have known it. . . . Who held his hand, who read to him, who brought him water? . . . What did they tell him about whatever it was that was killing him? Consumption, brain fever, Original Sin. All those Victorian reasons, which meant nothing and were the wrong ones. But they must have been comforting. If you are dying, you want to know why. (158)

If Torrington's doctor visits, it is to offer "Victorian reasons" that comfort only because any explanation will do for the dying. No comforting causal narrative at all is given to Vincent, lying packed in ice for the pain, without a doctor at his side. The "mutated virus" has no more cause than it has solution.[14] Vincent imagines that it came from "the Pod People from outer space. They said, 'All I want is your poddy'"; alternatively, he suggests, "It must have been something I ate" (160–61). The single moment of scientific certainty in the story follows. On television, the scientists "are excited, their earnest mouths are twitching, you could almost call them joyful. They know why John Torrington died . . . they've run [pieces of Torrington] through machines and come out with the answers" (161). In this decidedly ironic view, science is a grim, mechanical detective hunt for "the answers," one hundred and forty years too late. Vincent dies while Torrington is exhumed; Torrington's death is explained ninety-seven years after soldering on the inside of food tins has been banned. Looking back, scientists can identify toxic agents as a cause of death; but they cannot identify current poisons in the environment or shield living beings from their dire consequences.[15]

The lack of attainable certainty in the face of spreading toxicity gains added importance in modern Toronto, the setting for the interspersed story of Jane and Vincent. Damage—of related cultural and environmental sorts—has been done by the advance of civilization since the Franklin expedition came to Canada. The environment is toxic: "Maple groves dying of acid rain, hormones in the fish, pesticides in the vegetables, poison sprayed on the fruit, God knows what in the drinking water" (159). The economy is unhealthy; Toronto has many poor people "begging on the streets" (159). At more general levels, cultural assumptions produce ill health, despair, and wasted lives for many citizens. The mothers of Jane and Vincent serve as clear examples; seemingly typical of the women of their generation, both have suffered disastrous marriages. Jane's father

abandoned his family; Vincent's father drinks and stays out all night. The mothers' misery is exacerbated by the fact that their own seemingly healthy feelings and choices led to these toxic consequences. Like the evoked memory of the Franklin expedition, the interleaved story of Jane and Vincent occurs in a setting of growing waste and barrenness.[16]

Atwood's remarkable achievement in "The Age of Lead" is to suggest a provocative set of parallel relationships between the two stories. The Franklin expedition was set in motion by the commercial drive for bigger profits; it represents the British imperialist mission in its clearest form. The expedition aimed to find the Northwest Passage "so people, merchants, could get to India from England without going all the way around South America. They wanted to go that way because it would cost less and increase their profits" (150). This same commercial drive remains highly visible in contemporary Toronto: at Eaton's department store, where Jane's mother sells "glittering junk" that she can't afford to buy because her salary is too low (151); in real estate, where the "cheap artists' studios were torn down or converted to coy and upscale office space" (159); in Jane's kitchen, where the modern appliances are "waiting for her departure, for this evening or forever, in order to assume their final, real appearances of purposeless objects adrift in the physical world" (162).

Jane and Vincent try, in the way of their generation, to find alternatives to the Western legacy that infuses their culture with an abiding preference for settled workers, responsibility, and profits. Both of them reject the pattern of material success, refusing to settle down to a life of commitment, marriage, children, property, and the gravitational weight of *consequences* that their mothers have warned them will follow. Their slogan is adapted from an ad for tampons: "No belts, no pins, no pads, no chafing. . . . It was what they both wanted: freedom from the world of mothers, the world of precautions, the world of burdens and fate and heavy female constraints upon the flesh. They wanted a life without consequences" (154). They pursue freedom through careers that give them a measure of independence; Jane is a financial consultant who works on her own, and Vincent is an artist who opens his own design studio. They pursue freedom through relationships that leave them at liberty. Jane lives with several men but keeps several belongings in boxes to make moving out easier; she "could see no reason to tie herself down, to make any sort of soul-stunting commitment, to anything or anyone" (156). Vincent has many friends, thinks of sex as "a musical workout. He couldn't take it seriously, and accused her of being too solemn about it" (157). Each of them veers sharply away from the weight of solemnity, commitment, and especially that most heavy of consequences, "the tiny frill-framed goblin head in the carriage" (151).

But their avoidance of consequences carries its own enormous cost. They purchase freedom at the price of detachment, and aside from their

long relation to each other they appear to have no sustaining bonds. They wear costumes, adopt masks, play at roles, and suspend their relation in a make-believe dimension: "What went on between them continued to look like a courtship, but was not one" (158). Vincent wears a thick shield of irony to hold off consequences; his irony also closes off communication and leaves him and Jane isolated, even from each other. Every reference to Vincent is, like his relation with Jane, mediated and muffled by his irony. When he plays with the clichés of honesty—"what you see is what you get"—he twists them to different meanings as he twists "his nose into a horror movie snout" (148). He mocks, spoofs, and satirizes; he and Jane don't go out, but rather they "[make] fun of going out" (153). He imitates his mother's peevishness and (with "a mock sneer") Rhett Butler's disdain: "Franklin, my dear, I don't give a damn" (150).[17] He dedicates his life to "making fun, of obsolete books, obsolete movies, their obsolete mothers" (160). Even as he lies dying in the hospital, he can find no other position; "Lighten up," he says to Jane (160).

Jane survives, plants bulbs on Vincent's grave, watches the television program on the Franklin expedition, loses sleep, and meditates on what remains. For her, lightness has fled. In trying to stay light with Vincent, she has found inescapable heaviness instead. Their efforts to hold off consequences have not worked: "Their mothers had finally caught up to them and had been proven right. There were consequences after all; but they were the consequences to things you didn't even know you'd done" (161). Like Torrington, eating lead-poisoned soup in the hold of the *Terror*, they have unknowingly limited their own lives in the quest for health and strength. The most subtle and insidious poison of all for Jane and Vincent has come, in fact, through their quest for freedom: the mistaken notion that they could avoid consequences, evade the cultural damage inscribed in their mothers' lives, travel light, elude gravity by escaping commitment. The way they have lived leads to the heaviness of earth over Vincent's coffin, to the heaviness of Jane's grief, and to the final image of the story:

> Increasingly the sidewalk that runs past her house is cluttered with plastic drinking cups, crumpled soft-drink cans, used take-out plates. She picks them up, clears them away, but they appear again overnight, like a trail left by an army on the march or by the fleeing residents of a city under bombardment, discarding the objects that were once thought essential but are now too heavy to carry. (162)

This last image brings together various strands of the story in a mood of apocalyptic gloom. Ecological pollution—acid rain, lead poison, radioactive dumping—leads to people dying too early of undetectable causes, "as if they had been weakened by some mysterious agent" (159). The toxic legacy of the consumer culture, leading every citizen to expect

high standards of material ease, comfort, and convenience, generates material goods "thought essential" for a time; these turn to waste, excess baggage, pollution of the city as the owners begin to die. The body itself becomes "too heavy to carry," though John Torrington and Vincent are gaunt and almost weightless as they lay down their remains. History itself appears to follow a declining spiral. After a golden age, when humankind lived in tranquil harmony with nature, come silver, bronze, iron, and eventually lead: distinguished by a despoiled natural environment and an alienated populace that relies increasingly on technology to control the damage it has done.

The trail of things abandoned "by an army on the march" extends backward to the last days of the Franklin expedition. When the crew abandoned ship in 1848, they unloaded both vessels. As Atwood tells it, they "set out in an idiotic trek across the stony, icy ground, pulling a lifeboat laden down with toothbrushes, soap, handkerchiefs, and slippers, useless pieces of junk. When they were found ten years later, they were skeletons in tattered coats, lying where they'd collapsed" (161).[18] From the illuminating perspective of hindsight, it is easy to see that the trek was doomed, the goods useless and foolishly heavy to carry. At the time, the officers might have hoped to use these goods to barter with the Inuit for fish and seal. They didn't know the future, however, and couldn't see their doom. The image of these skeletons collapsed around their useless treasure stands as a warning to the citizens of Toronto, "fleeing residents of a city under bombardment," who compromise their environment in the manufacture, sale, and consumption of soft drinks, microwaves, and other "purposeless objects."

Yet, in the way of complex postmodern stories, Atwood's "Age of Lead" is not a call to rally for ecological responsibility, better packaging, more recycling, or increased donations for scientific research; it is not Atwood's answer to the problems she portrays. Rather, the story is a conundrum, built to explore the lead weight of uncertainty. Jane and Vincent, standing for the generation that came of age in the sixties and seventies, try to design a life of freedom in response to the damage they perceive in the planet and the culture they have inherited from the spiritual descendants of the Franklin expedition. They reject most of what is summed up in the image of the skeletons in tattered coats hauling soaps and slippers; they try for careers whose rewards go beyond material success and for relationships defined by other standards than patriarchal order, dominance, and submission. But their attempt at lightness turns out to generate other limitations and losses, and they fail to develop an alternative that fulfills their needs. The attempt to prevent or escape the problems of the mothers' generation opens the children up to different but related disasters. The virus mutates; as soon as science invents a cure, new and more complicated viral plagues arise. In the nature of things, there are no certain answers, and

the questions grow harder and weightier all the time.

The story itself takes a postmodern position on the question of knowledge: it rests in uncertainty. The third-person omniscient narrator is not all-knowing but, rather, limited and focused through Jane's perceptions. Since Jane does not know answers but only questions (why does Vincent die? who is he, behind the irony? how could they have led, how can she now lead a satisfying life? what could be done to remedy the social, economic, and environmental problems in Toronto?), the story does not resolve its own uncertainties. Even the story of the Franklin expedition, presented in the frame of a television program that is designed to bring closure, does not finish off the uncanny questions it raises. Torrington's face comes into focus at the start of the story with "tea-stained eyes": "an indecipherable gaze, innocent, ferocious, amazed, but contemplative, like a werewolf meditating, caught in a flash of lightning at the exact split second of his tumultuous change" (148). Torrington poses the unsolvable riddle of death, to which the scientists' solution—lead poisoning—is not an adequate answer and which neither the finality of his story nor its embedding within Jane and Vincent's manages to neutralize and resolve. The image of his "indecipherable gaze" hangs over the rest of the story, over Vincent's own tumultuous change, and over Jane's meditations on what remains. These meditations bring no resolution to her sense of loss and no resolve for the future; the story leaves "Victorian reasons" and the comfort they provided behind. In their place, "The Age of Lead" finds uncertainty: it arrives where it begins, with a sense of the unsolvable and the indeterminate that is the ground of postmodernism.

CONUNDRUMS AS POSSIBILITY

For postmodern science, the recognition that uncertainty frames its questions and limits its perceptions can be liberating. Rather than the joyless pursuit of an ever-more-clearly defined set of answers about reality, science is a process of creative theorizing. Einstein saw this potential in science: "physical concepts are free creations of the human mind, and are not, however it may seem, uniquely determined by the objective world" (Einstein and Infeld 31). Einstein defines both the danger—the concept bears an uncertain relation to the objective world—and the possibility for science: free and creative, its theories represent a human response to the objective world. Heisenberg makes a similar point: "What we observe is not nature itself, but nature exposed to our method of questioning" (*Physics*, 58). As I suggested at the outset, each era asks the questions it can in the way it must; a culture can only create to its own measure and fit. Postmodern science, literature, and culture join in allowing unanswerable questions new respect, in raising a healthy skepticism over the drive for answers, and in attending to the beat of a different conundrum.

NOTES

1. Michel Foucault is the most important among cultural critics. Others include Tania Modleski, Trinh Minh-ha, and Edward Said.

2. A more extensive reading of the intersection between scientific uncertainty and contemporary fiction appears in my *Fiction in the Quantum Universe*.

3. Thomas S. Kuhn argues the importance of paradigms for scientific inquiry in *The Structure of Scientific Revolutions*.

4. See Morris.

5. See Capek; Morris; Zukav; Bohr; Heisenberg, *The Physicist's Conception of Nature*; Heisenberg, *Physics and Philosophy*; Stephen W. Hawking, *A Brief History of Time* (New York: Bantam, 1988); John Gribbin, *Genesis: The Origins of Man and the Universe* (New York: Delacorte/Eleanor Friede, 1981); Paul Davies, *God and the New Physics* (London: J. M. Dent & Sons, 1983); Brian M. Stableford, *The Mysteries of Modern Science* (London: Routledge and Kegan Paul, 1977); Jeremy Bernstein, *Einstein* (New York: Viking, 1973); Werner Heisenberg, *Physics and Beyond*, trans. Arnold J. Pomerans (New York: Harper, 1971); Max Jammer, *The Philosophy of Quantum Mechanics* (New York: John Wiley & Sons, 1974).

6. See also Bohr 53–57.

7. For a different approach emphasizing the similarities between chaos and complexity, see Hayles, who argues that what Gleick calls chaos and what Waldrop calls complexity are really two branches of the same theory. The chaos branch emphasizes the deep structures of order within chaos; the complexity branch emphasizes the organized structures that emerge out of chaos. The chaos branch, Hayles observes, is "undertheorized" and has "more results than philosophy" while the complexity branch "has more philosophy than results," and has been criticized for the paucity of its results (9–10).

8. One of the novel's two epigraphs is from Hawking's *Brief History of Time* (1988): "Why do we remember the past, and not the future?"

9. For an extended reading of the way the new physics appears in and directs the subjectivity of *Cat's Eye*, see my *Fiction in the Quantum Universe*, 159–89.

10. Atwood, *Wilderness Tips*, 145–62. Like other stories in the collection, "The Age of Lead" was published previously—five times, in fact. It appeared earliest in *Toronto Life* (August 1989); it also appeared in *Lear's, The New Statesman, Neue Rundschau,* and *Colors of a New Day: Writing for South Africa.* In her generally negative review of *Wilderness Tips*, Sherill Grace singles out "The Age of Lead" for praise; it "is Atwood at her best." See Grace 75–76.

11. "The riddle of the last Franklin expedition has all of the elements required to elicit and maintain widespread interest—struggle, shipwreck,

murder, massacre, cannibalism, and controversy. . . . The Franklin saga is a puzzle without the prospect of complete solution," writes David Woodman in *Unravelling the Franklin Mystery*, 5, 7.

12. In 1991, she delivered four lectures at Oxford University on the subject of Canadian literature, focusing on what she calls "a few of the more *outré* menu items" in history and legend that emerge in Canadian literature. The first of the four lectures is about the Franklin expedition, which encapsulates Canadian themes of "being lost in the frozen North—and going crazy there." One of the fictional treatments she discusses in this lecture is her partner Graeme Gibson's 1982 novel *Perpetual Motion*. Atwood's lectures are published as *Strange Things: The Malevolent North in Canadian Literature;* I quote from page 3.

13. In the first publication of the story in *Toronto Life*, Atwood acknowledges this book as her source; a note following the story says, "Material dealing with the Franklin Expedition and exhumation of John Torrington is from *Frozen in Time*, by Owen Beattie and John Geiger, Western Producer Prairie Books, 1987. There was a television program on the subject; the one in this story is imagined" (54). I am grateful to Nina Kootnekoff, Assistant to the Editor of *Toronto Life*, for helping me locate a copy of the first printing of the story.

14. The virus appears to be distinguished from AIDS. Two friends of Vincent die of AIDS (159), but Vincent's virus "didn't even have a name yet" (160).

15. A final irony is that Beattie's autopsy found that the primary cause of Torrington's death was indeed "consumption"; the lungs were completely blackened and scarred with adhesions. Torrington, lead stoker on the vessel, had "anthracosis, caused by the inhalation of atmospheric pollutants such as tobacco and coal dust" (122). He also had emphysema and tuberculosis; according to Beattie, "pneumonia was probably the ultimate cause of death" (122). Though Torrington died of massive environmental poison, the lead he ingested onboard the *Terror* was only one component of a generally toxic environment.

16. Coral Ann Howells argues that the group of stories collected in *Wilderness Tips* presents a bleak reading of the wilderness under threat from pollution and urbanization; see pages 20–37.

17. He is assertive and comic in costume and mask, virtually indeterminate outside the series of roles he plays. He looks both very old and childlike; Jane wonders whether he is gay or not, but doesn't know; he has an "ancient" smile that discloses "juvenile" teeth (160).

18. Atwood follows Beattie closely here: Hobson, an early investigator, found "a lifeboat from the Franklin expedition containing skeletons and filled with relics." The boat contained an "amazing" quantity of goods, including "everything from boots and silk handkerchiefs to scented soap, sponges, slippers, toothbrushes and hair-combs were found."

M'Clintock, a second investigator, found the articles "a mere accumulation of dead weight, of little use, and very likely to break down the strength of the sledge-crews" (Beattie and Geiger 38–40).

WORKS CITED

Atwood, Margaret. "The Age of Lead." In *Wilderness Tips*. New York: Doubleday, 1991. 145–62.

———. *Cat's Eye*. New York: Doubleday, 1989.

———. *Strange Things: The Malevolent North in Canadian Literature*. Oxford: Clarendon Press, 1995.

Beattie, Owen, and John Geiger. *Frozen in Time: The Fate of the Franklin Expedition*. London: Bloomsbury, 1987.

Bohr, Niels. *Atomic Theory and the Description of Nature,* Cambridge: Cambridge University Press, 1934.

Čapek , Milič. *The Philosophical Impact of Contemporary Physics*. Princeton, N.J.: C. Van Nostrand, 1961.

Einstein, Albert, and Leopold Infeld, *The Evolution of Physics*. New York: Simon and Schuster, 1942.

Gleick, James. *Chaos: Making a New Science*. New York: Penguin, 1987.

Grace, Sherrill. "Collecting Tips." *Canadian Literature* 137 (Summer 1993): 75–76.

Gribbin, John. *Genesis: The Origins of Man and the Universe*. New York: Delacorte, Eleanor Friede, 1981.

Hayles, N. Katherine. *Chaos Bound: Orderly Disorder in Contemporary Literature and Science*. Ithaca, N.Y.: Cornell University Press, 1990.

Heisenberg, Werner. *The Physicist's Conception of Nature*. Trans. Arnold J. Pomerans. New York: Harcourt, 1955.

———. *Physics and Philosophy*. New York: Harper, 1958.

Howells, Coral Ann. *Margaret Atwood*. New York: St. Martin's, 1996.

Kuhn, Thomas S. *The Structure of Scientific Revolutions*. Chicago, Ill.: University of Chicago Press, 1962.

Morris, Richard. *Dismantling the Universe: The Nature of Scientific Discovery*. New York: Simon and Schuster, 1983.

Munro, Alice. *Friend of My Youth*. New York: Knopf, 1990.

Strehle, Susan. *Fiction in the Quantum Universe*. Chapel Hill: University of North Carolina Press, 1992.

Waldrop, M. Mitchell. *Complexity: The Emerging Science at the Edge of Order and Chaos*. New York: Simon & Schuster, 1992.

Woodman, David. *Unravelling the Franklin Mystery: Inuit Testimony*. Montreal: McGill-Queen's University Press, 1991.

Zukav, Gary. *The Dancing Wu Li Masters*. New York: William Morrow, 1979.

Postmodern Cuisine

The Cilantro Cannot Hold

Postmodern Cuisine Beyond the Golden Arches

Paul Budra

Powdered Orange Juice
Potato Chip Bars
Whey Cheese Spread
Dehydrofrozen Peas
Hormone and Antibiotic Enriched Pork and Beef
Lowfat Milk[1]

odernity came late to the table. Enlightenment optimism and the scientific domination of nature promised freedom from scarcity and want, which meant most pressingly the guarantee of a well-stocked pantry,[2] but the practical rationalization of cuisine required advanced technology to break the bond between garden and kitchen and to obliterate the seasonal and local cuisines that the perishability of foodstuffs had enforced. When modernity came, it came in stages: first to production, then to both haute and popular cuisines. And it came most forcefully to America.

Food production was modernized in Chicago in 1875. In that year both Gustavus Franklin Swift and Philip Danforth Armour set up shop in the city that had recently surpassed Paris as the beef-processing center of the world. While the production systems of the Chicago stockyards had already been rationalized by Joseph G. McCoy, who had ended the cattle drives by shipping cattle by rail in 1867, it was Swift's notion of

refrigerated cars carrying dressed meat, rather than live animals, that allowed for the final systemization of meat production. Chicago's increasingly automated abattoirs, in turn, required new technologies, systems of organization, and economic planning. All by-products were used and processed, and the products were shipped directly to butchers or, if preprocessed, to wholesalers in the newly invented triangular cans.[3] Fordism was born in the slaughterhouse.

These advances in production were accommodated with innovations in marketing. The most important were in packaging. The move in the nineteenth century from bulk to prepackaged food was touted as a breakthrough in hygiene. In fact, it was a financial windfall: packed foods were easier to transport, required less shelf space, and helped to minimize losses due to damage (Root and de Rochemont 240). Packaged foods ended up playing a large role in the new marketing ploy of George Hartford and George Gilman, founders of the Great American Tea Company in New York in 1859. Seeking to eliminate middlemen, Hartford and Gilman bought foods in bulk and imported their own foods. This led to the creation of the first chain merchandisers of food, eventually known as A&P stores, a chain so successful that it expanded across America between 1912 and 1915 at the rate of one new store every three days. A&P's franchise system and warehouse capacity placed it ideally for the move toward suburban supermarkets that took place in America after World War II and that accounted for 62 percent of all food sales by 1956. The supermarket revolution, in turn, directly affected production and, eventually, farming itself. In 1945 the head of A&P's poultry research sections would be urging the nation's poultry developers to invent a more efficient chicken through a national Chicken-of-Tomorrow contest (Levenstein 109–13). Marketing pressures would, by the 1950s, be redesigning nature. The factory farm was created to stock the shelves of the local Piggly Wiggly.[4]

The ultimate phase of the rationalization of food production was the elimination of food itself. The forties and fifties saw an explosion in food chemistry that made this possible. Additives—preservatives, coloring agents, artificial flavors, emulsifiers, smoothers, stabilizers, and flavor enhancers (MSG)—allowed producers for the first time in history to make the edible illusion of food out of nonfood. Coffeemate, the synthetic whitener, is made of glucose syrup, hydrogenated canola oil, sodium caseinate, dipotassium phosphate, tricalcium phosphate, color, diacetyl tartaric acid, esters of monoglycerides, mono- and di-glycerides, citric acid, acetic acid, BHA, and BHT. "Cheese foods" replaced cheese, and Tang took the place of orange juice. To paraphrase Lyotard, the question now asked by the "food scientist" was not "is it food?" but "is it edible?" (51).

> Tortue verte a la Waldorf
> Celeris Amandes salees Olives

Crabes d'huitres a la Newburgh
Pointre de pintade farcie, sauce diablee
Pommes douce a la Dixie Couers de laitue a la francaise
Pudding au riz a l'americaine
Cafe[5]

It took America to modernize haute cuisine. Whereas in France cooking could be divided into a series of practical (potager, bistro) and regional subsets, in America, and especially in New York, the fetishizing of the French as a *general* method gave haute cuisine a teleology. As in the arts, the European aesthetic defined modernist high culture and set its elitist tone. Chefs had to be French, waiters had to have French accents, and menus, no matter how parochial their offerings, had to be Frenchified. This trend entered America through the Delmonico family, who, in 1831, converted their New York pastry shop into a restaurant complete with a French chef. Delmonico's, in a variety of offshoots, would dominate the New York gourmet scene for the rest of the century and would pave the way for the Waldorf-Astoria and, especially, Le Pavillon, venue of the influential Henri Soule.[6] French cooking was brought to the masses by television, particularly by Julia Child, an American trained late in life in classic French cooking. Her show, *The French Chef,* while demystifying the techniques of French cuisine, nevertheless continued the association of serious cooking and France. The two words in the title of her show became synonyms.

To be fair, French cooking, as it has been exported, lends itself to modernity's rationalism. Escoffier betrays a Hegelian spirit of totality in his influential cookbook. On the first page, he lays down the law: "stock is everything in cooking" (1). Stocks are the basis of sauces, which can be divided into "the leading sauces, also called 'mother sauces,' and the small sauces" (15). Stocks, sauces, and garnishes form the general principles of "the science of cookery"; recipes are the particular manifestation of a combination of general principles and specific ingredients. And the entire system is regulated by principles that are Newtonian in their immutability: "hors-d'oeuvres should only form part of a meal that does not comprise soup, while the rule of serving them at luncheons only, ought to be looked upon as absolute" (Escoffier 139).

Nettle salad with green tomatoes and sorrel
Dialogue of fruit purees
Poached chicken breast with raw seasonal vegetables
Braised lentils
Oatmeal ice cream[7]

Nouvelle Cuisine, and its various spin-offs such as Cuisine Naturelle, which emerged in the 1970s and was especially popular in California, was

to classic French cooking what cultural modernism was to modernity: a supposed reaction to a moribund tradition that, in fact, shifted but did not disrupt the teleological certainties of Enlightenment rationality. So, while Nouvelle Cuisine presentation drew attention to surface details and even hinted at fragmentation—with the large plates, isolated components, and emphasis on "natural" colors—the entire project was directed by an inverted, but pervasive, narrative: "It claims to be a struggle of invention against tradition and of lightness against heaviness. But in fact it is merely reacting against another erudite cuisine, another 'invention', another academicism, rather than against true tradition, which is rooted in the soil" (Revel 270). The teleology was, of course, late nutritional science. Emphasizing freshness of ingredients; fetishizing presentation and, especially, color; and reacting against the excesses of classic French cooking by reducing the reliance on cream, butter, oil, and alcohol, this modernist cuisine nonetheless found itself, like cultural modernism, complicit in the systemization that it was putatively reacting against: "A good rich stock is one of the most important things in fine cooking. . . . [I]t is even more important in Cuisine Naturelle" (Mosimann 21). This wave of cooking simply restructured and moved the sauces: rather than cover the entrée, they were pooled beneath it. The subject was foregrounded, fragmented away from the theoretical base, but the base remained, forming a background to the fragmentation, a rapidly cooling, congealing nostalgia for the reassuring certainties of modernity.

> Large Coke
> Big Mac
> Large Fries
> Apple Pie

Popular restaurant cuisine was modernized by the franchise restaurant. The first entrepreneur to apply the full rigor of Enlightenment rationalization to the problem of restaurant cuisine production and marketing was Howard Johnson.[8] Beginning in 1935, Johnson designed a franchise chain of roadside restaurants that took advantage of the burgeoning car culture of America. The distinctive orange roofs of his restaurants were chosen for their visibility from the highway, and the food preparation was streamlined for speed (Levenstein 48). Franchisement meant homogenization, and when this was coupled with America's patriotic distrust of the foreign (and possibly the unhygienic) and with the innovations of the food-processing sector (soup bases, instant mash potatoes, and frozen foods) in the 1950s and 1960s, popular restaurants soon became machines for the reproduction of bland, consistent foods. The typical meal they served (green salad, roll, steak, two vegetables, coffee, pie) was based on the Midwestern cuisine that came to dominate American tables after World War II, which

had further homogenized the palate of the nation when meals based on this menu were served to American enlisted men fighting across the world.

The most potent example of Enlightenment rationalization in the production of popular cuisine came surprisingly late in the century. As Ray Kroc, founder of the McDonald's empire, notes in his wonderfully titled autobiography, *Grinding It Out,* the epiphany that he experienced when he visited the original McDonald's had nothing to do with food. Visiting the McDonald brothers' drive-in in San Bernardino, California, in 1954, Kroc explains, "I was fascinated by the simplicity and the effectiveness of the system. . . . Each step in producing the limited menu was stripped down to its essence and accomplished with a minimum of effort" (Kroc and Anderson 8). The rationality of the *process,* not the quality of the product, inspired Kroc to franchise McDonald's.[9] The resultant chain of stores became, through careful central planning and limited individual franchise innovation, the most potent symbol of modernity—specifically American modernity—in cuisine, perhaps in all twentieth-century culture. There is no more pervasive example of destructive universalization than the ubiquitous golden arches. As Paul Ricoeur puts it, "In order to take part in modern civilization, it is necessary at the same time to take part in scientific, technical, and political rationality, something which very often

Table 1

Modern	Postmodern
Julia Child	Emeril
Junk food	Comfort food
Paul Bocuse	Wolfgang Puck
Ketchup	Salsa
Parsley	Cilantro
McDonald's	Subway
Beef	Chicken
Steak	Pasta
Frying	Grilling
Margarine	Extra virgin olive oil
Wonder Bread	Foccaccio
Haute Cuisine	Bistro
Le Pavillon	Chez Panisse
Cabernet	Zinfandel
Joy of Cooking	*Adventures in the Kitchen*
Paris	San Francisco
Supermarket	Chacuterie
Coca-Cola	Crystal Pepsi
Gourmet	*Chile Pepper*
Factory farm	Free range

requires the pure and simple abandon of a whole cultural past" (277). And that means being able to offer a Big Mac. At the same time, the vast profits generated by this frenetic circulation of hamburgers are largely driven by advertisements—media images—rather than food. Ronald McDonald tempts children and their exhausted parents into McDonald's Land, a surreal, day-glow landscape peopled with talking burgers and cuddly monsters, with the promise of toys, not sustenance. Food has become the least important element of the modern food economy.

As table 1 makes clear, postmodern cuisine can be marked in several ways. It can be distinguished by both Lyotard's "degree zero of contemporary culture"—eclecticism—and the "incredulity toward metanarratives" resulting in the rise of "local determinism" (76, xxiv). To a lesser extent, postmodern haute cuisine has been marked by Baudrillard's simulacrum, the image for which there is no original, and Fredric Jameson's idea of "neoethnicity" (Baudrillard 13; Jameson 341–42). Whatever the defining dominant, the postmodern in cuisine has been caught in many of the same paradoxes as the postmodern in architecture. While rejecting the universalizing effects of modernity's rationalism, it cannot return to the premodern, that is, take a resolutely *arrière-garde* approach, because of advances in technology and shifts in culture.[10] Its relation to cultural shifts, especially the increasingly multicultural composition of contemporary urban centers, is worked out in glib metaphors of heterogeneity and the privileging of esoterica. Its relation to the past "is always a critical reworking, never a nostalgic 'return'," though that return may be marketed through cultural anamnesis (Hutcheon 4). However, unlike in architecture, there is no bourgeois nostalgia for premodern cuisine, the effects of modernity having been so pervasive in cuisine since the end of World War II that the nostalgia that does exist is for the very excesses of modernity that the postmodern rejects.

In terms of production and marketing, the postmodern has been a reaction against the technologies that allowed for the dissemination of exotic, if bland, ingredients and dishes in the first place. In reaction against canned goods, nonseasonal produce, and factory-farmed meats, the postmodern gourmet shopper frequents specialty shops for produce that is pesticide-free, relentlessly seasonal, and politically correct: its harvesting and production must not have threatened indigenous peoples or photogenic sea mammals. The chicken-of-tomorrow has been replaced by the free-range bird, the ubiquitous kiwi by the autumnal spaghetti squash. The return of the farmer and garden market in the city, the revival of the local butcher stores and delicatessens, the legitimizing of the health food store, and the springing up of cottage food production industries are all indicators of both a general shift in the economy—what David Harvey has called the move from Fordism to flexible accumulation—and the fragmentation of consumer taste.[11]

Rejection of the supermarket model of food distribution is, of course, not new.[12] What is new are the ways in which supermarkets have responded to the challenge. Increasingly the supermarket is offering the illusion of fragmentation within itself by creating semiautonomous sections—the deli, the bakery, the fish market—each given its own decor in the attempt to foster the collective illusion of a disparate, multi-owned public market. Alternatively, or concurrently, the supermarket manufactures the illusion of quirky individualism through its marketing practices. In Canada, Loblaws offers its own brand-name products (many of which declare their trendy internationalism with names like "Memories of Bangkok Fiery Dipping Sauce"), each bearing the seal of approval of the chain's then president, Dave Nichol, who became a Canadian celebrity through his advertising flyers, each of which details his personal discovery of the new products.

In cooking, the advent of local determinism can be seen in the return to regional and seasonal ingredients, itself a reaction to the ubiquity of the geographically displaced, weeks-old produce of the supermarkets. This at once marks much contemporary cuisine as both *pre* and *post* modern: *pre* because it is returning to the conventions of sense that prevailed before the homogenizing technology and theory of modernity invaded the market and palate; *post* because it has done so consciously, in reaction to modernism and with the aid of contemporary technology and intercultural sophistication that allows for the paradoxically wide dissemination of "regionality." The result has been the transportation of the regional out of geographical constrictions and into the hyperreality of restaurant space and yuppie kitchens.

An example might be the rise of Cajun cooking in the late 1970s. Promoted by Paul Prudhomme, chef at K-Paul's Louisiana Kitchen in New Orleans, this semitraditional cuisine (Prudhomme mixed Cajun with Creole) was itself representative of a move away from the bland French cooking that had become accepted as haute cuisine across America. But through cookbooks and television specials, Prudhomme's Louisiana cooking spread. Soon every major city on the continent could boast a Cajun restaurant selling blackened fish. Similarly, the traditional ethnic restaurants fragmented into regional groups. Chinese restaurants became Szechuan or Cantonese restaurants, and French restaurants became Provencal or Norman bistros. The restaurant public learned the differences, and so regionality became commodified, universalized, and at the same time ironically dislocated. The hyperreality of the restaurant quickly moved to the home kitchen. Regional and ethnic cooking classes sprang up in continuing education centers, and a knowledge of esoteric cuisines became a symbolic capital for the upper middle classes who might have no knowledge of the indigenous cuisine of their own locale or ancestors.[13]

This glib internationalism and *faux* regionality finds its most famous

spokesperson in television's Frugal Gourmet, Jeff Smith. Smith peppers his cooking lessons with a sort of cheery *National Geographic* summation of the culture from which the dishes he is cooking emerged. One of his recent cookbooks, *The Frugal Gourmet on our Immigrant Ancestors*, begins with what would seem to be a postmodern celebration of the diverse and ex-centric: "Thank God the concept of the melting pot has never worked" (Smith 2). America, Smith believes, forms "a sort of stew, in which many traditions and flavours and cultures can each add to the pot, but each can be distinguished" (3). The reason to learn foreign cuisines is "to know these particular immigrant groups. They live here and belong here, and they come from heroic circumstances. What a way to study peace!" (4–5). This rationale is offered without irony and certainly without the consciousness of historicity usually indicative of postmodern appropriations of the past. Rather, Smith declares that "ethnic cooking in our time is not 'in' just because it tastes good. It is historical and meaningful on its own" (5). Smith is engaged in a cultural practice without the consciousness of the implications or contexts of that practice. His confidence is founded in a Christian essentialism (Smith is a minister), but, like the "foodie" preparing sashimi in a New York loft as a currency of prestige, his celebration of difference is merely a display of difference. He creates the illusion of the eclectic without ever risking a centripetal fragmentation away from his control into the threatening alterity of, say, Phillipine roast dog. America may be a stew, but Smith chooses what goes in his pot.

> Spinach Soup with Garlic Croutons
> Tortellini Filled with Pumpkin Squash
> Mixed Grill of Quail, Guinea Hen, and Pigeon on a Wilted Salad
> Italian Cheeses
> Chianti Sherbert[14]

This is not to dismiss all cultural eclecticism and regionality as hopelessly complicit in the nostalgia for the certainties of modernity. The radical pluralism of some recent haute cuisine, cuisine that attempts to maintain an honest heterogeneity of ingredients, techniques, and the gastronomic practices and traditions they represent, seems to be a move toward the truly multivalent. This eclecticism stands in contrast to the established marriages of convenience—the American-Chinese restaurant that saw the promulgation of the profoundly nontraditional chop suey— by being a conscious attempt at cross-culture pollination, though it can devolve into a forced marriage of the disparate for shock value. And it sidesteps the struggle between innovative and traditional cooking that seemed eternal in haute cuisine.[15] The most famous exponent of this new eclecticism is the chef Wolfgang Puck, whose California restaurants consciously and successfully join, though do not blur, disparate cuisines: his

restaurant Chinois fuses French and Chinese, and Spago brings together Italian and Californian.[16] Wolf and, perhaps more importantly, Alice Waters have trained a generation of chefs who have no stake in perpetuating a standard repertoire of dishes.[17] Indeed, they have no stake in constructing classic menus for individual meals, drawing instead upon a broad cross section of cultures within the dining experience.[18]

And true regionality can still be found in restaurants that refuse to compromise with the popularized versions of their local cuisines. Tex-Mex food, for example, is now as ubiquitous as Cajun. Nachos are even dispensed by machines that glop warm processed cheese onto preservative-rich chips. But a restaurant such as the Coyote Cafe in Sante Fe, New Mexico, refuses to slip into the hyperreal version of its regional cuisine. It maintains a strict adherence to seasonal and local ingredients—an adherence that requires a daily updating of the menu—that makes a displaced re-creation of its food difficult. And it displays a deep historical sense of local cuisine which allows for a playful, but not trivial, relation with the past, a reworking of the historic that is grounded in shared tradition rather than ersatz nostalgia. A Coyote Cafe entrée like the pecan-grilled filet of beef with smoked vegetable barbeque sauce, red chile mashed potatoes, and artichoke-mushroom ragout evokes traditional cowboy fare with its large piece of grilled meat and its mashed potatoes, while at the same time being sophisticated in its preparation and presentation. The latter evokes not so much local history as it does local geography: the beef is perched on a mound of potatoes that has been framed by corn chips. The resultant sculpture evokes the mesas rising above the surrounding New Mexico desert. The price of such rootedness is, ironically, very high. Food production structures make it cheaper to offer bland French cuisine in New Mexico, or Tex-Mex in Halifax, than such resolutely regional fare.

But a true sense of history is rare in postmodern cuisine. As David Harvey observes, "Eschewing ideas of progress, postmodernism abandons all sense of historical continuity and memory, while simultaneously developing an incredible ability to plunder history and absorb whatever it finds there as some aspect of the present" (54). Much of postmodern cuisine can be defined by such plundering, but what results is usually a pastiche of historical allusion that is much less successful than the analogous cultural referencing. For example, in cooking techniques, the return of grilling is an obvious gesture at a historic cuisine: neanderthal. Now, however, the meats to be grilled are carefully skinned and marinated, and, once the image of the past is burned onto the meat in the form of the grill marks, providing it with an anamnesis that hints at both primitivism and childhood backyard barbecues, the food is whisked off the fire to be placed in a papaya sauce and adorned with shredded pickled ginger. The finished entrée is at once nostalgic in appearance, eclectic in seasonings, and regional in that all the ingredients would have been purchased at the

farmer's market that morning. But there is nothing outside the plate to which the meal can gesture, no historical, geographic, or ethnic referent. Served on a huge, brightly colored plate, we have Baudrillard's simulacrum: the evil dinner of images.

The anamnestic finds further outlet in the haute cuisine remake of popular cuisine. Four-star restaurants are preparing gourmet versions of fast food or deli specialities, exotic burgers and tri-colored french fries, all made to look the way the burgers of our childhood should have looked.[19] On the surface this would seem to be simply a postmodern breakdown of high and low cultures, but it is more complicated than that. The gourmet pizzas lovingly photographed in James McNair's *Pizza* cookbook at once reference popular cuisine while enforcing the distinction, through toppings, of high cuisine. The pizza crust is a historical referent, a playful allusion to the food of our youth and the bland cuisine of modernity,[20] but the toppings (Kung Pao shrimp, caviar) bring it into the present through an untraditionality that smacks of both the adult predilection for the esoteric and luxury consumerism, thereby foregrounding the socioeconomic conditions in which the pizza as a whole exists. The familiar foodstuff is relabeled; attention is drawn to its nostalgia value at the same time as its contemporary culture currency is being proclaimed in the sumptuous photographs that accompany every recipe.[21] In popular cuisine itself, Classic Coke attempts much the same self-parodic strategy, right down to the reissuing of classic bottle designs, but it has been upstaged by Crystal Pepsi, a cola that makes the reworking of its modern referent perfectly clear.[22]

> Pan-Fried Fillet of Beef
> Pommes Anna
> Braised Whole Young Carrots
> Sauteed Watercress
> Jane's Chocolate Mousse Tart[23]

Image, food as simulacrum, does not reach its postmodern epitome in popular or haute cuisine, however, but in the resolutely middle-class works of Martha Stewart. Stewart, a self-promoting marketing genius, has built a career out of selling lifestyle images. Her cookbooks rely heavily on recipes that give an image of traditional, usually American, cooking. Although avoiding the complex culinary traditions behind the various dishes she presents, her foods *look* good. The currency of value is entirely symbolic and derives from the presentation, not the nutritive or even taste value of the food. The lifestyle image being manufactured—urbane, quietly sophisticated, continental in a safely American way—is sustained in her cookbooks not by the recipes but by the notes on their presentation: "The table is set with hand-made linen placemats designed and woven by my daughter, Alexis, and illuminated by a grouping of . . . kerosene lamps" (Stewart,

Black, and Geiger 30) or "A simple salad of endive and red onion looks especially inviting on an old Majolica plate" (39). The present—the salad—is framed by the nostalgic—the handmade mats, the lamps, the plate. But the nostalgia is not a naive antiquarianism; it cannot so be while the very contemporary entrée sits in the center of the place setting. It is, rather, an empty simulation, a historical romance version of a time that never was.

Fast food, by definition, is complicit in modernity, and we should not expect to see a postmodern restructuring of the basic economic priorities by which it is sustained. Established chains such as McDonald's have reacted to the plurality of contemporary culture not with an overhaul of process but with the adaption of those processes to new, often transitory, products. In 1991 the chain had more test products in the market than it had ever had in its history. And it has been making tentative, and conspicuously bland, gestures at regional and ethnic foods, such as the burrito and fajita.[24] But the introduction of pizza by McDonald's hardly qualifies. After an initial ad campaign that emphasized the Italianness of their new product, McDonald's has gone to treating the pizzas, which come like the burgers with set combinations of toppings, as another American foodstuff. Perhaps the closest the fast-food industry comes to a postmodern franchise is the very successful Subway chain. The kiosk-style stores are reminiscent of New York sandwich bars, though appropriately simplified. The smallness of the stores and the limited number of staff blurs the line between management and worker. The bread for the sandwiches is baked on-site, giving the illusion of store autonomy. The sandwiches come in a variety of styles and can be customized with a wide range of toppings. Because the sandwiches must be constructed by hand, rationality can be applied only to the layout of the restaurant and the sandwich construction table. The employees are not, as they are in McDonald's, machine operators; they come perilously close to being cooks. But the final product fails as a sign of authentic cuisine. It is neither hoagie nor Philly Cheese Steak.

The image of postmodern plurality in fast food is best found in the mall food court. Here, foods that ostensibly draw on a variety of ethnic and nutritional concepts nestle side by side: an "olde English" fish and chip booth stands beside a "gourmet" cookie outlet across from a Japanese noodle stand and a deli sandwich bar. This Foucaultian *heterotopia* is, of course, illusionary. The stands are all united by their reliance on food preparation systems that employ all the tools of modernity's production science, and none of the attendants in the outlets is from the country the cuisine they serve purports to represent. But that illusion, preserved at least in the script of the neon store signs and the stylized food containers, is itself indicative of both postmodernity's dependence on image and its economic assimilation of diversity. The foods remain the same, deep-fried and heavily salted, but are variegated through image marketing into consumable ethnicities. Brillat-Savarin's famous maxim, "Tell me

what you eat, and I shall tell you what you are," has been transformed. In the postmodern restaurant, kitchen, supermarket, and food court, the new maxim is, "Tell me what you think you're eating, and I shall tell you what you think you are."

NOTES

1. Menu of a "research luncheon" served to President Dwight D. Eisenhower in 1953. Cited in Levenstein 113.

2. On this point, see Harvey 12.

3. See Root and de Rochemont 192–211.

4. Interestingly, the relation between Fordism and the economics of the supermarket may be very direct. See Hollander and Marple.

5. Menu for the Waldorf-Astoria dinner honoring the Prince of Wales in 1919. Cited in Root and de Rochemont 343.

6. See Claiborne (157) for an overview of Soule's influence on American haute cuisine.

7. Menu compiled from Mosimann's *Cuisine Naturelle*.

8. The idea of the franchise itself seems to have been developed from the production practices of General Motors. See Boas and Chain 147.

9. The emphasis on process in the fast-food industry finds its bureaucratic signifier in top-heavy management practices and the increasing reliance on computer modeling to streamline outlet production. See Reiter 119.

10. See Frampton 272.

11. David Harvey speculates that the "economies of scale sought under Fordist mass production have, it seems, been countered by an increasing capacity to manufacture a variety of goods cheaply in small batches" (155). The increasing popularity of locally produced foodstuffs would seem to be a case in point.

12. See Cross 1–13.

13. The cover story "Love in the Kitchen," in *Time* magazine (19 December 1977), glowingly recorded this new economy of prestige: "it's a real challenge and a status symbol to come up with something your company hasn't tasted before, something they don't even know how to pronounce" (54).

14. Menu from Chez Panisse. Cited in Michener and Prout 90.

15. See Revel for a discussion of the long-standing battle between cuisines of creation and tradition (269).

16. For an overview of Puck's career and its cultural significance, see Miles 191–303.

17. See Martin F5.

18. See Michener and Prout 90 for an example of how Waters constructs a menu at Chez Panisse. See "California Cuisine: The Passion of Puck" for a description of Puck's techniques (52–60).

19. For an example of such recipes, see Birsh 104.

20. Italian food was the first ethnic cuisine allowed into the modern American kitchen. It was, of course, carefully stripped of such esoterica as garlic. See Levenstein 29–30; and Root 311–12.

21. See James McNair. Fully half of the book, and the others in the series, is given over to stylized photographs. The series itself is an interesting example of postmodern disjunction: each book celebrates a particular foodstuff—potatoes, cold pasta, salmon—out of context of any culinary tradition or menu.

22. Coke's attempt to capitalize on its own history has led to odd, but suggestive, marketing practices. Recently issued *cans* of Classic Coke are decorated with a picture of a classic *bottle* of Coke.

23. Menu from Stewart, Black, and Geiger 163.

24. For a review of McDonald's (and other fast-food chains') plan for diversification, see "400: Overview," 13–154.

WORKS CITED

Baudrillard, Jean. *The Evil Demon of Images.* Trans. Paul Patton and Paul Foss. Sydney, Australia: Power Institute of Fine Arts, 1987.

Birsh, Andy. "Spécialités de la maison—New York." *Gourmet* 28 January 1994: 104–7.

Boas, Max, and Steve Chain. *Big Mac: The Unauthorized Story of McDonald's.* New York: Dutton, 1976.

"California Cuisine: The Passion of Puck." *Restaurant Hospitality* May 1985: 52–60.

Claiborne, Craig. *Craig Claiborne: A Feast Made for Laughter.* Garden City, N.Y.: Doubleday, 1983.

Cross, Jennifer. *The Supermarket Trap: The Consumer and the Food Industry.* Rev. ed. Bloomington: Indiana University Press, 1970.

Escoffier, Auguste. *The Escoffier Cook Book: A Guide to the Fine Art of Cookery.* New York: Crown, 1990.

"400: Overview." *Restaurants & Institutions* 24 July 1991: 13–154.

Frampton, Kenneth. "Toward a Critical Regionalism: Six Points for an Architecture of Resistance." In *Postmodernism: A Reader,* ed. Thomas Docherty. New York: Columbia University Press, 1993. 268–80.

Harvey, David. *The Condition of Postmodernity.* Cambridge, Mass., and Oxford: Blackwell, 1990.

Hollander, Stanley C., and Gary A. Marple. *Henry Ford: Inventor of the Supermarket?* East Lansing, Mich.: Bureau of Business and Economic Research, Graduate School of Business Administration, Michigan State University, 1960.

Hutcheon, Linda. *A Poetics of Postmodernism: History, Theory, Fiction.* New York and London: Routledge, 1988.

Jameson, Fredric. *Postmodernism, or, the Cultural Logic of Late Capitalism.* Durham, N.C.: Duke University Press, 1991.

Kroc, Ray, and Robert Anderson. *Grinding It Out: The Making of McDonald's.* Chicago, Ill.: Henry Regnery, 1977.

Levenstein, Harvey. *Paradox of Plenty: A Social History of Eating in America.* New York: Oxford University Press, 1993.

"Love in the Kitchen." *Time* 19 December 1977: 54–63.

Lyotard, Jean-François. *The Postmodern Condition: A Report on Knowledge.* Trans. Geoff Bennington and Brian Massumi. Minneapolis: University of Minnnesota Press, 1984.

Martin, Richard. "Top Chefs Predict Cross-Cultural Menus for 1987." *Nation's Restaurant News* 1 January 1987: F5.

McNair, James. *Pizza.* San Francisco, Calif.: Chronicle, 1987.

Michener, Charles, and Linda R. Prout. "Glorious Food: The New American Cooking." *Newsweek* 29 November 1992: 90–96.

Miles, Elizabeth. "Adventures in the Postmodern Kitchen: The Cuisine of Wolfgang Puck." *Journal of Popular Culture* 27.3 (1993): 191–203.

Mosimann, Anton. *Cuisine Naturelle.* London: Macmillian, 1987.

Reiter, Ester. *Making Fast Food: From the Frying Pan into the Fryer.* Montreal and Kingston: McGill-Queen's University Press, 1991.

Revel, Jean-François. *Culture and Cuisine: A Journey Through the History of Food.* Trans. Helen R. Lane. Garden City, N.Y.: Doubleday, 1979.

Ricoeur, Paul. *History and Truth.* Trans. Charles A. Kelbley. Evanston, Ill.: Northwestern University Press, 1965.

Root, Waverly, and Richard de Rochemont. *Eating in America: A History.* New York: Ecco, 1976.

Smith, Jeff. *The Frugal Gourmet on Our Immigrant Ancestors: Recipes You Should Have Gotten from Your Grandmother.* New York: Avon, 1990.

Stewart, Martha, Roger Black, and Michael Geiger. *Martha Stewart's Quick Cook.* New York: Clarkson N. Potter, 1983.

Afterword

Post-Modernism: A Whole Full of Holes

An Interview with Charles Jencks

MOVEMENT VERSUS CONDITION

AL: Why do you think post-modernism is so hard to define?

CJ: Any period in history is so *multiform* that it never comes down to one definer: historians always find six or seven reasons for the First World War. Any period, and post-modernism among other things is a period, has multiple causes that come as a network. Your question is a bit like asking a fish about the defining aspects of the Mediterranean Sea. Of course, there are some aspects to post-modernism that are clear: it comes after the modern.

AL: You would say that post-modernism is a period designation rather than a genre.

CJ: It's also a genre, a condition, *and* a movement. I understood four or five years ago, when engaging the deconstructionist postmodernists like Fredric Jameson, that they were talking about a *condition* rather than a movement. For many years I had been fighting for a movement or an agenda, and I had not sufficiently taken into account the fact that, inevitably, it is also a condition of civilization, something that is

much larger than the movement. But you have to distinguish the movement from the condition, and they were not doing that. The post-modern *agenda* has many normative aspects to it that are positive: a value system that includes the ecological movement, pluralism, double coding, ecofeminism, and resisting the negative aspects of modernity, etc. Whereas the post-modern *condition* is growing in spite of whether anyone wants it: the electronic revolution, the condition of a tertiary/quarternary economy, the postindustrial society, Madonna on MTV, and other aspects. It is part of the consumer society. In other words, Reaganism was a post-modern condition we suffered but was not like a movement—except for a few on the right.

AL: But was Reagan post-modern?

CJ: Not essentially, but he and Margaret Thatcher, Prince Charles, the Pope, and other "reactionary post-modernists" (or, really, traditionalists) make use, like Madonna, of the post-modern condition and manipulate it very strongly. They are people who have understood how important the simulacrum is and the importance of conviction politics. Even though they may have ersatz convictions, they understood the importance of simulating them through the media. In that sense they are important parts of the post-modern condition, just as is the rise of nationalism, tribalism, ethnicism, and other regressive revivals.

AL: Could you tell me what your argument is with Jameson and with deconstruction?

CJ: Their kind of post-modernism is different from what is now being called restructive or constructive or revisionary or ecological post-modernism. There is a split in the two agendas, in the two epistemes. If we say there are two post-modernisms, they grow out of the two modernisms that Frank Kermode and Robert Stern have written about. You could say that Jameson, looking at post-modernism from a Marxist or post-Marxist point of view, privileges economic determinism. Moreover, he ought to be talking about *late* modernism, because his whole thesis on long-wave and short-wave capitalist cycles shows that we are in a late-capitalist cycle of the economy, although there *are* other economic systems that are also running in parallel. After all, there are still feudal systems, and even Neolithic villages, around; but it is true that late capitalism dominates the world system. However, that late capitalism is led by a late-modern civilization, and Jameson does not begin to understand that this is the case. A second, minor, point is that he calls things such as the Bonaventure Hotel (which every intelligent architect knows is very late modern) post-modern because of its post-modern space. I don't want to nitpick because I understand he is talking about a certain kind of spatial confusion and ambiguity, which he says grows out of late capitalism—an interesting point—but

he usually emphasizes the negative implications. He's one of those people who is contradictory here because he came into the world hating post-modernism, and made his reputation attacking it, and then rather came to like it. He's never agreed with the larger post-modern agenda. He has often overinterpreted it as a kind of creepy form of consumerism, distortion, lies, and ersatz. If we date the early sixties as a key period when the early post-modern movements started (feminism was among them), it was an overturning of the modern episteme, the modern worldview, with its four big "isms": materialism, mechanism, determinism, and reductivism. These four "isms" had a stranglehold on Western culture and still do in their "late" forms. But it's crumbling now, and the sixties was the beginning of this breakup. The counterculture was the first crack, something Jameson only understands obliquely.

About 1977 and 1978, when I started writing on late modernism, I understood that there was a great confusion, so I distinguished between late modernism and post-modernism. Then, quite independently and maybe a little later, John Barth, Umberto Eco, and a few key writers and theorists also started to do the same. Then it became possible to see that, in order to define post-modernism, you have to define not only modernism but also the other reactions to it, because there have been several. Now there is even a new modernism or neomodernism. A historian or structuralist would predict this, because you define things in relationship to other things, and they grow in opposition. The meaning of any word depends on the sentence, or the civilization in which it is embedded, and the meaning of post-modernism is, very importantly, in tension and opposition with the other modernisms and the traditional culture. If you don't have that net of oppositions, you can't really understand the concept.

AL: Could you distinguish for me between post-modernism and deconstruction?

CJ: Both deconstruction and post-modernism come after the heyday of modernism. They both know that modernity has problems, and they both criticize and deconstruct the assumptions of modernism. They accept that a period and a worldview are waning, and they are critical of it, and both of them declare "a war on totality." In that way I agree with Lyotard and so many deconstructionists that one of the horrible aspects of modernism is its denying distinctions, or its being insensitive to difference. Both post-modernists and deconstructionists are attentive to qualities of difference. *"Differance"* is Derrida's term for the otherness that is unspeakable and, in a way, that points to the difference between deconstructionists and post-modernists. He and Lyotard and the others always try to speak about the unspeakable: they are, in this way, ultra-modernists who would like to leap into the limit of thought, the sublime, the

unspeakable. That to me is another kind of mystification, although I would agree that a lot of reality (maybe it's a crude thing to say, a quarter of reality) is amenable to deconstructive activity. Everything is, or can be, deconstructed, but the deconstructive worldview is that the universe is full of self contradictory knots, ruptures, and fragmentations. Some of the universe is like that, so I accept part of their worldview, but I disagree that nothing but deconstruction is possible, or that all metanarratives, as Lyotard says, are noncredible.

AL: We should, in the post-modern condition, have incredulity towards metanarratives?

CJ: Yes, we should have incredulity. But the point is that Lyotard accentuates the way metanarratives have broken down, whereas the greater truth is that they have been pluralized, or been made multiform. It's not that people have stopped believing in metanarratives, and not that they are unimportant—as you might guess from listening either to deconstructionists or Lyotard. It is the fact that now many people are contesting them from many different positions, that *belief* (including that reactionary belief I have mentioned) is coming back. That's the big news; the deconstructionists have got it slightly wrong.

AL: Critics seem to define post-modernism in oppositional terms. Two of the terms that come up constantly are homogeneity and heterogeneity, and some argue that post-modernism is trying to make everything homogeneous; trying to collapse distinctions. When there is a McDonald's in every city, and when you sleep in a Ramada Inn, it's a Kafkaesque nightmare because you never seem to be getting anywhere. You are always in the same place—of post-modernism—and some associate it with kitsch.

CJ: That's part of the post-modern *condition*, the ersatz in mass culture. Mass culture and ersatz are the downsides of the post-modern condition—like Reaganism.

AL: Why?

CJ: Modernism introduced mass production and post-modernism has electronicized it: media mass production is much more vicious in its negativity. I accept there is that dark side.

AL: Is Disney post-modern?

CJ: Disney is called the IBM of post-modernism.

AL: But you would argue instead that post-modernism is heterogeneous?

CJ: The "modernism" of post-*modernism* accepts universals. Opposed to the deconstructionists, who usually attack universals as hegemonic, post-modernists are partly *still*-modernists who accept the Enlightenment as

important. At the same time, its "post" qualities attack totality and promote difference as a social value in itself. So multiculturalism grows directly out of this large post-modern paradigm; it's the logical next step in politics and a great question.

POST-MODERN LIBERALISM

AL: What about post-modern liberalism?

CJ: Modern liberalism starts in the eighteenth century when the idea of universal rights is put on the agenda by Jean-Jacques Rousseau, the American Constitution, and the French Bill of Rights. Now most nations, including the United Nations, accept this as the main point of the Enlightenment. Individuals should be protected: free speech, free assembly, equality before the law, color-blind politics. There are about twenty or so aspects of modern liberalism that you and I assume as a background, that we know are socially constructed. We know that, in the beginning, all things are *not* created equal, but the idea of the American and French Constitutions is that all people should be treated as if they were created equal; in an ideal sense, the universe gives the birthright of equal treatment to every person. In nature only electrons and leptons are created exactly the same. But the minute an electron forms part of a larger system, it is unequal, something especially true of anything living. Every living thing is unique. Therefore, when Enlightenment thinkers said that all people are created equal, they were saying something more like this: we wish to have a normative situation in which we act as if all people were created equal. That goal is noble in its universalizing qualities. We in the West have lived two hundred or more years in that system. It works to a degree; the rest of the Second World and Third World is fighting to institute such rights, and the United Nations has even extended some of them to other species. In the nineteenth century, stemming from the Romantic period, another discourse started to grow about difference and, in the fifties and sixties, particularly in America and the North American continent, the notion that we should have a respect for differences grew out of modern liberalism. Then it was seen in terms of ethnicity, feminism, and a whole series of definers that make you and me different. There are ten or twelve things that are most important. Race, gender, and class are the big three, but, as Linda Hutcheon and others have pointed out, you can add nine more to those and you would have a good kind of wheel of difference. All are worth fighting for. Post-modern liberalism grows in the sixties to say, "not only should we act as if we are all created equal, but we have a supplementary goal: we should all act as if our *differences* are respected." This is what Charles Taylor calls the politics of recognition. We need another discourse, another language, that recognizes that these differences are important because they establish our identity. Thus post-modern liberalism

leads to a law, a jurisprudence, that respects equality *and* difference at the same time; something at odds, logically, with modern liberalism; it's a contradictory conflict between two absolute discourses. The post-modern liberal says we must have *both, and* we must balance the claims of both affirmative action *and* a kind of equality.

AL: Difference is often read by detractors of post-modernism as equaling relativism, and the problem with that is that some would see postmodern relativism not just as a celebration of multiplicity but as something that leads to anarchy, to nihilism. Is there something positive and negative about relativism, in the same way that you are speaking about liberalism and balance?

CJ: There are several relativisms, some good and some bad. The bad part is an "anything goes" consumerism, which obliterates distinctions in a mishmash of pseudoculture. Lyotard talks about the slackening of postmodern culture and attacks me as trying to promote it with eclecticism. Like Jameson, he doesn't understand this part of the post-modern agenda, which he equates with smorgasbord culture. But pluralism and eclecticism can be a heightening of discrimination and respect for difference, as well as a leveling—it depends on the creativity and intention of the creator. The good kind of relativism says no language is better or worse than any other language. German may have better qualities than English in some respects and worse qualities in others. Each one has its own quality, relative to each other, and it needs a positive relativism to acknowledge that. Is Gothic architecture better or worse than Classical architecture? A lot can be said for both sides, depending on the urbanism, the structure, and so forth. In an absolute sense one cannot draw the line. You can't do that without postulating a third, or absolute, position from which to judge the other two. That tolerance shows positive relativism—I suppose there are others.

AL: An important one for critics of post-modernism is the charge of moral relativism.

CJ: The most difficult one is the moral relativism that has accompanied the breakup of the modernist worldview and the Christian worldview. To a certain extent, both modernism and Christianity assumed an absolute knowledge of good and bad, right and wrong, better and worse. This is indeed being attacked by the pluralism that is part of the post-modern condition and that is leading to a kind of moral confusion. As Lyotard would say, "Which language game are we playing?" In situational ethics people are confused, legitimately. Who knows in certain circumstances how to act? That is not necessarily catastrophic: it would fall somewhere between the positive and negative relativisms I have already mentioned. If we talk about a post-modern morality, then we have to say that it comes from the cosmos on the large scale and the microcosmos on the small scale. We get

our morality from the universe, from the very big and very small, and of course from the mesocosm in between. We are importantly part of the universe, and therefore our morality is at these three scales. The universe is the measure of all things, not man, and you can make some absolute judgments about it. You can judge people on how they act with respect to the ecological situation, the bioregion, the local community, and other people; so morality hasn't disappeared. We should distinguish between absolute relativism in which anything goes and relative relativism, which is more positive. I would argue that post-modernism is a movement into relative relativism, and that situation is very similar to what fuzzy logic has pictured for us. Imagine a Rubik Cube made up of thirty-two squares. The eight corners represent extreme positions of truth and falsity—absolute truth and falsity, absolute right and wrong, absolute good and bad, absolute pretty and ugly. There are eight positions that are absolute in the old Christian traditional sense of "either/or," "yes/no." In the very center of the cube is the paradoxical space where opposites come together; the remaining twenty-three positions are a mixture of "more or less." In other words, the center contains such absolute contradictions as masculine/feminine, right/wrong, good/bad, and it is oxymoronic.

AL: You're using fuzzy logic not to mean fuzzy thinking?
CJ: It relates to fuzzy thinking.

AL: But you're using it in the terms that it's used in physics to create "thinking" robots.
CJ: I'm speaking of fuzzy logic in terms of how it's used today; in the fuzzy logic chip of computers or the Tokyo subway system or in NASA space vehicles. The fuzzy logic is a logical system that shows, in this cube of space, that some things are absolutes while the center is completely paradoxical, and *all* the other positions, the twenty-three other positions, are fuzzy. If you take away the center and the eight corners, that leaves twenty-three positions. The twenty-three cubes are cubes of more or less "kind of," or "sort of," and that is fuzzy thinking. Fuzzy thinking reflects the fuzzy universe, the fact that twenty-three out of thirty-two spaces are only relatively this or that. In that sense, a moral relativism reflects the nature of the universe. Since a lot of the universe is only "sort of" more this or "kind of" more that, I don't turn apoplectic when admitting relative relativism. The really bizarre space is the center, where part of us can be in two positions at once.

THE ECOLOGICAL AGENDA AND POLITICAL CORRECTNESS

AL: In *The Post-Modern Reader* you say that the end of communism is one of the post-modern shifts, as is the rise of the ecological worldview in

the West, as well as the post-Newtonian sciences. I'm interested in the ecological worldview as being post-modern. So many people seem to associate post-modernism with the consumerism of McDonald's and the kitsch of Disney; they would argue that to be a post-modernist is to be antinature and antiecological.

CJ: Again, the post-modern *condition,* insofar as it is a condition few of us want, is antiecological. The mechanistic, mass-cultural, consumer society, which is heated up by the world economy, is heating up the speed at which we consume nature. There are two kinds of economic growth. There's the GNP, the gross national product that every modernist wants to grow from 1 percent to, in Hong Kong and Taiwan during the 1980s, 15 percent. But look at the natural economy or the earth economy. As the gross national products of these countries go up, then the earth's economy goes down, and the earth's resources go down. We now know we are in an oxymoronic era of "uneconomic growth." We've never known that before—that is a post-modern breakthrough. We have this paradox because we're reaching the point that, the more we grow, the more the ecosystems are moving towards catastrophe. We may have gone past the point where we can get out of this self-organizing spin. We may have overconsumed the biosphere to the point that, the more we grow, the more we kill ourselves, directly. We don't know that, but, with species extinctions being what they are, it looks very much as if that's the case. The post-modern condition of electronic world trade has heated that up; McDonald's has made it worse. But ecology, as a word and a concept, started in the l860s, and it's grown in a series of jumps from the 1960s. Then in 1972 with the Club of Rome report on the limits of growth and the seventies and eighties ecological movement, it is now worldwide and growing by leaps and bounds. Every two years another fifty million people join the world ecological movement. Whether that growth is fast and effective enough we don't know. But in many ways the ecological movement shares the post-modern agenda in terms of its science, its *holism,* and its cosmic worldview. As Thomas Berry says, the earth is primary, we are secondary. The ecological worldview has importantly influenced post-modernism. My only criticism is that the ecological movement carries certain unfortunate bedfellows with it, certain tendencies towards a totalizing worldview that are not very attractive. We know the fascist tendencies and deep ecologists can be somewhat misanthropic. On the other hand, they can be wonderful, spiritual people. One of the great specters on our horizon is that when the ecological crunch becomes so vicious that nearly everyone is working hard to keep alive, the agenda for eco-facism will be extreme; to resist it might be very hard.

AL: In the post-modern formulation, as you have said and written, we would celebrate differences and see the legitimacy of other cultures. But this isn't happening. Political correctness, which in its positive senses

started out by encouraging difference, now seems to want to close down whole aspects of culture. It has been argued that post-modernism is what is behind political correctness in all its negative senses.

CJ: You have to accept that, when you get a change in worldviews, a lot of good things go. I accept the tragedy that a lot of good modern values worth saving and fighting for have been lost. Again, let me say that post-modernists are partly still-modernists, and so what you are talking about is not specifically a post-modern problem. The way reactionaries, such as Reagan, have used the post-modern agenda, which celebrates differences, as an excuse to cut funding for things they never liked in the first place is a form of traditional culture in reaction. That is ironic, and a similar thing happened in post-modern architecture. Architects are a microcosm of society. Prince Charles used post-modern architects to smash modernists, and then he smashed the post-modernists. Reagan used post-modernists the same way. Reactionaries, like others, will grab whatever arguments are at hand and use them to gain power again and, in Reagan's case, to cut worthy modern programs. That is absurd and certainly not on the post-modern agenda. I hope we can accept that post-modernists did not want these things to happen; they were an inadvertent consequence of the growth of the post-modern paradigm.

"Political correctness" is a very curious name and discourse, mostly a right-wing term used to beat off multiculturalism and minority rights by making them appear absurd. The positive aspect to political correctness is the unobjectionable truth that you should respect the rights, values, and languages of others, particularly minorities who tend to be discriminated against. That is a perfectly noble, liberal, and modern set of attitudes. In fact, it comes from the Christian and pre-Christian aristocratic position. It is obvious that you should be considerate toward people whose views differ from your own. That is one of the oldest moral truths. Yet when people try to legislate respect, political correctness becomes as absurd as trying to legislate love or spontaneity. It's bound to kill the very thing you want to bring about. You may be able to legislate the precondition for respect and love, or engender a background in which the respect can occur, but you cannot force it.

What the universe in fact does (so now we're talking about the cosmos) is to persuade or entice or convince, through sensual allure. Every time you try to coerce people, or animals, who are very adept in responding negatively to coercion, you are bound to produce a twisted understanding of the thing that you want. So if we say the master-slave relationship is what post-modernists are trying to get out of, it can't be done by another form of coercion. You cannot legislate the concept that everyone has to enjoy a particular kind of music. You can't legislate respect; but you can legislate the rights that modernists have fought for. If these universals are first established in principle, then the further post-modern rights of

positive discrimination can be attempted. The second presupposes the first and can exist insofar as it does not infringe the rights of another minority. But how do you achieve that respect for another minority? You need to immerse yourself in black culture, for example, and find out what is of value there. You have to go in with the presumption that it is equal to your own culture in some ways. So you go to black churches, listen to black rhetoric, and may find it powerful, truthful, and beautiful. Or you may hear black music and respond that way. But you cannot legislate a respect for a "black Shakespeare" because, if you try to do that, you won't find an exact equivalent of Shakespeare. Even if you do, you might have the inverted snobbery of saying he was better than white Shakespeare because he was black. People will rebel against this because it is condescending to blacks, to whites, and to culture. It is fundamentally wrongheaded, and yet the attempt to go beyond the universalizing culture of modernism is extremely important because we now know a very important truth about the human condition: our identity is constructed in dialogue. That means it is constructed in difference and the dialogue is always with a significant other or person you love or person you respect, or your peer or a person you hate. This dialogue is fundamental to constructing your identity, your personality, and we now know that the worst thing you can do to someone is to suppress their language, suppress their culture: that really kills them. What happens is that people who you suppress get an internalized version of themselves—the slave they have become. Psychologists say the worst oppression is internalized self-oppression; a point not generally granted thirty years ago. Now we are beginning to appreciate that this post-modern breakthrough must occur. Post-Modern liberalism is one of the great struggles of our time, one of the great "ifs" or, "can we do it?"

SOCIAL CONSTRUCTIONS AND THE SELF

AL: In the post-modern world we talk about the subject rather than the individual to emphasize that there is more than an individual essence; there is also a social construction. This is something I find difficult to put across to my students because they say, "Yes, I understand that I am a man or a woman and that I am middle class, but I am still me." You don't seem very keen on the idea of the subject as only socially constructed.

CJ: For a long time, perhaps under the romantics, people thought that the self was like the Christian soul, something like a little man, or homunculus. It might be inside the brain, sitting there, working away, pulling levers rather like the wizard in the *Wizard of Oz*. The self or the soul might be inside the heart or the body-mind, but it was something interior that had an essence, although you couldn't specify it, nor weigh it, nor see it. It was assumed to exist because we feel so strongly that it does exist. The feeling is there, it's undeniable, and it's in all cultures. We all

have a sense of the "I" that transcends the body. And it also transcends the social construction on two levels. Before I mention them I want to emphasize that this feeling is common, intuitive, folkloric, naive, and, I think, true. The position I'm upholding has been on the retreat for the last eighty years; it was attacked by Freudians, Behaviorists, all the modernists, and, today, by the deconstructionists. They, being ultramodernists, have beaten out the last vestiges of a Christian, or transcendent, soul. So few people want to defend what they nevertheless feel in their hearts, and this is a paradox. If you scratch a deconstructionist and make it squeak, it is more than a complicated, socially constructed machine that is squeaking. So there is this problem of the social constructionist who says the self is nothing but a social construction, an elaborated linguistic construction. My view is that social construction exists on a much deeper level than society and construction. That's strange because it exists on the level of your talking to yourself, voices that you internalize. You get that voice from other people socially but also from literature and from self-generation. You also get it from the future as well as the past. T. S. Eliot was in touch with a voice, or wanted to be in touch with the voice, of Virgil and Homer and Western literature. A hermit is in touch with the voice of God, whatever that is, and a lot of people are in touch with voices that are transcendent of the past and of present-day social construction. If the self is constructed socially through language, in dialogic, then you have to expand "society" to something in the future. Karl Marx was in dialogue with a future communist society. Thus social construction is very much an other that is projected out there by the self and then reflected back to the self. It's rather the way some physicists say the universe may have been bootstrapped into existence. By analogy, the self bootstraps itself into a real existence through social *self*-construction. You may not need a real society to do it. Let us be atheists for a moment and assume there isn't a God. That doesn't stop the hermit from talking to God or talking to himself. You could say, "Well, it's just a socially constructed God he's talking to." But it may be an idea that is personally constructed. It's true that as soon as there is a society, any person's idea of God will be mixed up with other people's, so I am not saying the self is not socially influenced. But social construction is a reductivism, another form of modernism.

AL: Does double coding or "use and abuse," as Linda Hutcheon calls it, mean that post-modernism is always folding back in on itself? It's almost like a feedback loop. If what is happening in the literary sphere is "use and abuse," all you have to do when you analyze works of fiction is to figure out what the convention is and then figure out how it's been questioned, and that's it. You end up in figure eights, just going back and forth.

CJ: I think the danger of post-modernism, like any worldview, is that it can easily become a formula. When it becomes loops within loops

everyone starts to hate it. That is a bit like irony. Irony is a wonderful method for questioning, but as soon as it's predictable it becomes self-defeating. As soon as post-modernism does too many loops it really is a bore and ought to start learning new pirouettes. Post-modernism, remember, is always partly within modernism and the universal, so the minute it collapses into internalized loops it is as bad as modernism. That's why I don't mind, occasionally, being called a modernist.

ELITISM AND DOUBLE CODING

AL: Is post-modernism elitist?

CJ: Surely post-modernism in literature and architecture is *anti*-elitist, the whole point of double coding. I agree with Leslie Feidler and the kind of post-modernist who says, "you close the gap, break up the boundaries, get in touch with popular culture, while keeping allegiance to high culture." To do this you have to adopt many voices, or the "many-voiced discourse" that post-modern writers have fashioned. That is why pluralism is always the essence of post-modernism. In regard to my talk about essences, I'm not worried about being a *pure* post-modernist. I think the essence of post-modernism centers around the question of multiple coding, which often comes down to double coding. But basically post-modernism concerns the many-voiced discourse, and that is why dialogic is so important to it and the other ideas of pluralism and multiculturalism. Lyotard, Welsch, and almost all writers, even hostile ones such as Habermas, accept that pluralism is the heart of the movement. If you have a pluralist "heart," what is this centered metaphor? A funny image, isn't it? To have a pluralist essence is also to have a diffused network.

AL: Someone who is not well versed in architecture may look at, for example, Michael Graves's Humana Building in Louisville and not be able to see the "conversation" that is going on between the four sides of that building and those around it. Someone visiting Disneyland may well be told that it is an example of "simulation" and not see the problem with that. Is it only in the academy that post-modernism has an urgency or creates concerns that spawn so many arguments in the halls and in print? Double coding or multicoding may be of interest to academics but may not strike our students as anything of particular interest.

CJ: But the results can be felt, intuitively! Remember that Shakespeare and Mozart were multiplicoding their works. Only in a modernist era do you have to insist on the obvious to get out of a reductivist, single-voiced discourse. The situation has historical causes. To follow Bakhtin's argument on the dialogical novel, Dostoevsky reaches a certain height of self-consciousness about his authorial voice and its relation to the many other voices in his novels. Bakhtin loves the novel because it develops

the open, dialogic form. While Shakespeare and Mozart existed with their many-voiced discourses, we didn't *need* a theory to justify their practice, but since we have been dominated by many years of modernism, specialization, and monologic and the elite forms of their discourses, post-modernists are putting forward a theory that ought to be common practice. So we are fighting a historical battle to bring back something that is lost and rediscovered. If the multiple coding is done well it should reach a broad public. In other words, the Humana Building should get through at many levels. For the same reason any good piece of post-modernism will have much that travels over your head, no matter how well educated you are, because it will have lots of private languages or professional codes. That is why the double coding, the elite coding that is always private, that is always personal, that is always poetic, that you really have to work at, will always be difficult. Post-modernists made a calculated attempt, as did Shakespeare, to bridge the gap. Anything less ends up in the ghetto of elitism. We may be forced back again and again into the ghetto, because we are still in a modernist culture, but the post-modern motive is to get

Humana Building, by Michael
Graves, Louisville,
Kentucky, 1982.

out. The university is still, largely, a modernist institution.

AL: So you would say that post-modernism is not going to go the way of modernism and become part of the establishment?

CJ: It already is part of the establishment. In the arts and architecture, modernism was a contestatory movement from about the 1820s, when it was called avant-gardism, to the 1930s. But with the emergence of democratic, liberal, modern America in the 1950s under Eisenhower, and the Pax-Americana of John Kennedy in the 1960s, modernism triumphed on Madison Avenue, on Wall Street, and at the Museum of Modern Art. It became part of the hegemony, the dominant discourse. Therefore it necessitated, even from within, a successor, a protesting movement, and the sixties were about protests, about taking on the establishment, not necessarily from a revolutionary position. The counterculture was not necessarily trying to overthrow power and take it—as Daniel Cohn-Bendit, the leader of the French student movement, very much understood. Binary power "either/or" struggles led to a succession of thugs. In the sixties this idea was formulated: the notion of the inclusive "both/and." Here is an important point: when post-modernism becomes part of the establishment it ceases to be post-modern because it can't be a ruling ideology, because it is pluralist, and pluralists don't rule or reign. They persuade and debate, and they are always in a position of contesting: they are a permanent opposition, although they may be momentarily in positions of power. So yes, when the discourse becomes part of advertising, or when it becomes the dominant, then it becomes as unpost-modernist as can be. By saying all that, we have defined post-modernism in its ideal, or beneficent, mode, and we have to recognize that, again, there is the rather banal post-modern condition.

Post-modernists trying to make bridges have the besetting sin of being too accommodating, of falling into kitsch; in the sixth edition of *The Language of Post-Modern Architecture* I try to deal with this tendency. It is a problem for the post-modern novel, music, and film, for Gabriel Garcia Marquez, Philip Glass, and Federico Fellini.

The attacks on post-modern fiction have some truth to them, but they are not deadly because they don't grant the complications of the post-modern paradigm, its basic, serious intention of dialogic.

THE UNIVERSE AS MEASURE AND TRAGIC OPTIMISM

AL: You argue in *The Post-Modern Reader* for something called tragic optimism. Could you explain it?

CJ: We live in a time when, among intellectuals, pessimism is the main mode of thought and mood, rather like the Platonic one: that it's all been downhill, that the universe is always going downhill. Since the 1840s,

with the theory of entropy, the view that things are always degenerating, decline has taken hold among the elite and many scientists. It seems now, however—and this idea grows out of entropy—that the universe is always building up things in a creative way. This idea is being theorized under two labels: complexity theory and anti-chaos; but neither is quite good enough. Self-organization might be a better term, but what they are showing is that the universe does have a tendency towards greater and greater order, complication and sensitivity. There is a direction to cosmogenic history that is optimistic because, over time, the universe is turning matter into mind.

Modernists, in their pessimistic mode, said everything is running down, getting worse, is meaningless—nothing ahead but greater and greater boredom. Wherever modernists looked they saw the wasteland; but they were not looking at the universe as a whole. On this planet you can see that we *are* using up energy and organization, as a consequence of modernist industrialization, so there is something to be pessimistic about. Einstein asked, "is the universe a good place or not?" Well, it is a beneficent place, with incredible, bountiful giveaways of energy, creativity, beauty, and goodness. That is what the rule of the universe seems to be. It seems to be giving away gifts, and, when you think of it deeply, you cannot but be impressed by the incredible free lunch that is not only free and a lunch but also beautiful and sexy. That is a basic truth. Second, from the largest position, it is going in a positive direction, getting more organized, more creative, better all the time. This neo-Panglossian worldview comes, however, with an incredible expense, and this is where the tragedy lies. Clearly, in our century, with two world wars, a Holocaust, and our present ecological crises, it sounds obscene to be an optimist; but if you put this against cosmic evolution you get an optimism that is tragic.

AL: You seem to be moving toward a kind of post-modern spirituality. Is there a post-modern religion or god?

CJ: The French post-structuralists Kristeva, Irigaray, Derrida et al. are theorizing a space of opening at the end of thought that has overtones of spirituality, that is a clearing away of everything else. This is being thematized with religious and spiritual metaphors, and it is the way in which the sublime has a spiritual dimension. Perhaps they are backing into the church of post-modernism? They won't go in the front door because it is much too vulgar, and they don't believe that anything is very positive; but their double negatives are pulling them into the sublime. The restrictive post-modernists are positively trying to carve out what a spiritual practice would be today that either comes from science or is not immediately disproved by science. One account comes out of quantum physics on the microlevel and cosmology on the macrolevel; so these two sciences have spiritual implications, sharing the metaphor with an individual, self-organizing universe.

These ideas have been current since the seventies. The problem is that some of them have veered off into New Age mysticism.

AL: Is there a post-modern god?

CJ: Not in the sense of a Deist God, God the absentee landlord, God the creator of the fireball, God the external character who turns the pages of a book that is already written; that God is no longer with us. Post-modernists have stopped believing in that Sky God, and those who use the word God see it as a process of formation. We have now gone beyond the theistic and deistic gods, although David Ray Griffin, one of these theologians, would dispute this. He wants to have both a theistic god and a god who works through persuasion. What is clearly the case is that some post-modernists are talking about God, along with physicists such as Paul Davies, who is another key player in this game. He has written *The Mind of God* and *God and the New Physics*. A prominent scientist has written on "The God Particle." Every day there is another book on God and the new physics, and most of it is cynical, like Hawkings's books, because these scientists don't believe in God, nor are they remotely religious or spiritual. There is a lot of exploitation here, but I believe you have to talk about God because there is what is called "a God-hole." If nature abhors a vacuum, then culture abhors a lack of articulated spirituality, and, as T. S. Eliot wrote in 1934, people run *After Strange Gods*. These strange cults will move in where there isn't some kind of spiritual commonality that makes sense; so I don't believe we can get on with a "God-hole." The question is, what fills it?

AL: From what you say of the massive changes within post-modernism, you clearly don't see it as a completed project?

CJ: "The uncompleted project"—paraphrasing Habermas—the unfinished project of post-modernity? Definitely. We are in the first stage of post-modernism. Every five years there is a doubling of the post-modern literature. There is a kind of crazy logic that shows why the term and concept are gaining strength with every year and transforming themselves, as you said, so that whole fields such as "post-modern geography" come into existence. The explosion is incredible really, isn't it? There is a mad logic in it. It may be dying momentarily in architecture, because it became part of the establishment and ersatz; then, suddenly, this next field takes the ball and runs with it, and opens up a whole territory. Then you say the larger post-modern paradigm is bigger than all its subfields that may, however, retheorize, deepen, and broaden it. Again, I am a tragic optimist about post-modernism.

AL: More so than a romantic?

CJ: Insofar as I'm a holist I accept the romantic label for theorizing the post-modern. It was Whitehead who, in 1925, wrote the very important *Science of the Modern World,* thought to be the first post-modern,

philosophical tract (until Griffin and Umberto Eco pushed it back to Charles Pierce). Whitehead said of the romantics that, in an age of mechanism, they carry forward a whole discourse about a generative nature, a world soul. Schelling, Heider, Hegel and Blake, Wordsworth, Coleridge. Coleridge on the imagination has always been my bible for understanding the important value of imaginative transformation in the universe. I accept the label 'romantic,' except that it is so overladen with junk.

AL: Is there a connection between the ecological worldview and the "romantic"?

CJ: Yes, except that getting in touch with nature now is seeing, on occasion, how horrible and kitsch it can be. I annoyed some of my nature-loving friends by showing that flowers, sunsets, and rocks, for instance, invented sentimentality and kitsch well before we came on the scene.

AL: They are not sentimental and romantic in themselves.
CJ: Oh yes they are.

Crystal rock, base designed by
Charles Jencks, 1994.

AL: We've imposed that on sunsets?

CJ: No. You are putting the modernist position that value is only in the beholder as culture, but I think that it is much more complicated than that: the sunset is not just a social construction, nor is its sentimentality. Nature really does have bad taste built into its structure, which, after a time, any sentient creature is bound to discover. Bad taste, cliché, the one-liner, sentimentality, overkill, excess are real attributes and not our projections or constructions (although there is an irreducible cultural component to our perceiving these attributes). Roger Penrose, the physicist, inventor, and writer of *The Emperor's New Mind,* is another New Platonist who believes in objective qualities, but I don't know that he believes *ugliness* really is in nature.

Evil also has a tendency to emerge in nature. If you look at artificial life—that is, the creation of cellular automata inside a computer—and watch the artificial species mutate, the typical early evolution is that they follow beneficent rules; they are nice and symbiotic. Then one species mutates and the parasite is invented, a vicious creation that gobbles up the others and preys on the symbiotic society. The parasite is not programmed into the rules—it evolves itself and sucks out the creative DNA of the host. It's program is a reduced version of the benign species. Soon there are more mutations, more parasites, until the society is dominated by them. Such evolution reminded me of the activity I see in large corporations, daily life, and academia: people acting like this "game" of life. The implication is that evil (asset-stripping, antisocial behavior, parasitism) will always evolve. It is *not* just a projection. If the universe gave birth to us and parasites, and the universe is unfinished, then it can be improved. To speak metaphorically, there is evil and good built into the laws of the universe, an inevitable clash that species will feel *before* they understand and label them. Ultimately this could mean that we have a certain role in the universe: to improve, where we can, on the laws of nature. For instance, some of the genetic causes of sickle-cell anemia have been discovered, a condition that blacks suffer from more than other people. Now, perhaps, we can get rid of the natural genetic predisposition (which was a defense against malaria) and balance the positive and negative aspects of the way the cells defend themselves. By neutralizing the bad part we are changing nature for the better, and this is one of our roles. We can never control nature, but we can improve it in piecemeal ways.

AL: Or make it worse.

CJ: On another level, an improvement in one place leads to an imbalance elsewhere. But a post-modern morality of intervention has yet to be articulated. In effect, the post-modern paradigm is a "whole full of holes." It works as a whole structure, yet there are many parts that are incomplete. Because of redundancy a holistic structure can function even when

there are a lot of holes. Many of them are being filled as new areas are theorized, and new ways of life come into existence, but the post-modern paradigm is still dominated by the modern structure and its primary assumptions of economic man and Neo-Darwinism. I take it that your and my role, as that of the many emergent post-modern movements, is to fill out and repair the "holes."

CONTRIBUTORS

Paul Budra is Assistant Professor in the Department of English at Simon Fraser University, Burnaby, British Columbia. He is the co-editor of *Part 2: Reflections on the Sequel* (1998) and the author of articles on Shakespeare, Marlowe, nondramatic literature of the English Renaissance, and twentieth-century popular culture.

Thomas Carmichael is Associate Professor in the Department of English at the University of Western Ontario. He is the co-editor of *Constructive Criticism: The Human Sciences in the Age of Theory* (1995) and the author of a number of articles on contemporary American fiction and postmodern culture.

Thomas Docherty is Professor of English at the University of Kent at Canterbury. His books include *Reading (Absent) Character* (1983); *On Modern Authority* (1986); *John Donne, Undone* (1987); *After Theory* (rev. 2nd ed. 1996); *Postmodernism: A Reader* (1993); *Alterities* (1996); and *Criticism and Modernity* (1999).

Diane Elam is Professor of English Literature and Critical and Cultural Theory at Cardiff University. She is the author of *Romancing the Postmodern* (1992) and *Feminism and Deconstruction: Ms. en Abyme* (1994) and is the co-editor of *Feminism Beside Itself* (1995).

Henry A. Giroux is Professor of Education at Penn State University. His most recent books include *Postmodern Education* (with Stanley Aronowitz) (1991); *Border Crossings* (1992); *Between Borders* (1994); *Disturbing Pleasures: Learning Popular Culture* (1994); *Counternarratives: Cultural Studies and Critical Pedagogies in Postmodern Spaces* (1996); *Fugitive Cultures: Race, Youth and Violence* (1996); *Channel Surfing: Racism, the Media, and the Destruction of Today's Youth* (1997); *The Mouse that Roared: Disney and the End of Innocence* (1999); and *Stealing*

Innocence: Youth, Corporate Power, and Cultural Politics (2000).

Wendy Griesdorf is a Toronto lawyer. The essay included here was awarded the Barry D. Torno Memorial Prize in 1992 for its contribution to intellectual property law. She is also the 1993 recipient of the Torno Memorial Prize for her essay "The Laugh of the Hypertext" (1994).

Glenn Hendler is Assistant Professor in the Department of English at the University of Notre Dame. He has published articles on film, television, and nineteenth-century popular fiction and is completing a book titled *Public Sentiments: Fictions of the Public Sphere in Nineteenth-Century America*. He is also the co-editor of *Sentimental Men: Masculinity and the Politics of Affect in American Culture* (1999).

Linda Hutcheon is University Professor of English and Comparative Literature at the University of Toronto. She has written on postmodern literature and culture in such books as *Narcissistic Narrative: The Metafictional Paradox* (1980; rpt. 1984); *A Theory of Parody* (1984); *A Poetics of Postmodernism: History, Theory, Fiction* (1988); *The Canadian Postmodern* (1988); *The Politics of Postmodernism* (1989); and *Irony's Edge: The Theory and Practice of Irony* (1994).

Charles Jencks is the author of many volumes on postmodernism and architecture, including *The Language of Post-Modern Architecture* (1977; 6th ed. 1991); *Post-Modernism: the New Classicism in Art and Architecture* (1987); and *What is Post-Modernism?* (1985; 4th ed. 1995). He is also the editor of *The Post-Modern Reader* (1992).

Alison Lee is Associate Professor in the Department of English at the University of Western Ontario. She is the author of *Realism and Power: Postmodern British Fiction* (1990) and *Angela Carter* (1997) and is currently working on women's suffrage fiction.

Margot Lovejoy is Professor of Visual Arts at the State University of New York at Purchase. Her book, *Postmodern Currents: Art and Artist in the Age of Electronic Media,* is in its second, fully revised edition (1997). She is exhibited internationally and is the recipient of a Guggenheim Fellowship and an Arts International Grant. She has had many solo exhibitions, including those in New York City at the Alternative Museum; PS #1, the Institute for Contemporary Art; the Newhouse Center for Contemporary Art; the Neuberger Museum; and the Queens Museum. Apart from her work in multimedia installations, she has created several visual books. She is the author of articles and essays for critical journals, anthologies, and museum catalogs.

Peter Lunenfeld is a coordinator of the Graduate Program in Communication & New Media Design at Art Center College of Design. He is the founder of *mediawork:* The Southern California New Media Working Group and is the director of the Institute for Technology & Aesthetics (ITA). His column, "User," appears in the international journal *art/text*. He is the editor of *The Digital Dialectic: New Essays on New Media* (1999) and the author of *Snap to Grid: A User's Guide to Digital Arts, Media, and Cultures* (2000).

Bill Readings (1960–1994) was Associate Professor at Département de littérature comparée, Université de Montréal. He is the author of *Introducing Lyotard: Art and Politics* (1991) and *The University in Ruins* (1996); the co-translator of Jean-François Lyotard's *Political Writings* (1993); and the co-editor of *Postmodernism Across the Ages* (1993) and *Vision and Textuality* (1995).

Susan Strehle is Professor of English and Vice Provost for Graduate Studies and Teaching at Binghamton University. She is the author of *Fiction in the Quantum Universe* (1992) as well as several essays on contemporary writers.

Michael Zeitlin is Associate Professor in the Department of English at the University of British Columbia. He is the author of several articles on psychoanalysis and modernist and postmodernist fiction.

INDEX